Vermeer's Wager

Speculations on Art History, Theory and Art Museums

Ivan Gaskell

REAKTION BOOKS

In memoriam Salim Kemal

Published by Reaktion Books Ltd
79 Farringdon Road, London EC1M 3JU, UK

www.reaktionbooks.co.uk

First published 2000

Copyright © Ivan Gaskell 2000

Series design by Humphrey Stone

Printed and bound in Great Britain by Biddles Limited,
Guildford and King's Lynn

Colour printed by Balding & Mansell Limited, Norwich

British Library Cataloguing in Publication Data

Gaskell, Ivan
 Vermeer's Wager : speculations on art history, theory, and
 art museums
 1. Vermeer, Jan, 1632–1675. Wager 2. Art appreciation
 I. Title
 759.9′492

 ISBN 1 86189 072 9

Contents

With every stroke of the brush, a new field of enquiry is laid open.
WILLIAM HAZLITT

The enlargement of a snapshot does not simply render more precise what in any case was visible, though unclear: it reveals entirely new structural formations of the subject.
WALTER BENJAMIN

Acknowledgements

We hear that we may speak.
RALPH WALDO EMERSON, *The American Scholar*

This book is the result not only of a period of study leave in 1998–9, but more particularly of looking at, reading about, discussing and thinking about the paintings of Johannes Vermeer, photography and art museums, over a protracted period. I owe a great deal to friends and colleagues – artists, art museum scholars, art historians and philosophers – too numerous to name here. I hope those to whom I am indebted, but who are not mentioned, will forgive me.

The Harvard University Art Museums gave me three months of paid study leave and a further three months of unpaid leave in 1998–9 for which I am grateful to the director, James Cuno, and to my curatorial colleague, Sarah Kianovsky.

Michael Conforti invited me to be among the first Clark Fellows at the Sterling and Francine Clark Art Institute, Williamstown, Massachusetts in 1998. Participation in that programme, directed by John Onians, enabled me to advance this project immeasurably. I am grateful to Michael Conforti and the entire Clark staff, and also to Richard Brettell, Cao Yiqiang, Charles W. Haxthausen, Samuel Edgerton jun., Elena Sharnova and the Clark–Williams Program graduate students for informal exchanges, and for criticism following my presentation of some of the ideas that find modified expression here in papers delivered to the Clark Seminar, and the Williams College Art History Faculty Seminar, both in October 1998. In addition, I presented part of what here constitutes chapter 1 as a constituent of a paper delivered at the first Clark Conference, *The Two Art Histories: The Museum and the Academy*, in April 1999.

Two very generous friends were kind enough to read the first draft in its entirety. In a series of weekly tutorials Justin Broackes saved me from at least some philosophical solecisms

(I am wholly responsible for those that remain), while John Walsh offered criticisms that allowed me in particular to improve the art-historical and museological elements of the book. I am immensely grateful to them both.

Among others whose ideas, information and encouragement I acknowledge with gratitude are James Ackerman (for comments on drafts of chapters 8 and 9), David Bomford (for invaluable photography), Christopher Brown, Norman Bryson, the late Nelson Goodman, Ralph Lieberman, Neil MacGregor, Frits Scholten and Arthur K. Wheelock. My participation in the Harvard University *Mind/Brain/Behavior Initiative* interfaculty work group on 'The Experience of Illness' greatly stimulated my thinking. I should like to thank my fellow members and especially the group's chair, Arthur Barsky.

Part of what now constitutes chapter 3 first appeared as 'Vermeer and the Limits of Interpretation' in *Vermeer Studies* (*Studies in the History of Art*, LV) (Washington, DC, 1998), which I edited with Michiel Jonker. Some of the material that finds revised expression in chapter 8 was first published as 'Historia, historia del arte y museos: ¿Una conversación a tres bandas?' in *En la encrucijada de la cienca histórica hoy: el auge de la historia cultural*, ed. V. Vázquez de Prada, I. Olábarri and F. J. Caspistegui (Pamplona, 1998).

No one ever obliged anyone else to write a book. While Jane Whitehead and Leo Gaskell always come first in my life, for months at a time they allowed me to put this book before them. I can now put it before them in another sense, in what can only ever be partial and inadequate recompense.

Many of the ideas expressed here emerged from my work with Salim Kemal, my friend of many years and closest collaborator. Over the course of the last decade we produced six books together. He offered terrifying philosophical critiques of several of these chapters. His sudden and agonizingly premature death in November 1999 robbed his young children of a dedicated father, his wife of a devoted spouse and philosophy of a brilliant and endlessly curious mind. These pages are dedicated to his memory.

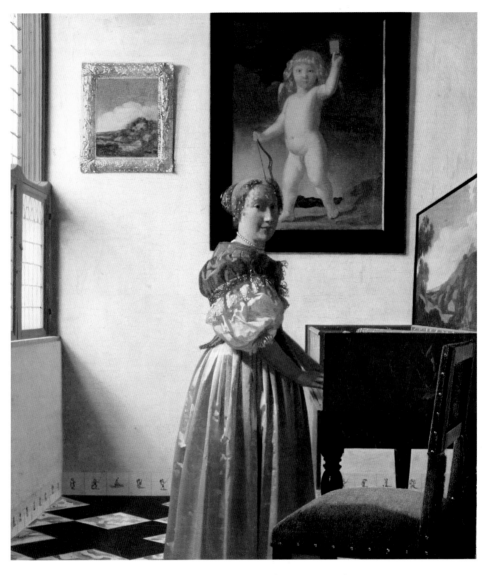

1 Johannes Vermeer, *Woman Standing at a Virginal*, c. 1672, oil on canvas, 51.7 × 45.2 cm. National Gallery, London.

Introduction

A prominent scholar who is a specialist in seventeenth-century Dutch art and who teaches at a university, but has privileged access to works of art, told me the following story. At the first meeting of each new seminar he brings a seventeenth-century Dutch painting into the room and introduces it to the seminar participants. He informs them that they will be spending the entire semester studying that one painting. His announcement is met with surprise, dismay and disbelief. People who are used to spending no more than three or four minutes before a painting on a museum wall, or viewing an image on a projection screen, can scarcely imagine what might hold their attention in just one painting, week after week. But at the last meeting of the seminar the same voices are raised: 'How can we stop now? We've only just begun to get to grips with this painting! We could go on for as many weeks again!'

This professor and his students had the advantage of being able to spend their weeks in intimate contact with an actual painting. In these pages I can offer only reproductions. None the less, I have been encouraged by my friend's example to discuss only one painting, confident of its inexhaustibility. Furthermore, the fact that it is unavailable to us in the present circumstances other than in reproduction becomes itself part of the story. One of the major themes of this study is the relationship in terms of use between works of art and their reproductions.

The painting for discussion is Johannes Vermeer's *Woman Standing at a Virginal* in the National Gallery, London. Normally we would accept this label without pause. Yet at the outset of this investigation we might do well to remind ourselves that the terms in play are not only art objects and their reproductions, but also talk about them. Those words – an artist's name and the title of a painting – are ostensibly a neutral designation. They exemplify one way in which we talk about works of art. If we pause to consider how we identify

paintings – that is, employ descriptive designations – we swiftly realize that the conventions we use embody values. These are themselves worthy of discussion for various reasons, not least because a seemingly neutral and informative description that we use to do no more than identify a painting unambiguously – we might think (misleadingly) to *name* it – typifies the involvement of the visual (the painting itself) with the linguistic (its identificatory description). The relationship between object and language – image and text as it is sometimes described – is one that will arise repeatedly in these pages and it is as well to be conscious of it at the outset. I attempt to deal with it initially in chapter 1.

The *Woman Standing at a Virginal*, ascribed unanimously in scholarly opinion over many decades to Johannes Vermeer, is the work that I have chosen to study. Why choose Vermeer? And, if Vermeer: why choose this work? Perhaps these questions are the wrong way round. Why choose this painting? My starting point is not an art-historical problem; nor is it a theoretical or philosophical question. It is far simpler than these things, and it is one that is shared by any number of museum visitors. My starting point is a response to a particular object, encountered in its actuality, on a museum wall. This object bewilders me. It quietly shocks me each time I see it. I turn away from it perplexed. It gets the better of me. I fear the confusion that overtakes me when I behold it. It evokes wonder in me, which itself is a bewildering and perplexing emotion.[1] This book is an attempt to deal with that confusion.

The *Woman Standing at a Virginal* is but a single case, though bewilderment of the kind that it arouses could result equally from encounters with numerous other art objects. Among those who deal with art professionally, admitting to, and then trying to deal with, that sense of utter inadequacy before a work of art is probably more urgent for curators than for anyone else. This sense of immediate inadequacy before art is what they share most profoundly with the museum visitors who are the viewers of their curatorial work. Art for curators is not a matter of theoretical or historical abstraction: it is a matter of present and urgent actuality. Where do curators and their peculiar concerns fit in with the larger art world?

The art world is made up of various institutions and interest groups. Seemingly disparate, it actually functions as a complex system with numerous interdependencies. The

institutions include art museums, auction houses, colleges and universities, and commercial galleries. The interest groups include museum personnel of various kinds, auction house personnel also of various kinds, dealers, collectors, agents, runners, consignors, professors, conservators and analytical scientists – even artists. Many within these groups like to have as little to do with each other as possible, and – on the face of it – succeed. They are woven together by webs of shared interest and competition, respect and contempt. In chapter 1, I demonstrate the complex and complete interdependency of the various categories of members of the art world.

Among these categories, curators have a particular set of concerns that arise from the particularity of their engagement with art objects in the setting of the art museum. This book is written from a determinedly curatorial viewpoint, though I am not the curator responsible for the *Woman Standing at a Virginal*. As far as that painting is concerned, I am three other things: an art historian with a special interest in the art of the Netherlands in the seventeenth century, a theorist with a special interest in aesthetics (though with no claim to philosophical competence beyond the elementary) and a museum visitor. Yet the questions I ask are all properly *curatorial* questions. This does not mean that they are exclusively so: curatorial scholarship overlaps the history of art and other disciplines, but is not in itself the history of art. Curatorial scholarship must deal with the here and now of those things that we designate works of art, or – more comprehensively – objects of sensually apprehensible interest. Curatorial scholarship is concerned with the current urgency of encounter between people and objects within the peculiar institutional setting of art museums. It can also be concerned with how those conditions relate to others: knowledge of objects differently mediated (by slide projectors or book illustrations, for instance); and with how we might best conceive of the boundaries – physical, conceptual, linguistic – of objects. This study is not a methodical exposition of my conception of the nature of curatorial scholarship, but it is curatorially driven. Each issue I raise in relation to the single work of art that is my case study is, to my mind, a *curatorial* question.

A note about 'I' and 'we' is in order. As has become far more common than used to be the case in scholarly writing, I sometimes use the first person singular. Many scholars find this

unnecessary, distasteful or even offensive; yet, first, it seems to me to be a matter of honesty in a text that is quite plainly to do with subjective opinion and firsthand impressions. As Henry David Thoreau reminds the reader in his own apology for the use of the first person singular in *Walden*, 'We commonly do not remember that it is, after all, always the first person that is speaking.'[2] Secondly, the first person singular helps me to guard against the imprecision that the use of the passive voice encourages.[3] Thirdly, the use of the first person implies that a concept of subjects as agents is in play. This is entirely appropriate because one of the major themes of this book is an examination of aspects of the definition of objects and subjects in relation to one another from a curatorial point of view. Successive chapters propose an ever more complex understanding of the constitution of the art object, and the book concludes with a consideration of some subjects who use them. Lastly, throughout the book I take 'we' to mean all of us who are competent participants in contemporary western hegemonic culture. A definition of 'us' pertinent to this case that incorporates a test might be those who recognize a painting in the European manner, and know how to use it appropriately.

What, then, is Vermeer's wager? To formulate it at all involves what Michael Baxandall calls robust inferential criticism.[4] I infer that Vermeer's art suggests, first, that it is possible to embody systematic abstract ideas that constitute methodical thought in purely visual form exclusively employing representations of plausible contemporary material reality. That is, after his early forays in history painting, he generally, though not invariably, eschews the seventeenth-century habitual visual codes of presenting abstract thought by means of the representation of either Christian sacred reality, classical mythological exemplification or personificatory allegory (found in the works of Peter Paul Rubens, for example) in favour of modern domesticity. Yet complex abstraction can result none the less. Through an examination of the *Woman Standing at a Virginal* I also infer, secondly, a further proposal on Vermeer's part: that we apprehend complex pictorial abstraction purely visually by means of the operation on the heart or soul directly through the eyes, evading language, in the manner of love. This is a concept with deep Platonic roots, as recollection of the *Symposium* and the

Phaedrus will confirm.[5] Thus through the love proper to art, on the part of artist and viewer alike, art can offer its wisdom, solace and reflection. This I take to be Vermeer's wager. It is not simply a matter of historical understanding: I take it to have urgent contemporary pertinence, as the discussion of therapeutics in the penultimate chapter demonstrates. However, in order to arrive at this understanding we must take account not only of the iconography and physical characteristics of the unique art object, but also of its afterlife, including its reproduction and incorporation within the art museum. Although to present these propositions as a wager is a dubious proceeding – after all, Pascal's wager is logically flawed – it has a certain rhetorical force.[6]

In exploring the dynamics of the peculiarly visual in Vermeer's art I am not denying the existence of deep structures of thought of a linguistic kind, though the subsumption of the visual by the textual – proposed by a preponderance of orthodox theorists – seems to me to be erroneous, for it involves an oversimplification of the artefact, and our responses to it. Jacques Derrida, whose work, directly or indirectly, has decisively shaped current orthodoxy, noted that a semiology that remained subordinate to linguistics must be inadequate, remarking that '*The linguistic sign remained exemplary for semiology*, it dominated it as the master-sign and as the generative model: the pattern [*patron*].'[7] I do not deny the applicability of semiotics – made familiar to orthodox theorists through the writings of Ferdinand de Saussure, C. S. Peirce and those, like Derrida, who have adapted them – to art objects, though I am sceptical of the applicability of a necessarily textual model of semiotics to such objects. As Martin Dillon has remarked, 'One way not to see the world is to read it as a text.'[8] More specifically, any schema that fails to account for infinite divisibility in the visual artefact – in every visual artefact – must remain incomplete. However, we should not dismiss a route to understanding based on the significatory structures by which works of art in part function. It can complement routes to understanding that depend on mimetic concepts of representation, on the one hand, and analysis of the material constitution of such objects in all its accidental specificity on the other. Therefore semiosis, mimesis and artefactuality all have a place in the examinations that follow.

In the course of these examinations I hope to convey a set

of ideas about the complex relationships among objects, between people and objects and among people mediated by objects. These, it seems to me, are among the fundamental relationships that govern the dynamics of the phenomenal world. The objects we understand as art play a particular role in these relationships. They permit and encourage thoughts that might not otherwise occur. They are constituents of our apparatus of social and ethical criticism. These relationships allow us to imagine the world – and shape the world – in ways that would otherwise be inaccessible to us. As Elaine Scarry has memorably put it, an artefact is a *'fragment of world alteration'*.[9]

I pursue these thoughts through a systematic series of examinations in the course of ten chapters. In chapter 1, I set out a number of fundamental problems concerning, first, the matter of naming and the related problem of the imbrication of the linguistic with the visual. The chapter concludes with a discussion of the 'Vermeerness' of Vermeer, the mystique of Vermeer and the interconnectedness of the art world (which has consequences repeatedly throughout the book). I propose that the knowledge of the artist sought by so many enquirers is of necessity fugitive, and of extremely limited extent. Vermeer provides such a fascinating test case in this respect because all the commentators have to go on is the paintings themselves. There is no serviceable corroborative evidence from other sources such as art historians habitually rely on.

Chapter 2 is concerned with pictorial interpretation. I look at the *Woman Standing at a Virginal* iconographically, in the mode that has become orthodox in Dutch art-historical studies. This turns out to be a productive exercise, in that it proves possible to relate the image to contemporaneous culture more thoroughly than heretofore. It turns out that this painting – like others of Vermeer's maturity – is itself about the art of painting as it relates to notions of love. Chapter 3 is an implicit criticism of the chapter that precedes it. The argument here is that no interpretation that fails to take account of the unique qualities of the painting *as an object* can fully satisfy critical scrutiny. I look at some aspects of what it means for the *Woman Standing at a Virginal* to be a three-dimensional object, and what the curator's role in presenting it might be. These considerations lead to a modification and enhancement of the interpretation of the painting offered in chapter 2.

A premise underlying chapter 3 is that there are qualities of objects that are peculiar to those objects themselves. They are not amenable to reproduction. None the less, it might be said that the case to be made for what I have termed Vermeer's wager, exemplified by the *Woman Standing at a Virginal*, as an exercise in art-historical understanding was completed at the conclusion of that chapter. Having examined the iconography of the work, and modified the resulting interpretation by referring to the work itself as a unique object, and thereby having proposed an interpretation consonant with late seventeenth-century ideas, what more is there to say? The chapters that follow seek to establish that art-historical retrieval, as it is often termed – the definition of what a work might have meant to its maker and original viewers – must take account of the afterlife of that work: that is, its changing use in the world between when it was made and the present moment. Part of that afterlife concerns the very development of the discipline of art history itself. Therefore chapter 4 examines the consequences of the premise that art history as a discipline has largely developed by concentrating on those qualities of objects that translate into reproduction. Using research conducted by the Getty Art History Information Program and the Institute of Research in Information and Scholarship at Brown University, I examine aspects of the internal contradictions of art historians' attitudes and practices regarding the use of reproductions. I discuss the varied character and application of photography in this context. The triumph of photography as a reproductive medium was neither inevitable nor uncontested in the nineteenth century. Yet it triumphed, and now, I argue, the scholar who studies an art object, such as the *Woman Standing at a Virginal*, no longer necessarily knows from whence any given impression of that painting derives: whether from scrutiny of the object itself, or from photographic reproductions of it. The *Woman Standing at a Virginal* can no longer be counted simply as a single thing. Rather, it is a complex nexus of prototype, material derivatives and knowledge.

We know precisely when, where and how the *Woman Standing at a Virginal* effectively entered the iconosphere (to use the late Jan Białostocki's term for the totality of art available to viewers at any given time). This occurred in Paris in 1866. Chapter 5 is an examination of that process, especially in

so far as it concerns the reproduction of the painting, and the emergence of a particular kind of empirical art-historical scholarship. The first occasion on which the painting was exhibited with others by Vermeer and the first reproduction of the painting, as an etching, are defining moments in its after-life that we must necessarily take into account even if our aim is to define a late seventeenth-century form of understanding.

Photography was of central importance in the emergence of empirical art history, and in chapter 6 I examine its role, and the place of both photography and the camera obscura as perceptually determinant instruments. The discussion necessarily explores the role of photography in art practice in some detail. I propose that not only can we no longer think of ourselves as dealing with one object when we discuss a single painting, but that the very mode of perception proper to one kind of visual object – the photograph – is inescapable when we turn our attention to another kind – the painting. Photography and photomechanical reproduction have permitted forms of commodification of that nexus of prototype, material derivatives and knowledge that constitutes the art object, comprehensively defined. In chapter 7, I examine this question of commodification and the status of the museum object as a particular kind of commodity. The changing nature of art as commodity is a vital part of the afterlife of any given work, and without taking this factor into account our understanding of the *Woman Standing at a Virginal* will be incomplete.

Having thus thoroughly complicated the procedure of perception as it applies to a single painting, I turn in chapters 8 and 9 to the institutional context that also affects our perception of such an object: art museums themselves. The fact that a museum object is a particular kind of commodity – as a prototype in one sense of the term and as a complex nexus in another – affects its relationship to the art museum as its framing institution. That relationship, and the uses to which the museum object is put, is in part determined by the finances of that institution, and by its relations with its donors. Chapter 8 is therefore concerned with the framing effects of a particular responsibility that art museums have: the accommodation of donors' interests. I discuss how this affects the use of objects within art museums, arguing that the *Woman Standing at a Virginal* has consistently been used well by those responsible. I contrast these uses with what I argue to be a poor use of

objects in another art museum. Although the claims I make are local, concerning good and bad curatorial practice, the introduction of an ethical dimension at this point is quite deliberate, as the discussion in chapter 9, of the therapeutics afforded by art museums and their contents, makes clear. Solace is not a purpose of art museums that is usually taken seriously. In this chapter I examine claims made for art museums as sites of beneficent security, despite any role they may have as instruments of social regulation, and contend that art museums have no higher purpose than to serve as therapeutic sites. This purpose of art museums itself necessarily affects the afterlife of the works within them, and this must be fully taken into account as we try to define our own position in relation to works of art and the understanding of them that we seek.

In the final chapter, I examine the subjects who use such objects as the *Woman Standing at a Virginal*, whether therapeutically or in other manners. I define four categories of viewers-as-subjects, which I describe in terms of their agency in relation to the objects to which they attend. This final examination of the definition of subjects and objects in relation to one another permits the presentation of a concluding proposal of the wager with which I begin. It pertains now not only to the ineluctability of the visual regarding art as a complex object of present attention, but also to the imperative of history as we face Vermeer's wager embodied in the *Woman Standing at a Virginal*. Relationships among objects, between people and objects and among people mediated by objects are diachronic as well as synchronic. Without the past we cannot imagine the future.[10] Those to whom the past is denied cannot change the world.

1 Problems

The first words of Arthur Wheelock's 1995 book on Vermeer are: 'A "Vermeer", like a "Rembrandt" or a "Van Gogh", is something more than a painting.'[1] Wheelock's just observation is not simply a matter of critical rhetoric. It is a matter of perception. That matter of perception has to do with how paintings are embedded in their institutional circumstances. Perception is equally a matter of how they are entangled with their verbal descriptions, with their reproductions and with the existing knowledge and conceptions of the viewers of both the paintings and their reproductions. It is also to do with names themselves. These entanglements are the subjects of this book. Let us begin with naming.

What we describe as a *Vermeer* has only recently become available to us in these terms. When, in the 1860s, Vermeer's art attracted sustained attention for the first time since his own lifetime (1632–1675) there was some doubt about his name. There are a number of other Dutch artists with similar names opening the way for confusion that persisted for decades.[2] Théophile Thoré (writing as W. Bürger) decided to call the artist whose revival he promoted 'Jan van der Meer de Delft'.[3] Only when archival research superseded deductive principles was 'van der Meer de Delft' succeeded by, first, 'Jan Vermeer' and, latterly, 'Johannes Vermeer'.

John Michael Montias, who has done more than anyone else to uncover the social circumstances of Vermeer's life and those of the members of his extended family, notes that Vermeer's baptismal name was Joannis, a Latinized form of Jan favoured by Roman Catholics and Protestants of prominent families.[4] His Christian name appears in subsequent documents as Joannes and Johannes, his surname as van der Meer and Vermeer. Vermeer himself did not use the form Jan. Montias suggested that Dutch authors dubbed him Jan to bring him closer to the mainstream of Calvinist culture, perhaps unconsciously.[5] Montias deals with the documented variants in the index of his book on Vermeer by referring to

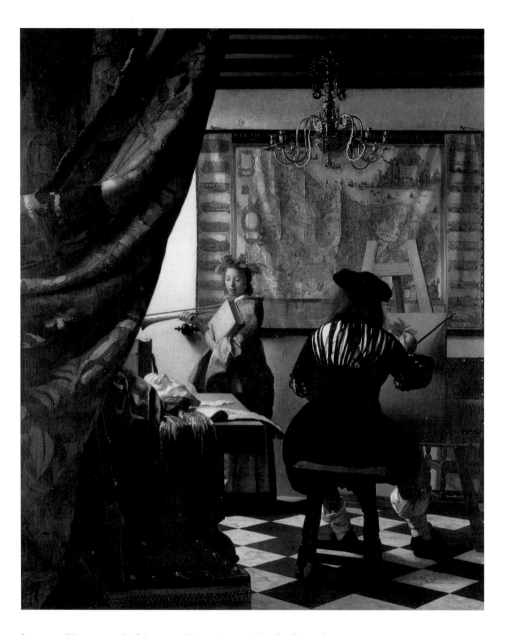

him as 'Vermeer, Jo(h)annes Reyniersz.' (including the patronymic), but I shall follow what has only recently become standard practice, and refer to the painter as Johannes Vermeer.

The names of paintings present different problems. Some works by Vermeer are referred to with what we take to be titles in early documents, but, even in these cases, there can be no certainty that they represent anything other than a

2 Vermeer, *The Art of Painting*, c. 1666–7, oil on canvas, 120 × 100 cm. Kunsthistorisches Museum, Vienna.

convenient description. The only exception is *The Art of Painting* (illus. 2), which, as Montias has demonstrated, Vermeer's widow, Catharina Bolnes, made great efforts to protect from her late husband's creditors. It was described in a notarial document of February 1676, just over two months after Vermeer's burial, as 'a painting done by her afore-mentioned late husband, wherein is depicted "The Art of Painting" ("de Schilderconst")'.[6] This title has now superseded that by which the painting was long known, *The Artist's Studio*. The circumstances suggest that *De Schilderconst* might have been how that painting was known to the painter himself.

The titles of all other paintings by Vermeer can be taken to be convenient descriptions, rather than titles in the modern sense. These descriptive titles none the less embody values and colour the way people look at the paintings to which they are applied. I have to refer to these paintings by titles (to use a museum accession number, or a catalogue raisonné number would be obfuscatory) so I have chosen to use those in the catalogue of the 1995–6 Vermeer exhibition in Washington, DC and The Hague, and the proceedings of the two symposia held on that occasion, published as *Vermeer Studies*.[7] This is purely a matter of convenience. The sole exception is our case study.

The 1995–6 exhibition title for our case study was *A Lady Standing at the Virginal*.[8] The title used by Neil MacLaren in his catalogue of the Dutch paintings in the National Gallery, London was *A Young Woman Standing at a Virginal*, and this was retained by his successor, Christopher Brown.[9] To make a social judgement about the person in the painting in its title seems pointless, so I reject 'Lady'; further, I see no point in making a judgement regarding her relative age, so drop 'Young'. I am left with the title that I use throughout this book, the *Woman Standing at a Virginal*. I set no great store by it. Like the other painting titles, it is no more than a convenience.

Before we turn to the problem of 'Vermeerness' and the mystique that surrounds it, it would be prudent to discuss some of the boundaries within which the entire enquiry will be conducted. These concern, first, what we might claim to know about artists through their work; secondly, the nature of the visually apprehensible object – the work of art – and by what means we might most conveniently analyse it; and,

thirdly, the limitations and opportunities that these conditions suggest.

A tacit assumption behind much writing about art is that our purpose is to know the artist's intentions and, thereby, the artist's psyche. Can we know artists through their work? Richard Wollheim has addressed this issue in a highly sophisticated manner in his study *Painting as an Art*.[10] I confess to being less optimistic than Wollheim about the possibility of knowing artists through their work. Even if this were possible, is it desirable? To risk a general observation, artists seem to be desperately remote from the art they make in the perception of those who apprehend that art. However, that distance – that unreliability of visual art as a tool of subtle or unambiguous personal communication – does not seem to vitiate the making of art as a project.

Although an oversimplification, we might consider in these circumstances art to be primarily artefactual rather than communicative. This is not to say that one cannot communicate visually; yet, generally speaking, the further towards the putative condition of art an object may be, the more idiosyncratic, obscure and subject to misunderstanding is its intentional communicative element. The use of language, too, can be more or less clear; though, when the visual and the linguistic are compared, we might (with various heavy caveats) claim more reliable knowledge of someone through what they write than through what they paint (sculpt, etch, photograph, etc.).

Writing can (though of course need not) convey information as unambiguously as human contrivance can allow. Visual sign making can convey information to a limited extent (hence the use of such signs to convey simple information where any given written language may not be comprehensible to all or to many people, as at airports). Writing can convey ideas equally unambiguously (though, once again, need not). Visual sign making can convey ideas unambiguously only at a remove. For instance, by painting a representation I do not thereby reliably convey a set of ideas about what is represented, though by means of shared visual conventions a viewer might justifiably infer ideas about choices among the protocols of representation available to me. To convey abstract ideas I must deploy representations within secondary systems of conventions that must be learned: conventions concerning

physical expression (for example, those codified by Charles Le Brun) and personification (such as those codified by Cesare Ripa). This is not to say that instances of visual representation are themselves in any sense transparent or natural. It seems more prudent, if less convenient, to treat as a cultural skill, rather than as an innate propensity, the ability to recognize, say, a tree in the contrived likeness of a tree, irrespective of whether or not this is actually the case. I suspect, though, that in the culture to which I belong (the Euro-American hegemony) mimesis, in the sense of an operative effect of transparency, and semiosis, in the sense of an awareness of shared conventions allowing sign recognition, are interdependent in any depiction.

Mimesis cannot usefully be reduced to the terms of semiosis, though there are those who insist upon it. They argue that the linguistic mode of analysis is indeed appropriate for discussion of all visually apprehensible, purposefully constituted objects, because any indexical characteristics (in C. S. Peirce's sense of the term, to denote a direct or motivated link between representation and referent)[11] are necessarily conventional. As Umberto Eco has put it:

> Everything which in images appears to us still as analogical, continuous, non-concrete, motivated, natural, and therefore 'irrational', is simply something which, in our present state of knowledge and operational capacities, we have not yet succeeded in reducing to the discrete, the digital, the purely differential.[12]

Whether or not Eco's assertion, based on what Peter Wollen characterized as 'a thoroughgoing binarism' in which the brain is conceived of as a computer,[13] is in the end accurate seems pragmatically beside the point. Its *effect* is Ptolemaic, for it anticipates ever more complex constructions within an existing paradigm to account for what might be described more persuasively by other means.

The description, let alone the explanation, of effects peculiar to the laying on and apprehension of glazes in oil paintings, or *pietra dura*, or veneers in intarsia, are not in practice conveniently reducible in their entirety to linguistic or even more generally semiotic terms. In questions of representation (or the creation and apprehension of likenesses) – itself a subset of objects of visual interest, but one which some

commentators erroneously assume comprehends all art worth discussing – the concept of mimesis is worth reconsidering as a possible explanatory tool, though as a complement to semiosis.

The consequence of these observations, for now, is that, in spite of the generative capacity of conventional iconography, accurate denotative abstraction is not directly available to the visual artist. Thus while I can write unambiguously and directly 'I am lonely', even with the most eloquent self-portraiture (or other visual representation) I cannot achieve the same in paint (or any other visual medium). The best I can hope for is the viewer's reaction 'He looks lonely', or 'He must be lonely.' This is an inference. The viewer's share in constituting meaning in a painting can profitably be thought of as different not only in degree, but in kind from the reader's share in constituting meaning in a text, so different from each other are the systems of signification.

There is a tendency in some recent writing about art to discuss objects of visual interest as texts. The justification stems from the application to the visual of linguistically focused semiotics. Semiotics can add much to the discussion of such objects, but language based entirely upon convention is but one subset of semiotics. Attention to this subset, predominantly by French and French-inspired theorists dominated by – as Martin Jay has demonstrated – a distrust of the visual,[14] has led to the subsumption of the entire field in its terms. Some commentators use the term *text* of an object of visual interest to signal a concern with it as a site of work, of contestation, of contingent constitution on the part of its beholders and users, as a fluctuating nexus. Thus it is to be distinguished from the object perceived as principally materially bounded, self-contained, essential, aesthetically constituted, passive and unchanging. While I have sympathy with the aim, to assign the term text to such objects is to swamp the visual with the linguistic. It is a form of catachresis, that is, 'the application of a term to a thing which it does not properly denote', in the words of the *Shorter Oxford English Dictionary*. As such, it is inhibiting rather than liberating, and indicates an unwillingness, or even an inability, to conceive and articulate in terms specific to the material.

Some would argue that the subsumption is not purely rhetorical, but describes a state of affairs in which all human-

made visually apprehensible marks do indeed constitute writing in a linguistic sense. Writing and object-making can indeed coalesce as somatic traces amenable to sexual, cultural and class differentiation – and have done from the *Book of Kells* to Mary Kelly. Yet the exclusive application of formulations developed to account for the linguistic to objects would seem to be as limiting as to discuss language predominantly in terms that we might aptly apply to such objects.

Many now think of the complex pictorial sign (which concerns us) as being made up of arbitrarily defined signifiers (which most resemble texts in their use), and indexical signifiers (in which recognition of any arbitrariness of composition is discouraged). The longevity of this conception is indebted, in part, to the considerable influence of the work of Jacques Derrida. Although Derrida is not uncritical of Ferdinand de Saussure's linguistics, the latter's conception underlies much of his own work.[15] Arguments have been advanced, notably by J. Claude Evans, that suggest serious flaws both in Saussure and, by transmission, in Derrida.[16] This is especially significant given the reliance of much subsequent theory on Derrida's model. However, it is largely beside the point in this context, because a third characteristic of the complex pictorial sign is what primarily concerns us here. I shall term this characteristic the *accident*. The importance of accidents is what James Elkins has identified as undermining purely semiotic accounts of art. 'If there is something partly irrational and opaque about the building blocks of signs', Elkins writes, 'then semiotics (and linguistic models in general) may appear more as simplifications than as adequate models.'[17]

In the reading of texts, the suppression of the recognition of visual variety generally operates, as Saussure demonstrated in the case of the letter *t*:

> The same person can write *t*, for instance, in different ways: The only requirement is that the sign for *t* not be confused in his script with the signs used for *l, d*, etc.[18]

Although there are occasions in which the specific visual character of calligraphy or typeface is valued differentially for its unique character (most notably in the Arabic script of a predominantly aniconic culture), our readings of texts usually depend on the suppression of that very individuality of the mark. Yet discernment of that very individuality is precisely

what counts so greatly in our viewing of art objects. And, as Elkins has pointed out, some of those marks are rationally unaccountable. They are part of the serendipity of making. They are beyond semiotics in terms of the analysis of the constitution of the object (though this need not affect a semiotic analysis of the uses of such an object, such as those offered by Roland Barthes, Jean Baudrillard and others). Those are the marks and forms that in the translation from the visual to the linguistic – the procedure that alone allows the kind of discussion that employs spoken or written language – constitute the untranslatable remainder of the purely visual. Inevitably they are of interest. To visual thinkers, such as artists and museum scholars, and to philosophers, it may even be that this untranslatable remainder is what is of greatest interest, owing to its being ineluctably distinct.[19]

Art historians might quite properly have other concerns. These include, first, those qualities of the visual that can be rendered adequately for the purpose of discussion in language, and, secondly, earlier talk about objects itself. Yet such qualities and such talk are no more inherently important or interesting than the linguistically inaccessible qualities of objects.

A suspicion of linguistic hegemonism leads me to be very cautious with regard to the term *reading* when applied to a visually apprehensible object. It is, however, a useful term, though my use of it is by analogy not with texts – as is the case in some studies – but rather with weather forecasting or stargazing. I *read* a painting much as I might *read* the sky.

A further argument advanced in favour of treating objects of visual interest linguistically is the imbrication of language with the visual from at least the moment of apprehension onwards. The assumption made is that we cannot think about the visual without using language, let alone conceive of it in discursive terms. The density and complexity of this interdependence cannot be underestimated, yet it does not in itself imply an absolute need for reductionism. It ought not to be beyond the capacity of language to permit discussion of non-linguistic phenomena in terms that admit of that distinction. While much of our talk about objects of visual interest is – as Michael Baxandall and others have pointed out – actually talk about thought about such things[20] (and therefore thoroughly linguistically implicated) this does not necessarily account for

either all our talk, or all our thought. Some thought (particularly that of artists and even of curators) is articulated visually. These articulations may themselves be amenable to semiotic as well as extra-semiotic discussion, so I am not claiming exemption for the visually constituted from linguistically related deep structures of thought.

Furthermore, it seems prudent to acknowledge the complexities of human response to objects of visual interest. We might bear in mind the likelihood that, even if modulated variably in accordance with distinct cultural conditions, we are, and always have been, prone to respond to such things in ways art historians, at least, are encouraged to disavow.[21] This is especially true of the subset that is in one way or another representational. Therefore, rather than adopt an unquestioningly semiotic strategy to deal with objects of visual interest, it seems more appropriate to treat them as complex artefacts. In doing so it would seem best to treat each not as discrete and circumscribed, but rather as having its life in a continuous complex dialectic with other complex artefacts, and with those who use them, including their makers.

This leaves us with the problem of what we might know of artists through their work. We rely upon inferential criticism.[22] We may be inclined to accept this, and collude tacitly to do so, fearing that its disqualification would impoverish the range of talk about art intolerably. Yet in all honesty we might acknowledge that robust inference could be mere flimsiness in terms of reasoning, and invention (however disciplined) in terms of criticism. That each inference is warrantable must be demonstrable.

One of the fields in which we may agree to collude in this manner is that of claiming to know artists from their work. Artists, of course, can join in the collusion and produce work designed to elicit the inference of emotional expression. To infer in this manner is to hold that the discernible trace of gesture in the art object is inadvertently or purposefully expressive of the artist's state of mind. In collusive work this becomes the basis of a set of conventions through which emotional states ostensibly informing the act of making are conveyed.[23] Thus Abstract Expressionism can be said to have functioned according to premises shared by its practitioners and their critics (pre-eminently Clement Greenberg), though its principles are inapplicable to earlier art. Furthermore, they

are obscure to us now in any precise sense, demanding critical acts of retrieval and historical understanding.

Vermeer's art has been discussed in terms of the artist's expression. His very lack of overt gestural expressiveness has been interpreted by Lawrence Gowing, and others, as inversely expressive. Taken together with its counterpart in Vermeer's subjects, this leads Gowing to infer character in an extraordinarily robust manner:

> The lack of facility in dealing with human issues, which emerges side by side with the elemental clarity of vision which is its counterpart, is the fundamental factor in the formation of his style. The lack itself is a common one. Vermeer's distinction is that, with the passivity characteristic of his thought, he accepted this part of his nature as a basis of the expressive content of his style. The instinctive seriousness of his assent to the requirements of his temperament is the sign of his genius. The lack of facility corresponds to a depth of feeling; his diffidence in dealing with the aspect of humanity is the measure of the meaning, which he attaches to it. The virtue in an artist is often like a bare nerve; sensitiveness may not only qualify but disable. In this Vermeer's development reveals, in microcosm, a situation in which more than one later painter has found himself.[24]

Inferring a quality from an absence is perilous reasoning, but can result in good fiction (a term never to be used slightingly).

Gowing would take us to the innermost intimacies of Vermeer's character by means of his art. I contend that this is not rationally possible because of the very nature of the material being used. I would argue that, where the application of specific conventions is not demonstrable, reliance on a general human understanding of represented gestures and facial expressions, and the association of states of mind with technical or stylistic features of the artefact, results in frail, ambiguous and uncertain deductions. In the case of Vermeer, certainly, I do not believe that such knowledge is reliably obtainable by means of scrutinizing art alone. In so far as I might claim to know Rubens as a person, it is through his letters, not his paintings and drawings, except to the extent that the latter are seen in the light of the former. The same is true of Van Gogh. The status of such presumed knowledge is itself

highly problematic, as various literary theories rightly warn. They hedge us with numerous qualifications so that nobody would read such texts as though they were transparently informative. However, at the very least, in relation to the extreme communicative ambiguity and complexity of the visually constituted art object, such texts can offer corroboration, whether in detail or general, of our visually derived inferences. A great part of orthodox art-historical method is quite properly to offer substantiation of inferences robustly drawn from the art itself by means of contemporaneous corroborative textual material: where appropriate, and often most persuasively, textual material produced by the same artists themselves. We put textual and visual material together, inviting a corroborative relationship to substantiate interpretative ideas about the latter. For instance, we feel that we have a clearer idea of what Poussin was up to (or at least thought he was up to – but that is another problem) thanks to his correspondence than we would have had his paintings alone survived.

In the case of Vermeer there are no such texts. There is no possibility of adequate corroboration, in spite of the very best efforts (which have been considerable and deeply rewarding) of archival researchers headed in recent years by John Michael Montias.[25] In Martin Kemp's words, 'The only substantial evidence of his [Vermeer's] intellectual life is provided by the paintings themselves.'[26] This might be thought of as a terrible disadvantage by those who highly value and rely upon corroborative relationships between visual and textual material for their interpretations. They are right, and they make earnest efforts to identify such material adequate to their methodological needs. Highly skilled scholars are tempted to draw inferences of character from what little there is. For example, from the fact that Vermeer corrected his name in two legal documents Albert Blankert suggested that he was obsessed with precision, drawing a parallel with the paintings themselves.[27] (What does it mean for an artist to be obsessed with precision? Was Vermeer any more so than Gerrit Dou, Peter Paul Rubens or Jackson Pollock?) This is flimsiness treated robustly indeed. Others, some of whom are less intellectually scrupulous than scholars of Blankert's calibre, in effect welcome the opportunity that release from the interpretative art-historical discipline of contemporaneous texts affords.

They present what at its best is robust inferential criticism (Lawrence Gowing, Harry Berger jun.),[28] but which in other cases can easily turn out to be no more than free association and fantasy.

Vermeer's case, therefore, provides as good an example as can be found in western art of freedom from directly associated texts. This is not to say that his art cannot be approached in association with contemporaneous texts. Such texts may demonstrably be amenable to connection with the paintings, whether generally or in specific instances (for instance, as when he can be shown to have referred to Ripa for his personifications), but none of these connections is firsthand. Unlike Poussin, or Rubens, we can only ever surmise what Vermeer was going on about from the paintings alone. Because of their ambiguity – well attested to in the cumulative record of interpretative effort – Vermeer remains not an enigma (for that term confers a particular status) so much as simply unknowable in any reliable sense. At least that is my hypothesis. Some may find this unduly pessimistic, even to the extent of threatening to curtail or vitiate the likelihood of interesting discussion. Yet I see it as positive. If we can understand our relationship to Vermeer's works, or at least to one work – for that seems an ambitious enough project to me – more clearly as a result of this enquiry I shall be satisfied.

With these qualifications and principles in mind, we can now ask what constitutes the 'Vermeerness' of a Vermeer, specifically the *Woman Standing at a Virginal*. I could not imagine encountering this painting without being aware of its association with its author. This is obviously not true of many paintings we encounter. Even auction house specialists, dealers and curators, who regularly confront the unknown, can find themselves in a church without a guidebook, or visiting a private house for purely private reasons. There they can be taken by surprise by a painting and suffer that anxiety of not knowing by whom it was painted when that fact is already established. This greatly embarrasses art historians, myself among them. One option, which art historians are trained to suppress, and which may be socially inconvenient on such an occasion, is to examine the work without seeking to identify it in terms of connoisseurship. If we do this, we may tend to focus on formal characteristics in accordance with the

remnants of our Modernist heritage, though this is only one possibility. However, it is not an option at all when considering the *Woman Standing at a Virginal*. Even if any of us might experience this painting, or any other by Vermeer, without initially associating it with that name, this state of affairs would not last long. Though we might still consider its formal characteristics, ignorance of its 'Vermeerness' can only be fleeting. One of the conditions of viewing this work from within western culture is that its substance is inseparable from Vermeer and 'Vermeerness'.

Why should this be? One reason has to do with art museums. Unlike the oeuvres of nearly every other western artist, all of Vermeer's unanimously accepted, known works have been formally institutionalized. Three paintings in private hands were recently acquired by museums: the *Portrait of a Young Woman* (illus. 41) by the Metropolitan Museum, New York in 1979,[29] the *Astronomer* by the Musée du Louvre, Paris in 1983[30] and the *Lady Writing a Letter with Her Maid* (illus. 30) by the National Gallery of Ireland, Dublin in 1993.[31] Only one work is left outside this international institutional framework. This is the painting traditionally known as *The Music Lesson* (illus. 60), belonging to Queen Elizabeth II of the United Kingdom whose vast collections are professionally administered within the royal establishment.[32]

The effect of this extremely unusual state of affairs is that one is far less likely to encounter a Vermeer unawares than to be struck by lightning. As many as ten paintings described as being by Vermeer that cannot be identified today are known from seventeenth- and eighteenth-century sources, though several of the more imprecise descriptions may actually refer to known works, while the association of Vermeer's name with others may be erroneous.[33] Their subjects include paintings of heads (the genre known in Dutch as a *tronie* and in eighteenth-century England as a 'fancy head'), the Three Marys at Christ's tomb, a self-portrait in a room with accessories, a man washing his hands with a view through to a further room with more figures, a view of houses and a woman combing her hair.

The possible existence of these – to all intents and purposes – phantom works itself enhances the mystique surrounding Vermeer, and that mystique can in turn heighten other mystiques. The reputation of great dealers, for example, is

enhanced by a mythology surrounding the depth of their tightly guarded and largely secret inventories. None has been more carefully preserved over the decades than that of the Paris and New York firm of Wildenstein. Given the smallness of Vermeer's known oeuvre and its distribution exclusively among great institutions, to be rumoured to have a secret Vermeer in one's inventory is to enjoy ultimate status of this kind. When in 1998 the Wildenstein firm and family incurred damaging press attention, the rumour surfaced that the firm has a long-held Vermeer in its stock.[34]

For the Vermeer mystique to operate in the art market, and hence, to an extent, in the museum world and in popular perception, it is extremely important that Vermeer's oeuvre should not be closed. Anyone with the right connections and sufficient means can buy a Poussin or a Rembrandt. Plenty of Rembrandts remain in private hands, and Poussins are discovered regularly, if not frequently. In recent years, though, only one candidate has been seriously and publicly advanced for Vermeerhood: *Saint Praxedis* (illus. 3). A brief account of what can be reconstructed of the discovery of this work may prove instructive.[35]

In 1969, Howard Hibbard, a professor of art history at Columbia University, organized an exhibition of Florentine baroque art as a student exercise. It was held at the Metropolitan Museum, New York between 16 April and 15 June 1969. A graduate student, Joan Nissman, catalogued the paintings, for the preparation of the exhibition was a pedagogic exercise. Among them was *Saint Praxedis*, which had been in a New York private collection since 1943, its earlier history being unknown.[36]

Saint Praxedis was published in the exhibition catalogue as being by Felice Ficherelli, called 'Il Riposo'.[37] Nissman noted in her entry:

> Although stylistically like other paintings by Ficherelli, the *St. Praxedis* bears the signature of a more illustrious painter, Jan Vermeer (*Meer* 1655). The inscription has been examined scientifically[38] and appears to be part of the paint structure. If authentic, this would be the earliest dated painting by Vermeer.

It was not long before a dealer acted on the information. By June 1969 – that is, before the close of the exhibition – *Saint*

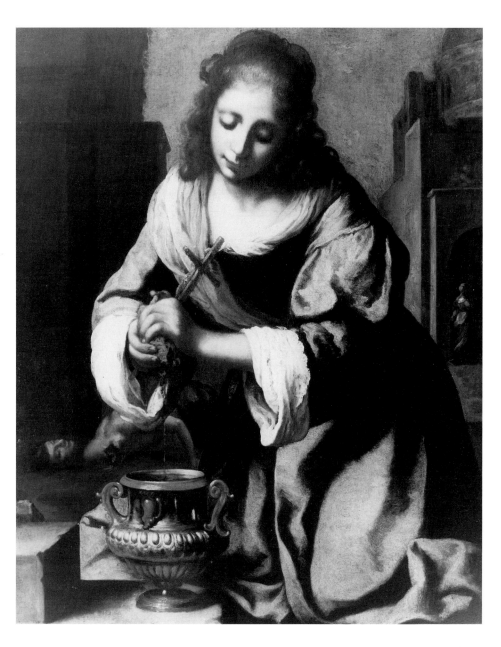

3 Attributed to
Vermeer, *Saint Praxedis*,
1655, oil on canvas,
101.6 × 82.6 cm.
Barbara Piasecka
Johnson Collection
Foundation,
Princeton, NJ.

Praxedis was published and illustrated in an advertisement supplement to the *Burlington Magazine*, 'Notable Works of Art now on the Market' (pl. 33) where it was unequivocally described as '*St Praxedis* by JAN VERMEER of Delft. Signed and dated 1655'.

The new owner was the New York dealer, Spencer A.

Samuels & Co. Ltd. The text in the *Burlington Magazine* supplement – presumably provided by the advertiser – makes an obeisance to caution with the phrase, 'The signature (if it really is his) of Vermeer appears lower left', but continues: 'One can imagine how anxious art historians would be to see it cleaned away – but it has triumphantly resisted their determined destruction.' (The peculiar syntax makes one wonder if the writer had the destruction of nay-saying art historians in mind, rather than that of the signature: an index of the passions involved, but usually concealed, in such circumstances.)

In the same issue of the *Burlington Magazine*, Michael Kitson of the Courtauld Institute of Art, University of London reviewed the exhibition at the Metropolitan Museum enthusiastically.[39] It is quite clear that the anonymous author of the Samuels advertisement had access to Kitson's positive opinion of the new putative Vermeer prior to its publication. It refers the reader to Kitson's review and incorporates his arguments. These are, first, that Vermeer is more likely to have seen Italian works in Holland than he is to have visited Italy (as Nissman suggested); and secondly – and more importantly – that Vermeer drew on a work by Andrea Vaccaro for *Christ in the House of Martha and Mary* which both Kitson and the anonymous writer cite as circumstantial evidence in support of attributing another work presumably derived from an Italian baroque prototype – Saint Praxedis – to Vermeer.[40]

Kitson's statement relating *Christ in the House of Martha and Mary* to an unspecified Vaccaro is an extremely abbreviated reference to a complex argument about Vermeer's early prototypes that had been conducted in the literature for some years.[41] Had the author of the Samuels advertisement come to this opinion by means other than Kitson's text it would have been readily apparent.

However, Samuels's gamble in acquiring *Saint Praxedis* in 1969 did not pay off for many years. It found little favour as a Vermeer.[42] The painting next surfaced when Samuels opened a refounded gallery in new premises in New York in November 1984. On that occasion it was confidently described in the catalogue as by 'Jan Vermeer van Delft'.[43] The entry also disclosed that the opinions of two conservation specialists – Hermann Kühn[44] and Stephen Rees Jones – had been sought. Kühn supplied a written report of his technical examination of *Saint Praxedis* which, one can infer from the

catalogue, included paint and ground sample analyses, X-radiography and infra-red and ultra-violet photography.

The dealer's carefully prepared unveiling of the painting after fifteen years in seclusion apparently led to renewed attention. In 1986 the highly respected Vermeer specialist, Arthur K. Wheelock jun., curator of Northern baroque paintings at the National Gallery of Art, Washington, DC, published the first major scholarly study of *Saint Praxedis*. He had first examined the painting early in 1984, at which time it was not actively on the market.[45] He concluded: 'It deserves to be recognized as an important addition to the body of Vermeer's work.'[46] Wheelock, long engaged in a thorough firsthand examination of paintings in Europe and America by, and attributed to, Vermeer, with the participation of conservators and scientists, set out his arguments with great care and probity.[47]

Whether or not as a result of Wheelock's published opinion, Barbara Piasecka Johnson acquired the painting in 1987.[48] Johnson was then assembling a significant collection of predominantly religious art. A considerable number of works from the Polish-born Johnson's collection, including *Saint Praxedis*, were exhibited in Warsaw in 1990.[49] A year later *Saint Praxedis* was exhibited in Cracow, the subject of yet another publication in which a repeat of Wheelock's 1986 article was supplemented with other material, including further technical data.[50] This occasion permitted a direct comparison to be made between the painting attributed to Vermeer and the Ficherelli prototype and was of considerable scholarly value. Both exhibitions and their publications were the responsibility of the Institut IRSA, a Liechtenstein corporation, and its director, Józef Grabski. IRSA is also the publisher of the journal *Artibus et Historiae*, in which Wheelock's crucial article had appeared, and Grabski is its editor. What interests were at stake, and how and when they became intermeshed, cannot be ascertained from published sources, yet it must be uncontentious to assume that it was quite understandably to the advantage of both the dealer and the new owner to establish the Vermeerhood of *Saint Praxedis*. Whether or not Wheelock's disinterested scholarship was unwittingly caught up in the pursuit of other agendas that may or may not have involved the new owner and IRSA is impossible to determine.

The way seemed clear for *Saint Praxedis* to take its place in

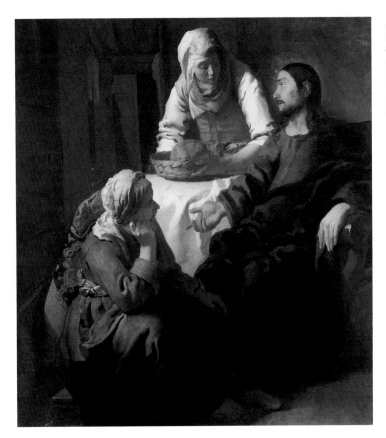

the great Vermeer exhibition held in Washington and The Hague in 1995–6. Indeed, the painting duly appeared in the company of the two early history paintings with which it had by then frequently been compared, *Diana and Her Companions* (Royal Cabinet of Paintings Mauritshuis, The Hague) and *Christ in the House of Martha and Mary* (illus. 4). In the catalogue Wheelock once again made the case for the attribution, as he also did in his book on Vermeer published at much the same time.[51] In the eyes of many scholars *Saint Praxedis* cannot be said to have survived the comparison.[52] The then chief curator of the National Gallery, London, Christopher Brown, noted in the *Burlington Magazine* that comparison with Vermeer's *Christ in the House of Martha and Mary* must be 'the acid test'. He wrote: 'There is nothing in the comparison to convince the sceptic that this really is Vermeer's earliest work; indeed, the comparison works against the attribution to Vermeer.' He concluded: 'Indeed it is not absolutely clear to

this reviewer that the painting is Dutch rather than Italian.'[53] Although the work has its defenders as a Vermeer, the painting was dismissed from his oeuvre – rightly or wrongly – by all who considered it in the proceedings of the symposia held during the exhibition.[54]

The point at issue here, however, is not whether the work actually is or is not by Vermeer: the truth of such matters is not decided by majority vote, though the aggregate weight of scholarly opinion will in practice rightly or wrongly determine the issue (though it is always subject to change).[55] Rather, the point to stress here is that a candidate for Vermeerhood *can* be found and *can* have a decent run at achieving it. Were another candidate to be found – and it is part of the mystique surrounding Vermeer that this is far from being out of the question – we might expect a similar bewildering mixture of high scholarship and dealers', collectors' and publishers' manoeuvrings to accompany the discovery.[56] For in this case we can see how academics (as conceivers of pedagogical exhibitions and as reviewers), museum scholars (as exhibition organizers and as attributers), conservators (as mythically imbued objective scientists), dealers (as business people trying to steal a march on their competitors and make a profit), editors (as controllers of the medium by which discussion occurs and decisions are ratified) and collectors (with agendas of their own) can all find their interests intersecting.

Let us not be deluded into thinking that anything faintly disturbing about it can be blamed solely on the corrupting power of commerce which in turn affects art museums and the scholarship conducted within them. *All* the parties – dealers, collectors, museum scholars, conservators, academics and editors – *together* constitute the system as it functions. One cannot lay blame for supposed corruption of the intellect at the door of a single party, for all are equally responsible. Those who discuss art professionally but, like some academics, who fancy themselves outside this system delude themselves. They play as great a role in fostering confidence and credulity as anyone else involved, for, in the art world as in any capitalist market, confidence and credulity go hand in hand.

Saint Praxedis may be the latest and the only recent serious example of a candidate for Vermeerhood, but we would do well to recall that the status of each and every work that we

now confidently attribute to the artist had once to be established. This includes the painting that is our case study, the *Woman Standing at a Virginal*.

The establishment of the mystique that surrounds Vermeer's name and work was brought about by a combination of circumstances that look like serendipity on the one hand, and hard work on the other. Much of that hard work, achieved over generations, consisted in the definition of an oeuvre.

An account of the creation of that oeuvre will have to be postponed,[57] though we might note that the corpus as we now think of it was in nearly every respect established by Ary Bob de Vries in 1948.[58] The works rejected by de Vries, like others rejected earlier, faded from even marginal consideration. In his 1952 book, *Vermeer*, Lawrence Gowing set the example followed by nearly all subsequent scholars by not even listing rejected works, as de Vries had done, in his catalogue.[59] Vermeer's achievement had been as good as defined, though to assume this was how things were viewed in the 1950s may, to some extent, be the result of the benefit of hindsight. Ben Broos has quite plausibly argued that uncertainty about the corpus resulting from its severe pruning was not finally laid to rest until the publication of Albert Blankert's book on the artist in 1975.[60]

The most dramatic aspect of the pruning of Vermeer's oeuvre concerned the identification of forgeries. The growth of his reputation in the first 30 years of this century led to fraud being committed. Arthur Wheelock has recently proposed the Dutch dealer, Theodorus van Wijngaarden, as the likely perpetrator of two Vermeer forgeries. Discovered and proclaimed to be Vermeers by leading scholars in 1926 and 1927 respectively, the *Smiling Girl* and the *Lacemaker* were both given to the National Gallery of Art, Washington, DC by Andrew W. Mellon in 1937. De Vries published his doubts about their presumed status in 1939,[61] and they were no longer unequivocally discussed as being by Vermeer thereafter.[62]

Considerably better known is the case of Han van Meegeren. It has been recounted many times.[63] Charged immediately after World War II with collaboration with the Germans (specifically with supplying a Vermeer to Hermann Goering), van Meegeren claimed to have forged not only that work (*Christ and the Adulteress*), but a number of other paintings accepted as Vermeers, including most notably the *Supper at*

Emmaus, which had been acquired by the Boymans Museum, Rotterdam in 1938. He convinced sceptical authorities of his claim by painting a further fake Vermeer. Charges of forgery and fraud replaced that of trading with the enemy, and, although he died soon after his conviction in 1947, he had succeeded in severely embarrassing and compromising the reputations of the distinguished specialists who had unquestioningly accepted his forgeries as real Vermeers. In doing so van Meegeren himself acquired a lasting mystique that in a sense is the obverse of that of Vermeer. Once Vermeer's oeuvre had been purged of van Meegeren's forgeries, it acquired a new purity, for in retrospect the forgeries were obvious, at least to the generation of specialists that succeeded those who had been duped and whose stylistic assumptions and 'blind spots' were different. The eventual consequence of the van Meegeren affair was to deflate the reputation of specialist scholars, while enhancing the mystique surrounding Vermeer's name.

That mystique is such that it now seems uncontentious that Vermeer has overtaken Rembrandt as the supreme Dutch artist of the seventeenth century – the cynosure of that culture – in informed public opinion. Why should this be the case?

If Rembrandt, imagined as an intense emotionalist, appealed to a Romantic conception of the artist that prevailed popularly until recently and still has a certain currency, then Vermeer is the very opposite. He was apparently self-effacing and undemonstrative, a sensitive and methodical person, who today might have been a brilliant computer software designer. If we use the metaphor of sound so beloved of even scholarly commentators, while paintings by Rembrandt encompass the entire dynamic range, from raucous shouting to quiet whimpers, those of Vermeer 'exude silence', a frequently used critical trope.[64] Many viewers understand Rembrandt to be always forcefully present in his works, whether in self-image or painterly touch.[65] Vermeer seems to many to be either utterly aloof, or so enwebbed within his works as to be indecipherable in any realistic sense. Allied to this are, on the one hand, Rembrandt's forthrightness about his own image and, on the other, Vermeer's reticence.

If we know what anyone looked like from his self-portraits we know what Rembrandt looked like. We see him contrive depictions of himself in innumerable moods and roles.[66]

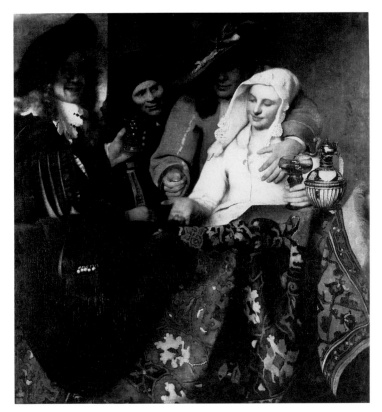

5 Vermeer, *The Procuress*, c. 1656, oil on canvas, 143 × 130 cm. Staatliche Kunst-sammlungen (Gemäldegalerie Alte Meister), Dresden.

Vermeer, however, remains unseen, as far as we know. Commentators have tried to identify him – with the painter seen from behind in *The Art of Painting*, and with the man on the left meeting our gaze in the *Procuress* (illus. 5) – but doubt or disbelief are the prudent responses to both these suggestions. A self-portrait may have existed – at least a painting that was described in the seventeenth century in those terms – but if indeed this was the case, it is lost.[67] We have no idea of Vermeer's physical appearance. His gaze never certainly nor unambiguously meets ours from canvas or panel. Rembrandt's is the mystique of the role player, the actor: a public mystique. Vermeer's is the mystique of a deity, extremely economical with his self-image: a mystique of simultaneous personal withdrawal and impersonal permeation. In an age in which the preservation of privacy on the part of figures in the public gaze is largely unattainable, Vermeer's apparent situation represents an ideal fantasy for those who would have renown, but not its concomitant inconveniences.

A further issue that separates Vermeer from Rembrandt to the relative advantage of the former's reputation concerns authorship. Ironically, the most sustained and concerted attempt to establish Rembrandt's painted oeuvre yet undertaken has had the effect – for now, at least – of contributing to the diminution of his reputation. The Rembrandt Research Project and its critics have evoked more doubts and fears than reassurance. As we have seen, Vermeer's corpus, in contrast, is as secure as any.

Furthermore, that corpus comprises paintings alone, and in public estimation paintings – not drawings or prints – are important art. Unlike that of Rembrandt, Vermeer's oeuvre is undiluted by works on paper that seem merely to distract attention from what really matters to most viewers. The economy of the corpus – a maximum at present of 36 known works – recommends itself to those who would encompass a total career achievement. Furthermore in Vermeer's work, unlike that of Rembrandt, there is little classical mythology or overt religion. Domesticity is preponderant, and this has a complex ideological appeal. Women see themselves taken seriously; men see their surrogate wives and daughters treated respectfully in safe roles.[68] Even Vermeer's treatment of lasciviousness is decorous to the point of prudishness, as can be seen in his handling of the *Procuress* in comparison with those of his Utrecht predecessors.[69] Lastly, to appeal to intellectuals, we have work that lays itself open to convenient theorizing (as we shall see), and we have the ultimate dead author (in Roland Barthes's terms) who transcends his creations and evades our grasp.[70]

The perceived homogeneity of Vermeer's oeuvre also contributes to the mystique with which he and his works are imbued. Although that perceived homogeneity dissipates when one begins to attend with care to the paintings, there is an important sense in which the total achievement seems none the less greater than the sum of its constituent parts. Arthur Wheelock expressed it thus: 'Although the individual paintings are well known, their cumulative impact is all the greater because the stylistic and thematic relationships among them reinforce and enhance each work.'[71] As we view each painting by Vermeer, our memory is at work, relating it to qualities perceived in other paintings by the artist. One result is the acquisition of a sense of the harmony of Vermeer's life's

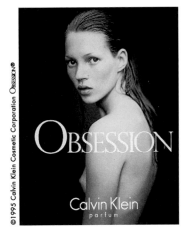

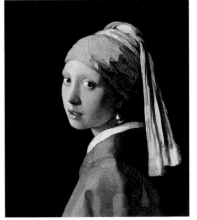

6 Advertisement for Calvin Klein's 'Obsession'.

7 Vermeer, *Girl with a Pearl Earring*, c. 1665, oil on canvas, 46.5 × 40 cm. Royal Cabinet of Pictures Mauritshuis, The Hague.

work, which is quite unlike that of any other artist. This, too, engenders mystique. This is a complex matter concerning the effective boundaries of objects, how we know objects and what viewers bring to objects, to which I shall return.

Contrivers of other images can play on memories of works by Vermeer, which in turn enhances mystique. This is nowhere more apparent than in advertising. An example is Mario Sorrenti's photograph of Kate Moss for an advertisement for the scent 'Obsession' (illus. 6). Her pose, meeting the viewer's gaze over her left shoulder while her hair falls down her back, reminds us of the *Girl with a Pearl Earring* (illus. 7).[72] As an image the advertisement works on two axes. First, it takes its place in the widely distributed repertory of commercial and media images of a super-model whose celebrity has been carefully manufactured. Simultaneously, it tunes into a set of contemporary responses to a Vermeer painting that itself has been all but subsumed by its identity as a mass media icon. One result of this complex exchange, as far as our perception of the Vermeer is concerned, is that the painting, or, more specifically, images of it, obtains a gloss of commercially derived glamour and super-model mystique. One might even say that Vermeer becomes a kind of fashion photographer in retrospect, a subject to which I shall return in chapter 6.

In the next chapter, though, I shall look at how we might approach Vermeer's *Woman Standing at a Virginal* from an orthodox, but productive art-historical point of view as we look at its subject and what might be said about it in relation to the culture of the time and place of its making.

2 Images

Vermeer's paintings have been thought to be about any number of things. The images have long been discussed in terms of form, style and subject matter. There are those who have thought of Vermeer's paintings predominantly in terms of the geometry of their design and who stress the abstract quality of their compositions. Vermeer has even been viewed as a forerunner of Piet Mondrian. Such a high Modernist approach, in which the subject matter of the image is secondary, has been largely displaced in the scholarship of the last quarter-century by a concern with iconography.[1] Iconography is the principal subject of this chapter.

Scholars have discussed the subject matter of Vermeer's paintings in a range of manners, from the poetically associative to the strictly iconological. In the case of the *Woman Standing at a Virginal*, however, discussion of the subject matter has always turned to love.

The very first published discussion of the painting – that by Théophile Thoré, writing as W. Bürger, in 1866 – proposed love as its theme.

> In . . . *Young Woman at a Harpsichord* the head is defined against a picture representing Cupid who rushes up with a letter in his hand. Love is scampering to her within her head. Undoubtedly he is on his way to bring her some love letter. Innocently disturbed, she hopes, she begins to play her piano – while awaiting love's coming.[2]

Most subsequent writers have followed suit, though not always proposing simple or coy explanations. For Lawrence Gowing this woman (and others) only had anything to do with love in so far as she represented the artist addressing his own fear of woman as a threat in part erotically defined. In Gowing's penetrating, subtle, yet ultimately unsubstantiated interpretation of Vermeer's oeuvre, the *Woman Standing at a Virginal* is a culminating work, a profound elaboration on what has gone before, concerning the 'remarkable order

which he extracts from the world, his elaborate evasion of its human claims, suggest[ing] the imminent possibility of opposite qualities, a fearsome anarchy, a formidable, exigent principle not to be trifled with'.[3] For Gowing the woman embodies those principles with which the painter finally brings himself face to face after a career of oblique approaches that began with the Dresden *Woman Reading a Letter by an Open Window*. Gowing concludes:

> The painter's style develops along a line of self-preservation; its infinite ingenuity is all directed to isolating from these latent, intimate perils the visible beauties among which they hide . . . Her presence has the force of a challenge. The picture has no other theme.[4]

In contrast, Neil MacLaren, who catalogued the painting for the National Gallery in 1960, was guarded about its pictorial meaning. He tentatively identified the object held by Cupid as a playing card, rather than a letter, and wrote 'and if so the picture presumably symbolizes the hazards of love'.[5] Whether considering that object to be a playing card or letter, and however transformatively, however guardedly, commentators on this painting invariably consider it in relation to the subject of love.

A cursory consideration of interpretations of the subject of the *Woman Standing at a Virginal* shows that it and the other paintings of Johannes Vermeer pose in acute form a problem that has dominated the study of seventeenth-century Dutch art for many years concerning the nature of pictorial meaning. Once taken to be reliable transcriptions of a presumed actuality, from the early 1960s onwards such paintings were asserted by various scholars to have an allusive, allegorical or emblematic character. A prevalent literary genre, derived from sixteenth-century Italian prototypes, the emblem book consisted of prints each accompanied by a motto. The association of the brief text with the picture encapsulated a conceit, often in Dutch practice moral in nature, at times ostensibly derived from classical learning, or embodying proverbial wisdom. Commentaries elucidating the associated image and text that formed the emblem often accompanied it. The association by scholars in the 1960s and 1970s of such emblems in contemporary illustrated emblem books with paintings that resemble those illustrations was sometimes too formulaic.

This prompted a reaction in which other scholars stressed the visually descriptive quality of paintings, both in pursuit of a pictorial goal in its own right, and as a means of knowing the world.[6] How are we to place Vermeer's works, notably the *Woman Standing at a Virginal*, in this interpretative context?

Vermeer's paintings form a far from homogenous group. They were presumably made over a period of little more than twenty years, between his entry as a master into the Delft Guild of Saint Luke in December 1653 and his death in December 1675. They include the historically imaginative (such as *Christ in the House of Martha and Mary* in the National Gallery of Scotland, Edinburgh), the overtly personificatory and allegorical (such as the *Allegory of Faith* in the Metropolitan Museum, New York and *The Art of Painting* in the Kunsthistorisches Museum, Vienna), the plausibly realistic, such as his two cityscapes (the *Little Street* in the Rijksmuseum, Amsterdam and the *View of Delft* in the Royal Cabinet of Pictures Mauritshuis, The Hague) and the majority of his scenes of domestic interiors with between one and three figures. Among them are works that appear to be hybrid: that is, paintings that seem to combine the characteristics of the plausibly realistic with the allegorical or emblematic. These include the *Woman Holding a Balance* (National Gallery of Art, Washington, DC) and the *Woman Standing at a Virginal*.

The relationship between the ostensible depiction of a presumed actuality on the one hand, and allegory or emblematic allusion on the other – such as we might assume to be the case in the *Woman Standing at a Virginal* – remains problematic. Scholars have related such paintings to prints in contemporary emblem books that are accompanied by mottoes and verses that together produce a didactic, ethical or proverbial conceit. They hold those emblems to be the key to the pictorial meaning of the paintings themselves. Although not the first to explain Dutch paintings by pointing to such presumed relationships, Eddy de Jongh has been the most effective proponent of this interpretative method.

In 1967 de Jongh proposed an interpretation of the *Woman Standing at a Virginal* by relating it to an emblem with the motto, 'A lover ought to love only one', in Otto van Veen's emblem book of 1608, *Amorum Emblemata* (illus. 8).[7] De Jongh's proposal was taken up without question in the catalogue of the 1995–6 Vermeer exhibition:

8 'A lover ought to
love only one',
from Otto van Veen,
Amorum Emblemata
(Antwerp, 1608).

Contemporary viewers would have recognized the icono-
graphic source for Cupid as an image from Otto van Veen's
emblem book *Amorum Emblemata* of 1608. Although Van
Veen's image is more detailed – Cupid holds aloft a card
containing a laurel wreath and the number '1' while step-
ping on another card containing multiple numbers –
Vermeer clearly intended the painting to convey the same
sentiment: 'a louer ought to loue only one'.[8]

De Jongh himself had been a trifle more cautious in his
assumptions when he wrote:

> Although the card of the painted amor is blank and the
> card with the other ciphers is itself missing, there can be no
> doubt that Vermeer had been inspired by the very same
> notion when he painted the woman at the virginal.[9]

However, by 1993 de Jongh was re-examining his interpreta-
tion. Indeed, he has returned to it on three occasions. He sig-
nalled his dissatisfaction with it in his essay for the catalogue
of an exhibition on representations of reading and reading
matter in seventeenth-century Dutch art in Frankfurt in 1993.[10]
He elaborated upon his observations there in articles pub-
lished in 1996[11] and 1998.[12] In these pieces de Jongh assessed
his earlier interpretation of the *Woman Standing at a Virginal* as
naive, though he did not question the link he supposed to

exist between the emblem and the painting, nor the purported nature of the allusion itself. However, he tried to introduce a greater precision in his consideration of the structure of the allusion. He wrote:

> I restate the hypothesis that Vermeer was thinking of Van Veen's meaning when he conceived his painting. This hypothesis, however, does not solve very much. Even if correct, we are still in the dark about Vermeer's precise intention. The crucial question is: how did the painter intend the inserted moral to function?

His answer is an appeal to multivalency, though flaccidly conceived:

> Perhaps Vermeer wanted to present Cupid's message as a reflection of the conduct of his charming musician. Equally, though, he could have been confronting her with the moral precisely because her conduct was not above reproach. A third possibility is that the moral is being recommended to us as viewers or, projecting back to the seventeenth century, to Vermeer's contemporaries. But (a fourth option) Vermeer left all of these alternatives open, inviting the viewer to make the choice, or a combination of choices.[13]

Rather than examine this train of thought any further now, I propose to start again with a clean slate.

There is no compelling reason to relate Vermeer's Cupid painting-within-a-painting to van Veen's emblem in any direct quotational sense. There are Cupids galore in seventeenth-century Dutch prints, emblem books and paintings.[14] Vermeer's Cupid holds something up in the air, but it does not have a wreathed number '1' on it – nor anything on it for that matter. Neither does he trample another plaque with ciphers. We have already seen suggestions put forward that the object is a letter – specifically a love letter – (by Thoré-Bürger), or a playing card (by MacLaren). These are ideas that warrant further examination, but for now it seems best to acknowledge that it is not at all clear exactly what the object is. All we can do is describe it. The surface presented to the viewer is flat, blank, smooth and evenly planar. That it is of a uniform thickness is suggested by its shaded bottom and right edges. It is difficult accurately to estimate its size within Cupid's

pictorial world, though it might be somewhere between that of a playing card (about 10.2 × 6.4 cm) and a postcard (about 15.2 × 10.2 cm). Its discernible thickness is greater than that of either. The two-dimensional representation of three-dimensional objects can be very misleading,[15] but it seems a warrantable visual inference that the object held by Cupid can conveniently be described as a tablet.

Let us take a closer look at the figure who holds the tablet. As we have seen, Thoré-Bürger described him as Cupid and this identification has never seriously been challenged. Many commentators have assumed that an actual prototype of this painting-within-a-painting existed. This is not a necessary assumption, for Vermeer could well have invented it solely for the purpose of inclusion in this work (and others). However, there are instances in Vermeer's oeuvre in which the proto-type of a painting-within-a-painting has been identified. First, both the *Concert* (Isabella Stewart Gardner Museum, Boston; stolen 1990) and the *Woman Seated at a Virginal* (National Gallery, London) include close derivations of Dirck van Baburen's *Procuress* (of which the prime version is in the Museum of Fine Arts, Boston). The apparent reference to this painting in a document concerning Vermeer's family makes it likely that such a painting actually existed in Vermeer's

9 Vermeer, *Girl Reading a Letter at an Open Window*, c. 1657, oil on canvas, 83 × 64.5 cm. Staatliche Kunst-sammlungen (Gemäldegalerie Alte Meister), Dresden.

10 Vermeer, *Girl Interrupted at Her Music*, c. 1660–61, oil on canvas, 39.3 × 44.4 cm. Frick Collection, New York.

possession.[16] Secondly, the landscape painting behind the *Guitar Player* (Iveagh Bequest, Kenwood House, London) and the landscape on the lid of the virginal in the *Woman Seated at a Virginal* both derive from a *Landscape with Hunters* (whereabouts unknown) by the Delft painter, Pieter Jansz. van Asch.[17] Thirdly, both landscapes in the *Woman Standing at a Virginal* – that on the lid of the instrument and in the gilt frame – may derive from a painting by the Delft artist Pieter Anthonisz. Groenewegen (private collection).[18] Most significantly, though, for the discussion of the Cupid painting in the *Woman Standing at a Virginal*, 'a Cupid' appears in the inventory of movable goods from Vermeer's estate compiled in February 1676.[19] This has been consistently identified with the painting-within-the-painting in the *Woman Standing at a Virginal*.[20] Suggestions have even been made for the authorship of the Cupid painting. In 1928 Gustav Delbanco associated it tentatively with the Haarlem classicist, Caesar van Everdingen (1616/17–1678), who in 1657 returned to his native Alkmaar.[21] This is the ascription that has found most favour,[22] though, while possible, it must be admitted that to attribute unknown originals on the basis of copies as paintings-within-paintings is a hazardous undertaking.

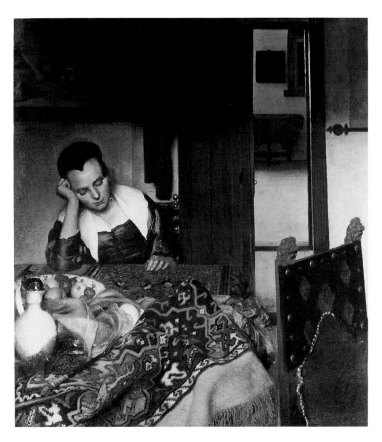

11 Vermeer, *Woman Asleep at a Table*, *c.* 1657, oil on canvas, 87.6 × 76.5 cm. Metropolitan Museum of Art, New York (bequest of Benjamin Altman).

The Cupid painting (if we can assume its independent existence) appears in other works by Vermeer. His first identifiable use of the work is in the *Girl Reading a Letter at an Open Window* (illus. 9), which X-radiography has revealed included the Cupid painting on the rear wall, though it was painted out in the course of execution.[23] It is also found on the rear wall of the *Girl Interrupted at Her Music* (illus. 10), and fragmentarily, with an important variation (a mask by Cupid's foot), in the *Woman Asleep at a Table* (illus. 11).[24] While MacLaren was sensibly cautious about proposing that any allegorical allusion might be identical or even similar in all three works, other commentators have assumed a more or less common meaning relating to fidelity. There are great differences among these four paintings in their respective inclusions of the Cupid painting.

The four paintings were made over the course of some fifteen years, between about 1657 and about 1672. One might

propose a progression in the usage of the Cupid painting over this period: from expurgation (in the Dresden work) and fragmentary allusion (in the Metropolitan Museum canvas), both of about 1657, to a recessive presence in the Frick Collection painting of some three or four years later, followed eventually by uncompromised presence in the London canvas. It is as though the artist first judged the allusion planned for the *Girl Reading a Letter at an Open Window* to be too literal during the course of execution and therefore expunged it entirely; secondly, countered such heavy-handedness by means of representing only a fragment in the *Woman Asleep at a Table*; thirdly, used the entire painting, though literally in shadow, in the *Girl Interrupted at Her Music*; and, fourthly, exposed virtually the entire painting in bright light only in the *Woman Standing at the Virginal*. It is almost as though each painting is an implicit commentary on the use of the Cupid painting in its predecessor. The bending figure of the man in the *Girl Interrupted at Her Music* almost precisely conceals that very area of the Cupid painting represented in the *Woman Asleep at a Table*; the *Woman Standing at a Virginal* shows that same area, but, unlike the former painting, it contains no mask at Cupid's left foot. However, the forward part of Cupid's right foot in that work is concealed by the virginal player's head which is where we might expect to find a second tablet similar to that under the Cupid's right foot in van Veen's emblem if we follow the emblematic interpretation. However, any suggestion of a development is too glib. The time period is too long and the sample of works too small to describe the differences as constituting a meaningful progression in its own right. Yet the differences revealed by comparisons – differences of resolution, illumination, selective inclusion, exclusion and concealment – should prompt our consideration of precise contrivance in any given instance. There is a literal pictorial blatancy about the presence of the painting of the Cupid in the *Woman Standing at a Virginal* that has to be accounted for, exclusive of any discussion of emblematic allusion.

Cupid is a slippery figure both in classical antiquity and in the post-classical world, in which he takes on further guises.[25] It may be worthwhile to try to ascertain whether or not there is any direct classical precedent for what we see in Vermeer's painting-within-a-painting. It has not been noted previously that Vermeer's Cupid is standing on a seashore, waves behind,

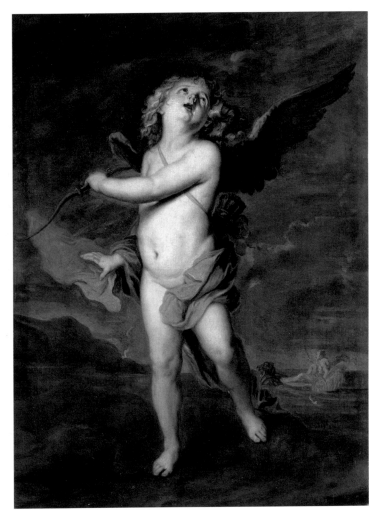

12 After Anthony van Dyck, *Cupid*, original *c.* 1628–30, oil on canvas, 123.5 × 93 cm. Whereabouts unknown (formerly Baroness Adolph Bentinck van Schoonheten Collection).

dunes to his left. In this respect we can compare him with a depiction of Cupid long attributed to Anthony Van Dyck (illus. 12).[26] Although this canvas may be a contemporary copy of a lost original, a painting – perhaps this one – or paintings of Cupid by Van Dyck are mentioned in a year-end account for 1663 by the Antwerp dealer, Guillaume (or Guillermo) Forchoudt,[27] and in the Antwerp post-mortem inventory of Jan-Baptista Borrekens in June 1668.[28] Three apparently early painted copies – one in reverse – were noted by Horst Vey in his discussion of the drawn copy in Berlin.[29] It was certainly a well-disseminated image of Cupid.

There may well be no direct connection between the

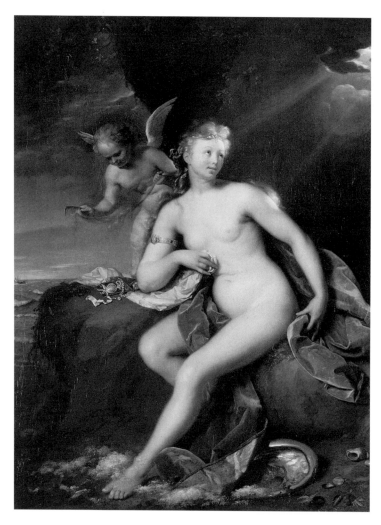

13 Godfried Schalcken, *Venus Attended by Cupid*, 1690, oil on canvas, 70.5 × 54 cm. Gemäldegalerie Alte Meister, Kassel.

painting-within-a-painting of Cupid in Vermeer's works and Van Dyck's invention, whether mediated by Caesar van Everdingen, an unidentified artist or none. But it is worth noting that Van Dyck's Cupid, like that in the Vermeers, is on a seashore. It rises to his right, while we see the waves and Neptune in his watery chariot to his left.

The Cupid we see in the Vermeers and the Van Dyck derivation is that incarnation of him as Eros, attendant – or about to be – on Aphrodite (Venus Anadyonene) immediately following her birth from the waves. This is the role assigned to him by Pausanias in his second-century description of one scene in the decoration of the platform supporting

53

Pheidias' statue of the Olympian Zeus: 'Eros welcoming Aphrodite as she rises from the sea.'[30] Yet we do not have to go directly to Pausanias. We need go no further than Karel van Mander's *Wtleggingh op den Metamorphosis* of 1604. This commentary on Ovid's *Metamorphoses* was Dutch artists' principal source of material for the depiction of mythological themes in the seventeenth century.[31] Six pages in Book 4 are devoted to Venus. Van Mander describes the birth of Venus in a shell on the coast of Cyprus: 'and was there first welcomed by Cupid, for thus was she depicted in a temple in Greece according to Pausanias' description.'[32]

This episode has to do with the birth, origins and the source of Love. It was occasionally elaborated upon by Dutch artists, as, for instance, in a painting by Godfried Schalcken, dated 1690, of Venus newly born from the spume of the waves, attended by Cupid who combs her hair (illus. 13).[33] As in the Van Dyck, we see Neptune in the background. If *Venus Attended by Cupid* is firmly set in classical antiquity, its pendant, *Venus Handing Cupid a Fire Arrow* (illus. 14), places the mythological figures in the seventeenth century. This is not initially obvious, but, once again, Cupid is on the beach, or a dune above it, though not in Cyprus, but rather on the North Sea coast of Holland where contemporary Dutch men and women stroll. Four men walk in one direction beside the waves. Two women walk in the other direction. The two parties must have passed each other a moment before. One of the men lingers and has turned to look in the direction of the women. This all happens beneath the bow and through the legs of Cupid. We can imagine at whom his arrow will be aimed. Schalcken has depicted the moment immediately prior to the conception of love.

When Cupid's arrows find their mark the gazes of those mutually smitten lock together. This can be seen in an emblematic marriage print under the motto 'Ce deux sont un' by Pieter Serwouters from the marriage commemoration book of 1648 of Iacob Abrahamsz. Bierens and Kornelia van Hoeck (illus. 15).[34] Their hearts are pierced by Cupid's arrows and they have eyes only for one another. The same convention can be seen in what is probably a *portrait historié* in literary guise by an unidentified Dutch artist, dated 1673 (illus. 16). It is based on the very moment in Dutch adaptations of Miguel de Cervantes' short story, *La Gitanilla*, when a Spanish noble-

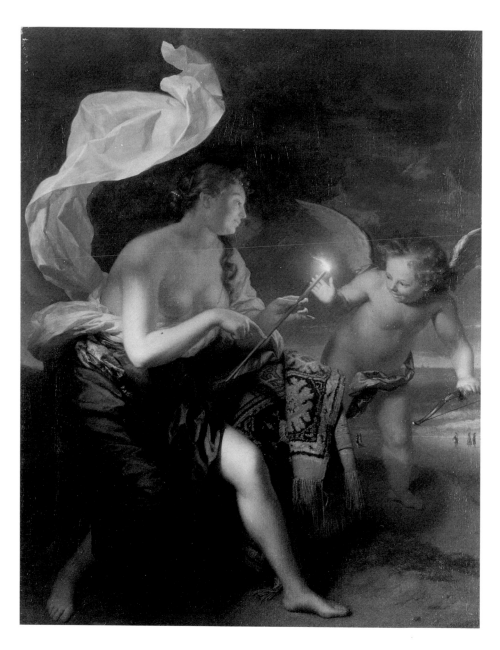

14 Godfried
Schalcken, *Venus
Handing Cupid a Fire
Arrow*, 1690, oil on
canvas, 70.5 × 54 cm.
Gemäldegalerie
Alte Meister, Kassel.

man sees and falls in love with a Gypsy girl (who turns out not to be a Gypsy).[35] In one Dutch stage version Cupid himself leads the Spaniard to the girl,[36] and in the painting Cupid can be seen between the gazing lovers. In any such instance the gaze is crucial. These stories and conceits, and the role of Cupid with his arrows within them, all appeal to contemporary

55

15 Pieter
Serwouters,
'Ce deux sont un',
from the marriage
commemoration
book of Jacob
Abrahamsz. Bierens
and Kornelia van
Hoeck (1648).

classically derived theories about the perception of beauty which, in turn, inspires love.

The hugely influential Dutch medical writer, Johan van Beverwyck, explained the principle in his frequently republished text of 1642, *Schat der Ongesontheyt, ofte Genees-konste van de sieckten* (Treasure of ill-health, or the art of healing the sick). Van Beverwyck, who quoted Jacob Cats's adaption of *La Gitanilla* in his discussion of erotic melancholy, enunciates the sensationalist principle that beauty enters the heart through the eye more quickly than an arrow, and the eye binds the heart of the lover.[37]

Vermeer may not have had his Cupid in the *Woman Standing at a Virginal* use his bow in conjunction with arrows, but the insistence of his gaze, and that of the woman standing before him, is part of the conventional visualization of love. Vermeer has placed his classical Cupid, depicted as the newborn Venus' attendant, Eros, in a specifically modern setting, using the device of the painting-within-a-painting to allow ancient and modern to be juxtaposed without anachronism.

One of the issues in seventeenth-century Dutch painting that has not been much discussed is the self-conscious creation of a specifically *modern* art. This self-consciousness is clear from the use of that very term by, for instance, Gerard ter Borch sen. in a letter of advice to his namesake son written in 1635.[38] The art of Vermeer, like that of Gerard ter Borch jun. (whom Vermeer knew, for he witnessed an act of surety on Vermeer's behalf two days after Vermeer's wedding in April 1653),[39] is a very specifically *modern* art in the terminology of the time.[40] Indeed, Vermeer turns from an art of history early in his career to an art of modernity, and even explores

16 Dutch artist, *Don Juan and Constance*, 1673, oil on canvas, 70.6 × 59.5 cm. Museum of Fine Arts, Boston (bequest of Charles Sumner).

this relationship in his allegory, *The Art of Painting* (Kunst-historisches Museum, Vienna).

The most detailed discussion of modernity in art, as it was conceived in later seventeenth-century Holland, is by the painter and theorist, Gerard de Lairesse, in his *Groot schilder-boek*, first published in 1707.[41] The creation of a specifically modern art, as an art of ideas, in a culture in which art, like so much else, was sanctioned by the theories and the reported examples of antiquity was no straightforward matter. De Lairesse cites the practice of Dutch painters in the 'bourgeois modern' manner, such as Gerrit Dou and Frans van Mieris, but his sympathy is firmly with those who worked in the ancient manner – he cites Raphael and Poussin – which in his view never becomes outmoded.[42] However, he argues that many concepts and the human qualities associated with them can be treated in both the ancient and the modern modes.[43]

Furthermore, as Lisa Vergara has pointed out, in distinguishing between 'high' and 'low' modern subjects, de Lairesse explicitly allows that the former can approach the antique in dignity and seriousness, as well as being more convenient for contemporary painters to depict.[44] His account, therefore, reflects an equivocation that had probably dominated the production and reception of paintings of elegant modern subjects by artists such as ter Borch, Dou, van Mieris, Metsu, de Jongh and others, including Vermeer.

How did such artists – from the point of view of this study, principally Vermeer – imbue the elegant modern subject with a dignity usually associated with antiquity? We have already seen several possible strategies in examining artists' use of Cupid in their paintings. Anthony Van Dyck treated both ancient and modern alternately. The *Cupid-Eros* attributed to him is wholly ancient in its subject matter, albeit in a baroque articulation. Indeed, Gerard de Lairesse specifically praised Van Dyck as one who was outstanding in both the ancient and the modern manners.[45] Godfried Schalcken contrasted the ancient and the modern in his pendant pair on the subject of the newly born Venus with her attendant Cupid-Eros, but a vision of antiquity – albeit late seventeenth-century – prevails utterly. The *portrait historié* derived from one or more Dutch adaptations of Cervantes's *La Gitanilla* is an example of the growth in status during the seventeenth century of the modern exemplary tale to complement and even rival those drawn from biblical and classical literature. Indeed, it first entered Dutch literature as an exemplary poem by Jacob Cats in his most popular book, the *Trou-Ringh* (1637), in which it was one of six specifically modern stories placed after two groups of exemplary stories drawn from biblical and classical sources respectively.[46] Vermeer, though, did not choose to base any of his works on modern literature.

One of Vermeer's principal means of lending his modern subjects the sanction and dignity of history – both biblical and classical – was the use of the painting-within-the-painting. This is what we see in the *Woman Standing at a Virginal*. The device allows a complete avoidance of anachronism, though it can have been far from easy to arrive at this solution.

Vermeer's extremely economical method, perfected in such late works as the *Lady Writing a Letter with Her Maid* (National Gallery of Ireland, Dublin), the *Woman Seated at a Virginal* and

17 Jan Steen,
The Doctor's Visit,
c. 1661–2, oil on
panel, 47.5 × 41 cm.
Wellington
Museum, London.

the *Woman Standing at a Virginal,* contrasts with that essayed by the learned and experimental painter, Jan Steen. Steen's *Doctor's Visit* (illus. 17) was painted perhaps some ten years before Vermeer's *Woman Standing at a Virginal.* In it the classical and the modern, and, within the modern, elegant high life and farcical low life, are not separated from one another so neatly as in Vermeer's works that were to follow. Steen's lovesick young woman who is being diagnosed by a

59

physician was a readily recognizable modern subject, but one that was a stock comic situation.[47] Steen reinforces the folk comedy of the subject by including as one painting-within-the-painting Frans Hals's depiction of the comic character, *Peeckelhaering* ('Pickleherring') (Staatliche Kunstsamlungen, Gemäldegalerie, Kassel), who enjoys the fool's licence to poke fun at folly.[48] On the wall at right angles to this clown is a painting-within-the-painting of *Venus and Adonis*, lending the scene an Ovidian dimension of tragic love.[49] The classical allusion, however, is not confined to the separate world of the painting-within-the-painting. In the foreground a small boy seated on the floor plays with a bow and arrows.[50] Like Vermeer's Cupid in the *Woman Standing at a Virginal*, this Cupid's gaze pointedly meets that of the viewer, but, unlike Vermeer's Cupid, he has taken on a modern guise and inhabits the modern world. This is precisely the kind of inter-mingling to associate ancient and modern so that the latter might benefit from the sanction of the former that Vermeer avoided in the *Woman Standing at a Virginal*. Vermeer's solution has an economy not to be found in Steen's invention.[51]

Yet is the distinction between antiquity and modernity in the Vermeer so absolute? Might not Vermeer's virginal player herself be a thoroughly modern Venus, just as Steen's boy is a thoroughly modern Cupid? A passage in van Mander's *Wttlegginghe* might tempt us to think so, for, just after describing Cupid welcoming Venus on the seashore, he quotes the Homeric hymn that describes Venus after her arrival on the Cyprus coast as being clad in the robes of a goddess, and her beautiful fair hair being bedecked with small gold ornaments.[52] Vermeer's *Woman Standing at a Virginal* (like his *Woman Seated at a Virginal*) wears the gold filigree spiral ornaments in her hair that became fashionable in the early 1670s.[53] In addition we might note her necklace. This pearl necklace is an item of jewellery of too common a type to carry an allusive charge in itself, yet the association of pearls with the new-born Venus – the pearl incarnate – might in this instance be thematically appropriate in combination with her other ornaments.[54] Vermeer may not necessarily thereby have been pre-senting the woman standing at the virginal specifically as a modern Venus – the references are in turn surely too obscure or too general. Yet we should be aware of the connection, and entertain the possibility that such an allusion underlay this

fashion in jewellery as a whole. This much might have been apparent to an informed contemporary viewer of the painting. None the less, as far as the operation of the painting is concerned, a clear distinction exists between the modern pictorial world (that occupied by the virginal player) and the mythological pictorial world (that occupied by Cupid). Nothing is apparent to the viewer that might compromise the realistic plausibility of the modern world inhabited by the virginal player, yet the authority of antiquity accrues to it.

The perception of beauty and origin of love can now be seen to be central to Vermeer's *Woman Standing at a Virginal*, conveyed in part by a precisely controlled classical allusion managed in such a way as to enhance a specifically modern articulation of the subject. The perception of beauty and the

18 Gerrit Dou, *Girl at a Clavichord*, c. 1665, oil on panel, 37.7 × 29.8 cm. Dulwich Picture Gallery, London.

emotion of love are not the province of sexual attraction alone. They are also the province of art. The exchange of gaze between the viewer and the woman, and the exchange of gaze between the viewer and Cupid, are to do with the perception of beauty by the eye, which is as proper to the perception of painting as it is to sexual attraction. The viewer perceives the beauty of art and is smitten by it much as he might perceive the beauty of a woman and be smitten by her. Although, as we have seen, love could be conceived of as mutual between man and woman as their gazes lock, the articulation offered here assumes a male viewer whose gaze meets that of a female figure in the painting. As the viewer lingers before the painting he perceives beauty – the beauty of art represented by female beauty – with the effect like that of an arrow through the eyes to the heart. The gaze of the woman – regardless of her expression – informs the viewer that the regard is mutual, and that art is the active factor in the relationship.

The woman's other action also signifies in this scene. Her hands are on or above the keyboard of her instrument. Unlike in other paintings of female keyboard instrumentalists whose gazes meet that of the viewer, such as the *Girl at a Clavichord* by Gerrit Dou (illus. 18) or a *Girl Standing at a Virginal* by Hendrik Martensz. Sorgh (whereabouts unknown),[55] the precise relationship between fingers and keys is concealed. Is she engaged in playing the instrument? Or is she in a state of readiness and about to play? Or is she adopting a pose that suggests engagement with the instrument, yet is no more than a pose for the purpose of depiction, thereby drawing attention to the fiction of the representation? The moment depicted is musically indeterminate. Indeed, such indeterminacy is part of the structure of the painting – a point to be explored in the chapter that follows.

Music must be taken into account in an iconographic interpretation of the painting. If the conventional relationship between music and love between the sexes finds endless elaboration in seventeenth-century Dutch painting, the depiction of music making can also be associated with the nobility of the art of painting and artistic inspiration. While the poetic *ingenium* of the painter might be represented by his self-depiction playing a musical instrument,[56] he might in turn depict himself before an easel, studying a female instrumentalist. This is the case in Gabriël Metsu's *Self-Portrait with a*

Viola da Gamba Player (whereabouts unknown), in which – whatever the precise personificatory reference might be – an inspirational analogy between the ideal harmoniousness of painting and music is drawn.[57] The love of men and women and the love of art are presented in the *Woman Standing at a Virginal* as analogous. Music is there to ensure that the analogy functions, for it serves both.

The love of art is not a matter for the viewer alone. It is of great consequence for the artist. In his book published in 1678, *Inleyding tot de hooge schoole der schilderkonst*, Vermeer's contemporary, the painter and theorist Samuel van Hoogstraten, contended that there were three fruitful consequences of artistic effort for the artist himself. He cited Seneca's ascription, in *De beneficiis*, of benefits that accrued to the sculptor Pheidias

19 Samuel van Hoogstraten, *Painting and Its Benefits*, c. 1670–75, ink and wash on paper, 17.9 × 13 cm. Musée Nissim de Camondo, Paris.

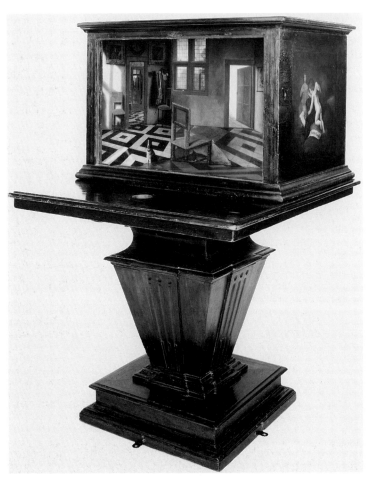

20 Samuel van Hoogstraten, *Peepshow with Views of the Interior of a Dutch House,* c. 1655–60, oil on panel, 58 × 88 × 60.5 cm (exterior), 54.5 × 80 × 53 cm (interior). National Gallery, London.

by means of his art.[58] These were, first, the knowledge and the satisfaction of the conscience gained when the work was complete; secondly, reputation; and, thirdly, the practical advantage of profit to be gained from its sale or other disposal.[59] Van Hoogstraten goes on to explain that the first benefit demonstrates that painting must be counted as one of the liberal, rather than the mechanical, arts, a point he elaborates with many references to both classical and modern examples.[60] He contends that what is to be learned from the practice of art is itself the reward of art; therefore it is to be loved for its own sake. Love of art, as well as of fame and wealth, must therefore inspire and propel the artist.

Earlier in his career van Hoogstraten had treated this theme visually on two occasions. An allegorical ink-and-wash

drawing of *Painting and Its Benefits* (illus. 19) depicts a female nude painting at an easel surrounded by personificatory figures apparently representing the Senecan benefits.[61] Secondly, he painted three allegorical depictions of these concepts on the exterior of his *Peepshow with Views of the Interior of a Dutch House* (illus. 20). Each of these three scenes includes a cartouche, with the words 'Amoris causa', 'Gloriae causa' and 'Lucri causa' respectively.[62] *Amoris causa* (illus. 21) depicts a winged putto – perhaps to be identified with Cupid – guiding an artist who draws the figure of the Muse Urania before him. Urania is the Muse of Astronomy and represents the artist's striving for the heavenly heights. She reappears as the patron of the ninth book of the *Inleyding* in which the Senecan benefits are discussed, each book being under the patronage of one of the Muses. In the etched title page for Book 9 depicting Urania the artist, palette and brush in hand, scales a ladder towards the brilliant heavens.[63]

On the peepshow exterior van Hoogstraten therefore makes the role of love in the ideal production of art a quality to be explicitly perceived by the viewer. Further, he incorporates its sexual analogue within the box itself. The scenes visible through two peepholes suggest, first, male scrutiny of a domestic interior and its female inhabitants; and, secondly, the male viewer sees, as it were, his own accoutrements –

21 Detail (*Amoris Causa*) of van Hoogstraten's *Peepshow* (illus. 20).

65

cloaks, sword and hat – with a dog attending to him. The first view (illus. 22) not only includes two women as though unobserved – one reading in the *voorhuis*, the other in a curtained bed – but prominently placed female accessories, such as a string of pearls and a comb (attributes of the new-born Venus – compare the Schalcken discussed above) upon a chair. It also includes the silhouette of a man as though spying through the furthest window upon the reading woman who thereby mirrors the male viewer's own activity. Furthermore, details such as a coat-of-arms and a letter addressed to the artist suggest that this is to be seen as van Hoogstraten's own domestic interior. The interior scenes can therefore be interpreted as an obliquely eroticized commentary by van Hoogstraten on his own artistry.[64]

If sexual love, visually constituted and rendered through art, is to be seen within the peepshow, love of art itself appears on the exterior, as we have seen. They are united by the

painted depiction on the top of the exterior of the box. This scene represents two naked figures in bed in anamorphic projection (illus. 23). One is certainly Cupid, the other has been identified as either Venus,[65] her hair decorated with pearls, or Erato, Muse of Love Poetry to whom, according to van Hoogstraten, Venus sent Cupid.[66] This invention further allegorizes the analogy offered between sexual love in the domestic sphere and love of art found in the interior of the box and on its side respectively.

Vermeer's posthumous inventory indicates that he owned two *tronie* paintings (fancy heads) by van Hoogstraten.[67] Yet no connection need be demonstrated between the two painters, from Dordrecht and Delft respectively, to argue that in very different ways Samuel van Hoogstraten, in his peep-show, and Johannes Vermeer, in the *Woman Standing at a*

23 Detail (Venus [or Erato] and Cupid) of van Hoogstraten's *Peepshow* (illus. 20).

67

Virginal, dealt with the same theme: the analogy between love in the domestic sphere and love of art.

With this in mind, let us now return to the object held by Cupid in Vermeer's painting-within-the-painting. We reach it by traversing picture planes. First, our gaze crosses the picture plane of the painting itself and is reciprocated by the woman at the virginal. Then it crosses the picture plane of the painting-within-the-painting and is reciprocated by Cupid-Eros, the newborn Venus' attendant. Lastly, it attempts to cross the picture plane of what constitutes a third pictorial world in recession from us, that of the tablet, shown to us so insistently by the figure who holds it. However, it is blank. We see here the *mise en abîme* of representation: the infinite potential, as yet unmarked by realization, of art's power to represent in the hands of Love. The invitation of our gaze as viewers by those of Cupid-Eros and the woman is an invitation to the love of art. Vermeer presents us with a specifically modern representation of the preconditions for the successful creation and perception of art as a thing of beauty.

This power to represent is in the hands of Love not only because beauty, as we have seen, was held to have entered the heart through the eye, but also because love and art were further linked associatively. Love for a woman and love of art – whether as its maker, viewer or both – were united not only by

24 Adriaen van der Werff, *Self-Portrait*, 1697, oil on canvas, 89 × 73 cm. Galleria degli Uffizi, Florence.

a common model of sensory perception, but also by the idea
that the love for a woman could itself inspire the artist. 'Love
gives birth to art' (*Liefde baart const*) was the motto inscribed
by the painter Wybrand de Geest in the *album amicorum* of
his colleague, the Delft painter Leonaert Bramer.[68] Bramer
was no stranger to Vermeer – in April 1653 he was a witness at
Vermeer's request to a notarial statement concerning his wed-
ding banns[69] – but the conceit he had employed as a young
man had, of course, a long history. In the course of the six-
teenth and seventeenth centuries it informed the depiction
of the artist's love for a beautiful woman outside the bonds of
matrimony (such as the subject of the classical Greek artist,
Apelles, painting Alexander's mistress, Campaspe, and falling
in love with her himself) as well as numerous paintings by
artists of their spouses and offspring.[70] Painters adapted this
long-standing convention to express an ideal relationship to
Pictura, the personification of their art, in the place of a
spouse. For example, Adriaen van der Werff depicted himself
holding a painting of Pictura in his *Self-Portrait* dated 1697
(illus. 24), commissioned by his patron, the Elector Palatine
Johann Wilhelm as a gift for his father-in-law, the Grand Duke
Cosimo de' Medici of Tuscany in the previous year.[71] Pictura
is accompanied by two putti facing one another whose signi-
ficance has to date eluded commentators, yet which are

25 Adriaen van der
Werff, *Self-Portrait
with a Portrait of
the Artist's Wife,
Margareta Rees,
and Their Daughter
Maria*, 1699, oil on
canvas, 81 × 65.5 cm.
Rijksmuseum,
Amsterdam.

26 Bartholomeus
van der Helst,
*Portrait of Paulus
Potter*, 1654, oil on
canvas, 99 × 80 cm.
Royal Cabinet
of Pictures
Mauritshuis,
The Hague.

immediately reminiscent of the putti in Samuel van Hoog-
straten's *Allegory of Painting and Its Benefits* where, as we have
seen, they represent the benefit of the satisfaction of know-
ledge gained through art.[72] In his *Self-Portrait with a Portrait
of the Artist's Wife, Margareta Rees, and Their Daughter Maria*
(illus. 25) of two years later, van der Werff adopts a more
directly uxorious model of allusion, depicting himself hold-
ing a portrait of his wife and seven-year-old daughter,
Maria.[73] The little girl is shown meeting the viewer's gaze,
about to draw upon a blank support, so again – wholly trans-
formed, of course – we see a recession across picture planes
leading to the as yet empty surface of art's potential, as in the
Woman Standing at a Virginal. Love giving birth to art here
receives a filial articulation.[74]

The blank support, such as we see in the paintings-within-
the-paintings by Vermeer and van der Werff, is a motif that
appears occasionally in other portraits of artists, for example
in Bartholomeus van der Helst's *Portrait of Paulus Potter* of
1654 (illus. 26). More particularly, there are two self-portraits
by the Utrecht painter, Paulus Moreelse, in which he holds
blank supports. In one (illus. 27) he holds a small near-oval
plaque, possibly a copper support suitable for a miniature.[75]
In the other (illus. 28) he holds a blank sheet of paper.[76] In both

cases he holds the supports demonstratively for the scrutiny of the viewer. The conceit most likely concerns the artist's role as inventor and the infinite possibilities of representation at the artist's command.[77] Such an infinity of visual possibility in the hands of Love is what we see in Vermeer's invention.

An invitation to partake of art through love, united by the perception of beauty through the eyes, is part of what is going on in the *Woman Standing at a Virginal*. Getting to grips with its world of ideas involves more than performing a simple transfer of meaning from an emblem book to a painting, even if one allows a certain tolerance of contemporaneous interpretation, as de Jongh argues. Vermeer's painting is a complex invention in its own right to which we must try to do justice in contemporaneous terms.

The intellectual context in which the *Woman Standing at a Virginal* originally functioned concerning the complex relationship between love and art had had a long history in the Europe of the Renaissance. Vermeer's modern pictorial invention functioned in a world of ideas about love and artistry that had been defined generations earlier in the first instance through commentaries on Plato's *Dialogues* by Marsilio Ficino (1433–1499). Ficino's commentaries on the *Symposium* and the

27 Paulus Moreelse,
Self-Portrait, c. 1630,
oil on panel,
69.7 × 55 cm.
Niedersächsisches
Landesmuseum
(Landesgalerie),
Hannover.

28 Paulus Moreelse,
Self-Portrait, c. 1630,
oil on panel,
72 × 62.5 cm.
Royal Cabinet
of Pictures
Mauritshuis,
The Hague.

Phaedrus – Plato's principal discussions of love – were partic-
ularly influential.[78] Many of the themes discussed above in
relation to the operation of love are to be found in these texts.
For instance, that beauty enters through the eyes as the
natural route to the soul, filling the soul of the loved one with
love in return, is proposed by Socrates in the *Phaedrus*.[79]
Ficino followed Plato in seeing love as a motive force in the
universe. Crucially, Ficino associated love with artistic inven-
tion. He proposed that artistic invention was a means of
attaining the world of ideas beyond the reach of the senses in
accordance with Plato's conception of the role of beauty in
giving a glimpse of ideal forms.[80] Ficino regarded the artist as
one thereby enabled to transcend and perfect the phenomenal
world. And he specifically associated this ability with Eros,
whose form and arrows he discusses in detail.[81] Ficino's con-
ception of the artist's role in inspiring love through beauty,
thereby leading the soul towards ideal forms, had a long after-
life in late and post-Renaissance transformations as artists
claimed liberal status for their art as an intellectual and inspi-
rational undertaking.[82]

The role of Eros in inspiring art to transcend the senses is
clearly articulated, for example, in the *Allegory of Art* (illus. 29)
reasonably attributed to Charles-Alphonse Dufresnoy (1611–
1668).[83] In an interior a female figure who may be presumed

to be Pictura, the personification of the art of painting, sits at an easel. She paints the likeness of a young winged male figure standing before her clad only in exiguous blue drapery. At this figure's feet is a quiver of arrows and a bow. He can be identified as Eros, and with his right hand he points upwards, while in his left he holds a laurel wreath and an olive branch. On a banderole about the quiver an inscription can be made out: 'ARTES MEA FLAMMA DECORAT' ('The arts, my passion to embellish').[84] There are two putti on the floor before Pictura, one handling a pair of compasses, the other regarding the viewer and pointing to an open book on which the name '[LEON]ARDO DAVINCI' can be read: presumably an allusion to Leonardo da Vinci's *Trattato della pittura* (Treatise on painting), which had been published in Paris in 1651 with illustrations by Nicolas Poussin, whom Dufresnoy closely emulated.[85] Dufresnoy shows Painting attending to Eros who inspires her to acts of transcendence as his upward pointing gesture and carefully labelled quiver and bow – with which he directs his shafts of love – indicate.

29 Charles-Alphonse Dufresnoy, *Allegory of Art*, *c.* 1660, oil on canvas, 62.8 × 77.5 cm. Whereabouts unknown (sold through Phillips Auctioneers, London, December 1998).

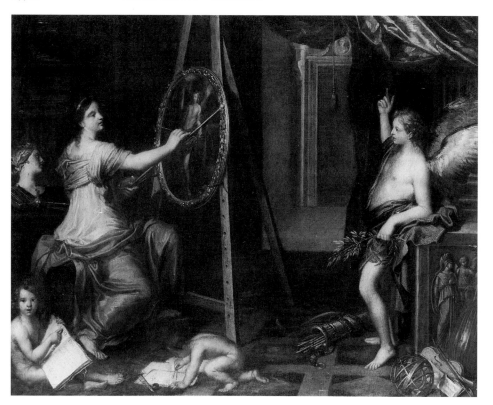

Vermeer's *Woman Standing at a Virginal* inhabits the same world of ideas as Dufresnoy's *Allegory of Painting*. Employing the mutual association of Eros and Cupid, Vermeer directs the gaze of love inescapably straight towards the viewer of his painting. Vermeer's allegory functions by two principal means: first, by the immediately recognizable representation of a mythological figure (Cupid); and, secondly, by means of an allusive structure analogous to exemplification in classical rhetoric as taught in seventeenth-century Dutch schools.[86] The means may be different from those employed by Dufresnoy – infinitely more guarded and sophisticated – but the matter is in part the same. In the *Woman Standing at a Virginal* we see the late fruit of Renaissance ideas, stimulated initially by Marsilio Ficino's readings of Plato, about love, art, desire and transcendence.

3 Objects

We have seen Vermeer's *Woman Standing at a Virginal* as an iconographically complex image in which the perceptions of the beautiful in both womankind and in art are presented as united by a visual metaphor of love. To view the painting in this manner might satisfy those of us who value explanations of pictures in terms of the retrieval of contemporaneous pictorial meanings, yet it can only be a partial account. In this chapter I shall examine further issues concerning pictorial meaning, but specifically as it is to be found in the material object.

In advancing the interpretation in the previous chapter in terms of the historical retrieval of an iconography, I made two assumptions: first, that the painting functions in this interpretative context exclusively as an image; secondly, that this image functions within a contextual, rule-governed system of meaning generation. Nearly every point advanced concerning the functioning of that image in the previous chapter is independent of the material character of the painting that embodies it. It might be fair to note that each observation could have been made equally accurately either from the original or from a reproduction; that is, knowledge of the original in this context was largely beside the point.

The kind of art history that can be done adequately and accurately without knowledge of the original has much to recommend it. First, it is extremely convenient to make use of book illustrations and photographic reproductions at one's own desk. Secondly, this mode of enquiry circumvents the tyranny of uniqueness. One of the consequences of the uniqueness of objects of visual interest is the advantage it gives to those who have access to them. In practice, access is not freely available to all. Although anyone can enter the National Gallery, London during opening hours, without charge, to view the *Woman Standing at a Virginal*, relatively few of those who might want to live close enough to do so conveniently. The modern pilgrimage to view works of art may have a romantic or even ethical appeal, yet it is hardly a realistic

option financially for many people who might wish to undertake it. Those who can travel easily enjoy an advantage, and there is something inherently offensive to the egalitarian sensibility about such a state of affairs. To be able to treat such works as infinitely reproducible, on a par with established texts that can be acquired from libraries or bookstores the world over, is undoubtedly politically attractive as well as materially convenient if one wishes to evade the tyranny of uniqueness. Yet if we are to explore fully the character of objects that interest us we must submit – however unwillingly – to that very tyranny, for an object is not its reproduction. Here I want to explore the ramifications of this premise in the case of the *Woman Standing at a Virginal*. To do so I propose to examine certain conditions of encounter that might otherwise be ignored.

The *Woman Standing at a Virginal* exists independently of any viewer, yet it exists meaningfully only in so far as it relates to actual viewers. Who might these viewers be? Various constituencies of viewers exist, have existed and might exist in the future, identifiable according to any number of categories. The categories that presently preoccupy us concern sex, ethnicity and class. Yet the argument presented here does not depend upon this type of distinction, beyond the assumption of a relevant cultural competence on the part of the viewer that includes familiarity with the notion of painting as an art.

Viewers' meaningful experience of the *Woman Standing at a Virginal* is not confined to experience of its image component. Experience of its image component alone, abstracted as a reproduction, is not to be confounded with experience of the painting as a meaningful object. As viewers we experience the painting in a contingent manner. Conditions of viewing affect the relationship. Some conditions are certainly legitimate or fair, while others that put the painting and its viewers at a disadvantage are not. Because this painting is in a museum viewers are unlikely to experience it in illegitimate conditions. The painting framed, hung at a height of 155 cm on a museum wall, coloured appropriately, in the presence of other paintings, is in legitimate conditions for viewing. Our experience of the painting is not visual alone. The eye itself is a bodily organ, but it functions within a larger somatic context. We experience the painting in a state of liminal awareness of our own bodily activity. The relationship between the painting

and the viewer is dynamic: the work of the painting and the work of the viewer are in flux. For instance, the viewer of the painting is in constant movement, adjusting the position of the head and of the entire body in relation to the painting, to say nothing of the eyes which are in constant movement before any image. These movements allow our complex apprehension of the painting as an object, taking account of the three-dimensionality of its paint structure and surface in relation to the fall of light. All this could be said of any painting, yet the character of the *Woman Standing at a Virginal* accentuates the urgency of these conditions owing especially to two features: first, the visual address by the figures within the painting to the viewer and, secondly, framing, both within and around the painting.

The *Woman Standing at a Virginal* as both image and object is a representation of which the design and all the details are contrived and significant. As a representation it is autonomous. It bears no certain relationship to any supposed actuality external to itself. The painting is best thought of as a fiction. Its interpretation does not depend on any demonstrable or supposed relationship to a prototype in actuality as a real state of affairs, other than as a contrivance realized in order to create the fiction of the painting. While acknowledging that what Vermeer depicted may well have been informed by where he lived, and that his pictorial world is contrived so as to appear continuous with the world in which he lived, these depictions must none the less be counted fictions. Much effort has been expended in attempts to relate this painting and others to uncontrived actualities in Vermeer's domestic sphere.[1] All that can be said is that, though contrived down to the structure of the chambers depicted, such paintings are plausible as representations of reality within certain constraints.

The fiction includes the depiction of the activity of light, and the representation and embodiment of colour as the consequence of that activity, and as constitutive of the visible world and its reconstitution in paint. The fiction extends to the perspectival construction of space. Our address by the woman at the virginal implies a community of space, yet the pictorial space is constructed so as to deny us any accurate sense of actual spatial relationship between ourselves and the woman in the room. We can be confident that the fictive space

of the painting was constructed by means of a single vanish-
ing point located in the left part of her proper right sleeve.
This is physically marked by the trace of a pin suggesting that
the orthogonals were delineated by means of a thread or
threads stretched from that pin.[2] The horizon line therefore
runs just above the sounding box of the instrument on the
right, and the lowest horizontal window lead on the left.

Let us look at the geometrical construction of the painting.
Using the floor tiles we can calculate the distance point and
hence the view point. It is approximately 89 cm from the
picture plane. Therefore, to achieve a maximum impression
of spatial involvement, viewers should position themselves
with their eyes level with the horizon line at little more than
arm's length from the picture. Even so, there are features that
seem purposefully to render imprecise the viewer's relation-
ship with the fictive space of the painting.

Our interpretation of the pictorial space is based on certain
warrantable inferences. The principal inference is that the rear
wall is parallel to the picture plane and the window wall is at
90 degrees to it. Secondly, we infer that the sounding box of
the virginal is placed with its sides parallel to these walls.
Therefore we are facing a structure of interlocking rectilinear
spaces. Thirdly, we infer that the tiles forming a frieze at floor
level are equal in size. Therefore they act as a calibration of the
space in breadth and depth. We can calculate that the far wall
between the corner and the right edge of the painting is
eighteen-and-a-fraction tiles in width. All or part of twelve of
these tiles can be seen. The depth of the pictorial space
between the near corner of the second pale floor tile from the
picture plane nearest the window wall and the visible corner
of the room is nine tiles. That distance is therefore half that of
the extent of the breadth of the space between that corner and
the right edge of the painting. There exists, therefore, an
extensive area of floor within the painting upon which it
might be possible to perceive the relative position of objects
placed upon. We can even approximately calculate the size of
that area if we assume each tile in the frieze to be 13 cm square
(a reasonable assumption based on the size of similar actual
tiles). It would therefore measure some 234 cm by 117 cm. The
one object that falls partly within that space is the virginal.
However, the positions of its two feet on the floor that are fur-
thest from the viewer relative to the calibrations provided by

the tile frieze are concealed. The far front leg is wholly concealed by, first, the receding rectangle of the front flap of the instrument and, secondly, by the billow of the player's skirt. The far rear lower leg and foot is concealed by the seat of the blue upholstered chair.

We infer that the woman stands before the right side of the virginal at the keyboard placed to the right of centre in the Netherlandish fashion of virginal construction. Therefore her position is most likely bounded on her right by the visible side of the instrument's sounding box. However, because the precise relation of the figure to the floor is information denied to the viewer, and similarly that of the virginal to the floor, we are also denied an accurate spatial apprehension of their positions in relation to each other and to the calibratory tile frieze. The information we need in order to establish an unambiguous spatial relationship with the figure of the virginal player is incomplete. This might normally be of no consequence, but in this case it is a vital part of a structure of indeterminacy that runs counter to our immediate assumptions, for the structure of the fictive space at first seems so clear to us. This lack of sufficient information regarding the placement of the figure means that her spatial relation to the rear wall is equally uncertain, again, in spite of the first glance appearance of mensurability afforded by the tile frieze. Crucially, this means that we cannot ascertain the distance of recession from her eyes to those of the figure of Cupid in the larger of the two paintings on the wall behind her.

The single most peculiar aspect of this painting is the dual visual address of the viewer by the woman at the keyboard and by Cupid in the painting-within-the-painting. The visual address of the viewer by a figure within a painting and simultaneously by a figure within a painting-within-that-painting is a configuration that has a long history within the Northern tradition. It is usually employed in portraiture, in which circumstances the dynamic is subtly but vitally different from that of the present case. In instances of portraiture the ruling conceit is often one of equivalence between actuality and its depiction within the depicted world and thus between the depicted world and that of the viewer. The subject of the painting-within-the-painting achieves the same degree of fictive real existence as the figure within the painting. An example discussed in the previous chapter is the *Self-Portrait*

by Adriaen van der Werff (Rijksmuseum, Amsterdam) in which he holds a portrait of his wife and daughter. This device had a long life in Dutch art, going back to Jacob Cornelis van Oostsanen's *Self-Portrait with a Portrait of the Painter's Wife* (Toledo Museum of Art, Toledo, Ohio). In such works there is a purposeful elision of the distinction between the pictorial world at two removes from the viewer and that of the pictorial world at one remove. This in turn implies an elision of the distinction between the pictorial world and the actual world in which the viewer exists. In the *Woman Standing at a Virginal* the relationship between the three worlds (those of the viewer, the woman virginal player and Cupid respectively) is subtly different.

First, we have already seen that the spatial construction of Vermeer's painting is such that the viewer cannot place the virginal player accurately in space, so the distances between the viewer and the woman on the one hand, and between the woman and the painting of Cupid on the other remain approximate in the perception of the viewer. Secondly, the execution of the painting of Cupid is such that it is signalled to be a painting. That is, just as the relationship between the viewer and the painting as a whole is one of viewer to painting acknowledged as such, not viewer to illusion of reality, so the relationship between the virginal player and the painting of Cupid is one of potential viewer to painting as an object, not an illusion. This is clear from the use of a limited palette and selective irresolution of features in the painting of Cupid that are not due to mild abrasion alone. Also, the fall of light on the inner right edge of the frame, and the umbra and penumbra on the wall beyond it, showing that the painting is canted, serve to underline its objecthood at the expense of illusion within the pictorial world of the woman. All these signs of distancing and distinction are enhanced by the facts of the frames. Distinctions among pictorial worlds are drawn by means of the frames: the narrow black border distinguishing the landscape on the virginal lid from the grey wall above and beyond it; the carved gilt frame of the landscape to the left of the Cupid painting; the black frame of the Cupid painting; and the fact of framing of the painting itself: currently a late nineteenth-century polished walnut frame in a seventeenth-century Dutch style consisting of a plain hollow moulding with a gilt sight edge. This frame casts an umbra and penumbra

upon any wall on which the painting hangs and the viewer becomes particularly conscious of it owing to the depiction of the same phenomenon within the painting itself. The frame serves to distinguish the space of the painting from our space. It functions in conjunction with size and scale: with a painting measuring some 52 by 45 cm encountered at a distance of about 89 cm, plenty of the peripheral vision of any viewer is engaged with the immediate surroundings of the painting, so its objecthood and artificiality are amply and continually confirmed during the act of viewing. Furthermore, when the painting was made a choice was possible between two basic types of frame: gilt and plain. We see both possibilities represented within the picture, and this alerts us to the contingency of the decision made for the framing of the painting itself, making the viewer all the more conscious of the presence of that frame.[3]

This matter of size, scale, artifice and even possible placement with other works on a wall is brought to the attention of the viewer by the presence of the two paintings variously framed and of different sizes juxtaposed on the rear wall of the pictorial space. The approximate size of both paintings and the height at which they are hung can be worked out if we assume that the tiles along the skirting are 13 cm square. The Cupid painting, framed, is therefore approximately 117 × 86 cm hung at a height of 210.7 cm, while the landscape, framed, is 44 × 35 cm and is hung at 213.5 cm. Furthermore, if we assume that the woman is 150 cm tall (which can only be an approximation, of course), were she to stand in the corner her eye level would be between the second and third window leads from the top of the lower window light; that is, she would occupy much the same space proportionally in relation to the architecture as the maid in the Dublin Lady Writing a Letter with Her Maid (illus. 30).

However, all these signals of spatial difference and distinction coexist with their opposite: lateral juxtaposition and the implied suppression of the third dimension to associate the woman at the virginal with the figure of Cupid. Both figures are engaged in the same act: that of visually addressing the viewer. Indeed, our concentration upon the operative head and eyes is specifically contrived by employing the frame of the Cupid painting to incorporate the head of the virginal player within its space when apprehended two-dimensionally. Her

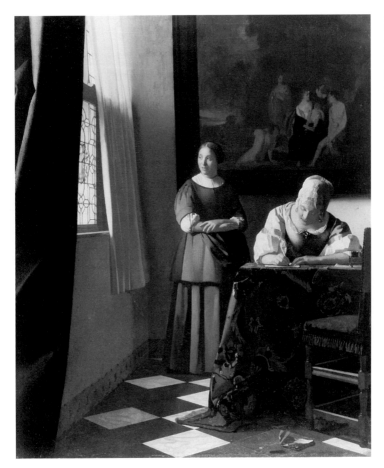

30 Vermeer, *Lady Writing a Letter with Her Maid*, c. 1670, oil on canvas, 71.1 × 58.4 cm. National Gallery of Ireland, Dublin.

eyes are thus an index of the activity of the viewer in engaging the figure of Cupid.

The achievement of an equal weight of visual address by both figures presented the artist with a particular problem concerning the depiction of the operative organs: the eyes of both figures. The eyes of the figure of Cupid have to be emphasized in order to be present to the viewer with the same force as those of the virginal player. They could not be depicted in the same stylistic register as the eyes of the woman, but rather must necessarily be compatible with the abbreviated style proper to the pictorial world of Cupid as delineated by the artist. This requirement accounts for the emphatic character of the eyes of Cupid, balanced internally only by the mode of depiction of his bow, that has so troubled various commentators.[4]

This pictorial structure is integral to the structure of meaning proposed in the previous chapter concerning love and its associations. While I dismissed the notion of a straightforward allusive relationship of the *Woman Standing at a Virginal* to the emblem concerning fidelity in Otto van Veen's *Amorum Emblemata* as proposed by Eddy de Jongh, both images could readily be said to have functioned within a common structure of associations as outlined in the previous chapter, but generatively. When we know of van Veen's emblem, we can infer that informed contemporary viewers might have associated it with Vermeer's invention, though we should err if we were to infer that Vermeer necessarily intended a specific allusion. However, this far from exhausts the case. The structure and fiction of this painting are such that the attention of the viewer is drawn not to emblematic allusion as a principal means of establishing pictorial meaning, but rather to the conditions under which such an allusion is created, and hence to the conditions of the apprehension of pictorial fictions.

We have seen that the scale and spatial construction of the *Woman Standing at a Virginal* suggest ambivalences. Certain elements prompt acknowledgement of a community of pictorial space between pictorial worlds within the painting and between the pictorial world of the painting and the space of the viewer. Other elements signal distinctions between these spaces at each turn, subtly undermining any sense of illusion and somatic involvement. That is, the painting is spatially generative. This condition is the corollary of its quality of being iconographically generative. The viewer is drawn across both picture planes (that of the painting itself and that of the Cupid painting within) to become involved with the demonstrative activity performed by Cupid. His action is not alone incidental to any emblematic allusion: rather it invites the attention of the viewer in a specific manner to a specific object. His action prompts us as viewers to do self-consciously in relation to the painting-within-the-painting what we are likely doing unself-consciously in relation to the painting as a whole: that is, to examine a representation. Yet this small hand-held object within the painting-within-the-painting, on which we might expect to discern a further representation, is blank. That it is so is not an effect of physical loss, nor of irresolution proper to a differentiation between the world of the virginal player and that of Cupid. It

is purposefully blank. As such it constitutes a fourth pictorial world, the furthest point of the *mise en abîme* of representation that we attain upon visually traversing our own world before the picture, the world of the woman and that of Cupid. As such it is differentiated from Cupid's world in a manner other than that of the world differentiations that precede it in the recession. As we have seen, the latter are effected by framing and by stylistic distinction. The object with the blank surface is unframed, and, in this sense as well as stylistically, it forms part of Cupid's world. However, Cupid's key act of demonstration serves to differentiate it and endow it with distinct status.

At this point, whether or not the viewer is aware of the wreathed figure '1' on the object similarly held by Cupid in the emblem by van Veen, or associates it with a love letter, is irrelevant. If it is a card or tablet, we should avoid the inference that the viewer is necessarily expected to supply the missing figure from existing knowledge of the emblem. If it is a letter, we should avoid the inference that the viewer is necessarily expected to supply a missing inscription. However, to do either would be a possible response. Even so, such a knowledgeable viewer does not necessarily interpret the absence of an inscription or figure on the letter, card or tablet as simply pictorial shorthand, for the absence is too obviously calculated. Instead we should acknowledge the state of blankness itself in relation not to a specific expected presence (a figure '1' or an inscription), but to the expectation of presence itself. The disclosure of absence attendant upon close visual scrutiny that the viewer is specifically exhorted to undertake is the point. Only by means of this representation of the degree zero of representation can the mind of the viewer become engaged with the act of scrutiny itself and its complex relation to representation.

This act of scrutiny draws the attention of the viewer not to an allegorical or emblematic allusion as a pictorial goal, but to the very conditions that govern the creation and apprehension of such an allusion. The artist as purposeful agent thereby designates the form of visual scrutiny he has so subtly isolated and defined as anterior to, and as taking precedence over, the distillation of meaning consequent upon such an act. At issue is our relation to artifice, our relation to fiction in visual terms. There is a strong sense in which

the human participants, the artist and viewers, as creative agent and as interpretative agents, are implicitly presented as quite separate and distinct from the pictorial worlds. Contiguity may be suggested only to be compromised. We stand in relation to the *Woman Standing at a Virginal* as to a thing that is a representation, not as to a figure in any calculable proximity. We are instructed to keep our distance even while visually entering the complex pictorial world. Consideration of the work itself, in legitimate viewing conditions (which include now paradigmatically hanging on a museum wall), alone permits understanding of certain of its qualities which are part of its meaning. That is, the lateral conflation of the planes of the gazes directed by the woman and Cupid, combined with the calculated uncertainty in relation to other pictorial elements and the picture plane of the position of the woman in space, and the scale of the object and its image in relation to the viewer, together produce a distancing effect: an effect not of unalloyed pictorial illusion, but rather of contrivance and artifice. In spite of the gazes crossing the picture planes, it is as though we are invited to apprehend a connection between viewer and representation that is severely and precisely qualified and circumscribed. This quality is an aspect of the painting that is utterly integral to its work as an object, to our relationship to it as users of that object, but that is confined to that precise relationship. That is, apprehension of this quality by means of photographs is out of the question.

We can now integrate what we have learned from a consideration of our somatic relationship to the *Woman Standing at a Virginal* as a spatially generative three-dimensional object with what we have learned earlier about its iconographically generative character. We can conclude that distance seems proper to the art of painting as it is here presented to us. Love in Vermeer's world presupposes two discrete entities – man and woman, artist and model, artist and painting, viewer and painting.[5] Even following the perception of beauty symbolized by Cupid's intervention, a paradox remains in the conception of the union of love. The two entities must remain distinct for the relationship to continue to obtain. In the case of painting this means that the world of the painter and the viewer can never be conflated with that of the painting. The perfect illusion that would unite the two sought by Samuel

van Hoogstraten is itself an illusion. Vermeer presents this distinction and distance as properly characteristic of the art of painting and the love it inspires.

The discussion to date of the *Woman Standing at a Virginal* has been of the painting as a unique object hanging in a gallery irrespective of its circumstances. I mentioned the importance of the viewer's peripheral vision and the likely presence of other paintings within that field of vision. Our consciousness of these other paintings might be enhanced by the representation of paintings hanging on the rear wall of Vermeer's painting itself. However, I did not discuss how meaning might be generated by the juxtaposition of such objects.

That no object is perceived in isolation and that how any given object is perceived is vitally affected by its juxtaposition to other objects is a truism of curatorial practice. Any exploration of exhibiting as a discursive activity takes this into account, together with other factors (most obviously gallery and lighting design) that affect viewers' somatic relationship to objects. There is a gulf between such practice and curators' understanding of it on the one hand, and recent theoretical discussion of aspects of its consequences on the other. That discussion largely ignores the scholarly achievement by generations of curators from Wilhelm von Bode onwards through the purposeful manipulation of exhibition as a medium.[6]

Museum exhibition, even of a permanent collection, is only ever temporary. I have seen Vermeer's *Woman Standing at a Virginal* in several settings over the years at the National Gallery. Changes occur as curators modify their visual arguments and as galleries are refurbished. Between 1972 and 1998 such decisions were the responsibility of the curator then in charge of Dutch and Flemish paintings, latterly also chief curator, Christopher Brown.[7] Whatever the site of its installation, the *Woman Standing at a Virginal* has almost inevitably been hung in close relation to the other Vermeer painting in the collection, the *Woman Seated at a Virginal* (illus. 31).

Reasons for treating the two paintings as a pendant pair have been discussed for many years. They are of near-identical dimensions,[8] their dresses and the *tabbertslijf* bodice that each woman wears[9] are similar or identical, their hair is similarly dressed and ornamented, and the fact that one is seated and the other standing, but facing in opposite

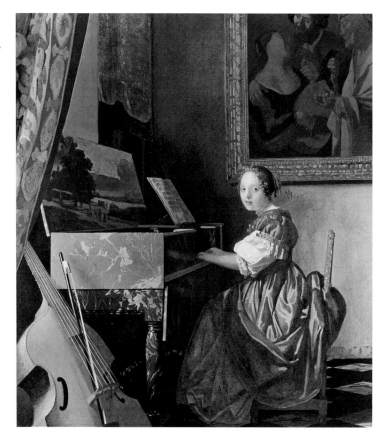

directions allows for their complementary arrangement.[10] Complementarity has also been discerned iconographically. An elaboration of de Jongh's emblematic interpretation of the *Woman Standing at a Virginal* presents the *Woman Seated at a Virginal* as its iconographical opposite. In this view the paintings-within-the-paintings (*Cupid* in the former and Dirck van Baburen's *Procuress*[11] in the latter) produce contrasting meanings for the two paintings of faithful and mercenary love respectively; thus together they have been said to evoke the theme of the choice between two paths of life, virtue and vice.[12]

Various reasons have been put forward that cast doubt upon this interpretation of the two paintings as an iconographically determined pair. Not least is the physical difference between them in terms of execution. Commentators have noted that the schematization of forms through tonal notation, already to be seen in the *Woman Standing at a*

Virginal, is more accentuated in the *Woman Seated at a Virginal*, to be seen, for example, in the rendering of the gilt, carved frames in each work. This might suggest a progressive development of the artist's notational manner, and hence a later date for the latter painting.[13] Blankert goes so far as to discern 'a noticeable decline in Vermeer's powers' in the *Woman Seated at a Virginal*, thus firmly dissociating the two paintings from each other.[14]

There is nothing to suggest in the admittedly incomplete and ambiguous provenance records that the two paintings were ever owned together prior to the acquisition of the *Woman Seated at a Virginal* by the French critic, Théophile Thoré, at a sale of works from the great Schönborn collection in May 1867. It then joined the *Woman Standing at a Virginal* already in Thoré's possession. The two paintings were separated in 1892, when the Lacroix family, which had inherited Thoré's collection, dispersed it. The National Gallery acquired the *Woman Standing at a Virginal* shortly after that sale, but the paintings were reunited only when the *Woman Seated at a Virginal* entered the National Gallery with the George Salting Bequest in 1910.[15]

The question here is not whether the two paintings were conceived by Vermeer as a pendant pair, or even whether they were treated as such early in their existence, but rather how they are available to viewers as objects of present experience on the wall or walls of the museum that owns and displays them. Part of the viewer's experience of the *Woman Standing at a Virginal* is its almost inevitable juxtaposition with the *Woman Seated at a Virginal*.

On their return from the Vermeer exhibition in Washington and The Hague in 1995–6, the two paintings were reincorpo-

32 National Gallery, London: floor plan of Rooms 15 and 16 with adjacent galleries.

33 National Gallery, London: Room 16 from across Room 15.

rated within Room 16, a small gallery, one of three devoted to seventeenth-century Dutch cabinet paintings that had been refurbished and rehung in 1991. Visitors approaching Room 16 along the main east–west axis of the main building, or from the North Galleries, must obliquely cross the neighbouring octagonal gallery, Room 15 (illus. 32). The *Woman Standing at a Virginal* is placed so as to be the axial work on the far wall seen through the slightly off-centre entrance as one approaches along a diagonal from doorway to doorway from the east, across Room 15 (illus. 33, 34). When one draws level with the doorway into Room 16, however, and faces the *Woman Standing at a Virginal* symmetrically, that painting's apparently central position is ceded to a Saenredam church interior, the *Interior of the Grote Kerk at Haarlem*. The Saenredam appears in the doorway, flanked by the *Woman Standing at a Virginal* on the left and the *Woman Seated at a Virginal* on the right (illus. 35). Once inside Room 16, one can see that the *Woman Standing at a Virginal* is the second painting from the

89

left on this wall facing the entrance (illus. 36). Between it and the corner is another church interior by Saenredam, the *Interior of the Buurkerk at Utrecht*. In his arrangement, Brown contrived an elegant solution to the problem of how to engage viewers during an initially oblique approach to the gallery. First, the Vermeer *Woman Standing at a Virginal* leads the approaching viewer and appears to be central, only to give way to become one of a trio of paintings framed in the doorway. This arrangement addresses a number of curatorial problems, not only that of address through space as the physical relationship between the viewer in motion and the static objects changes across the longest axes of the galleries concerned.

By alternating the Vermeers with church interiors, Brown makes discursive statements. He pointedly avoids a comparison between Vermeer's domestic interiors and those of his contemporaries. A perception of visual qualities comes into play in curatorial work of this kind that can easily degenerate into mere connoisseurial ranking. Even though such ranking

34 National Gallery, London: Room 16 from the doorway between Rooms 15 and 16.

35 National Gallery, London: west wall of Room 16.

has not yet been explained adequately in theoretical terms, it continues to be employed in practice, however contentious it may be. That is, we can acknowledge that the Vermeers (especially the *Woman Standing at a Virginal*) have a commanding presence that attracts attention more readily than many other paintings of their culture and size. We can recognize that their presence will tend to distract attention from any painting of remotely similar subject matter placed beside them, even if such a painting itself has a strong presence when viewed on its own or in other circumstances. Curators must make pragmatic judgements about the differential power of attraction of paintings placed in proximity to one another, for in any group of paintings to be hung together there is almost always a hierarchy of this kind. Curators then generally distribute the works with the greatest perceived power of attraction evenly about the gallery, sometimes using one to hold an axis (usually a central point visible during a viewer's initial approach to the gallery), sometimes to hold a spot in the gallery that is perceptually weak in terms of the relationship between the architecture and the viewer, such as near a corner, or beside a doorway.

There is, in effect, a conventional hierarchy of placement within any given gallery space, and of the relative power of visual attraction among paintings for viewers, both immediately and for sustained attention. These are obviously conventional because a shared cultural understanding of how both are constituted can and does change. Indeed, by means of

their discursive manipulations curators can contribute to the precipitation of such change. Their work – at least with non-contemporary art – may usually be less overtly spectacular in this regard than that of artists creating installations (from at least the example of Kasimir Malevitch onwards), but I cannot imagine that there have been many curators, at least since the inception of modern museology in the late eighteenth century, who have regarded any gallery arrangement as inevitable or natural, as some critics occasionally imply.

With the National Gallery Vermeers and church interiors, Brown sets up subtle counterpoints and comparisons that run at a tangent to much recent discussion of genres in scholarly debate. Not only does he accommodate their relative power of attraction, but he invites an immediate comparison not with other domestic interiors, but with works from a genre that is usually considered only tangentially in relation to Vermeer's interiors. Although this comparison is likely indebted to Roger Fry's early Modernist observations regarding the shared formal and abstract qualities of Vermeer's and Saenredam's paintings, it has acquired additional connotations.[16] Not only do we see a contrast between type of interior – intimate domestic and public ecclesiastical – but between scale of representation. The spaces in the Saenredam and the Berckheyde are obviously extensive and architecturally complex, while those in the Vermeers are but corners of domestic rooms, both architecturally and perspectively simple. These juxtapositions might arouse the viewer's curiosity not only about the depiction of space, but about contrasts between the private and the public spheres in Dutch art, and the society in which it functioned. Fry's Modernist, Abstractionist concerns may have been superficially superseded, but their evocation none the less gives the display critical and art-historiographical depth.

Christopher Brown's arrangement of Room 16 in the National Gallery can be usefully contrasted to the incorporation of the Vermeers in Wouter Kloek's arrangement in Gallery 212 of the Rijksmuseum, Amsterdam. There the explicit comparison invited is between the works of Vermeer – the *Little Street*, the *Woman in Blue Reading a Letter*, the *Love Letter* and the *Maid Pouring Milk* – and the domestic interior and exterior paintings of his fellow Delft artist, Pieter de Hooch, and others, even though the *Maid Pouring Milk* is hung

between two Emmanuel de Witte church interiors. The comparisons Kloek prompts are more traditional than in Brown's arrangement, and the power of attraction of the Vermeers is toned down in favour of an attempt at visual even-handedness towards all the paintings in the gallery. Kloek's visual argument cannot be faulted, yet it is neither so visually surprising nor associatively dense as Brown's.

Christopher Brown's counterpoint between the church interiors and the Vermeers not only invites formal and thematic comparisons between depictions of the two types of space, but it subtly reinforces the pairing of the *Woman Standing at a Virginal* with the *Woman Seated at a Virginal*. That one of the Saenredams and the Berckheyde both depict the same church implies a relationship between them that can only be, in actuality, coincidental. Yet the perception of that relationship strengthens the perception of a pendant relationship between the Vermeers, even though any analogy of this kind that the viewer might make must be known to be inexact. Even if the Vermeers do not belong together in historical terms, they function together in museological terms, and Brown has contrived a subtle way of visually expounding certain aspects of that museological relationship.

John Nash has addressed the contrast between any purported original pairing of the two London Vermeers and the pairing they incontrovertibly enjoy on the National Gallery walls. He makes the point that much is to be discerned by prolonged study of the paintings in relation to each other irrespective of their earlier history. He writes:

> The significance of the contrast between these paintings does not lie in a conceit to be uncovered by interpretation. After an extended and concentrated exploration of the *Woman standing at the virginals*, what is the experience of turning to the *Woman seated at the virginals*? Is it not to discover that every proportion, harmony and tone is countered, contrasted, inverted? Is it not to discover that every term that might define a quality of the one must be abandoned for its converse in the other?[17]

This sense of detailed contrast is almost binary in its semiotic functioning, but neither arbitrary nor mechanistic (as was the case with Eco's binarism mentioned in chapter 1).[18] Consideration of the *Woman Seated at a Virginal* can lead to a

sharpening of our visual awareness of the representational contrivances in the *Woman Standing at a Virginal* in the light of a point by point series of contrasts between the two paintings. These include, first, a near-central vanishing point in the standing woman's sleeve, as opposed to a vanishing point to the far right of the composition, behind and beyond the seated woman's back; secondly, a face depicted largely in shadow, the principal light source being partly represented in the visual field, as opposed to a face receiving a full fall of light from a source wholly beyond the depicted area. Such comparisons sharpen our awareness of the contrivance involved as a matter of pictorial decision-making in any given instance. The gallery arrangement contrived by Brown in response to the opportunity afforded by the fact of the National Gallery owning both paintings heightens the viewer's ability to discern these, and many other, characteristics. Only in the actual presence of the paintings themselves – and of these two paintings in relation to each other – is their full semantic density discernible.

We might infer that certain elements of this semantic density are most apparent, or perhaps even only apparent, when the *Woman Standing at a Virginal* is a real presence coincident with that of the *Woman Seated at a Virginal* in an authored museum display. How might awareness of those elements further affect our interpretation of the painting in question? Two interdependent characteristics that assume an enhanced significance in this context are the depiction of the fall of light, and how paint constitutes representations.

In many of Vermeer's interiors, including the London paintings, the white rear walls parallel to the picture plane act in a sense as the ostensibly neutral indicators of the fall of light within the pictorial world against which all else that is represented is defined. In each case that wall is a screen of reference establishing the range of illuminative possibilities within the pictorial world. The treatment of the rear wall differs radically from painting to painting as Vermeer explores the representation of optical phenomena in various registers. That treatment ranges from drawing attention to the wall's complex surface articulations in the *Maid Pouring Milk* (illus. 36) to the conflation of the wall surface as represented with the physical characteristics of the actual paint surface in the *Woman Seated at a Virginal*. Nowhere is the role of this screen of vision –

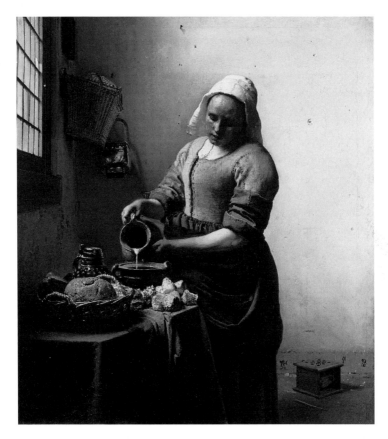

36 Vermeer, *Maid Pouring Milk*, c. 1658–60, oil on canvas, 45.5 × 41 cm. Rijksmuseum, Amsterdam.

which has been termed aniconic[19] – as an ever varying contingent reflector of the viewer's gaze more apparent than in the *Woman with a Pearl Necklace* (illus. 37). In the working of this painting two implicitly reflected gazes intersect in a perspectival void: that of the woman observing herself in the looking-glass at right angles to the viewer whose own gaze is directly confronted with a representation of a blank wall. In each of these paintings the rear wall is defined by the represented fall of light as contrived by the artist to be registered by the viewer differentially and mensurably.

In the case of the *Woman Seated at a Virginal* the visible window is shaded. Light penetrates the weave of the blue blind irregularly. The wall beside it is in subtly varying shadow as far to the right as the seated woman. Beyond her the wall catches more light, presumably as though it enters from in front of, and to the left of, the picture plane. Enough of this light penetrates the area to the left of the woman's head to

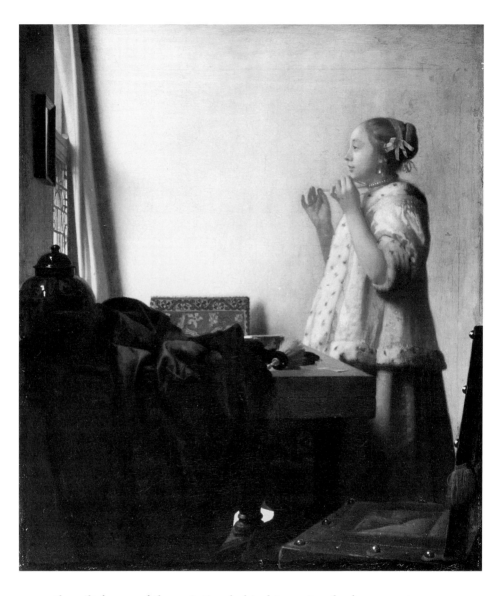

cause the gilt frame of the painting behind to cast a shadow beneath itself. Yet it is at that very point where the fall of light on the wall becomes discernible as a positive presence, immediately to the right of the woman's head, that the painter introduces the most obvious sign of authorial artifice, his signature.

The rear wall in the *Woman Standing at a Virginal* is utterly different. Principally it is represented registering the fall of shadows – umbra and penumbra – as light from the window

37 Vermeer, *Woman with a Pearl Necklace*, *c.* 1664, oil on canvas, 51.2 × 45.1 cm. Staatliche Gemäldegalerie, Berlin.

partially visible on the left encounters obstacles, such as the window frame, the interior sill and the paintings on the wall. Vermeer's signature – now scarcely discernible – is in an area of pictorial shadow rather than light, to the upper left of the side of the virginal. The calligraphic presence against the wall, metaphorically, is not a signature, but the silhouette of ribbons belonging to the woman's *tabbertslijf* bodice.

The factors in play here form signifying pairs of elements discernible through contrast between the two paintings visible in their full semantic density. These, and others, add up to provoke the viewer to acknowledge details of the artifice of paint even as it constitutes a representation. Nowhere is this more apparent than in the contrast between the surfaces of the virginal and the surfaces of the floor tiles in both London paintings. The painted marbling of the virginals, and the real marble of the floor, are indistinguishable when rendered in paint, other than contextually within the representation. The marbling of the virginals is in both cases – in shadow in the *Woman Standing at a Virginal,* and in full light in the *Woman Seated at a Virginal* – painting-within-the-painting. That marbling bears a relationship to the represented marble floors analogous to that of the representational paintings-within-the-painting. But the marbling of the virginals is not representational within those pictorial worlds themselves. The marbling is explicitly no more than paint within those worlds irrespective of its illusionistic function. Furthermore, this particular element of the representation of the virginals is indistinguishable from the other elements of their representation, principally their structural rendering as objects. The contrast between the marbling of the virginals and the marble floors isolates how painting itself constitutes the represented object, as well as the representation of the object. It is both sign and signified. It exists identically *as paint* in both the viewer's world and the worlds of the women at the virginals. Its existence isolates the fact of painting itself as constitutive of all these worlds. Paint constitutes these pictorial worlds quite literally, no less in terms of the artisanal artefacts within them than in terms of the representations of further pictorial worlds.[20] Therefore in the case of the *Woman Standing at the Virginal* there is a continuum of paint from the floor tiles, through the summary pictorial worlds of the blue-and-white tiles of the frieze, through the plausible pictorial worlds of the

landscape paintings and the Cupid painting, to the painted element at the furthest remove: the blank tablet held by Cupid. The painting reveals that illusionism – Samuel van Hoogstraten's highest goal for art – is itself only illusory. This paintedness of the pictorial world and the pictorial worlds within it, whether themselves purely artefactual (like the floor tiles, the plaster of the wall or the case and stand of the virginal) or representational (as in the frieze tiles, the landscapes and the Cupid painting), is only truly apparent when the ever shifting viewer faces the paint of the painting itself. And this is the very quality that must interlock with the love of art, iconographically and somatically evoked, finally to vindicate the *Woman Standing at a Virginal* as *object*.

4 Copies

Experience of a work of art, and thought about a work of art, must be based on two premises. The first is that there are qualities of objects that are peculiar to those objects themselves and that are not amenable to reproduction. This was argued in the preceding chapter. The second premise is that the history of art as a discipline has developed largely by concentrating upon those qualities that translate into reproduction. (What that translation may consist in is not itself necessarily a straightforward matter.) A form of orthodox art-historical discussion of such ostensibly reliably translated qualities (principally iconographic) was given in the first chapter. What is the relationship in art-historical practice between attention to these two sets of qualities, the untranslatable and the translatable? How might attention to this matter affect our understanding of our case study, Vermeer's *Woman Standing at a Virginal*?

Whatever their field of study most art historians readily acknowledge, first, that there is a distinction between prototype and reproduction and, secondly, that this distinction must be taken into account in the course of study. This is a truism of art-historical research. It was amply confirmed by the study of art historians' methods undertaken by the Getty Art History Information Program and the Institute of Research in Information and Scholarship at Brown University (IRIS) published in 1988.[1] One of the topics addressed in some detail in this study concerned the scholars' attitudes towards original works of art and reproductions of them in relation to their research. The questioning revealed that scholars are perfectly well aware of the problematic nature of the relationship between objects and their reproductions. All the quotations from the interviews with art historians, cited anonymously, suggest an awareness of differences between these two classes of things, and of those differences having consequences for the study of art. The researchers' narrative is at pains to stress that 'For most scholars original works of art are the starting point of art-historical research . . . [F]irsthand experiences

99

with the objects themselves are valued and usually essential aspects of the research process . . . [O]ne comes to understand the work of art in unique ways through immediate contact with it . . . Physical involvement with the original monument or work of art is seen as indispensable to the study of art history.'[2] Concomitantly, 'the manipulative nature of reproductions and the relative merits and deficiencies of various media demand wariness'.[3] Yet art historians do not necessarily act in accordance with their beliefs.

What follows is not a critique of theory, but concerns practice alone. The anonymous scholars' quotations from the researchers' interviews reveal a certain tension between theory and practice. Scholars will suggest that reliance on a reproduction to the exclusion of acquaintance with the work reproduced occurs, but is always someone else's practice, not their own.[4] Indeed, this accusation is a topos of hostile scholarly criticism in book reviews and elsewhere. For instance, David Carrier, reviewing Norman Bryson's *Vision and Painting: The Logic of the Gaze* (1983), wrote:

> Bryson's claim that European art treats its medium as if it were transparent is odd – especially after Gombrich has described at such length that tradition's fascination with the 'beholder's share', with seeing pigment turn into what it represents. *Only looking too much at photographs of paintings could cause anyone to hold this view.*[5]

Carrier suggests that, if one treats photographs of paintings as transparent equivalents of the paintings themselves, one is all the more likely to ascribe the same transparency to the relationship between paintings and what they represent. When I asked Bryson about his practice in the light of this accusation, he denied a reliance on reproductions at the expense of examining works of art themselves. He stressed that one has to 'spend a zillion hours looking at things' and that in the presence of the object one can see things 'a hundred times sharper than in reproductions'.[6] Even a scholar whose work suggests to many of his critics attention to art at a remove from the objects themselves makes a coherent and spirited case for the absolute necessity of examining prototypes firsthand owing to their irreproducible 'syntactic density', as Bryson put it, using Nelson Goodman's term.[7] The density of the prototype – in whatever terms it is expressed (and there are constraints on

how it might be expressed) – in comparison with its reproductive derivatives is axiomatic in art-historical study on a number of rationally coherent grounds. But it is more than that. It is a basic article of professional faith. Irrespective of whatever a scholar's day-to-day practice might actually be, that scholar's credibility would be severely compromised if she or he admitted to behaving as though reproductions were the exact equivalent of the things reproduced. Yet actual practice is often expedient to the extent that reproductions are deemed to suffice. 'The issue is, you do the best you can because that's what we do in real life', one of the anonymously quoted scholars in the Getty/IRIS study admitted.[8] That is, the convenience of using reproductions is often decisive.

Expediency is not the only determining factor in the use of reproductions. The ubiquity of photographic reproductions in various forms – books, photographic archives, slide collections – has actually shaped the discipline. This, too, has become a truism to the extent that its careful analysis and demonstration has been all but supplanted by careless assertion.[9] As one scholar quoted anonymously in the Getty/IRIS study noted, 'Modern art history is basically unmanageable without photographs because it's completely comparative by method.'[10] Once art historians were satisfied that reproductions were accurate, forms of enquiry based on the direct visual comparison of an original work with such reproductions, or between such reproductions alone, became possible. For instance, on 28 September 1869, the directors of the National Gallery, London and the Galleria degli Uffizi, Florence compared a photograph by L. Caldesi of the National Gallery's newly acquired *Entombment* directly with Michelangelo's *Doni Tondo*, and concluded that the former was indeed also by Michelangelo.[11] In these same years scholars were comparing photographs of works with other photographs of works and recognizing that this represented a revolution in their methods. The former Superintendent of Art Collections at the South Kensington (subsequently Victoria & Albert) Museum, Sir John Charles Robinson, wrote in 1870 that:

> the invention of photography has in our own time effected an entire revolution: the drawings of the ancient masters may now be multiplied virtually without limit: and thus, what was before a practical impossibility, namely the

actual comparison of the numerous dispersed drawings of any particular master, has now become quite practicable.[12]

Robinson made this observation in his hugely influential catalogue of the Raphael and Michelangelo drawings in the Ashmolean Museum, Oxford, which has been described by Francis Haskell as 'perhaps the single most important contribution to scholarly connoisseurship made by an Englishman in the nineteenth century'.[13] Privately assembled collections of reproductions – many of them photographic – came to be complemented in the present century by institutionally adopted photographic archives. The Witt and Conway Libraries at the Courtauld Institute of Art, London, the Frick Art Reference Library, New York and the Rijksbureau voor Kunsthistorische Documentatie, The Hague are but four such originally private collections of reproductions that have been perpetuated and developed institutionally, and are indispensable to students of seventeenth-century Dutch art.

As the example of Robinson suggests, the comparative method was early developed in the field of Italian art. Bernard Berenson was among the first to develop a photographic archive, and far from the last. The late Federico Zeri bequeathed his private archive of photographs of Italian paintings and drawings, reportedly numbering over a million items, to the University of Bologna in 1998.[14] As the Getty/IRIS researchers noted, 'The large photo archive can offer a view of art seldom afforded in any other setting. Access to such diverse exposure can alter one's art-historical perspective.[15] The director of the Louvre Museum, Pierre Rosenberg, described the kind of comparative connoisseurship noted by Robinson as newly possible in 1870 in the case of the late Federico Zeri:

> He was one of the great 'attributionists', an equal of Bernard Berenson and Roberto Longhi. His method was essentially pragmatic: he looked at the innumerable photographs – preferably black and white – that came his way and identified first the subject, the origin, the date, the hand of the painter. Nothing to it, apparently, but it was the fruit of a daily asceticism, of hourly practice, of permanent observation and above all a fresh and critically powerful way of looking.[16]

Of course, this is hardly an analytical account, but both the

102

practice and description of connoisseurship – the discernment of characteristics in works of art for the assessment of quality and the proposal of authorship – are notoriously difficult to analyse.[17] We see here, none the less, a testimony to a procedure premised on the assumption that the reproduction is a reliable analogue of the prototype. This seems scarcely compatible – or at least to exist in a deeply problematic relationship – with Rosenberg's reported quotation of Zeri, "'My only passion is direct contact with works of art", he said.'[18]

Whatever the permutations of the relationship between the examination of prototypes and reproductions may be in any given instance, there can be no doubt that the perusal of large quantities of reproductions has come to represent a major means of identifying and formulating art-historical problems and questions. Not only has the availability of reproductions of a kind and in quantities and orderly arrangements (whether by attribution or subject) hitherto unavailable shaped the very definition of art-historical problems and questions, but the generation of art-historical discourse as well. The comparative method utilizing reproductions that stimulated attributive connoisseurship from at least the 1860s onwards formed the basis of much other new art-historical scholarship. Vermeer's oeuvre was among the first to be defined from scratch in this manner, so our experience of his paintings is to an important extent defined by the consequences of this process. This kind of scholarship could involve complex and progressive combinations of a use of notes made before original works of art, reproductions which range from a scholar's own sketches of the original to photographs of it and, especially with the proliferation of the carbon arc electrical projector from the 1890s onwards, the use of photographic slides in lectures.[19] The initial articulation of an art historian's ideas is often – though not invariably, of course – in the form of a lecture, seminar or symposium paper illustrated with pairs of projected slides.[20] The pattern was apparently set from the 1890s onwards by Heinrich Wölfflin, who may have been the first regularly to use twin projectors in his lectures, and accelerated with the introduction of 35 mm colour slides in the mid-1930s.[21] In this way scholars can create their arguments in visual terms, using both sequence and simultaneity, their text being essentially a commentary on what the viewers of the projected slides see. A publication,

then, is often an elaboration of a presentation conceived in terms of a dynamic and comparative sequence of reproductive illustrations. As one scholar quoted anonymously in the Getty/IRIS study put it, 'So many of my books or writings originated in lectures, and the lectures had slides. [The publication process] usually starts with slides.'[22] The Getty/IRIS researchers conclude that, in the writing and publishing of art history, the arrangement of the illustrations 'often forms the initial and fundamental framework upon which art-historical arguments are built, whether for lectures, exhibitions, or publications'.[23] And those illustrations are reproductions that bear an uncertain relationship – we are forced to acknowledge – to the things they represent.

Scholars make the point that, even if they make extensive use of reproductions in the formulation of hypotheses, those hypotheses can be tested against the originals of the works reproduced. In practice there is a hierarchy of testing. Certain points must indeed be confirmed by examination or re-examination of the original if they are to survive critical scrutiny by the writers themselves in the first instance, and a learned readership. First, certain characteristics of works of art are known not to be discernible in reproduction. This is most obviously so in the case of site-specific works, such as those incorporated within the fabric of a building. For example, in their book on Gian Battista Tiepolo, Michael Baxandall and Svetlana Alpers included a detailed discussion and illustration of the delivery of light to the huge vault of the Treppenhaus (staircase hall) of the Prince-Bishop's Palace in Würzburg decorated by Tiepolo in 1752–3.[24] Baxandall had studied this site with great attention on more than one occasion, returning there to test hypotheses.[25] I was able to study the site over the course of three days in 1996. A snowfall in the night of 8–9 February completely changed conditions in the Treppenhaus, vastly increasing the amount of light reflected upward from the courtyard. The light reflected from the snow, rather than from dark stone setts, led to an utter transformation of the appearance of Tiepolo's vast ceiling painting, and to what could be discerned within it by the viewer on the stairs and on the surrounding landing. Details, as well as overall effects, that could be witnessed only in these extraordinary, though entirely natural, winter conditions are irreproducible in their subtlety and interdependence. Much the

same can be said of paintings on a domestic scale. Among the characteristics of oil paintings that are known not to be discernible in reproduction are details of the facture of paint surfaces, or the depth of successive layers of oil glazes. Viewers' richness of perception in both the Würzburg Treppenhaus and before a painting in oils depends upon changing points of view: effected bodily in the former case, and by a slight shift of the head in the latter. Only thus is complex depth perception possible. The qualities thus perceived are not present in reproductions (other than precise copies in the same medium). Therefore any discussion that turns on characteristics discernible only in this manner is clearly beyond the scope of dependence on reproductions, and any infringement of these conditions will be apparent to readers irrespective of their acquaintance, or lack thereof, with the work being discussed.

Secondly, any discussion of well-known and readily accessible works that suggests physical inaccuracy on the scholar's part can be detected far more readily than if the work discussed is obscure or inaccessible. The kinds of arguments that works of art can sustain therefore vary, and depend on the nature of the scrutiny that is possible in any given instance. The kind of argument presented in chapter 2 would be largely feasible without firsthand knowledge of the *Woman Standing at a Virginal*. That given in chapter 3 would not. Capable scholars therefore appreciate the type and weight of argument their knowledge of any given work of art will sustain. For central and complex discussions of a work, especially when that work is well known and readily accessible, a lack of attentive firsthand examination is at the very least imprudent, at worst both irresponsible and discreditable. For subsidiary points made from features that are of a class generally acknowledged pragmatically to reproduce reliably, especially in the mitigating circumstance of the inaccessibility of the original, such scrupulousness is theoretically inconsequential and, in practice, beside the point. For example, in chapter 2 the points made about Godfried Schalcken's *Venus Attended by Cupid* and *Venus Handing Cupid a Fire Arrow* derive from a firsthand examination of the paintings at the Rijksmuseum, Amsterdam on 18 November 1989 (the paintings were included in the exhibition *De Hollandse Fijnschilders*). The discernment of the detail of the figures on the beach referred to in the argument was possible thanks only to that examination. Even the full-

page colour illustration in the exhibition catalogue is inadequate.[26] The *Cupid* attributed to Van Dyck, on the other hand, was known to me only from the photographic illustration in Gustav Glück's 1931 *Klassiker der Kunst* volume on the artist when I first wrote about it in chapter 2.[27] I subsequently found full-page colour illustrations of it in a Japanese exhibition catalogue and a Sotheby's sale catalogue.[28] That acquaintance with poor substitutes alone might be adequate to the use made of it on this occasion, but could hardly sustain a more detailed analysis or sophisticated deployment in further argument. For some purposes, then, reliance on reproductions – as long as one can be confident of their accuracy (which entails placing trust in the consistency of a process) – not only must suffice in practice, but actually suffices in theory. The caveat about the accuracy of the reproduction is, however, vital, and depending upon it here involves begging several questions.

Photography, its derivatives and successors, including computer images, did not establish a monopoly in the reproduction of art from their inception, nor have they entirely done so to this day. However, art-historical practice is generally dependent on three types of photographic reproduction and their mass-produced derivatives in print: first, the panchromatic monochrome print (derived from a negative whose emulsions are equally sensitive to all parts of the visible light spectrum); secondly, the large-format colour transparency; and, thirdly, the 35 mm colour slide. Although photography in these forms dominates the use of reproductions in art history, it did not become preponderant either immediately upon availability, or as a matter of course.[29] The irreproducibility of the photograph directly in print before the development of photomechanical processes in the later nineteenth century inhibited its use, other than as a matrix for manual wood engraving, in the published media. As far as the photography of paintings went, two considerable technical difficulties had to be overcome. First, early exposures required considerable amounts of light, and many works – especially large ones – simply could not be illuminated sufficiently. Secondly, emulsions were selectively sensitive across the light spectrum, resulting in a translation from hue to tone that was either wholly obscuring or palpably misleading. The registering of yellow by a dark tone meant that it was often quite

impossible to acquire any photographic image whatsoever of a heavily varnished painting.[30] This characteristic began to be overcome only with the development of isochromatic emulsion in the 1890s – appreciated and praised by Bernard Berenson[31] – and panchromatic film in the 1920s. By that time the photograph of the painting had assumed the cultural status in the practice of many art historians of natural index, conforming to Richard Shiff's contention that 'during the modern era photography has provided a kind of fabricated image that can successfully masquerade as a natural one'.[32]

The Getty/IRIS study of art-historical practice found that art historians express an awareness of the limitations of photography in respect of its reproductive capacity. Yet the definition of those limitations, as perceived, is not wholly straightforward. We have already seen that scholars believe that photographs do not fully register all the features of the original: they lack syntactic density. The loss of a sense of size and relative scale – especially potentially misleading when works of wholly unequal size are juxtaposed on the same scale in reproduction, as frequently happens on projection screens – is a common caveat. Scholars are aware that photographs of works of art can be interpretative rather than purely documentary.[33] This is to be seen more clearly, even to the casual observer, in the cases of architecture and sculpture than in the case of paintings. Why this should be, though, receives little discussion. The choices apparent in the photography of sculpture, for example, depend upon the unavoidable three-dimensionality of the object, and therefore the photographer's overt choices of angle and lighting. In actuality, a painting is no less three-dimensional than a sculpture, and, in the case of an old master oil painting, perceiving it often involves apprehending qualities of transparency and translucency as well as surface variation and the character of the support. In a photograph of a painting its three-dimensionality is transformed. On occasion the contours of its surface, whether an effect of painted impasto or of the character of the support, or both, can be registered two-dimensionally in a photograph. In the photograph that two-dimensional registration of three-dimensional features exists in relation to other photographically rendered features of the painting in a distinct manner. This is different from the relationship between the various prototypical features in the painting

itself. At its simplest, texture becomes pattern. The most common and blatant indication of the suppression of three-dimensionality is the exclusion of any frame that may surround a painting. The painting, then, is habitually rendered photographically as an image more uncompromisingly than could be achieved in the case of sculpture. Indeed, one can discern a consistent aim on the part of photographers to achieve this effect. The result has been naturalized to the extent that paintings are commonly perceived and treated as two-dimensional images whose three-dimensionality (if relevant) is a matter solely of the representational function of the painting itself. The naturalization of the object as an image is one of the most radical and far-reaching consequences of the overwhelming use of photographic reproductions and is especially exaggerated in the case of the reproduction of paintings.

Only in four types of photographs of paintings is their objecthood clearly visible: large-format colour transparencies, conservation photographs, amateur slides usually made in museums and certain artists' photographs. (The monochrome photograph is, of course, habitually cropped at the photographic printing stage, so only those with access to the negative or contact print can view the photographically rendered context.) The large-format transparency is an expensive specialist tool. Although museum scholars use them regularly, most art historians usually use them only in the final stages of a project when such photographs may be hired from a museum or agency for a limited period for use in the process of publication. When published (and these transparencies form the basis of most colour reproductions in books) the photograph is almost invariably cropped to exclude the marginal registration of the physical context – often an easel, a colour bar and a glimpse of studio – in which the painting existed as an object when it was photographed. Conservation photographs, often made in the course of the examination and treatment of a painting, are similarly specialist tools, usually, though not necessarily, seen only by conservators and curators. Here attempts are usually made to register particular aspects of the objecthood of a painting as they relate to conservators' and curators' tasks. They include photographs in raking light, from angles oblique to the surface, of the back and of the progressive removal of old varnish and

38 Abelardo Morell, *Europa Dimly Lit, Gardner Museum,* 1998, photograph. Isabella Stewart Gardner Museum, Boston.

retouchings. In the amateur slides, often made by academics for lectures, the rendering of the objecthood of the painting, frequently on a museum wall, is usually inadvertent. In keeping with the mythology of art-historical practice discussed above, a slide of a painting in situ on a museum wall is perfectly acceptable – even adaptable for rhetorical purposes that cast the lecturer-cum-photographer in a good light by demonstrating firsthand acquaintance with the object (presumably not exclusively through the viewfinder), whereas a slide derived from a book illustration that obviously betrays its source (though many slides for lecturing are made in this way) can be a cause of embarrassment. The artist's photograph employing a painting, as a work of art in its own right, is perhaps the most illuminating of the four categories as regards exposing by implicit comparison the contrivance of the naturalized form of photographic reproduction commonly in use. A work such as Abelardo Morell's *Europa Dimly Lit, Gardner Museum* (illus. 38) in which Titian's *Rape of Europa*

is exposed apparently by the light of a single bare bulb on the floor beneath it, which is included in the visual field, alerts us to the three-dimensionality of the painting in its frame, as well as the contingency of conditions of viewing – principally light – in a manner unobtainable by any other reproductive means.[34]

In the standard reproductive photograph of a painting, the suppression of three-dimensionality, part of which results from the inevitable loss of variable viewpoints so essential to the complex perception of the object, may well represent a loss. Indeed, the received wisdom concerning the photography of works of art is generally a matter of acknowledging visual impoverishment. Yet is this entirely fair? Here we must briefly consider the three photographic forms mentioned above. The 35 mm slide, when projected, allows examination of detail that in the case of the original could only be comparable with what could be achieved in a laboratory. The large-scale colour transparency intensifies certain features, especially those of hue and tone, and that exaggeration can alert the scholar and prompt further enquiry. In some instances the panchromatic monochrome photograph can find a use similar to that of infra-red and ultra-violet photographs, for, as in their cases, the emulsion responds to a set of wavelengths different from those registered by the human eye. Therefore features that may exist, yet be scarcely visible or indiscernible to the unaided human eye, may be clearly rendered in such a photograph. This is especially to be seen in the differential rendering of deep tonal values. This characteristic, combined with the compositional condensation inherent in the diminution of scale, can make anomalies of both tonal rendering and spatial construction more readily apparent in the photograph than in the original. For instance, the relative tonal gradations of the marbling on the shaded side of the virginal in the *Woman Standing at a Virginal* are usefully accentuated in a panchromatic photograph of the painting (illus. 39). Photographs, therefore, can be seen to have a place in the examination of works of art, not only as comparative material and aids to memory, but as technical information requiring – like X-radiographs, for example – their own appropriate modes of interpretation.

Trevor Fawcett, among others, has demonstrated that the triumph of photography as a reproductive medium was neither

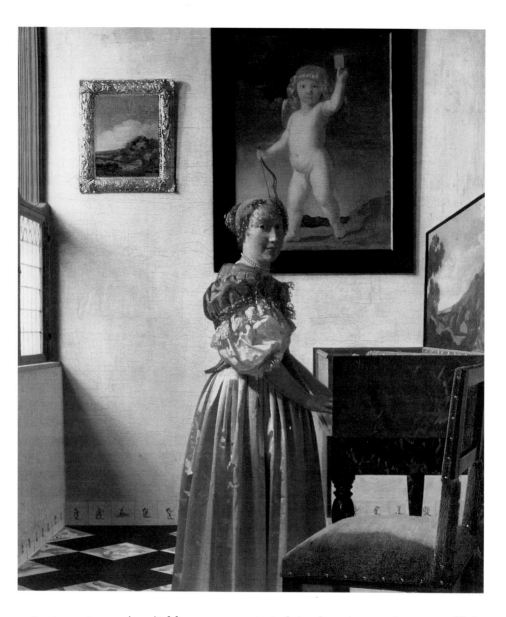

39 Panchromatic
photograph of
Vermeer's *Woman
Standing at a Virginal*
(illus. 1).

inevitable nor uncontested in the nineteenth century.[35] In
addition to regular technical advances, its causal relationship
to its subjects, which leads to consistency within a range of
tolerance that allows for authorial interpretation and manipu-
lation, eventually outweighed any advantages apologists of
manual reproduction discerned in such openly interpretative
procedures as engraving or etching. Increasingly, the avail-
ability of photographic reproductions, perceived as mechanical

and non-interpretative, led manual reproductions to be perceived as inaccurate and even unwarrantably capricious by comparison.[36] Yet when paintings attributed to Vermeer entered the realm of public consideration in any number for the first time – in 1866 – photography was available only equivocally as a reproductive medium. We can say that the identification of Vermeer's art, and its successful designation as desirable, dates from precisely that period when photography was emerging competitively as a means of knowing art, both popularly and in terms of scholarly endeavour.

Before we look in the next chapter at how precisely Vermeer's *Woman Standing at a Virginal* entered the iconosphere (the sum of visual material available at any given time),[37] a few further general observations may be pertinent. We have seen that there are qualities of objects that are wholly peculiar to those objects themselves and that are not amenable to reproduction. We have seen that, although art historians believe that examination of works in the original is imperative, to do so is not invariably their practice. However, we have established that such firsthand examination is not strictly necessary for the legitimate success of every argument. We have also established that photographic reproductions are reliable and consistent simulcra, provided that the possibilities of authorial interpretation of the subject and the character of the medium and its manipulation are taken into account. They are not merely degraded or impoverished substitutes, as various art historians fear.

The physical properties of photographs can lead them to expose characteristics of objects photographed that may otherwise be obscure or even undiscernible to the human eye. Panchromatic photographs in particular can therefore be classified with other photographically or digitally recorded materials (such as X-radiographs and computer-captured infra-red reflectograms) as technical material that can enrich our knowledge of the object concerned, rather than acting solely as a substitute for it. We must bear in mind that the use of such photographs, like all technical material related to works of art, is dependent on appropriate interpretation. Photographs that show features not otherwise available are potentially misleading for two principal reasons. First, such a photograph can make some aspect of the work more salient

than it otherwise might be, thereby affecting interpretation. Secondly, such a photograph can occasion an interpretation that might be incompatible with an account derived from the prototype alone. Therefore scholars accept as technical material only those features of photographs that are compatible with features discernible directly in the prototype. Certain features of X-radiographs, for example, therefore remain enigmatic.

A further instance of photography providing information about objects otherwise unavailable is its ability to register the state of any given object at any given time. The objects themselves change unceasingly, whether radically owing to human intervention (such as conservation treatment), or incrementally owing to chemical processes induced by exposure to light or atmospheric impurities. Through photography we can be informed about states of objects long since changed. This matter is further complicated by the fact that techniques and styles of photography change over time, so that once again we should never assume that the medium that we take to be informing us of the state of a prototype at some given time in the past is transparent.

Photography vastly enriches the sum of information available about works reproduced by its means. However, its use involves two drawbacks. First, certain qualities of works of art are amenable to reliable reproduction through photography while others are not. This state of affairs may vary in its effect across the variety of works reproduced, being more obvious in the case of a site-specific mural than in that of portable easel paintings, for example. Even so, the study of all such things has been affected by the editing of attention that photography encourages, or, when relied on exclusively, determines. Secondly, although photographically edited attention might be reliable in respect of the characteristics it succeeds in conveying, reliance on photographs can lead to error. This is because photography fails to register, or inadequately registers, certain characteristics, and permits the viewer to ignore others. For example, size is not conveyed by photographs, so some scholars who rely on photographs have proposed similarities among works that in reality are considerably more different from one another than their photographs may suggest.

We sometimes hear the cry that we must return to the object. This is a call that should be treated very cautiously. The assumption underlying such imprecations is that a reproduction in

itself is necessarily misleading or an impoverishment. This is not the case. Further, if we assume that certain qualities of objects are amenable to accurate reproduction, we should not assume that these are in some sense inferior to those that are not. That is, what is not represented in reproduction is no more than that: not represented. That which exists but is not represented is not inherently superior to that which is successfully represented in reproduction. There is no hierarchy of qualities proper to objects and their reproductions. This, though, is to assume that the qualities amenable to reproduction are not modified in the process. What is significant in this case is undemonstrable either way. In practice, empirical comparison is all that can establish useful differences between and similarities among objects and their reproductions.

Much art-historical discourse ignores distinctions among the material under discussion. Relatively rarely does a scholar explicitly state that an observation in any given instance is derived from firsthand examination of an object, if this is the case, or from a reproduction. The reader or listener is left to draw inferences, wherever possible, such as when the tell-tale phrase 'whereabouts unknown' accompanies an illustration, suggesting the likelihood that the scholar was able only to consult a photograph. The only types of art-historical text that regularly, though not invariably nor necessarily consistently, reveal the status of the visual material under discussion are catalogues, whether catalogues raisonnés, collection catalogues or auction house catalogues. In more discursive discussions art historians habitually avoid specifying whether their discussion is based on examination of objects, or of reproductions of objects. At least, when discussion is based exclusively on reproductions this is rarely admitted. Even if, as we have seen, for certain observations the equivalence between object and the reproduction of certain characteristics can justifiably be assumed, this is not invariably the case. The result in most art-historical texts is a blanket treatment of reproductions as transparent or natural in relation to what they represent: an assumption regarding representation the validity of which many art historians would, in theory, deny. Is it feasible to be precise in each instance regarding the actual material to which reference is being made in the course of an argument? Ideally, yes; but in practice, no. Using the *Woman Standing at a Virginal* in the next chapter, we shall see where the difficulties lie.

Once an object is reproduced and reproductions become part of the iconosphere, and we are aware of such reproductions, we can no longer assume that our knowledge of the object is drawn exclusively from the prototype, even when we consult it in detail. Once the work is a 'varied multiple', in the sense of being reproduced, whether manually or photographically, or both, we become hard-pressed to isolate precisely from which source our knowledge is derived. Indeed, we may go so far as seriously to consider Jean Baudrillard's notion concerning the supersession of the mimetic *'obliged* sign' by the *'counterfeit'*, that is, the 'free' sign 'free only to produce the signs of equivalence', epitomized by industrially produced images.[38] We may imagine, in effect, that once the *Woman Standing at a Virginal* becomes a 'varied multiple' it loses its obligatory referentiality to the painting by Vermeer itself, if for no other reason than that proposed by the behaviour of human memory.[39]

A scholar may spend long hours with the *Woman Standing at a Virginal* in London, and wherever else it may be exhibited (Washington and The Hague during the 1995–6 Vermeer exhibition, for example), but, if studying it seriously and consistently over a protracted period, that scholar inevitably spends considerably longer with a variety of reproductions: black-and-white photographs, a colour transparency, illustrations in books and even the National Gallery's postcard reproducing the work. That is, the scholar can no longer necessarily be sure that his or her knowledge of a particular aspect of the *Woman Standing at a Virginal* is derived from scrutiny of the painting, from one or more among many varied reproductions of it, let alone from existing, elaborative encoding of all or some such scrutinies in the memory.[40] In other words, a painting such as the *Woman Standing at a Virginal* becomes, in our practical experience, a complex of objects, material images and mental images. It is not – and probably never was, in terms of our perception – a single thing.

5 Etchings

In the last chapter we saw how distinctions can be made among the various sources of our knowledge of an art object, and established that a painting, such as the *Woman Standing at a Virginal*, is in our experience a complex of objects, material images and mental images. The painting existed not only at its moment of completion and initial consumption in the 1670s, but ever after, and in progressively differing circumstances. This is its afterlife. The complex of objects, material images and mental images that constitute the painting in our experience is formed by what happens during its afterlife. We are obliged to view the work from our own temporal and cultural vantage point, which is in part defined by what has occurred during the afterlife of the painting. We cannot leap back to a state of original interpretation as it might have been in the 1670s, though to admit this does not preclude our attempting to construct an understanding of the work that conforms with what we might establish about the circumstances of its creation and initial reception. In order to take account of the formation of our own viewpoint we must begin to examine how the *Woman Standing at a Virginal* became an object of sustained attention over time, and how it became a complex of objects and images through reproduction. We begin by looking at how it was first exhibited, became the subject of scholarly enquiry and was first reproduced.

During much of the eighteenth century, and well into the nineteenth, the name of Vermeer had lost any strong or certain power of association with a defined corpus of works, even among specialists in the art world. The story of the rediscovery or rehabilitation of Vermeer in the 1860s, principally by the art and social critic Théophile Thoré (who in exile had adopted the pseudonym William Burger or Bürger), is both well known and somewhat controversial.[1] The name of Vermeer may indeed never have been lost entirely, and his paintings may well have been traded under that name occasionally in the eighteenth and earlier nineteenth centuries, but

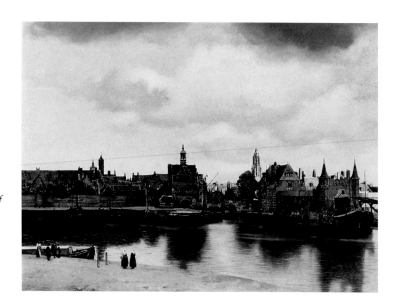

40 Vermeer, *View of Delft*, c. 1660–61, oil on canvas, 98.5 × 117.5 cm. Royal Cabinet of Pictures Mauritshuis, The Hague.

any celebrity attaching to it remained provincially Dutch, while any enthusiasm in the centres of taste and trade – Paris and London – remained fitful and marginal.[2] Paintings by Vermeer may well have occasionally appeared at auction in the Netherlands and elsewhere under Vermeer's own name, as well as others, but not until the Dutch government purchased Vermeer's *View of Delft* (illus. 40) for the Royal Cabinet of Paintings Mauritshuis in 1822 did the name elicit serious attention.[3] Even then, knowledge of Vermeer's work was so sparse that the pioneering student of seventeenth-century Dutch art, the scholarly dealer and cataloguer John Smith, could make only incidental references to him in the fourth volume of his great catalogue published in 1833.[4] Only after the opening of rail services northwards encouraged travel to Belgium and the Netherlands did French writers begin to publish accounts of their travels to the Netherlands in the later 1850s.[5] The visit to the Netherlands in 1861 by the Goncourts is only one example among many of the new accessibility afforded by such rail travel. Edmond de Goncourt's description of the visual similarity between the fall of light on a dozing fellow rail passenger and the fall of light on the faces in Rembrandt's *Night Watch* demonstrates that not only access itself, but also the very mode of that access, provided opportunities for striking new perceptions of art in the Netherlands.[6] Only in these new conditions was serious

international attention given to the paintings associated with Vermeer.

Works by Vermeer in addition to the *View of Delft* existed in accessible collections in the Netherlands and Germany, but not all were recognized as Vermeers. For instance, the *Girl Reading a Letter at an Open Window* (illus. 9) had entered the collection of the Saxon electors in 1742. It was engraved by Johan Anton Riedel in 1782, but as the work of Govaert Flinck. By 1826 the attribution had been changed to Pieter de Hooch. A marginal annotation in his copy of the 1826 catalogue suggests that John Smith may have been the first to recognize it as by Vermeer.[7] The director of the Berlin museum, Gustav Waagen, published it as being by Vermeer in his own judgement in 1858.[8]

Waagen's attribution reminds us that Thoré-Bürger was not alone in Vermeer-spotting from the late 1850s onwards. The progress of Thoré-Bürger's curiosity can be followed in part in his publications. He mentions the *View of Delft* in the Mauritshuis in his *Musées de la Hollande* published in 1858.

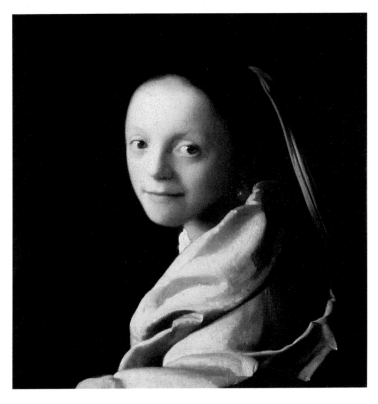

41 Vermeer, *Portrait of a Young Woman*, c. 1666–7, oil on canvas, 44.5 × 40 cm. Metropolitan Museum of Art, New York (gift of Mr and Mrs Charles Wrightsman, in memory of Theodore Rousseau jun.).

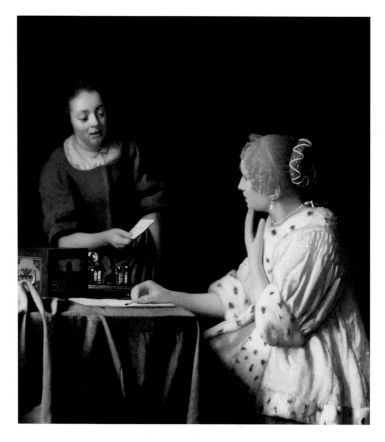

Noting only two other works known to him – the *Little Street*
and the *Maid Pouring Milk* (both Rijksmuseum, Amsterdam),
then in the Six Collection, Amsterdam – he termed Vermeer 'a
great painter' whom he had to leave among the 'illustrious
unknowns', though he was far from uncritical of the artist's –
to his eye – exaggerated use of impasto.[9] Unqualified admira-
tion of Vermeer is to be found for the first time in Thoré-
Bürger's response to the *Portrait of a Young Woman* (illus. 41) in
the Arenberg Collection, Brussels, which he discussed at
length in his article on the Galérie d'Arenberg published in
the journal *L'Indépendence belge* and in book form in 1859.[10]
The *Portrait of a Young Woman* had long been recognized as a
Vermeer, but Thoré-Bürger was the first to draw attention to
what he perceived as evidence of great mastery:

> But here is another great artist, an incomparable original,
> an unknown of genius, certainly less familiar than Nicolaes

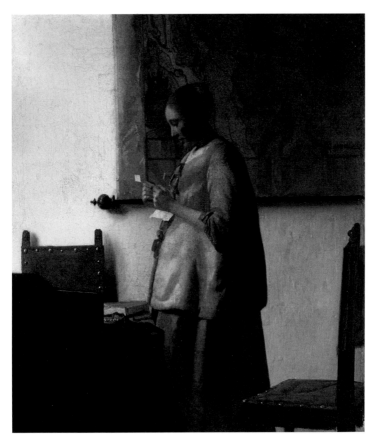

43 Vermeer, *Woman in Blue Reading a Letter*, c. 1663–4, oil on canvas, 46.5 × 39 cm. Rijksmuseum, Amsterdam (on loan from the city of Amsterdam).

Maes and Philips Koninck, and who perhaps has a greater genius than them, and who, like them, is also connected, in my opinion, to Rembrandt.[11]

Stating that he knew for certain of only four works by Vermeer (unspecified, but presumably the *View of Delft*, the *Little Street* and the *Maid Pouring Milk*, in addition to the Arenberg painting), and perhaps another two, also unspecified, he appealed for information about others that might be known to readers.[12] In the book version of his study Thoré-Bürger inserted a footnote reporting the results of his appeal, which were considerable, especially from Germany, but facsimiles of signatures suggested to him that most concerned works by the other known Vermeers, the two Haarlem painters and the artist who worked in Utrecht. The only acknowledged discovery was that of the *Lady with Her Maidservant* (illus. 42) in the Dufour Collection, Marseilles.

The existence of this work had been published in the *Gazette des Beaux-Arts* by Léon Lagrange in 1859 in direct response to Thoré-Bürger's appeal,[13] and in the footnote mentioned above Thoré-Bürger quoted Lagrange's notice in full.[14]

During the following year Thoré-Bürger made huge progress in the identification of paintings by Vermeer of Delft. In the second volume of the *Musées de la Hollande* of 1860 he added the *Woman in Blue Reading a Letter* (illus. 43), which he encountered in the Museum Van der Hoop in Amsterdam,[15] to the works he had already cited. Prompted by this painting – the first unsigned work that he accepted – he recounted the current state of his knowledge. To the *Woman in Blue Reading a Letter*, the *View of Delft*, the *Little Street*, the *Maid Pouring Milk*, the *Portrait of a Young Woman* and the *Lady with Her Maidservant*, he added the *Girl Reading a Letter at an Open Window* (recently attributed by Waagen), the *Lacemaker* (Musée du Louvre, Paris) in the Blokhuysen Collection, Rotterdam, *The Art of Painting* (Kunsthistorisches Museum, Vienna) in the Czernin Collection, Vienna, the *Girl with the Wineglass*, then and now in the Herzog Anton Ulrich-Museum, Brunswick and the *Procuress*, then and now in Dresden. Subsequent scholarship has sustained all these attributions, but Thoré-Bürger also included a painting the attribution of

44 Derk Jan van der Laan, *Rustic Cottage*, late 18th/early 19th century, oil on canvas, 49.5 × 41.4 cm. Staatliche Museen zu Berlin (Gemälde-galerie).

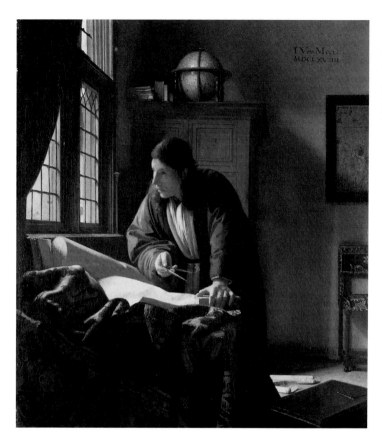

45 Vermeer,
The Geographer,
c. 1668–9,
oil on canvas,
52 × 45.5 cm.
Städelsches
Kunstinstitut,
Frankfurt-am-Main.

which to Vermeer had considerable consequences for the
erroneous construction of his oeuvre for the remainder of the
century and beyond: the *Rustic Cottage* (illus. 44), now given
to Derk Jan van der Laan,[16] and then in the collection of Thoré-
Bürger's friend, the Aachen collector, Barthold Suermondt.
Waagen had catalogued this painting as by Philips Koninck,
but Thoré-Bürger demurred, perceiving the same landscape
and stylistic qualities he saw in the *View of Delft* and the *Little
Street*.[17] Thoré-Bürger also included every mention of paint-
ings by Vermeer culled from Gerard Hoet's published sales
records as a guide to works yet to be discovered.[18]

Paul Mantz's publication of the *Geographer* (illus. 45) in the
collection of Alexandre Dumont, Cambrai in the same year as
the second volume of Thoré-Bürger's *Musées de la Hollande*
confirmed that Thoré-Bürger was not alone in his quest,[19] but
when in the following year Charles Blanc published a fascicle
on Vermeer in his monumental study of European art, the

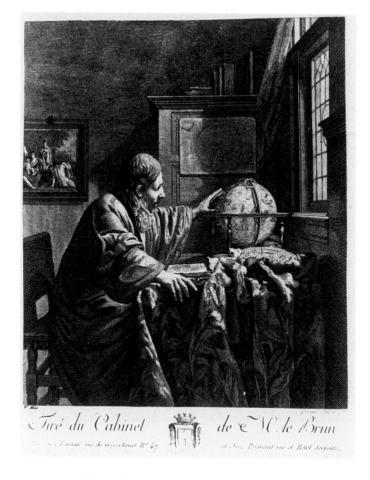

very possibility of its existence was acknowledged by him to
be entirely dependent on Thoré-Bürger's work.[20]

Blanc's publication marked the beginning of the modern
reproduction of Vermeer's paintings. Prior to its appearance
only three works by Vermeer had been reproduced, of which
one – the *Girl Reading a Letter at an Open Window* – as we have
seen, appeared attributed to another artist, Govaert Flinck.
The *Astronomer* (Musée du Louvre) was engraved in reverse
by Louis Garreau in 1784 when it was in the possession of the
great Paris dealer, Jean-Baptiste-Pierre Le Brun (illus. 46). It
was included in Le Brun's three-volume publication cham-
pioning seventeenth-century Dutch art in revolutionary France,
the *Galérie des peintres flamands, hollandais et allemands*.[21] Le
Brun also caused the *Lady with Her Maidservant* to be engraved
in outline in 1809[22] (illus. 47) which allowed Lagrange so

VANDER MEER de Delft, P.ˣⁱˣ
hauteur 33 pouces, largeur 29 pouces, sur Toile.

47 After Vermeer, *Lady with Her Maidservant*, 1809, outline engraving (see illus. 42).

confidently to ascribe the painting in the Dufour Collection to Vermeer. The two woodcut reproductions that Blanc published were of the *Rustic Cottage* and the *Geographer*, recently published by Paul Mantz in the *Gazette des Beaux-Arts* of which Blanc was the editor.

Given the paucity of reproductions – and Thoré-Bürger was unaware at this stage of Garreau's engraving after the *Astronomer*[23] – on what did he base his connoisseurship decisions? In the case of the paintings in the Netherlands and Belgium, he could work from firsthand examination. At this stage the paintings in France were inaccessible to him, as he was in political exile. He examined works in Germany himself, notably in Aachen, Brunswick and Dresden. He described climbing a ladder in the Dresden gallery to study the *Procuress*, finding thereby the signature and date, 1656.[24] He set great store by the form of signature for comparative purposes and he published facsimiles.[25] They were particularly important because by at least 1860 he could not help but be aware of the extreme stylistic and technical variety of the paintings he was – for the most part at this stage correctly – attributing to Vermeer. 'This devil of an artist without doubt had a diversity of styles', he wrote in the second volume of the *Musées de la Hollande*.[26] On occasion he would accept the advice of others concerning a work that he had not himself seen, as in the case of *The Art of Painting*.[27] The publication of

his major study of Vermeer, the series of three articles published in the *Gazette des Beaux-Arts* in 1866, reveals a further means of comparative study: 'To obtain a photograph of such and such a Vermeer, I have pulled out all the stops.'[28] If he had a photograph of a work he made a point of mentioning the fact in the relevant catalogue entry.[29]

Although Thoré-Bürger set great store by photography in the positivist art history he was pioneering in his *Gazette des Beaux-Arts* study of Vermeer's paintings, photomechanical reproduction for publication was not yet technically feasible. Between 1853 and 1854 Charles Blanc had published a set of 100 photographic reproductions after Rembrandt's etchings under the title, *L'Oeuvre de Rembrandt reproduit par la photographie*,[30] yet not only was a combination of letterpress and photographic printing impossible, but a great deal of prejudice had to be overcome before photographs of works of art could be accepted. This distrust is exemplified by the telling slip made in ordering Blanc's Rembrandt set by the secretary of the Dutch Royal Antiquarian Society (Koninklijk Oudheidkundig Genootschap). He wrote *reduit* ('diminished') in place of *reproduit* ('reproduced').[31] There were those who held that interpretation by a skilled engraver or lithographer was preferable to the supposedly impersonal, undiscerning quality of a photographic reproduction, and indeed essential if the character of the original were to be adequately conveyed. 'Photography is impersonal', wrote Philippe Burty in the *Gazette des Beaux-Arts* in 1859,

> it does not interpret, it copies; therein is its weakness as well as its strength, for it renders with the same indifference the trifling detail and that scarcely visible, scarcely apprehensible quality that gives soul and causes resemblance . . . but it stops short of idealization, and it is there truly that the role of the skilled engraver and lithographer begins.[32]

The *Gazette des Beaux-Arts* was, none the less, sympathetic to photography, in part because of its perceived influence on contemporary painting, and not least because of anticipation of the consequences for art publishing should a satisfactory method of photomechanical reproduction be developed. Burty wrote as much in its pages in 1865.[33] However, in the absence of such technology, the journal experimented with

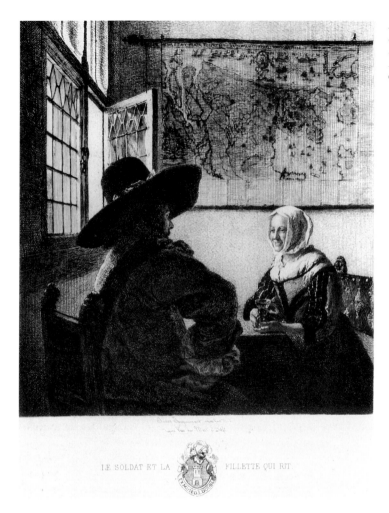

LE SOLDAT ET LA ⁄ FILLETTE QUI RIT.

various kinds of reproduction. The 1860s saw the revival of etching as an artists' medium, and the *Gazette des Beaux-Arts* notably sponsored some of the finest forays into a specialist branch of the etching revival, the reproductive etching. In freehand etching the interpretative character of printmaking was emphasized to the full, which, in combination with the characteristic dense and vibrant tonal qualities of the medium, produced prints at the hands of its finest practitioners of startling clarity and stature. The most distinguished exponent of reproductive etching was Jules Jacquemart, but other highly skilled etchers turned to the genre.

Thoré-Bürger's 1866 publication was illustrated with eight reproductions of whole works, plus a reproduction of a detail

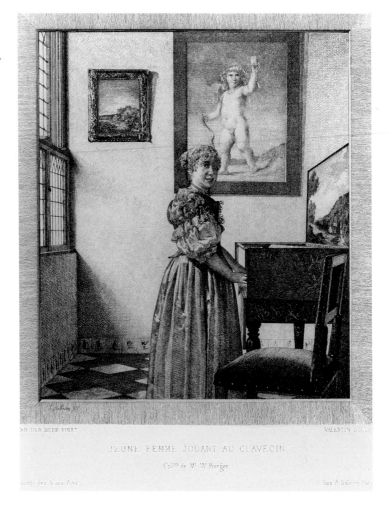

49 Henri-Augustin Valentin after Vermeer, *Woman Standing at a Virginal*, 1866, etching (see illus. 1).

AN DER MEER PINXT. VALENTIN SCULP.

JEUNE FEMME JOUANT AU CLAVECIN

Col?⁹ de M. W. Burger

used as part of a decorative title design. They were of three types and were inevitably hierarchically presented. The four woodcuts, and the title design in the same medium, were set with the letterpress, whereas the single lithograph (by Maxime Lalanne after a drawn sketch thought by Thoré-Bürger to be preparatory to the *View of Delft*),[34] and three etchings were set apart as full-page reproductions printed on distinct paper by intaglio press, and interleaved into the letterpress signatures. Two woodcuts were after genuine Vermeers: the *Woman with a Pearl Necklace* (Staatliche Museen zu Berlin, Gemäldegalerie) and the *Geographer* (Städelsches Kunstinstitut, Frankfurt-am-Main), the latter reused from Blanc's publication.[35] Two further woodcuts were after works owned by Thoré-Bürger and

127

mistakenly attributed by him to Vermeer: a *Sleeping Maid-servant* (whereabouts unknown) and a supposed *Self-Portrait* (whereabouts unknown).[36] The etchings were by three different artists: the *Rustic Cottage* (owned, as we have seen, by Barthold Suermondt) was by Léopold Flameng;[37] the *Soldier with a Laughing Girl* (Frick Collection, New York), which had recently entered the collection of Léopold Double, was by Jules Jacquemart[38] (illus. 48); and the *Woman Standing at a Virginal*, our case study, then in Thoré-Bürger's own possession, was by Henry Augustin Valentin[39] (illus. 49).

The varying quality of the reproductions and their disposition in the articles lent a particular weight to the three etchings. The *Woman Standing at a Virginal* thereby became one of the three most prominently reproduced works attributed to Vermeer at the moment when his paintings entered the public domain *en masse* for the first time since the late seventeenth century. That mass entry was not confined to reproductions in the *Gazette des Beaux-Arts*, for it simultaneously involved the works themselves.

Thoré-Bürger was closely involved in the organization of a large and prominent old master exhibition that would shortly precede the publication of his articles on Vermeer. His involvement began when he was approached not only to prepare the catalogue, but also to lend the *Woman Standing at a Virginal* to the exhibition. A letter to Suermondt reveals that he explicitly took this as an opportunity to advance the reputation of Vermeer.[40] This Exposition rétrospective was held between May and the end of July in four galleries of the Palais de l'Industrie des Champs-Elysées, in the very same building as the annual Salon and directly adjacent to it.[41] The exhibition opened with 180 paintings, borrowed from private collectors and ranging from the fifteenth to the mid-nineteenth century in date, but such was the response that further works were constantly offered for inclusion by their owners, so that 293 paintings were eventually shown.[42] No fewer than eleven were attributed to Vermeer. Of these, the four interior scenes – the *Geographer*, the *Officer and a Laughing Girl*, the *Woman with a Pearl Necklace* and the *Woman Standing at a Virginal* – have remained as unquestionably by Vermeer. The others have not. They consisted of four town views (one of which is now known to be by Jacobus Vrel)[43] and three landscapes, including Suermondt's *Rustic Cottage*.[44] The critical impact of these

works, some rightly, others wrongly, attributed to Vermeer, was considerable.[45] Vermeer was never again to lapse into obscurity. Zacharie Astruc's judgement in *L'Etendard* is representative: 'Only yesterday his many virtues were appreciated by the merest few – and it is no exaggeration to say that the Salon rétrospectif has brought him to light.'[46]

The manner in which the returned political exile Thoré-Bürger's advocacy of Vermeer and the art of other seventeenth-century Dutch artists (he had championed Meindert Hobbema and was to do the same for Frans Hals) was ideologically motivated has been discussed at length elsewhere.[47] The critic Champfleury, in dedicating his study of the Le Nain brothers to Thoré-Bürger, epitomized him thus:

> You have returned after a long sojourn abroad to bring your niceness of perception to the discussion of the real; and, just like the new school of criticism based on positivism, you have pointed out interesting works lost in foreign collections, indicating their distinctive characters in the course of recovering these precise findings of a hardy and fully independent aesthetic.[48]

Discussion in terms of Realism as a politically charged movement in art was already somewhat stale by this time, but scholarship colloquially termed positivist – soon to be exemplified by Thoré-Bürger's articles on Vermeer – was to have a long future in art history,[49] and can be seen to owe its genesis in part to ideological as well as to economic circumstances.

Thoré-Bürger's class-consensual (rather than class-conflictual) socialism led him to advocate art which, like Dutch art of the seventeenth century, in his view, depicted contemporary life rather than the oppressive mysteries of religion, mythology and heroic history: 'Art for man' ('L'Art pour l'homme') in his concise formulation. Vermeer's art, as he was defining it, fitted his requirements for Realism perfectly, comprising landscapes and scenes of streets and contemporary domestic interiors. If Thoré-Bürger's idealism was implicated in general terms in his rehabilitation of Vermeer, we shall see how it may be detected governing the specific manner in which the *Woman Standing at a Virginal* entered sustained public awareness and scholarly discussion.

The visual introduction of Vermeer's works as original paintings, in the Exposition rétrospective (May through July

1866), and as reproductions, in the *Gazette des Beaux-Arts* (October through December 1866), shows Thoré-Bürger making use of the entire apparatus of modern art-historical procedure to familiarize his audience with his chosen subject: both the temporary loan exhibition and the monograph with catalogue raisonné. This was not a carefully planned campaign: rather, he took advantage of the opportunity presented to him by the exhibition, pushing ahead with the publication at the same time as he contrived to flood the exhibition with Vermeers, even though the state of the catalogue component of his publication reveals that much remained to be resolved. Thoré-Bürger was aware that the combined impact of the works themselves, a monographic treatment of the artist in print and a catalogue of works, including those that remained to be discovered, being known only from sales catalogue references, would have a far greater impact if they appeared close in time, than would each element separately. By these means he could define through his commentary not only the predominant terms in which Vermeer's art would be discussed, but also the very manner in which Vermeer's art would be seen, both in the exhibition and in reproduction. Vitally, all this involved questions of attribution, but it meant far more besides. It was a question of juxtaposition, of visually defined hierarchy and even of physical manipulation and modification.

We have seen that one of the key stimulants for Thoré-Bürger's flood of Vermeers in 1866 was the request by the Exposition rétrospective organizers for the loan of the *Woman Standing at a Virginal*. Frances Jowell has recently established that Thoré-Bürger had acquired the painting from the German dealer, Otto Mündler, sometime between 1860 and 1862 for 500 francs.[50] For at least fifteen years previously the work had presumably been in England, appearing in London salerooms at least twice, in 1845 and 1855.[51] The painting represented a further significant discovery – or, at least, recovery – for Thoré-Bürger, so it is hardly surprising that he and Blanc decided to feature its reproduction prominently in the first of his three *Gazette des Beaux-Arts* articles on Vermeer in October 1866.

The *Woman Standing at a Virginal* was etched by Henry Augustin Valentin. Valentin was a modest painter-etcher, born in 1822, who was a pupil of François Rude and Pierre-Jean David d'Angers. He exhibited genre paintings at the

Salon, having made his debut in 1845. He found his niche as a reproductive etcher from the 1850s onwards. He collaborated to produce a set of ten etchings, plus a title sheet, of Norman town views and hunt scenes in 1851, a suite of allegories of modern arts and industry after Dominique Magaud, and plates for the publication of Francisque Duret's sculpture.[52]

Whether or not Valentin worked from an intermediary drawing of the *Woman Standing at a Virginal* is unclear, although the accurate transcription of so much detail suggests that he was unlikely not to have had access directly to the painting itself. We have noted that a manual reproduction has consistently been seen as an interpretation of the object it represents, and, indeed, that to some commentators this was a positive advantage, even a condition necessary for the achievement of excellence. Valentin's etching is self-evidently an interpretation in several respects, though only two need be mentioned here. These concern a presumed addition and a revision.

The presumed addition is that of the frame. The painting must have been framed when exhibited at the Exposition rétrospective, but no record exists of its appearance. Its current frame is late nineteenth century. The frame represented by Valentin may reflect historical actuality, or – more likely in view of its simplicity – it may be pure invention on his part. Whatever the case, its incorporation is integral to the presentation of the work: this frame is a vital part of the entry of the *Woman Standing at a Virginal* into public awareness.

This frame was excised when Valentin's etching was illustrated in the catalogue of the 1995–6 Vermeer exhibition.[53] Its excision is characteristic of the art-historical tendency to reduce objects – even reproductions (for they are objects too) – to images, as discussed in the previous chapter. The result is a diminution and denaturing of the object; that is, Valentin's etching. The frame in Valentin's etching is an integral part of his interpretation of the painting. By its means the progression of pictorial worlds-within-worlds that, as we have seen, we understand in its full richness only in the presence of the painting itself, is strongly suggested. The plain fictive frame repeats the profile of the frame surrounding the painting-within-the-painting of Cupid, only lighter in tone, thus inviting consideration of equivalence that eases progression across successive picture planes. The fall of light on the inside edges of the two frames is directly comparable: fictively light falls

from the same direction – upper left – in all three of Valentin's pictorial worlds: that of Cupid, that of the woman and that of the framed painting of the woman at her virginal. Furthermore, by placing his signature on the fictive frame itself, Valentin stresses that it is integral to his interpretative etching.

By adding a fictive layer to those already associated with the painting itself by means of the frame – a further pictorial world – Valentin has interpretatively been true to the experience of the painting itself as an object. This is the very quality of interpretative truth to the experience of the original that apologists for manual reproduction valued. This is the very quality that is unobtainable – at least so demonstrably purposefully and inventively – by means of photography. Whoever was responsible for cropping the illustration of Valentin's etching to exclude the frame in the 1995–6 Vermeer exhibition catalogue was suppressing this interpretative aspect of the etching to achieve as closely as possible the image-like quality associated with photographic reproduction. This was presumably done in the belief that what most counts in the etching are its qualities that most closely resemble those of a decontextualized photographic print. Such an error perfectly illustrates the baleful effect of reducing objects to images that can be laid at the door not of photography itself, but of those art historians at whose behest such use of it has consistently been made.

As well as Valentin's addition to the *Woman Standing at a Virginal*, a major revision must be discussed. There are several discrepancies between the etching and the painting in points of detail. In the etching the figures on the skirting tiles behind the virginal are less distinct than in the painting; the pale marble floor tiles are less clearly veined in the etching than in the painting; what have been described as gold filigree ornaments in the woman's hair have been rendered by Valentin as corkscrew curl locks. While these differences may not be entirely insignificant, they may be considered inadvertent, and they have no bearing on the present argument. The most obvious revision, however, can only be deliberate, for it concerns a key detail well within the capacity of the etcher to render accurately in relation to the painting. That key detail must be counted the principal focal point of the composition: the eyes of the woman standing at her instrument.

In Vermeer's painting the woman's eyes clearly, unam-

biguously and most pointedly meet the viewer's gaze directly and uncompromisingly. In the etching they peer above and to our right. There is no eye contact.[54] What accounts for this difference? In the woman's own left eye, Valentin has omitted a slight lightening of tone to the right of the pupil to be seen in the painting, and has added a highlight on its left side. In her right eye he has enlarged the pale area of the white of the eye to the left of the pupil, which is thereby rendered brighter than the white of the eye to its right. He has also added a highlight, not present in the painting, to the pupil. There is nothing about the condition of the painting to suggest that the current condition of the woman's eyes differs significantly from what it might have been in the past. In other words, Valentin is most unlikely to have been transcribing what he saw in this area, unless the painting itself had been emended too. What is the reason for this alteration?

We can make most progress in attempting to answer this question by considering the *Woman Standing at a Virginal* in relation to existing codes of perception and decorum that would have governed the reception of the work in 1866.[55] Moral probity in the art he sponsored was important politically to Thoré-Bürger. The *Woman Standing at a Virginal* was conspicuously introduced to public notice in Second Empire Paris at a prominent exhibition and in a major publication at a particularly sensitive point in the history of the representation of single women in painting. Just one year previously, the

50 Edouard Manet, *Olympia*, 1863, oil on canvas, 130.5 × 190 cm. Musée d'Orsay, Paris.

exhibition of Edouard Manet's painting of a naked courtesan, *Olympia* (illus. 50) had caused a scandal at the Salon.

As several scholars have noted, the portrayal of the courtesan in these years took on considerable significance, and the uncompromising, appraising gaze of the woman at the viewer – a usurpation of a male prerogative – was a potent element in the articulation of the subject.[56] For instance, at the Salon of 1868 Charles-François Marchal exhibited two pictures of women in contemporary dress, the Greek titles of which contrasted virtue with vice: the modest *Pénélope* (illus. 51), faithful to Odysseus throughout his absence, and the brazen

Phryné (illus. 52), who bewitched the Athenians with her beauty. As can be seen from a contemporary wood engraving,[57] the courtesan *Phryné* meets the viewer's gaze uncompromisingly with her own. Manet's own ultimate study of the forthright courtesan who stares back at the viewer was his portrayal of his friend and supporter Emile Zola's character, *Nana*, of 1877 (illus. 53).

In all these paintings the subject's indecorousness in not averting her eyes was explicitly associated with courtesanship. In contrast, contemporary notions of propriety can be seen in works by Alfred Stevens, the Belgian painter who took leisured female domesticity as his principal theme. Stevens enjoyed a great success with such pictures at the Paris Exposition universelle in 1867, the year following Thoré-

135

Bürger's revelation of Vermeer. Thoré-Bürger discussed the eleven paintings by Stevens at length in his review of the exhibition, stating at the outset that Stevens deserved one of only two medals of honour that he should like to see the jury award.[58] Politics dictated that his admiration of the subject matter should be distinctly equivocal. The subjects were scenes from the monotonous lives of 'women of quality', he noted. 'The *insignificance* of the subjects in these pictures by Alfred Stevens thus has its significance, perfectly expressive of the manners of aristocratic, and even bourgeois, society.'[59] But he stated that it was simply the painting itself that he admired, and he compared Stevens's work directly with the domestic interior scenes of the seventeenth-century Dutch painters. He cited Johannes Vermeer by name, together with Gerard ter Borch, Gabriël Metsu, Frans van Mieris and Pieter de Hooch, as though less than a year after the launch of his protégé, Vermeer should already unquestionably keep such company familiarly and of established right.[60]

The painting by Stevens shown at the Exposition universelle – mentioned by Thoré-Bürger – with which an interesting direct comparison with the *Woman Standing at a Virginal* can be made is *Miss Fauvette* (illus. 54). This work was first shown to acclaim at the Brussels Salon of 1863.[61] She stands beside her piano, removing her gloves in preparation to play and sing, as her name – 'Miss Warbler' – implies. She is depicted as though at a moment just prior to that represented in the *Woman Standing at a Virginal* (known to its then owner, Thoré-Bürger, familiarly as *La Pianiste*).[62] Yet while Vermeer's musician is impassive, even – according to the fears and conventions of late Second Empire Paris – ocularly confrontational, contemporary critics remarked on the balance between innocence and flirtatiousness in *Miss Fauvette*.[63] That purposeful ambiguity was enhanced by the use of the English form of address in the title.[64] Crucially, Miss Fauvette avoids eye contact with the viewer, maintaining her coyness. Cocking her head to her right, she gazes beyond the picture plane, above and to the left of the viewer. Why, then, did Valentin alter the direction of the virginal player's gaze in his etching to avoid the kind of ocular confrontation we have seen in contemporary, highly charged works depicting courtesans? Why was the picture revised in reproduction to resemble the *Miss Fauvette* type?

54 Alfred Stevens,
Miss Fauvette, 1863,
oil on canvas,
61 × 48 cm.
Whereabouts
unknown.

Not all direct gazes by women as though at the viewer in pictures in Second Empire Paris suggested impropriety. Yet Thoré-Bürger's recognition of the immediacy of the theme of love – 'Love is scampering to her within her head'[65] – suggests that a contemporary viewer might well have connected that Cupid-related theme with her forthright gaze so as to tip the balance towards an ascription of impropriety. Valentin's emendation, therefore, is clearly a purposeful revision of meaning. In a subject in which historical distance was easily forgotten (unlike the *Procuress*), as Thoré-Bürger's comparison with works by Stevens confirms, decorum could be made to prevail, at least in reproduction. And it was through reproduction that reputation – the reputation implicitly claimed for Vermeer as early as his discussion of Stevens's work at the Exposition universelle – was to be made.

137

If, as Griselda Pollock has argued,[66] *Olympia* shocked precisely because, when exhibited at the Salon, the painting was available to bourgeois ladies, invading a social space compatible with femininity, how much more dangerous might Vermeer's *Woman Standing at a Virginal* have seemed if, 'Love scampering to her within her head', she had infiltrated the private domestic space, the feminine sphere of the home, in an unmodified, unchaste state under the very cover of the *Gazette des Beaux-Arts*! Thoré-Bürger, in seeking to define and place his chosen discovered artist, Vermeer, in the heated atmosphere of Second Empire Paris, tried to ensure that no hint of immorality might be associated with his protégé. Hence *his* virginal player – and we should remember that it was indeed his virginal player – entered the world of pictorial reproduction in a carefully emended, coy state.

That Thoré-Bürger did not hesitate to associate works by Vermeer with contemporary paintings of similar subjects is

55 James McNeill Whistler, *At the Piano*, 1858–9, oil on canvas, 67 × 91.6 cm. Taft Museum, Cincinnati (bequest of Louise Taft Semple).

138

demonstrated by his attempt, revealed in a letter to Edouard Manet, to acquire a painting by James McNeill Whistler, *At the Piano*, 1858–9 (illus. 55), which had also been exhibited in 1867. He explained that 'this painting would go very well with my Van der Meers de Delft', by which he meant the *Woman Standing at a Virginal* and the *Woman Seated at a Virginal*, which he acquired in May of that year.[67]

Thoré-Bürger associated the art he despised – the art of religion and mythology – with the world of courtesans. Thus he wrote in his review of the Salon of 1865:

> Who is it that encourages mythological art and mystical art, the Oedipuses and Venuses, or the Madonnas and saints in ecstasy? Those who have a concern that art should signify nothing and should not refer to modern aspirations. Who encourages the nymphs and gallant rococo courtly scenes? The Jockey-Club and Boulevard Italien. To whom are such paintings sold? To courtesans, newly enriched stock speculators, and the dissipated members of a peculiar aristocracy.[68]

Thoré-Bürger presented Vermeer's art as the epitome of Realist, humane and politically just values. This was how he calculated his introduction of Vermeer into the visual, moral and political world of Second Empire Paris in 1866. His *Woman Standing at a Virginal* was not to be mistaken for a courtesan. By means of Henry Valentin's etched reproduction the painting was introduced to the world in a revised state, her newly contrived coyness ensuring that there could be no grounds for confusion or offence.

Yet even the updating of a Vermeer to assume the appearance of an Alfred Stevens could not ensure its sale (assuming that he wanted to sell it). The painting remained in Thoré-Bürger's possession at his death in 1869 and passed to his heirs, the Lacroix family, to enter the National Gallery only after their sale of their inheritance 23 years later.

6 Photographs

In the previous chapter we saw that Thoré-Bürger made use of photographs in his pioneering attempt to define an oeuvre of Vermeer's works, even though their publication was impracticable, and existing reproductive techniques could promote selective reinterpretation of individual works through the modification of pictorial elements. Woodcuts, engravings, lithography and etching, therefore, had an important role to play in the progressive afterlife of Vermeer's paintings, etching in particular in the case of the *Woman Standing at a Virginal*. Now we must consider how photography played a role in changing conceptions of art – specifically that of Vermeer – and its study from the mid-nineteenth century onwards. In this chapter I shall propose that photography has permitted and promoted forms of comparative visual study, thereby enhancing a particular kind of connoisseurship. In addition, and more fundamentally, photography has promoted a mode of viewing learned from the apprehension of photographs that is now commonly applied to the apprehension of paintings. We can say that the photographic has been inscribed in the perception of the very paintings themselves.

For curiosity about art to be inspired by commercial interest – or at least for commercial interest to be involved in curiosity about art – was not a new phenomenon in the 1860s. Yet Thoré-Bürger's Vermeer project took on a form that was new in art-historical scholarship. Photography played a part in bringing this about.

The authority of statements accurately derived from empirical observation, propounded by, for example, Auguste Comte (1798–1857), increased in the years following the 1848 revolution. Petra ten Doesschate Chu observed, 'Studying the statements about Dutch art from 1830 to 1870, one is struck . . . by a marked difference in outlook between the writers before and after 1848. While the former were subjective, given to associating and careless of facts, the latter were on the whole

detached, dogmatic and scholarly.'[1] Photography played a part in this conceptual shift, for photographs gave what appeared to be an unsurpassable plenitude of visual information about the appearance of things. As we have seen, the availability of photographs of works of art encouraged the comparative study of their subjects. Scholars recognized that they could produce comprehensive catalogues raisonnés only with the aid of the new medium.

In 1839 Johann David Passavant published a pioneering attempt to define and study the oeuvre of Raphael.[2] Obviously, he worked without photographs. In 1870 John Charles Robinson could write in his catalogue of the drawings of Raphael and Michelangelo at Oxford, 'For the purposes of his present undertaking, the writer has been enabled to make use of photography in the most complete manner.' He acknowledged that 'The comprehensive work of Passavant, though abounding in errors, a great proportion of which the art of photography, had it been available in the writer's time, would have enabled him to avoid, was a great service.'[3] Thoré-Bürger's considerable and consistent use of photographs of paintings associated with Vermeer was more than a novel art-historical convenience. He observed a consonance between the reproductive medium and the paintings reproduced thereby. Commending the realism of seventeenth-century Dutch painting (at least the sort that he favoured), Thoré-Bürger described it as 'a sort of photography of their great seventeenth century'.[4] He was not alone in this perception.

Mid-nineteenth-century critics and practitioners pointed out, and at times depended on, a perceived consonance between the assumed realism of photographs and the assumed realism of Dutch seventeenth-century painting. The pioneer photographer William Henry Fox Talbot appealed to the sanction of seventeenth-century Dutch painters' practice in his first publication of the results of his invention of the negative–positive process, *The Pencil of Nature*. This comprised 24 mounted photographs (salted-paper prints from calotype negatives), each with a commentary, published serially between 1844 and 1846. Opposite plate vi, *The Open Door* (made 1 March 1843) (illus. 56), depicting the door to a building ajar from the exterior with a besom leaning against the jamb, he wrote:

> We have sufficient authority in the Dutch School of art for taking as subjects of representation scenes of daily and familiar occurrence. A painter's eye will often be arrested where ordinary people see nothing remarkable. A casual gleam of sunshine, or a shadow thrown across his path, a time-withered oak, or a moss-covered stone may awaken a train of thoughts and feelings, and picturesque imaginings.[5]

Open doorways and the casual disposition of brooms can obviously be found in numerous Dutch paintings of the kind to which Fox Talbot refers. *The Open Door* could almost be a detail of Vermeer's *Little Street* (illus. 57). Yet the significant point in this context is not his appeal to Dutch practice to sanction the direct referentiality of the new medium of photography. Rather, Fox Talbot's appeal is to a shared quality of mimesis, an ascription of transparency to both media – painting and photography – owing to their shared realism that allows the contrived representation of sunshine, shadow, a time-withered oak or a moss-covered stone to evoke not only thoughts and feelings, but also those things themselves. This apparent transparency of the medium in both cases – seventeenth-century Dutch painting and the calotype – is, for Fox Talbot and many of his contemporaries, the value of both. That value was a wholly reliable verisimilitude of representation achieved in the photograph without human intervention

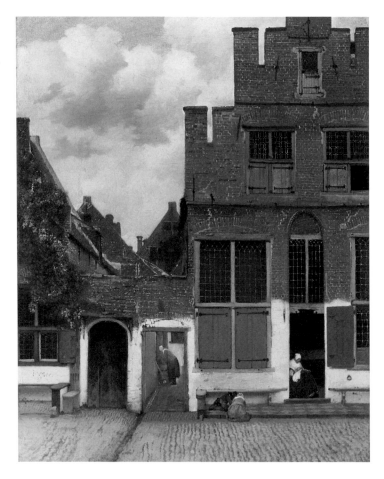

57 Vermeer,
The Little Street,
c. 1657–8, oil on
canvas, 54.3 × 44 cm.
Rijksmuseum,
Amsterdam.

('the pencil of nature'), but authorized as a matter of human orchestration fit for human attention by the precedent of Dutch painters' painstaking observation and craft. Whether this perception is epistemologically false in either case – and much effort has been made, generally successfully, in recent years to argue that is – is not a concern here. What matters in this context is not the semiotics of either seventeenth-century Dutch painting or photography; but rather the mid-nine-teenth-century belief in the representational and mimetic immediacy of both.

Even as late as the early writings of Roland Barthes, photography was commonly seen as initially purely denotative, in Barthes's words, *'a message without a code'*.[6] From the earliest days of photography this perception derived from what has been described as the medium's automatism, and the paradox

143

that this perceived quality, while limiting or even excluding human invention, yet guaranteed the veracity of the resulting image. This assumption has bedevilled much discussion of photography ever after. Thus, when discussing the merits and demerits of the photographic reproduction of works of art (discussed in chapter 4) in 1865, de Saint-Santin wrote, 'Photography, completely dumb as it is, is a mirror, a crude but direct emanation of the created work, which is incapable of misleading us.'[7]

The perception of photography as sharing basic characteristics with seventeenth-century Dutch painting was not confined to the historical moment of the mid-nineteenth century when photography was emerging and its practitioners and apologists were seeking precedents in the visual arts. It has been long-lived. In 1975 Carl Chiarenza could write, 'The eye of the seventeenth-century painter and the eye of the nineteenth-century photographer seemed to respond to the same visual stimuli, and in a like manner', and further assert that 'The Dutch *saw* photographically.'[8] Some might detect a trace of this view even in Svetlana Alpers's *The Art of Describing* (1983), where she asserts that 'If we want historical precedence for the photographic image it is in the rich mixture of seeing, knowing, and picturing that manifested itself in seventeenth-century images.'[9] However, as Martin Jay has pointed out, Alpers's noting of the similarities between what she describes as the Northern descriptive mode in painting on the one hand, and photography on the other, is not one of assumed equivalence, but rather one of a precedent of conventions.[10]

In contradistinction to earlier assumptions of an equivalence of mimesis between seventeenth-century Dutch realistic painting and nineteenth-century photography, we might account differently for perceptible similarities. The visual persuasiveness of nineteenth-century photography, which, as we saw in the case of the reproduction of works of art in chapter 4, allowed it to overcome its rivals in other media, might be ascribed to its undiscerning recording of a plethora of visual detail. We might hypothesize that this characteristic functioned successfully in the reception of photography because of a disposition to value the depiction of such detail owing to the example of the Netherlandish pictorial tradition. If the registration of pictorial detail by photography exceeded that of Dutch paintings, it gained sympathetic attention in the

mid-nineteenth century because it was understood in terms of an enhancement of verisimilitude, thereby, as Martin Jay has noted, raising questions about the assumed verisimilitude of what had preceded it.[11] Yet this impact of the camera also had the effect – once accepted – of prompting a sympathetic re-evaluation of those types of art-making – notably by seventeenth-century Dutch painters – that most seemed to anticipate photography.

The very density of attention to incidental visual detail to be seen in certain of Vermeer's works ensured that in mid-nineteenth-century France the comparison between photography and seventeenth-century Dutch painting was most acutely formed in the case of the apprehension of paintings by Vermeer. In those paintings themselves such attention to the accidents of visual appearance finds its apogee in the *Maid Pouring Milk*, characterized not only by the much remarked-upon *pointillé* highlights, but the unprecedentedly attentive rendition of the fall of light across the whitewashed rear wall, revealing its subtle irregularities, pits and protrusions. Edmond de Goncourt's journal description of this painting in 1861 is extremely sensitive to these qualities. Lawrence Gowing argued that Goncourt's description was no more than a reductive comparison of Vermeer's painting with still lifes by Jean-Baptiste-Siméon Chardin, so admired by the Goncourt brothers.[12] The case is more complex. If, in Goncourt's description of the *Maid Pouring Milk*, the quality of a Chardin is explicit, the quality of a photograph is implicit. That photographic quality becomes explicit in the passage that immediately follows the description of the *Maid Pouring Milk*: Goncourt's description of the *Little Street*, which he and his brother also saw when visiting the Six Collection in Amsterdam. 'A STREET IN DELFT' he wrote: 'the sole master who has made of the brick house of the country a daguerreotype that springs to life.'[13]

Scholars have elaborated upon the mid-nineteenth-century photographic perception of paintings by Vermeer over the past 50 years by repeatedly discussing the painter's possible or presumed use of the camera obscura. The bibliography on this topic, beginning with Hyatt-Mayor's article, 'The Photographic Eye', published in 1946, is considerable.[14] Whatever the details of their differences in appealing to the technology of the camera obscura in attempts to account for

various characteristics of Vermeer's paintings, the authors generally share a common assumption that the camera obscura is the direct forerunner of the nineteenth-century photographic camera. This assumption also characterizes standard historical accounts of the history of photography.[15] In so far as Joseph-Nicéphore Niépce and Louis-Jacques-Mandé Daguerre and others depended upon the technology of the camera obscura in their experiments to fix light-constituted images, there are grounds for comparison, but the assumption of seamless continuity fails to take into account the very real differences between the two technologies.

Scholars have further argued that the reaction to painting that both of these technologies evoked in seventeenth-century Holland and nineteenth-century France was identical. This sense of a common perceptual identity is exemplified by the epigrammatic responses of Constantijn Huygens to his first experience of the camera obscura on the one hand, and Paul Delaroche to his first view of a daguerreotype on the other. In a letter to the physicist Dominique-François-Jean Arago, Delaroche famously penned the phrase, 'From this day on, painting is dead.'[16] In 1622 Constantijn Huygens had written of a camera obscura demonstration by Cornelis Drebbel that he witnessed in London, 'The art of painting is dead, for this is life itself . . .'[17] Commenting on these seemingly parallel utterances separated by over two centuries, Martin Kemp noted that it 'becomes understandable in a context in which art could be viewed as a direct and empirical form of representation, rather than as a systematically perfected recreation of nature in the Italian manner'.[18]

While a certain conceptual coincidence might legitimately be identified, the epistemological worlds of Huygens and Delaroche, and hence their respective working assumptions, were in most ways utterly different from one another. None the less, in the opinion of some commentators this coincidence seems to sanction the projection of a nineteenth-century and later photographic model of visual registration and creation upon the Holland of the seventeenth century. As much as anything, this limiting, if not wholly erroneous, conception has encouraged critics in their determination to argue that Vermeer must have employed a camera obscura in order to achieve both the perspectival construction of his compositions and the depiction of certain ostensibly optical

phenomena. That Vermeer used a camera obscura has become a commonplace of incautious, ill-informed and amateur discussion of Vermeer's art. The most careful commentators draw inferences about Vermeer's possible use of the camera obscura directly from analyses of the paintings. However, the discussion as a whole is at least in part sanctioned – and even made inherently plausible to some – by the unqualified identification of the photographic camera with the camera obscura, and the projection of the perceptual values associable with the former on to the seventeenth century. Yet, again, the differences between the two technologies must be taken into account.

The most elaborate example in discussions of Vermeer's paintings of the unquestioning substitution of the photographic camera for the camera obscura, presuming an exact equivalence, is the work of Philip Steadman. This research is based on the assumption, first extensively acted upon by P.T.A. Swillens, that the part of a room represented in any given interior scene by Vermeer permits the accurate reconstruction of the supposed entire chamber. Swillens argued that each of Vermeer's twenty interior scenes that allow perspectival extrapolation depicts part of one of only five actual rooms. Further, he asserted that the sizes of the first three rooms he reconstructed were such that they were to be found

58 Philip Steadman, Model of *The Music Lesson* seen from the side.

59 Philip Steadman, Model of *The Music Lesson* seen through the camera lens.

in the same house. In his book he included plans and elevations of the five supposed rooms.[19] Referring to Steadman's elaboration of Swillens's work, Martin Kemp reports that ten paintings can be assumed to be set in either the same room, or in rooms that are closely similar to one another. Six of these, including the *Woman Standing at a Virginal*, contain enough features to have permitted Steadman to propose their architectural proportions entirely. He then constructed a model of the room in which he argues all six of these works must have been painted.[20]

With the help of model makers, Steadman arranged this model room with furniture, accoutrements and costumed dolls to reproduce the appearance of *The Music Lesson*, the *Concert* and the *Woman Standing at a Virginal* (the latter without the figure) in miniature, three-dimensional form. Using standard mathematical means to establish the viewing points for all six paintings within this room, Steadman argued that if visual pyramids are projected through the viewing positions, as though through the aperture of a camera obscura, as far as the rear wall of the room, the bases in four instances correspond very closely to the dimensions of the actual paintings.[21] Steadman drew a plan of the putative room including the angles of vision of the six paintings and their extrapolation to

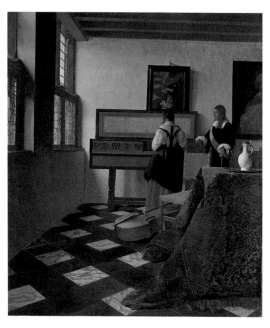

60 Vermeer, *The Music Lesson (A Lady at the Virginals with a Gentleman)*, c. 1662–5, oil on canvas, 74 × 64.5 cm. Buckingham Palace, London.

secondary triangles, the bases of which equal the widths of the paintings.[22] Steadman's architectural model of the room set up with the scene depicted by Vermeer in *The Music Lesson* was photographed from the side (illus. 58). The viewpoint is perpendicular to that of the painting itself, facing the window wall. The two figures at the virginal are visible on the right, and, where the painter-viewer of the scene in the painting itself might have been, a camera is directed towards those figures. The camera, of course, is enormous in relation to the model. It substitutes directly for the assumed original camera obscura. A photograph taken with this camera of this very scene (illus. 59) must be admitted to bear a striking resemblance to the projection, relative proportions and disposition of light in *The Music Lesson* (illus. 60). The same can be said for similar comparisons between photographs of the model set up to simulate the *Concert* and the *Woman Standing at a Virginal* and those works themselves.[23]

There is no doubt that this is an extraordinary project. However striking the resulting photographic images, though, it would seem to be open to question. First, the underlying assumption behind both Swillens's and Steadman's projects is that Vermeer's paintings depict real rooms, unmodified in their structural essentials in the painter's depictions. The

relationship between the depictions, actuality and invention in any given instance remains undemonstrated. Neither can it be demonstrated. That the paintings unproblematically depict a once existing physical state of affairs is a necessarily frail inference. If one concedes, as one must, that allegedly incidental details vary from depiction to depiction of what is purportedly the same room – the patterns of floor tiles, for example – how else might not the painter have deviated from observable reality?

Fred Dubery and John Willats were more circumspect in their reconstruction of the room in which *The Music Lesson* is set (illus. 61) than was either Swillens or Steadman. Dubery and Willats set out the mathematical procedure, and conclude with an axonometric projection drawing, but – crucially – they assume that only that part of the room which is actually depicted by Vermeer, plus what falls within the angle of vision of the presumed painter-observer, can be known.[24] They are correct in assuming that nothing else is warrantable. Secondly, in a series of publications Jørgen Wadum has conclusively demonstrated that in fifteen cases – including the *Woman Standing at a Virginal* – Vermeer proceeded by means of the pin-and-line method of perspective construction. He placed a pin at the vanishing point (which left a discernible puncture in each of the paintings) from which he could trace the orthogonals by means of a rule or thread.[25] The use of a camera obscura to construct the projection of these works would have been simply beside the point. We should note that these findings are the result of close attention to the objects themselves and to X-radiographs, further vindicating the contention that reliance on reproductions, and the photography that sustains it, is insufficient for informed discussion of works of art. Thirdly, the geometrical results of the two methods – pin-and-line and camera obscura – cannot necessarily be distinguished, so the ostensibly photographic appearance of Vermeer's interiors need not necessarily be accounted for by appealing to a use of camera equipment.

Even though there is absolutely no reason to suppose that Vermeer used a camera obscura in the construction of his interior scenes, certain other points must be born in mind. A camera obscura may have been unnecessary to Vermeer within the procedure of perspectival construction, yet this in itself does not mean that he could not have used the

61 Axonometric projection derived from Vermeer's *The Music Lesson*, from Fred Dubery and John Willats, *Perspective and Other Drawing Systems*, rev. edn (London, 1983).

instrument for preparatory observation, whether specific to any given composition, or to investigate optical phenomena more generally. As Gowing and others have observed, and Kemp and others have argued, Vermeer's representations of the effects of the fall of light, of the phenomena of reflection and refraction, are unprecedented in art, and can only be the result of many hours of purposeful looking. The particular qualities enhanced or produced by the camera obscura – condensation, intensification, coalescence of highlights, halation – are all to be seen in Vermeer's paintings of the 1660s. Yet, as Kemp and others have pointed out, Vermeer depicts such effects where they would not have occurred in nature – on relatively dull surfaces, for example (as in the *Lacemaker*).[26] Vermeer's procedure is one of ever increasing schematic notation of hue and contour through minute tonal abbreviation to produce in the 1670s paintings – such as the *Woman Standing at a Virginal* – of obvious artificial contrivance. These differ from his earlier works characterized by an unexceeded striving for a 'reality effect'. Yet his work of the 1660s was no less artificial and contrived than was the manner that was to succeed it in the following decade. The minute and accurate

transcription of phenomena observed by means of a camera obscura to achieve the appearance of pure pictorial transparency was never on the agenda, though Vermeer's manipulations may well have been informed by the experience of such observations. This much only can be inferred from the internal evidence of the paintings themselves, for, as Kemp notes, there is no written evidence of any seventeenth-century Dutch painter using the camera obscura.[27] Such a use, though, putative or actual, ought certainly not to be conceived in nineteenth-century and later photographic terms. To think of Vermeer's practice as the transcription of a fall of light on a surface that after the invention of photography would be chemically rather than manually registered would be to fall into serious error.

Jonathan Crary has described the differences and discontinuity between the technologies of the camera obscura and the photographic camera, and the epistemological frameworks within which they functioned. He proposed that an epistemological break occurred even before the invention of the photograph. He maintained that the use of the camera obscura proceeded in a basically Cartesian mode, necessarily involving the assumption of the existence of a detached internal observer of physical (and mental) phenomena. Invoking the model of a Foucauldian epistemic rupture in the first quarter of the nineteenth century, he proposed, in contrast, that the use of the photograph was dependent upon a wholly participatory, affectively involved and mentally interpolated user. He identified the stereoscope as the optimum manifestation of this mode of viewing.

There are serious objections to Crary's model. First, in spite of the continued use of large-scale cameras which the observer physically entered (necessary to Crary's description of the Cartesian subject), the seventeenth- and eighteenth-century camera obscura was as likely to be as portable and external to its user as was the photographic camera in the nineteenth. The notion of a detached internal observer persisted long after the 1820s. Secondly, there was a demonstrable technological continuity in the very process of invention. And, thirdly, if the nineteenth-century stereoscope invited a form of interiorizing involvement for the viewer, then so did the seventeenth-century painted peepshow (of the kind described in chapter 2), albeit monocularly rather than binoc-

ularly. The deprivation of peripheral vision, and the ensuing loss of reference points by which relative scale might be judged, is the same in both cases. All in all, the story of change in modes of visual apprehension and its associable mental processes is far more complex than Crary's Foucauldian model of epistemic rupture allows.[28] In spite of overstating his case, Crary is right to draw attention to features of discontinuity that characterize the emergence of photography, rather than the continuity that is the habitual subject of most histories. Among the differences between the photograph and the image produced by the camera obscura are qualities of fixity and abstraction from the flow of time, as opposed to momentary contingency; portability, as opposed to site specificity; and – with the introduction of the negative–positive process – potentially infinite replication, as opposed to uniqueness. As Walter Benjamin put it in the case of one of these distinctions:

> Of the countless movements of switching, inserting, pressing, and the like, the 'snapping' of the photographer has had the greatest consequences. A touch of the finger now sufficed to fix an event for an unlimited period of time.[29]

The photograph is a potentially perpetual commodity that can circulate readily and conveniently, whereas the camera obscura image, inseparable from the equipment that produces it, can only be commodified either by giving rise to a further item, or as a service (a performed demonstration). It is fitting, then, that some form of epistemic distinction be drawn between the use of the camera obscura and that of the photographic camera. The replication and circulation of the images achieved by the latter technique is the crucial difference, and the epistemological significance of this development cannot be underestimated. This is obviously terrain that has been carefully and fruitfully considered by Walter Benjamin, and many subsequent theorists.[30]

The (at least) partial uncoupling of the way of seeing and depicting the world associable with the photographic camera from that associable with the camera obscura obliges us to be far more specific about the nature of any proposed analogies between Vermeer's paintings and the ostensibly 'natural' image obtainable by either technology. It should now be quite clear that a photographic perception of Vermeer's paintings

62 Ben Shahn, *Three Men*, 1939, tempera on paper mounted on masonite, 45 × 76.8 cm. Fogg Art Museum (Harvard University Art Museums), Cambridge, Mass.

can no longer be sanctioned in an unqualified way by an appeal to Vermeer's supposed use of the camera obscura. As far as this enquiry is concerned, further consideration of the analogy between Vermeer's paintings and the camera obscura image can be left out of the account. Apart from a brief mention, questions of perspective can also be left aside. It is, however, pertinent to note that the science of optics, and the epistemology of vision within which it operates, prompts consideration of a different kind from that applicable to the geometry of pictorial construction.[31] Furthermore, consideration of pictorial construction is often vitiated in theoretical circles by an insufficiency of technical knowledge.[32] Many scholars have discussed perspective, among them, Erwin Panofsky, Samuel Y. Edgerton jun., Martin Heidegger, John White, Hubert Damisch, Martin Kemp and James Elkins.[33] As far as Vermeer's art is concerned, perspective has been discussed by Jørgen Wadum,[34] and Christopher Braider (who elaborates a theory of Vermeer's Cartesianism from an analysis of the perspectival geometry of *The Art of Painting*).[35] Instead of developing these themes, though, the relative dissociation of the product of the camera obscura from that of the photographic camera now permits a concentration on photography alone.

We have seen that analogies drawn between photographs and Vermeer's paintings must in one sense be anachronistic, in

154

63–5 Three untitled photographs of the Lower East Side of New York City, 1933–4, used by Ben Shahn for *Three Men* (illus. 62). Fogg Art Museum (Harvard University Art Museums), Cambridge, Mass.

spite of a certain coincidence of geometrical structure, and a coincident registration of particular kinds of pictorial detail. If it is clear that a photographic perception of Vermeer's paintings can no longer be sanctioned in an unqualified way by an appeal to Vermeer's supposed use of the camera obscura, we must seek to account for the relationship between photography and those works in another way. In chapter 4, I argued that we can no longer necessarily know from which precise derivative manifestation of a work of art, or the thing itself, any given recollection of that work derives. We can no longer necessarily be sure that our knowledge of a particular aspect of an art object is derived from scrutiny of the prototype, from one or more among many varied reproductions of it, let alone from existing, elaborative encoding of all or some such scrutinies in the memory. Now I wish to argue that this state of affairs is not merely a matter of discrimination and its inevitable failure in the face of varied multiplicity. Rather, I propose that the perceptual triumph of the photographic, encompassing also the cinematic, has been such that it has invaded our apprehension of the painterly and reconfigured it radically in our shared understanding. This development can be seen particularly clearly in the reception of Vermeer's paintings owing to their peculiar susceptibility to a form of

155

engagement directly associable with the products of both the camera obscura and the photographic camera.

In order to trace, define and account for this phenomenon we must consider not only the vast changes in the nature of the iconosphere since the mid-nineteenth century, in an age that has famously seen the technical reproducibility of visual material to a hitherto unprecedented extent. We must also take into account the interpolation of photography within artists' practice.

The use of photographs as source material by mid-nineteenth-century artists, such as Eugène Delacroix, has long been discussed and requires no elaboration here.[36] Painters continue to use photographs, either as prints or even as patterns projected directly on to supports from slides, in much the same manner as Vermeer might have proceeded according to the fancy of those scholars who assumed that he used a camera obscura. This practice in itself need not have changed the forms of painting. Things changed from the 1890s onwards, once the camera became available as a handheld instrument requiring almost instantaneous exposure of a frame of roll-film which could be mechanically developed and printed. This allowed painters to use cameras as notebooks. The apparently uncontrived and informal moment, in terms of both the life of the subject and the composition of the frame, became available as a pictorial model for painters with a fresh authority and convenience. One can say, then, that the interpolation of photography in painting practice was different in kind in the work of, for example, Ben Shahn (illus. 62–5) from what it had been for the painters of Delacroix's generation.[37]

If painters such as Shahn adapted representational features from their photographs to their paintings, other painters have since explored the interdependency of the media of representation in searching ways. Gerhard Richter has examined the particularities of photographic prints themselves in paintings that depict the accidents to which such prints are subject (illus. 66). Sigmar Polke has examined the peculiarities of reproductions of photographic prints. Both artists subvert expectations that have informed much art theory and practice since the 1960s concerning the potentially infinite reproducibility to which objects of visual representation are ostensibly subject.

Charles W. Haxthausen has argued that Polke's oeuvre, in

66 Gerhard Richter, *Untitled*, 1964, oil on canvas, 16.2 × 18.3 cm. Busch-Reisinger Museum (Harvard University Art Museums), Cambridge, Mass.

particular, constitutes a highly effective critique of both errors within, and theoretical misreadings of, Walter Benjamin's influential essay, 'The Work of Art in the Age of Mechanical Reproduction' (first published in 1936, but only conveniently available in German since 1963, and in English since 1968).[38] In the course of a subtle exploration of the effects of reproduction on the unique work of art, and the generation of works of art that exist only as mechanically produced multiples (notably the cinema film), Benjamin assumes that the essential features of a work of art are transferable to its mechanical reproduction. This is in spite of his acknowledgement that 'Even the most perfect reproduction of a work of art is lacking in one element: its presence in time and space, its unique existence at the place where it happens to be', which he associates with its authenticity. Authenticity, according to Benjamin, is 'outside technical – and, of course, not only technical – reproducibility'.[39] Yet even so, he holds that confronted with technical – that is, mechanical – reproduction, the prototype loses its authority. In Haxthausen's words, 'What is essential to an object is therefore reducible to its *image*, which can be extracted from its material constitution and its spatial being, which for him [Benjamin] are identified with its aura.'[40] And as Benjamin himself puts it, 'That which withers in the age of mechanical reproduction is the aura of the work of art.'[41]

Polke's work is to question not the assumed authority of the unique object, but rather that of the reproduced image, for authenticity still adheres to multiplicity, in spite of Benjamin's

denial.[42] Polke proclaims the mutability and uniqueness of the work of art irrespective of its medium. This is exemplified by his eight photographically based works of 1984 derived from Goya's painting, *The Old Women* or *Time* (*c.* 1808–12).[43] That proclamation is not in any sense reactionary, but proceeds by means of the dissolution in the very substance of his work of such binary opposites constitutive of contemporary theorizing, such as uniqueness/reproducibility, painting/photography and even art/nature.[44] Thus, as far as painting's relationship to photography is concerned, both find a rehabilitation that the theorists and practitioners of either painting or photography would deny to its rival.

Polke's practice, then, would seem implicitly to subvert the premises upon which much of the art that was produced by his contemporaries is based. Yet numerous artists – many of them women – turned to photography in part out of revulsion against a perceived inexpungeable contamination of painting, polluted, in their eyes, by a long history of male exclusivity culminating in the masculine posturings of the Abstract Expressionists and their successors. Their grievance is justifiable.[45] The promotion of photography within the world of art production as an *artists'* medium (as distinct from its promotion within the world of photography as an *art* medium) in part results from this conception. It has contributed to the redefinition of the relationship between painting and photography, and the ways in which either can be thought of.[46]

Related to a laudable desire to overturn male dominion, other Conceptualist practices are aimed in part at dethroning painting from the status it enjoyed until recently as the preeminent visual art medium.[47] For instance, Susan Hiller reemployed numbers of her own paintings in works such as *Hand Grenades*, 1969–72 (twelve stoppered glass jars each filled with the ashes of a burnt painting), *Painting Blocks*, 1970– (blocks made of paintings cut up into rectangles of identical size superimposed and sewn together) and *Work in Progress*, 1979– (paintings pulled apart thread by thread and reworked) (illus. 67).[48] Especially considered within the totality of Hiller's practice, in which photography and video play a large part, work of this kind relocates painting. It takes a new place within a nexus of objects representationally, artefactually and temporally conceived in which photography plays an equal role.

158

67 Susan Hiller, 'Tuesday', one of seven objects created from a recycled painting during *Work in Progress*, a week-long solo event at Matt's Gallery, London, 1980 (the recycled painting dated from 1973–4).

A state of affairs has now existed for decades in which painting in itself need be regarded as no more an art than is photography, hewing stone, welding metal or even vomiting; yet all these activities can be used to make art, none being inherently better or worse than any other.[49] This realization has had a profound effect on the way in which we approach and address paintings made long ago. It increases an awareness of their artefactuality, and of their place in time: that is, as 'objects as events extended over time', in Susan Hiller's formulation.[50] This newfound ability to apply any medium to a conceptual problem as appropriate and convenient signalled the eclipse of the Modernist assumption that each medium has a particular logic that it is the principal duty of the contrived object to disclose. The total subsumption of painting within a democracy of artists' strategies means that painting as an art has different connotations now even from those that obtained in Richard Wollheim's consideration of that topic,[51] let alone from when Thoré-Bürger promoted the paintings of Vermeer, or when Vermeer made the objects concerned.

Even setting aside any effects attributable to contemporary artists' practice, we might recognize that the profuse availability of photographs and their reproductions, which – as was discussed in chapter 4 – find practical acceptance as reliable substitutes for the things they represent, has itself had a

159

68 Detail showing
Cupid holding
a tablet from
Vermeer's *Woman
Standing at a Virginal*
(illus. 1).

profound effect on the way in which we address paintings themselves. As was discussed in chapter 4, a photograph of a painting renders just that part of it which is compatible with photography as a medium. It suppresses other aspects. Unless we have a very specific agenda, such as conservation, we therefore tend to return to a painting with those photographically compatible elements foremost in our minds. Furthermore, acquaintance through photography leads us to approach the painting with a photographic model of attention: not solely in terms of paying attention to those features favoured by photography, but also in transferring to the painting photography's infinite capacity for excerptibility and revision of scale.

For example, in my interpretation of Vermeer's *Woman Standing at a Virginal* I have suggested that the object held by

Cupid – the blank tablet – signals the precondition of representation itself. But in doing so I have used knowledge derived from photographs of various kinds, and book illustrations, as well as examination of the painting itself on many occasions in several different places. In constructing this interpretation I focused progressively on a detail, isolating it by blowing it up (illus. 68). In doing so I have been thinking about the work photographically. The photographic details that have been made are not transparent likenesses of the painting: they are artefacts in their own right. They are photographic artefacts that I have caused to be created. These blowups are themselves things: photographic things. They bear a very uncertain and problematic relationship to the painting. As Walter Benjamin expressed it in 'The Work of Art in the Age of Mechanical Reproduction' (the passage used as an epigraph for this book): 'The enlargement of a snapshot does not simply render more precise what in any case was visible, though unclear: it reveals entirely new structural formations of the subject.'[52]

In Michelangelo Antonioni's film *Blow-Up* (1966), one of the most profound cinematic meditations on the nature of perception and its mediations, the photographer, Thomas, discovers what he thinks is an otherwise overlooked reality through a process of progressive photographic enlargement. This has its precise analogy in art-historical practice. Not only

69 Still from Michelangelo Antonioni's 1966 film *Blow-Up*: 'It looks like one of Bill's paintings.'

161

can we not necessarily be precise about our sources – prototype or reproduction – we view the prototype (the painting) with techniques derived from viewing reproductions. Indeed, our entire mode of perception might be described as photographic, a notion that Antonioni treats with supreme irony in *Blow-Up*. Looking at the final enlargement that looks meaningless in itself, but which in the context of the progression of enlargements can be seen to be an image of a dead body, the wife of Thomas's painter friend, Bill, says: 'It looks like one of Bill's paintings' (illus. 69).

Cinema is, of course, photographic.[53] We readily accept its illusion as we watch. Just as Vermeer in the *Woman Standing at a Virginal* presents us with a meta-painting-within-a-painting-within-a-painting, Hiroshi Sugimoto, too, captures the photography of cinema meta-photographically. In his work *Metropolitan Orpheum, Los Angeles* (1993) (one of a series of such works) (illus. 70), Sugimoto depicts the sum total of the visual element of cinematic representation, exposing his photographic plate in the cinema for the length of time a film

70 Hiroshi Sugimoto, *Metropolitan Orpheum, Los Angeles*, 1993, photograph.

runs, thus seemingly blanking out the screen to produce his own plenitude of representation. By appealing to this photographic conceit, and acknowledging our current mode of perception, can we not now see the tablet held by Cupid in the *Woman Standing at a Virginal* not in terms of an absence of representation, but of its very opposite, of utter plenitude? It is as though in alluding to the conditions of representation Vermeer presents us not with a *tabula rasa*, but with surfeit, a washing out through over-exposure, such as he depicts elsewhere to convey the eye's inability to accommodate great concentrations of reflected light, as in the case of the depiction of certain folds of silk in the virginal player's dress. Through Cupid-Eros and the love of art, Vermeer shows us the sum total of representation as potential, just as Sugimoto shows us the sum total of cinematic representation. Whether we look at paintings, photographs, films, paintings of paintings, photographs of paintings of paintings, to whatever degree of representational remove, we are dealing in each instance with objects. Those objects are events extended over time, ever subject to change, whether physical, chemical or perceptual. They are objects that are in the world, and of it. 'Perhaps', as Nelson Goodman put it, 'rather than art being long and life short, both are equally transient':[54] a case of *vita brevis ars brevis*.

Even when we enter the art museum and find the *Woman Standing at a Virginal*, we confront it imbued with the forms of knowledge – within the 'scopic regime' – proper to photography in all its forms.[55] However hard we try to abandon modes of seeing that postdate those of the later seventeenth century, we cannot help but see as only *we* can see. We enter the museum as part of an iconosphere in which the painted representation has no independent conceptual existence. Inevitably we measure the representations we see there against the contemporary norm provided by photography. Much of what we are trained to attend to are those qualities that can successfully be mediated by photography, even if those qualities – such as the patterns of brush strokes – can be discerned independently of their representational function. Few of us, though, might be said to think of the surface of a painting in three-dimensional terms, or of a whole painting as a complex three-dimensional object, in spite of any awareness we might have of the patterns formed by paint applied as impasto.

It is often said that paintings, especially in American

museums, are cleaned to states of brightness and are artificially lit so as to simulate the glowing effect of photographic slides. Even if there is no demonstrable causal connection, the very existence of such a perception suggests a readiness to view one class of objects in terms of another on the part of at least some critics, with photography accorded a normative status. This is not to say that contemporary viewers necessarily suffer from a category confusion when confronted with a painting and are consequently unable to distinguish it from a photograph, but rather that even in doing so their normative reference is to the photographic. The very fact of representational verisimilitude has lost its power to surprise. In sum, on entering the museum we may well find the *Woman Standing at a Virginal*, but each time we find it, we find it *now*, and we see it from within the constraints of our own photographically determined mode of seeing. If we are to understand such an object, both historically and aesthetically, we must acknowledge this condition and take measures to accommodate it. A failure to do so results in the kind of art-historical misjudgements discussed in the first part of this chapter in which I looked at how photography and seventeenth-century Dutch painting came to be associated in the mid-nineteenth century, and how the specific appearance of Vermeer's art in particular came to be attributed to his supposed use of the camera obscura.

In the next chapter I turn to examine, first, how art objects and the photographic products derived from them are related to commodification, and, secondly, the status of a work of art, such as the *Woman Standing at a Virginal*, as a particular kind of commodity, in part photographically created and defined.

7 Commodities

No technique contributes more efficiently to the commodification of art and its derivatives than does photography. Once photomechanical processes became available in the late nineteenth century, photography permitted the smooth transposition of active commodity status from the museum object to its reproductions. Most obviously, the provision of commodities derived directly from museum objects is represented by a constantly revised and renewed flow of reproductions sold in the form of prints, posters and postcards in museum stores and elsewhere. The ready photographic reproducibility of museum objects also encourages illustrated discussion in books and journals. These include a wide range of commercial products, from popular magazines to museum exhibition catalogues and academic monographs. The ready availability of slides, whether derived from museum objects themselves or from book illustrations, encourages reference to them in academic teaching at all levels, but most particularly at colleges and universities. Such education is itself a commodity. It enfolds photographic images of museum objects. Therefore commodification can be said to spread efficiently from museum objects, themselves apparently sacrosanct and commercially inert, in any number of directions by means of photography. How does this phenomenon affect the structures of art-historical scholarship, and what is the nature of the museum object itself in terms of commodification?

As we saw in chapter 1, art-historical scholarship can never be entirely insulated from commerce. In considering the relationship between art and commerce, many theorists have worked themselves into lathers over the iniquities that follow from the 'triumph of exchange-value over use-value', in Victor Burgin's words.[1] Some critics propose that those who care for art objects do so – wittingly or unwittingly – because of their exchange value. Indeed, some associate the awe in which the public, collectors and curators hold art objects as being at least in part determined by their exchange value.

Only when this consideration is removed, some theorists suggest, can art be adequately discussed.[2]

In discussing the case of *Saint Praxedis* in chapter 1, I argued that art and commerce are inextricably linked. There can be no outside position from which one might talk about art without being implicated in commerce. Furthermore, the theory of the participatory observer, a conception used in fields of enquiry as diverse as anthropology, quantum mechanics and photographic theory, also suggests as much. There are those who believe that they can evade any involvement in commerce, however indirect. They subscribe to what Michael Ann Holly has called 'interventionist commentary'. This is the term she applies to the 'variety of approaches (for example feminism) in which the issue is less how history can serve art than how art can serve as a basis for cultural and social criticism'.[3] That is, these critics address and cite art objects principally as instrumental evidence in the discussion of a range of topics defined a priori in relation to those objects. It might be said that this is what all who discuss and cite such objects do, whatever the subject of their discussion, whether feminism or connoisseurship. However, certain interventionist commentaries proceed most efficiently only when attention to the art object is displaced by attention to the framing discourse. There are occasions when ignorance of the complexities of art objects, and of users' relationships with them, conveniently encourages forms of discussion – usually interventionist commentary – that close attention to those complexities would call into question. Reproduction by means of photography, and its proliferation predominantly by means of book illustrations, has fostered the growth of interventionist commentary.

The nature of objects and objecthood has been a topic of fraught philosophical contention from the time of Plato onwards. The term can occasionally be used with specific connotations, for instance in Jean Baudrillard's 'system of objects' in which the 'object' is a unit of signification within a semiotically construed cultural system.[4] However, the pragmatic, unreflective use of the term 'object' commonly in use among art museum scholars and art historians implicitly emphasizes the material, discrete and sensually apprehensible character of objects, though without excluding other characteristics. Objecthood is a complex condition. I take it here to mean, in

part, the quality of things that themselves are inextricable from forms of human attention. In doing so I am loosely following the example of Martin Heidegger in his essay, 'The Thing', in which he states: 'An independent, self-supporting thing may become an object if we place it before us, whether in immediate perception or by bringing it to mind in a recollective re-presentation.'[5] Even if we describe objecthood as 'sacrosanct', it is so because of the bewildering and dynamic nature of people's confrontations both with the things they take to be endowed with 'objecthood', and with the variable, contingent status of such things themselves. It is not *necessarily* so because of their exchange value. Exchange value may at times contribute to, but does not in itself account for, the objecthood of objects in its complexity. In order profitably to introduce the concept of exchange value into the discussion of objects and objecthood we must also introduce the concept of the commodity.

Before examining the concept of the commodity, however, we should be aware of Theodor Adorno's observations regarding the origin of exchange value. Consideration of time, ownership and fear of loss of the object are sufficient, in Adorno's opinion, to produce exchange value:

> Whatever is, is experienced in relation to possible non-being. This alone makes it fully a possession and, thus petrified, something functional that can be exchanged for other, equivalent possessions.[6]

The anthropologist Arjun Appadurai has demonstrated that exchange value is the sole salient feature that defines the commodity.[7] None the less, exchange value, while being a necessary condition for the definition of an object as a commodity, may not in itself be a sufficient condition. The presence of exchange value in any given instance may be far from stable. Appadurai's fellow anthropologist, Igor Kopytoff, has demonstrated that objects can move in and out of the state of being commodities.[8] They may none the less retain their exchange value in Adorno's sense even when they are not commodities.

We can complement Kopytoff's notion with Nelson Goodman's proposal that objects can move in and out of the state of being works of art.[9] In the schema proposed by Appadurai, museum objects are ex-commodities: 'things

retrieved, either temporarily or permanently, from the commodity state and placed in some other state'.[10] Let us examine this schema more closely with reference to de-accessioning, a clumsy term denoting the removal of the names and unique identification numbers of museum objects from the register of such objects within the museum concerned, usually (though not invariably) followed by their physical removal.[11] The de-accessioning of a museum object usually leads to its sale.[12] The sale of a de-accessioned museum object returns it to the commodity state (though without necessarily compromising its status as a work of art). Yet is the difference between the two states of the object in such a case – commodity and ex-commodity – as distinct as Appadurai's arguments would have us believe?

First, while not subject to exchange itself as a commodity while in a museum, the status of the museum object sanctions the exchange value of other, similar objects that are unquestionably in the commodity state. The museum object is therefore implicated in the life of such non-museum objects as commodities. This was discussed in chapter 1.

Secondly, some art museums treat their objects as though they retain exchange value. Such treatment is wholly in accord with the possibility that their objects might be de-accessioned and returned to unequivocal commodity status. This is the case even where art museums are forbidden, on pain of censure according to the terms of agreements promulgated by professional bodies (such as the American Association of Museums and the Association of Art Museum Directors in the USA), to use the proceeds of de-accessioning for purposes other than the purchase of further works of art.

In many US art museums the trustees or the director claim a right to review, approve or reject decisions by curators about the status (attribution or other defining description) of objects in the collections. Such curatorial decisions are usually made on scholarly grounds. Directors' or trustees' reviews are generally not confined to determination on scholarly grounds, but take other factors into account. These may include more immediately perceived institutional interests, such as prestige, donor relations and asset protection. In spite of the emotive connotations of the term, this procedure is best described as censorship. Censorship implicitly acknowledges the potential commodity status of art museum objects. The interference

with disinterested museum scholarship that such censorship represents provides a strong argument against de-accessioning by those who regard art museums as sites of scholarship.[13]

I propose to refine Appadurai's schema by terming objects in art museums that permit de-accessioning not ex-commodities, but *dormant commodities*. They may not be on any market actively, but the fact that they might be one day leads to their being treated institutionally in such a way as to attempt to protect their potential exchange value by means of internal censorship. The efficacy of such mechanisms, however, is extremely poor, for such censorship is purely local and cannot affect publications outside the control of the institution that imposes it. In these circumstances, the obvious exercise of censorship can only lead to needless institutional embarrassment.[14]

The National Gallery, London does not permit de-accessioning. The paintings in its collection – including the *Woman Standing at a Virginal* – are regarded by the museum staff as being quite literally without monetary value, so that their scholarship can be untrammelled by any concern for financial consequences, however remote. Concomitantly, the scholarship of the staff is not subject to censorship by either the director or the trustees. Of course, exchange value is not entirely expunged under this regime; rather it is simply more deeply dormant than in the case of de-accessionable objects. This is because financial concerns – such as insurance or indemnification – still attach to the works. Furthermore, the transposition of commodification from the object itself to its reproductions (sold in the museum store, and elsewhere), and to academic products (scholars' books and teaching are commodities), affects museums whether they permit de-accessioning or not, and still pertains to the object itself.

Those who promote 'interventionist commentary' by seeking to avoid any form of attention to art objects that might be construed as serving commercial interests run the risk of producing flawed arguments for a second reason. The establishment of empirical data about works of art, by examining both the works and related documents, can serve the practical and theoretical investigation of a complex condition, *as well as* aiding commerce in the objects concerned. Furthermore, art historians' aid to commerce can at times appear paradoxical. For example, an art historian's downgrading of the attribution

169

of a work in a dealer's inventory might be immediately and locally disadvantageous to that dealer. However, by thereby promoting the apparent disinterestedness and probity of the commercial system in respect of its commodities – works of art – such a reattribution helps to sustain confidence in that system more generally.

A third reason to be sceptical about 'interventionist commentary' is that its claims to independent efficacy must be doubted. While art can indeed (and, I believe, should) serve as a basis for cultural and social criticism, those who would have it so must at least have some idea of what it is they are talking about. It is certainly relevant to the argument of this book that the *Woman Standing at a Virginal* was made by Johannes Vermeer, most likely in the early 1670s, that it entered the public awareness and scholarly consideration by exhibition and reproduction in 1866, and was then related by Thoré-Bürger to other paintings by, or thought by him to be by, Johannes Vermeer. All this is empirically established data. Similarly, other theoretically inclined scholars who have written about Vermeer and his work, such as Lawrence Gowing, Norman Bryson and Daniel Arasse,[15] depended in their speculations upon empirically established data.

Fourthly, Thoré-Bürger's project with regard to Vermeer in Second Empire France was itself an exercise in 'interventionist commentary'. He sought to mobilize art to 'serve as a basis for cultural and social criticism' no less than do contemporary theoretically inclined art historians. Holly's laudable project, though hostile to commerce, is yet inscribed within it, just as Vermeer's art and Thoré-Bürger's scholarship were themselves.[16] This is the case in spite of what can justifiably be inferred to have been his interest in the paintings themselves for both political and aesthetic reasons.

Indeed, we might argue that Thoré-Bürger's greatest achievement with regard to Vermeer's art was to create the market in it. Of the eleven works he attributed to Vermeer in the 1866 Exposition rétrospective, no fewer than six belonged to him at the time, two had been acquired through him by their then owners (the *Geographer* for which Thoré-Bürger actually negotiated the price for its purchaser, Isaac Péreire; and the *Soldier with a Laughing Girl*, then owned by Léopold Double) and one – the *Rustic Cottage* – had recently been attributed by him to Vermeer.[17] At the very least, we can

acknowledge that Thoré-Bürger's achievement in creating this market had an effect as profound as his scholarship on the reputation of the artist and the reception of his works.

It is often assumed that in the case of Thoré-Bürger commerce and art-historical scholarship were necessarily interdependent; that the very structure of Thoré-Bürger's investigation in pursuit of both his disinterested curiosity and his socio-political agenda was actually determined by the needs of commerce. The consequence was the creation of a modern, positivist art-historical scholarship of oeuvre definition and biographical investigation. Is this the case? Had Thoré-Bürger not had direct commercial interests, would the structure of his investigation have been any different? Would not an aesthetic and socio-political agenda with regard to Vermeer's art alone have sufficed to engender positivist art-historical scholarship of oeuvre definition and biographical investigation?

These questions remain unanswerable because, as Nelson Goodman remarked often occurs in philosophy, they are the wrong ones.[18] The motivating factors – aesthetics, politics and commerce – did not – and do not – exist independent of one another. In relation to commerce, the difference between aesthetic attention to works of art and 'interventionist commentary' is one not in *kind*, but of *degree*. No commentator on art can evade implication in the market, other than by silence.[19] For Thoré-Bürger commerce was one way of efficiently furthering the satisfaction of his aesthetic curiosity no less than was his art-historical scholarship an efficient means of furthering his commercial activities. Thoré-Bürger's sponsorship of the art of Vermeer and that of other seventeenth-century Dutch portrayers of everyday life was in part socially and politically motivated, but it was also commercially motivated. Politics, aesthetics and commerce are simply inextricable under capitalism for *anyone*. To admit as much is not to propose that everyone's motivations must be identical, nor that choices regarding conduct are not available, some of which may be ethically or politically preferable to others. It is, rather, to recognize that any enquirer, from dealer to interventionist commentator, must take the determining conditions fully into account.

However, not all projects of oeuvre definition were necessarily primarily commercially driven. The attention of

nineteenth-century museum scholars may have been focused predominantly on collections, rather than on monographic studies with catalogues raisonnés,[20] but Johann David Passavant's innovative study of Raphael, published in 1839, including a catalogue raisonné, was the work of an artist and historian, not a dealer or curator.[21] On the other hand, the example of the dealer John Smith's monumental project of corpus definition – his nine-volume catalogue of the oeuvres of Dutch, Flemish and French old master painters published between 1829 and 1842 – suggests that catalogue raisonné scholarship was at least in part commercially inspired.[22]

The overriding determining condition under which scholars make their choices of conduct is that exchange value is inseparable from art in most of its manifestations. This has been the case at least since the dawn of capitalism,[23] though subject to refinements of understanding – such as the differential dormancy of a museum object's commodity status – as discussed above. One might even say of the easel painting (and of many other forms of art for that matter) that its exchange value – whether active or dormant – is an immanent quality of it as an object no less than is its physical construction or its significatory capacity. After all, the paintings of Vermeer were from their very inception implicitly or explicitly commodities in a capitalist economy, and have continued to function as such ever after. This is the case even though all works currently known are out of immediate and literal circulation owing to their institutionalization.[24] (Chapter 1 demonstrated what happens when a half-way credible putative Vermeer enters the market.) Those who merely summarily condemn, and then ignore, the commodification aspect of a painting such as the *Woman Standing at a Virginal* in favour of attending to its more intellectually congenial qualities, such as its place in semiosis, implicitly subscribe to that perversion of understanding of human relations as mediated by the production of objects that was so roundly condemned by the thinker whom Elaine Scarry has correctly termed 'our major philosopher on the nature of material objects', Karl Marx.[25]

We have seen how the commodification, whether active or dormant, affects attention to the art object, making forms of attention a matter of contention among those who respectively engage in commerce, those who acquiesce in it and those who resist it naïvely. We have also seen that a museum

object never entirely loses its commodity character. Its reproducibility by means of photography serves to inscribe it within a further, partially dependent commodity: interventionist commentary. Yet before an object assumes the status of museum object it has another, though at that stage it need be no less of an art object than after it has entered the museum. In that earlier state it has not yet become commercially dormant. It might well be on the market – as was the case when the *Woman Standing at a Virginal* was offered at auction by the Lacroix family in December 1892 – or it might be a potential gift or bequest from a possible museum benefactor. Aspects of a museum object's past existence adhere to it even after it has entered the museum and can affect its use within the museum. If photography was one framing institution that affects the perception and use of museum objects, the museum itself is another.

I now turn to discuss aspects of the art museum and its use – both good and poor – of art. I use those terms in spite of and not because of their uncompromising unambiguousness, because ethics has a central role to play in curatorial practice. The judgements called for are actually more nuanced than this initial statement would suggest, and are not global in their implications. However, curatorial practice is so important and must be amenable to ethical examination because it is curatorial practice that allows us to see much, if not most, of the art we may wish to see at all.

8 Donors

Photography is one of the means by which the afterlife of paintings created before its invention has been shaped, affecting not only the perception of paintings themselves, but their commodification. Art museums have had a similarly vast impact. In the nineteenth and twentieth centuries photographic reproduction and art museums have affected and continue to affect our relationship to works of art more pervasively than any other innovations.

Of all the factors that shape the conduct of art museums, their economics is fundamental. Therefore in this chapter I shall look at art museums from the point of view of their finances and examine aspects of the relationship between institutions and donors in two instances: the National Gallery, London and the Indiana University Art Museum, Bloomington, Indiana. I look at the place of objects in this relationship. In the case of the former, I examine the role of Vermeer's *Woman Standing at a Virginal*. In this chapter, and in the one that immediately follows it, on the subject of therapeutics in art museums, I am concerned with the use of objects, and in discussing both topics I look at both the good and the poor use of objects in art museums.

The role of art museums as instruments of power has never been more relentlessly examined than in recent years. Scholars have given accounts of the various ways in which museum visitors are disciplined by the architecture and the arrangement of objects. They have also discussed ways in which the subsumption of certain objects by such institutions sanctions esteem for others like them, while implying the ordinariness of those implicitly categorized as unworthy of museum attention – all with financial and socially symbolic consequences.[1]

The commemorative aspect of art museums in proclaiming and perpetuating the reputation of their donors – the museum as mausoleum – has received some attention, and deserves more.[2] However, in this connection, remarkably little attention has been paid to the financial mechanisms of art museums.[3]

This is probably because the necessary records are, for the most part, sensitive and confidential. Art museums, like other not-for-profit cultural institutions that are not wholly supported by governments, including orchestras, libraries, colleges and universities, require a steady stream of income, both financial and in kind, in order to function.[4] These resources must be acquired by continuous effort on the part of each art museum. They come from four principal categories of provider: local, state and federal government and their agencies; business corporations; charitable foundations, great and small, which can overlap with the fourth category, private donors. Resources provided include money or financial instruments, and goods, including works of art. While the works of art enhance the collections, the money can be for various purposes determined by negotiation between donor and institution: general or specified, wholly disposable, or for investment to produce income.

The financial efforts most American art museums make are vast and continuous, claiming the attention of directors, curators, development staff and grant application researchers. The truism that there is no gift without recompense to the donor leads many scholars to make observations critical of the accommodations that an institution will make in order to secure resources. At times the tail that is the donor, actual or potential, may seem to wag the dog that is the art museum. For example, 'vanity exhibitions' and their associated publications, devoted to individual private collections, can at times appear to determine an art museum's programming. The balances of taste and understanding that govern an institution's sense of propriety in donor relations usually remain unarticulated. In contrast, a museum's occasional capital campaigns permit forthrightness in the association of donation with recognition.

Capital campaign leaflets can appear to be the upmarket equivalent of mail order catalogues. For $1 million the patron can name a gallery, for $2 million endow (and name) a curatorship and so on.[5] Yet such transactions are rarely simply a matter of a cheque arriving at the art museum in response to receipt of an appeal leaflet. Usually they are the culmination of a good deal of patient diplomacy on the part of museum staffs and trustees on the one hand, and the putative donor on the other. It is well understood that a generous donor can

expect not only public recognition, but also influence, and even a degree of power, through participation in the governance of the beneficiary institution. Appointment to advisory committees, and eventually the board of trustees, is a common *quid pro quo*. However, there is a delicate balance that must be respected if the appearance of an obvious purchase of influence is to be avoided.[6]

Most visitors, and most art museum staffs, are either effectively blind to the visible symptoms of such transactions within the institutions, or ignore them. They take for granted the naming of galleries, wings or even whole museums, not to mention the presence of a donor's name, sometimes elaborated with further material, on the label of every exhibited object (known as the credit line). All this seems entirely natural, being as old as the foundation of modern art museums. One might find, for example, more than one painting bearing a label including the credit line 'Bequest of Grenville L. Winthrop' within the Armand Hammer Galleries in the Archibald A. Hutchinson Wing of the William Hayes Fogg Art Museum, itself part of a university named for a seventeenth-century benefactor, John Harvard. When noticed, such inscriptions are amenable to interpretation as signifying the discharging of any obligation on the part of the institution to the donors, as the anthropologist Igor Kopytoff has argued.[7] Obviously, such devices are far from natural, being mechanisms of capitalism reflecting the desires and perceived needs of members of its successful classes.

Usually the most obvious signs of patronage are confined to the linguistic sphere of signage and labelling. In one sense, this is marginal and unobtrusive when it comes to considering the agenda – whether purposive on the part of the curators, or ideological – to be discerned in the arrangement of objects and mode of display in any given gallery. By that consideration it is immaterial whether any given display is presented under the rubric, 'The Burrell Collection' or 'The People's Palace', to cite two examples from a single city, Glasgow. From this point of view, only the choice of objects and their arrangement truly matter, for the linguistic apparatus is marginal, however much it might appear to affect the viewer's response. This is because the name of the donor is usually entirely subsumed by the institution with which it becomes associated to the extent that the name comes to have

no practical meaning beyond that of the institution itself. This subsumption is all the more complete when, as in older English-language practice, a name is used in its adjectival derivation, such as, for example, 'Ashmolean', 'Hunterian' and 'Smithsonian' (to honour Elias Ashmole, William Hunter and James Smithson respectively). Yet even in unmodified, proper-noun form, most visitors to the institutions associated with the names of Carrara, Tate and Sackler (to cite three at random) would be hard pressed to identify the individuals concerned. Those visitors might even not realize, without reflection, that the names actually refer to identifiable people who exist or have existed. Language, in the sense of naming, is peripheral, and its referents eventually subornable to the institution.

Even when a donor's will dictates that a group of bequeathed works of art should remain intact when displayed, curators are often adept at disguising the fact by juxtaposing a gallery dedicated to such a group with others containing similar material. Thus all but particularly observant visitors to the seventeenth-century Dutch galleries in the Metropolitan Museum, New York are likely to be unaware that Gallery 14 is dedicated solely to paintings from the 1913 bequest of the department store magnate, Benjamin Altman, while neighbouring Galleries 12 and 13 contain further works from the same culture that entered the museum from a variety of other sources.[8] The visitor in pursuit of paintings by Vermeer may momentarily be puzzled that while four hang in Gallery 12, three of which occupy an entire wall (*Woman Tuning a Lute*, *Portrait of a Young Woman* and *Woman with a Water Jug* – the fourth is the *Allegory of the Faith*), the fifth – the *Woman Asleep at a Table* – is two rooms distant, in Gallery 14, dedicated to the Altman paintings. Since the reception of Altman's bequest, similar accommodations of donors' wishes to preserve the separate identity of their collections have been made at the same museum, all subject to dilution and increasingly ingenious interpretation.[9]

Although founded and funded by government initiative, the National Gallery, London has consistently accommodated donors' interests since its inception in 1824. The earliest example is the use in 1823 by Sir George Beaumont of the conditional gift of his own paintings to secure the purchase for the nation of the collection of the recently deceased John Julius

Angerstein.[10] The two collections formed the nucleus of the National Gallery.[11] Donor politics has been integral to the functioning of the National Gallery ever since. Indeed, the membership group for individuals and couples who make the highest annual donations, and who thereby gain the opportunity to attend events with the director and curators unavailable to others, is named the George Beaumont Group.[12] The support of this growing group, as well as of corporate benefactors[13] and corporate sponsors,[14] has been increasingly important to the National Gallery since it was obliged to take over responsibility for the building from the Property Services Agency in 1988.[15] Funds it provides allow the director and trustees flexibility of spending that would be impossible were the Gallery to be wholly dependent on the government grant-in-aid. In 1996–7 such funds went towards a new acquisition – Francisco de Zurbarán's *Cup of Water and a Rose on a Silver Plate* – and the exhibition, *Masterpieces from the Doria-Pamphilj Gallery*, Rome (22 February–19 May 1996).[16] Among the benefits for the members of the George Beaumont Group was a private evening visit to the 1996 Vermeer exhibition at the Mauritshuis, The Hague, in which both the *Woman Standing at a Virginal* and the *Woman Seated at a Virginal* from the National Gallery were displayed. This privilege was, in effect, magnified in the light of extreme difficulty of access to the exhibition owing to the huge international demand for advance-purchase timed tickets.[17]

The sum raised by the George Beaumont Group is not disclosed in the financial report based on unaudited receipts and payment records that forms an appendix in the annual *National Gallery Report*. The 1995–6 financial report gives a breakdown of receipts and expenditure expressed to the nearest £1,000. Income from sponsorship and donations was divulged as £14,686,000 within a total income of £35,780,000.[18] The following year no such breakdown was given, the headings being merely 'Grant-in-aid', 'Other operating income' and 'Other income'. Total income and expenditure were reported as corresponding exactly at £34,000,000 each. Furthermore, figures were far more approximately expressed than in previous years (to the nearest £100,000 rather than £1,000), and the statement in the 1995–6 *Report* (p. 69) that 'A copy of the full audited accounts can be obtained from HMSO [Her Majesty's Stationery Office] in the autumn' was not

repeated. As private and corporate sources of funds have grown in relation to the government's grant-in-aid, the National Gallery's public financial reporting has become increasingly summary. Public accountability appears to be giving way to private discretion.

Never has private munificence been more important to the National Gallery. Two instances are referred to in the 1995–6 *Report*. The section on 'Friends and Benefactors' was headed with the statement, 'The Director and Trustees would like to express their lasting gratitude to Lord Sainsbury of Preston Candover, the Honourable Simon Sainsbury and Sir Timothy Sainsbury, for the Sainsbury Wing and to Mr J. Paul Getty Jr. for his endowment.'[19] This refers to the National Gallery's most significant expansion this century, the Sainsbury Wing, which opened in July 1991, and the provision of an endowment fund for acquisitions. A third instance is noted in the 1996–7 *Report*, which succinctly stated:

> In December 1996, Sir Denis Mahon announced that he is to bequeath sixty-one paintings from his outstanding collection of Italian Baroque pictures to the National Art Collections Fund. Twenty-six of these are to come to the National Gallery, provided that free admission is retained and that the Gallery does not de-accession any works from the Collection.[20]

Sir Denis Mahon – a member of the George Beaumont Group – has been even more blatant than Sir George Beaumont was in using his collection for leverage. He has used the prospect of an immensely important bequest of works of art in a forthright attempt to determine the policy of the institutions that would be his beneficiaries. By using an intermediary institution (the National Art Collections Fund), he shrewdly incorporated a mechanism that would make his conditions considerably more difficult to thwart than, say, those of Benjamin Altman to the Metropolitan Museum of Art, New York. Sir Denis Mahon's conditions differ from those of most donors in not being primarily concerned with self-aggrandizement or posthumous reputation. He expressly intends to use his bequest to frustrate politically influenced or government-dictated museum policy in accordance with his own – widely shared – conception of the public interest.

More immediately pertinent for the future of the *Woman*

Standing at a Virginal is the redevelopment of the North Galleries. The circumstances of display of the *Woman Standing at a Virginal* have changed considerably in the course of some 30 years, and are inextricably bound up with the history of the building and its internal treatment. An architectural ethic of modernization in the 1960s and early 1970s has been superseded by an architectural ethic of building restoration, and purported truth to original appearance. Ironically, perhaps, this does not extend to the treatment of those parts of the building that originally date from those very years.

Timothy Clifford, successively director of the Manchester City Art Gallery and the National Galleries of Scotland, Edinburgh, has been the most vocal and practical proponent of the restoration of museum buildings to their purported original appearance. Yet the ostensible motive of restoring nineteenth-century appearance as a search for authenticity is belied by Clifford's artificial archaizing of the 1970s mezzanine extension to the National Gallery of Scotland. It is characterized by, in the accurate words of a hostile editorial in the *Burlington Magazine*, 'marbled skirting, dados, cornices, pseudo-Victorian carpet, fringed corduroy ottomans and violently coloured Lyons silk wall-coverings . . . draining colour even from the Van Goghs'.[21] We see here not disinterested restoration, but the decoration of social and political reaction, in which archaism, a mythology of an unchanging past where goodness and truth are alone located and must be perpetuated and concealed museum authoritarianism mix to produce a potent ideological cocktail.[22]

In London, the stripping of the early 1970s false ceiling and raised platforms within the bays of the National Gallery's Room 28 in 1995 marked a return to the original proportions of this gallery, including a coffered barrel vault. It had opened in 1928, funded by the dealer, Lord (then Sir Joseph) Duveen.[23] In its 1970s manifestation, seventeenth-century Dutch cabinet paintings had been hung there, including the two Vermeers (illus. 71). This long gallery serves not only as display space, but also as a primary route between the main body of the building and the North Galleries, which opened in 1975. As the space was arranged in the 1970s, the visitor could choose to remain in the long central well of the gallery, cursorily taking in the paintings hung in the shallow bays while walking through. Alternatively, the visitor could divert

71 National Gallery, London: Room 28 in 1979.

72 National Gallery, London: Room 28, post-1995.

to take a few steps up to the platform that occupied each bay for an intimate inspection of the Dutch paintings that hung there against the pale wall, among them the *Woman Standing at a Virginal*. The minimal railings that bounded each platform, as well as the steps, meant that distant perusal was visually interrupted. Yet entry to the raised space of a platform encouraged in the viewer a sense of intimacy with the pictures immediately to hand through the simple device of being set apart with them. As Gaston Bachelard observed of climbing to an attic in his analysis of the human experience of built interior spaces, this was an 'ascension to a more tranquil solitude'.[24] Visitors literally raised themselves out of the flow of human circulation to a state immediately conducive to quiet contemplation. Since August 1995, in place of these compartments of intimate encounter, the visitor experiences a single, unifying floor level, and walls hung with rich dark green cotton damask against which hang works by Rubens and Jordaens[25] (illus. 72). This arrangement precludes the possibility of individual visitors setting themselves apart with a small group of paintings, as was the case previously.

181

In its 1970s form, Room 28 had a distinct effect on the manner in which visitors could engage with the *Woman Standing at a Virginal* and other seventeenth-century Dutch and Flemish cabinet paintings. It promoted intimacy, and a sense of physical removal to a literally and metaphorically higher plane. Yet the refurbishment of this gallery as the 'Duveen Room' can fairly be presented as an exercise in restoration. The alteration of the North Galleries, on the other hand, cannot. This project aims to 'improve the appearance of the rooms and to clarify the circulation'.[26] Divided into two phases, work began in November 1996 and was completed in September 1999. In August 1999 the central room and the three to the west were complete and open to the public. The realization of the project is dependent on private donations. The *Woman Standing at a Virginal* was to be placed in one of the four new planned cabinet rooms, adjacent to Room 28, though the plan in August 1999 is for it to remain in Room 16, as before.[27]

In 1995 a committee to support the work of the Development Office – the North Galleries Committee – was formed, with trustee and George Beaumont Group member Sir Ewen Fergusson as chair.[28] Funds for the redevelopment have been forthcoming from the Wolfson Foundation, the Government of Flanders, several dealers and others. Two dealers who specialize in seventeenth-century Dutch paintings, Robert Noortman and Richard Green, are reported to have agreed to support the creation of two of the planned new cabinet rooms.[29] Their donations were thought likely to provide the future setting for the *Woman Standing at a Virginal*.

This redevelopment of the North Galleries is different in character from the restorations that have been undertaken elsewhere in the building, such as that of Room 28. It comes about reportedly because the 'North Galleries, which were designed in the late 1960s and constructed in the early 1970s, are woefully ill-suited to the display of the Gallery's fine seventeenth-century Dutch and French collection'. The *Report* continues:

The rooms are ill proportioned, poorly lit, and lack a positive architectural character. The layout is confusing and there are no spaces of appropriate scale for the smaller Dutch paintings . . . The new design provides a coherent

layout, with a long central gallery flanked by six principal rooms. This symmetrical arrangement should allow visitors to find their way around with ease and provides a direct route to the Orange Street entrance [at the rear of the building]. Additionally, the plan creates four new cabinet rooms, adjacent to Room 28, for the display of small Dutch and Flemish pictures. The interiors will be remodelled with simple vaulted ceilings, stone skirtings and architraves, and oak floors with slate borders, to provide handsome galleries with high quality finishes.[30]

There is a great deal of rhetoric in this apology, especially in the passage of complaint against the North Galleries as they were between 1975 and 1996. Far from lacking a positive architectural character, they exhibited a very distinctive architectural style of their own time (illus. 73). Whatever practical shortcomings they may have had – and the absence of spaces of appropriate scale for the smaller Dutch paintings is pure disingenuousness as criticism – the projected redevelopment as described in this passage, and as is to be seen in the new central gallery which opened in 1998 (Room 22), suggests an attempt to homogenize the North Galleries with the late nineteenth-century character (even though dating from 1928) of the adjoining galleries, such as the Duveen Room (Room 28) (illus. 74). Above all, the fabric wall coverings and the vaulted ceiling imply a return to nineteenth-century norms, and the danger exists that this refurbishment could be construed in the same manner as that of the 1970s mezzanine in the National Gallery of Scotland mentioned above. On the other hand, the relative simplicity of the details – the lack of profile of the dark green slate skirting and architraves, for instance, in contrast to those in the Duveen Room – suggests a more complex case.

Irrespective of the ideology of reaction, it could be argued that a nineteenth-century style gallery is simply a more congenial space for the effective display of old master paintings than is a 1970s late Modernist pale rectilinear box. It could also be argued that sufficient distinction from the architecture of the past is conveyed by the simplification of detail in the redevelopment. Robert Venturi's historicizing design of the Sainsbury Wing galleries, which opened in 1991, could never lead it to be mistaken for a nineteenth-century building, in

spite of its purposeful evocation of such spaces. The same may turn out to be true of the North Galleries, for one vital consequence of the revision of the proportions of those spaces, the renewal of the roofs and the provision of an integrated controlled daylight and artificial light system ought to lead to an improvement in the lighting conditions of the galleries. This is already observable in those galleries (Rooms 19–22) opened in March 1998. Although not mentioned in the complaint quoted above, the fall and distribution of light was the greatest failure of the North Galleries in their original form.

Yet however practical the results, an ideology remains discernible in the North Galleries redevelopment scheme, and it is one that depends on evoking the nineteenth-century museum norm architecturally throughout the National Gallery, from the redeveloped North Galleries to the Sainsbury Wing. In terms of conscious museum policy, the ideals consonant with such an architectural vocabulary are those of public education and enjoyment, and, perhaps above all, access without charge to the collections as a matter of public trust. Neil MacGregor, director of the National Gallery, has been among

73 National Gallery, London: North Galleries, pre-1996.

74 National Gallery, London: North Galleries, Room 22, 1998.

the staunchest opponents of admission charges. In this respect, as in others – such as his belief in the therapeutic value of art museums, and the ability of a wide range of publics to appreciate well-presented high scholarship – he is a firm upholder of nineteenth-century humane traditions, though in a wholly contemporary manner.[31]

If this is one side of the coin, the other – readily pointed out by some theorists – is the element of social control in the interests of the dominant classes enforced by the acquisition of self-discipline associated with museum visiting.[32] The social interest of the art museum in preserving such a status quo may, furthermore, be architecturally discernible in the use of forms that evoke the past, rather than others that look to the future. What is more, the pervasive architecture evokes a past associated with ostensibly dignified commerce through the resemblance of the National Gallery rooms, such as those in the redeveloped North Galleries, to those of Bond Street dealers.[33] That association is also undeniably tangible, given the source of largesse – the dealers Robert Noortman and Richard Green – for the realization of part of the North Galleries redevelopment, just as it had been for Room 28, funded in 1928 by the arch-dealer, Joseph Duveen. Yet whatever business or personal advantages their philanthropy might bring them, it is most unlikely to have a visually discernible effect on the presentation of the paintings. The new Room 20, containing the Poussins, has been conspicuously inscribed in gold lettering high on the wall as 'The David-Weill Room'. While few visitors are likely to recognize the family name of one of the most respected twentieth-century Parisian art dealers, association with commerce familiar to almost all is unavoidable in the central, long gallery (Room 22). This is conspicuously named the 'Yves Saint Laurent Room', thereby associating the French paintings displayed there and their setting with French consumer goods from *haute couture* to off-the-peg clothes, accessories and scents. Indeed, the couturier's name appears in gold above Philip de Champagne's portrait of Cardinal Richelieu, a conjunction to which attention is specifically drawn in the 1998 *Report*.[34] Yves Saint Laurent is a name that is literally a label in the late twentieth-century commercial sense, and its presence conspicuously associates the National Gallery with commerce in a declaration of sought mutually enhanced prestige.

In the use of a donor's name that is also a trade mark the National Gallery has crossed a subtle boundary. 'Yves Saint Laurent' denotes a cluster of commodities more readily than it does a person. This state of affairs may be unfortunate for people whose names are thus reified, yet it is an inevitable effect of the commercial use of personal names.[35] Furthermore, this state of affairs inadvertently illustrates Daniel Sherman's remark that 'museums, in their pervasiveness and inevitability, monopolize certain fields of vision, and thus constitute a strategy of power linked to hegemonic capitalism'.[36] Nevertheless, the point seems unremarkable. Other institutions constitutive of the social order – such as banks, courts of law and universities – function analogously; but, like art museums, they succeed in serving other functions too, including those that are explicitly on Neil MacGregor's agenda.[37] The display of the *Woman Standing at a Virginal* cannot adequately be discredited, either as it was when in Room 28, or subsequently in Room 16 (as discussed in chapter 3), by appealing to art museums' socially repressive functions. This is so even if we acknowledge that the relationship between the modes of display in commercial galleries, private houses and art museums is complex in its mutual influences and interdependencies.[38] However, as we have seen in the case of the *Woman Standing at a Virginal*, the arrangement of the objects has consistently been according to scholarly criteria, not others, such as donor flattery.

It is true that in the past the National Gallery has displayed parts of its collection to flatter or commemorate. For instance, the 77 predominantly seventeenth-century Dutch paintings bought by the National Gallery in 1871, which had been owned by Sir Robert Peel, were exhibited together in one gallery in the new extension built between 1872 and 1877[39] (illus. 75). There they constituted a memorial to the politician who had been prime minister from 1841 to 1847, and whose fortune derived from the Lancashire cotton industry. The National Gallery had every reason to commemorate Peel. As home secretary he had been instrumental in the founding of the National Gallery and, in 1832, had proposed to the House of Commons the erection of the National Gallery building on the Trafalgar Square site.[40] The installation of the Peel Collection most likely inspired the terms of the bequest to the National Gallery of another sometime politician and textile

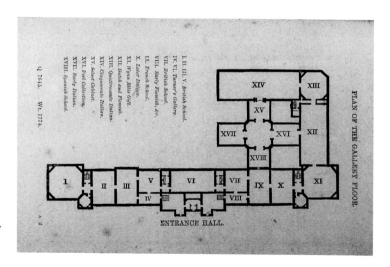

75 National Gallery, London: floor plan, 1878.

magnate, Wynn Ellis. Ellis bequeathed 403 old master and modern British paintings to the National Gallery on his death in 1875, 94 of which were accepted by the trustees. In doing so they acceded to strict terms, as follows:

> I make this bequest upon this express condition that a room or rooms in the Gallery at Trafalgar Square and not elsewhere be appropriated and set apart by the last named trustees within two years from the time of my decease for the separate and exclusive exhibition of the said pictures for a period of at least ten years and that such pictures be called the 'Wynn Ellis Collection' and that no other picture or pictures be placed or exhibited in the same room or rooms with them.

Thereafter the pictures might be exhibited as the trustees saw fit, provided that a label bearing the phrase 'The Gift of Mr Wynn Ellis' was attached to each frame.[41] The terms were strictly adhered to, and the Wynn Ellis pictures were exhibited for ten years in the easternmost gallery of the original building.[42]

Such interruptions of the scholarly arrangement of the paintings by school in the galleries were exceptional and temporary, and the National Gallery is currently unencumbered by arrangements resulting from such demands. However, it has shown itself ready to be flexible when opportunity arises. In 1991, the collector Heinz Berggruen placed 68 works by Braque, Cézanne, Van Gogh, Picasso and Seurat in various media on loan. For three months they were exhibited together

187

in their entirety. Thereafter the paintings and sculptures were integrated with the permanent collection in three adjoining galleries (the works on paper being shown in rotation), though the Berggruen objects dominated the Post-Impressionist and Cubist display. Although the lender subsequently added six more works, by March 1997 all but five by Cézanne and three by Seurat had been returned.[43]

The use of the works lent by Heinz Berggruen may have been uncomfortably close to equivocation, though a scholarly exposition of works from late nineteenth- and early twentieth-century France handily coincided with the strength of the collection on loan. The display in Rooms 44 to 46 appeared to serve two purposes simultaneously: potential donor propitiation and methodical, scholarly display. Museum staffs are constantly seeking to engineer the coincidence of donor and scholarly interests. To do so successfully does not represent a freedom of scholarly choice, but only the best possible outcome in structurally constrained circumstances.

Art museums should not be passive containers of objects. They have responsibilities, central among which is to use their objects well, in spite of, and in full knowledge of, the constraints to which they are subject, including the need to accommodate donors' expectations.[44] The National Gallery fulfils this responsibility, as the analysis in chapter 3 of the disposition of the *Woman Standing at a Virginal* in Room 16 confirms. It does so consistently in both its long-term displays and in its temporary exhibitions. The interference of donor politics is minimal to public perception (though not invisible) and – with the recent borderline exception of the Berggruen Collection – is confined to textual acknowledgement, which is usually marginal. In the case of Room 16 it is very easy to walk past the discreet wooden plaque commemorating its refurbishment in 1991.[45] However, some may feel that the 'Yves Saint Laurent Room' in the newly refurbished North Galleries makes the link between art and commerce too explicit. Yet is the gilt text in neighbouring Room 19, 'In 1998 this room was restored under the patronage of Her Majesty the Queen and Her Majesty Queen Elizabeth The Queen Mother', any less indicative of the realities of art museums' places in the socio-economic structure of late twentieth-century capitalism than the former inscription? These inscriptions are conspicuous and may even be said to thematize the art beneath them and its display, yet

76 Entrance to the
Raymond and
Laura Wielgus
Gallery of the Arts
of Africa, Oceania
and the Americas,
Indiana University
Art Museum,
Bloomington,
late 1990s.

visitors can ignore them. Objects themselves cannot be ignored. When museums display objects solely in the service of acknowledging patronage, there is an immediately discernible and substantial difference. This is a poor use of objects.

We now turn from the museum circumstances of the *Woman Standing at a Virginal* in London's National Gallery, where it is used well, to the Indiana University Art Museum, Bloomington, Indiana for an example of a poor use of objects. The case concerns donor politics, but here acknowledgement is not confined to the textual, and therefore marginal, but extends to the display of objects themselves. The case is all the more striking for being aberrant in a sophisticated institution in which the displays are of a high professional standard.

Three large galleries in the Indiana University Art Museum are dedicated to the permanent collection, that on the third floor being devoted to the art of Africa, Oceania and the Americas prior to European colonization. Over the glass door the name 'The Raymond and Laura Wielgus Gallery' has been

placed. The very first objects one sees, even before crossing the threshold, are two shining pistols in a slanted wall case (illus. 76). The case is affixed to the wall that runs at an angle inward from beside the doorway to its right so as to confront the viewer immediately. To the right of the case is a large, dry-mounted photographic print depicting the Pyramid of the Sun at Teotihuacán, Mexico. Above the case is a two-panel wall text, also headed 'The Raymond and Laura Wielgus Gallery'. This text is unusual in art museum terms, for it gives the visitor a glimpse of aspects of museum–donor relations that are generally concealed from public view.

The label beside the pistols not only encapsulates an ideology, but also usefully serves to identify the objects in some detail:

Raymond Wielgus
Chicago, 1920–
Top: Remington Elliot Patent Derringer
 .32 caliber, serial no. 21993
 ca. 1860, embellished 1988
 steel, gold, ivory
Bottom: Remington New Model Pocket Revolver
 .32 caliber, serial no. 15364
 ca. 1860, embellished 1987
 steel, gold, ivory

Each nineteenth-century pistol has recently been embellished (to quote the label) by Raymond Wielgus with intricate, incised linear designs, some impressed with gold to contrast with the polished steel of the weapon using the ancient technique of damascening. The workmanship is delicate and exact, evidently requiring precise manual skill, patience and a considerable expenditure of time. The embellished pistols are presented unabashedly as art, and Raymond Wielgus, by means of the convention employed in the label, is presented unequivocally as the artist.

The intrinsic characteristics of these pistols, whether as works of art or otherwise, are not at issue here. Art museums are able to adopt any object for their purposes and present it in the same manner as any other object in their displays. From the museological point of view, such an object attains museum status by that very act. Nelson Goodman has argued that things that do not function as works of art at certain times

can yet do so at others.[46] However, designations cannot be capricious if the distinction between museum objects and non-museum objects, on which the efficacy of museum object designation depends, is to function so that irony is occasionally possible. Furthermore, failure to choose objects for demonstrably appropriate reasons, or the deliberate choice of objects that are unironically inappropriate, produce museum objects as kitsch in the service of a mere mythology of art.

By the conventions of art museums, objects within them are either art or non-art. All those displayed with the apparatus proper to prompting the viewer's attention as art are – in practice – art. (This does not mean that the same objects are necessarily art when outside the museum; nor does it mean that the choice of objects to be considered as art in the museum cannot be contested.) Other things that are also present within an art museum – security cameras, fire extinguishers and seats for visitors or attendants – are not art. In spite of the contrivances of generations of contemporary artists, there can be no in-between, or compromised status for things in art museum galleries.[47] Curators can ascribe a differential hierarchy to displayed objects by means of their arrangement and lighting, but all objects purposefully displayed constitute art, whether temporarily or seemingly permanently. From the point of view of such a hierarchy of arrangement, the recently embellished mid-nineteenth-century American pistols in the Raymond and Laura Wielgus Gallery are prominently displayed, and they are not substantially set apart from other objects in the gallery which obviously pertain directly to the topic of that gallery. Meso-American objects in vitrines stand just to the viewer's left on entering, while the pistols are to the right. Furthermore, large-scale dry-mounted photographic prints are distributed throughout the gallery, so the print beside the vitrine containing the pistols does not in itself mark it as peculiar.

The last paragraph of the wall text about Mr and Mrs Wielgus placed above the vitrine containing the pistols gives visitors further information about them:

Native midwesterners, the Wielguses lived for many years in Chicago, where Raymond Wielgus founded Wielgus Product Models, a business producing prototype models for design organizations and industry, and Laura Wielgus

devoted her professional life to nursing. They retired and moved to Tucson, Arizona, in 1970. There, Raymond Wielgus has pursued a new interest: the embellishment of firearms. His creations have been heralded for the originality of his designs and the fineness of his craftsmanship. In 1987 The Art Institute of Chicago acquired twenty-five of Raymond Wielgus's decorated firearms; his work is the only example of the twentieth century in their arms collection today. The Indiana University Art Museum is proud to have on extended loan two of his firearms, which clearly demonstrate that Raymond Wielgus is not only a great connoisseur, but also an artist in his own right.

The text seeks to enhance the authority of Raymond Wielgus as a collector and donor, and the reliability of his discernment of quality, by presenting him not simply as a connoisseur, but as a creator. This extends from the implied association of his former business (modelling prototypes) with creativity, to his retirement interest, the embellishment of firearms. That this pursuit truly constitutes an art, and gives Mr Wielgus the status of an artist to trump that of his status of connoisseur, is implied by the observation in the text panel concerning the Art Institute of Chicago. By its acquisition of 25 of Mr Wielgus's embellished firearms, the reader is invited to infer that this renowned art institution recognized their inherent artistic qualities; or, at least, effectively transformed them into art by their acquisition. This designation (or recognition) superseded how they might previously have been considered as non-museum objects. How they actually entered the Art Institute's collection is unstated, and there is a world of difference in status between purchase (high, because ostensibly disinterested) and gift (relatively lower, being tinged, whether appropriately or not, with the implication of donor self-interest). The decorated firearms were a gift to the Art Institute of Chicago from Mr Wielgus[48] (illus. 77).

By the test described above – that of designation – the embellished pistols must indeed constitute art, and it is this test that is not only applied directly to the two objects themselves by the Indiana University Art Museum, but textually by appealing to the acquisition of similar objects by the Art Institute of Chicago. But what else are these objects, notably in relation to the display of which they are a part?

77 Cover of *Arms and Art: American and European Firearms Decorated by Raymond J. Wielgus* (Art Institute of Chicago, 1988).

As pistols, they are mass-produced industrial commodities originally distinguishable from others like them by their serial numbers (given on the label). In their original, unembellished state, they were functional devices the sole purpose of which was efficiently to discharge a lethal projectile. Their embellishment over 120 years after their manufacture is an overlay of the expurgation of signs of alienated labour proper to their original state with a literal inscription of individual, unalienated labour.[49] These fetishized commodity objects are fetishized in a further sense by means of this inscription, for to embellish them is to claim them as synecdoches for a myth of the American West that is centred upon such instruments of violence.[50] Furthermore, they have been subsumed calculatedly as art, but the only definition of art under which they can be claimed – which we have adumbrated above – is, as we have seen, not essential (deriving from inherent qualities), but rather mythological. The pistols, then, are in the museum in the name of the myth of art. Both the myth of the American West and the myth of art are kitsch, so the pistols themselves are not only fetishes, they are kitsch. Their embellishment serves to enhance their fetishistic status in the service of kitsch.[51]

193

that, whereas in the latter the production and reproduction of knowledge are formalized and transmitted rationally, medical education is the acquisition of an internalized set of skills constituting an art. In consequence, the relationships between the teacher-patrons and the pupil-clients differ markedly within the two institutions. Conditions in art museums more closely approximate the medical model than they do those of the arts and science faculties. Bourdieu writes:

> It is indeed enough to think of the qualities required of the 'great surgeon' or the 'supremo' of a hospital department who must exercise, often with great urgency, an *art* which, like that of a military leader, implies a total mastery of the conditions of its practical accomplishment, that is to say, a combination of self-control and confidence able to inspire confidence and dedication in others. What the co-optation technique must discover and what the teaching must reinforce in this case is not knowledge, not a package of scientific knowledge, but skill or, more exactly, the art of applying knowledge, and applying it aptly in practice, which is inseparable from an overall manner of acting, or living, inseparable from a habitus.[5]

For Bourdieu's '"great surgeon" or the "supremo" of a hospital department' we need only substitute 'museum director' or 'head of a curatorial department'. The pupil-clients in this instance are interns or junior curatorial staff. Their process of learning is one of clientage, of accompanying a teacher-patron on his or her rounds in the museum.[6]

The analogy need not be confined to the education of hospital and art museum staffs. It encompasses fundamental purpose. Furthermore, in the USA there is a certain commonality of governance between not-for-profit hospitals and art museums. Not infrequently the same lay person has served as a trustee of both a hospital and an art museum, concurrently or consecutively. Private philanthropy towards both often comes from the same donor, and such donors may even contrive to employ the one as a check upon the other. For example, the greatest single benefactor of the Harvard University Art Museums, Grenville L. Winthrop (1864–1943), stipulated that, if the terms of his bequest to the Fogg Art Museum were ever broken, the institution should be obliged to make a substantial payment to a New York City hospital in recompense.[7]

A donor's definition of dereliction in the case of one institution directly benefits another.

Before examining instances of the therapeutics associated with art and art museums, I should state that this is not the place to make or pursue claims for the inherent efficacy of art or the institutions that house it to improve the human lot. Yet in so far as people make claims for the ameliorative effect of art on themselves and others, and such claims in their variety are endorsed by those who attend to art, it is pertinent to examine the role of art museums in providing the setting for encounters described in such terms. Before considering claims concerning therapeutics made about art itself, I shall discuss such claims made for the institutions that provide the predominant setting for encounters with works of art – that is, art museums – and begin by pursuing the comparison with hospitals.

Much has been made in recent years of the function of hospitals as sites of social discipline and surveillance. Some critics have extended this analysis to discussions of art museums, claiming them to be – like lunatic asylums, hospitals and prisons, in Michel Foucault's opinion – spaces of 'exclusion and confinement'.[8] It takes little skill or imagination to make such a case once the obvious factors of, first, security measures and, secondly, class, sex and ethnic discomfort are taken into account. Like so many institutions constitutive of the social order – including hospitals, prisons and universities – art museums are both socially prescriptive and proscriptive. The point is worth making, even though it is unremarkable.[9]

Art museums are sites for the learning and rehearsal of self-enforced social discipline. In this sense, among others, from the viewpoint of bourgeois capitalist norms they are sites for the acquisition of civic virtue.[10] We learn early and quickly what outward behaviour is expected of us within an art museum. We do so no differently from how we learn appropriate conduct in a hospital (as either visitor or patient), school or university, baseball park, subway car or any other place of public social encounter. The volume and extent of anonymous public contact in modernity requires a strict regime of self-discipline, or 'social skills'. Active policing would generally be inadequate to the task of enforcing behaviour convenient to the powerful without such self-discipline, though the promise (or threat) of such policing is always

implicit, whether in hospital wards, classrooms, ballparks or the subway. Sometimes policing is more than a promise, and is a visible presence. Generally, it is readily visible in art museums through the presence of gallery invigilators.

The number, physical appearance and demeanour of gallery invigilators all make a great difference to their perception by visitors. The need for their continuous presence in the first place may not be apparent to casual visitors, including academic critics of art museums. However, it is scarcely contested by art museum staffs, who are all too aware of invigilators' regular, active role in thwarting the theft of, and violence towards, vulnerable works of art. Most such incidents never become publicly known. Constantly obliged to tread a fine line between allowing maximum access to works of art and protecting them from damage or theft, art museums must devise immediately efficient, yet discreet security provisions. The key question in defining appropriate techniques must be: At what point does visible policing cause such discomfort to a majority of visitors that the purpose of the visit is frustrated? If this line is not crossed, and the visitor feels neither threatened nor indignant, the presence of invigilators can actually enhance the visitor's sense of security.

The precise security measures taken to protect the *Woman Standing at a Virginal* are unknown to me. This is quite as it should be. Concealed means of protection and readily visible deterrents complement each other. As far as visible invigilation is concerned, on countless casual visits to the National Gallery, London, as a generally conforming, middle-class, white male, I have invariably found the gallery attendants – known as warders – to be discreet, unobtrusive, observant and courteous. They are in uniform, exhibit a carefully fostered *esprit de corps* and serve a dual function of both policing and giving directions to visitors when approached.[11] Only once have I witnessed a commotion at the National Gallery. I saw a young man being bundled away by two warders. I later learned from a curator that he had been apprehended while allegedly attacking a painting in one of the galleries (not a Vermeer). As the history of attacks on works of art at the National Gallery makes clear, from the time of suffragette Mary Richardson's defacement of Velázquez's *Rokeby Venus* in 1914 onwards, all its paintings – including the *Woman Standing at a Virginal* – are vulnerable on a daily basis.[12] The

latter painting may not have suffered, but the *Woman Seated at a Virginal* was severely damaged in an attack in 1968 when a knife was used to inflict a nearly circular cut the length of the face through the nose and to the right of the head.[13]

Iconoclastic attacks on works of art in museums, whether politically motivated or not, have such resonance not only because of the ideally inviolable status of works of art, but because of the nature of the museums themselves as sanctuaries from the casual and indiscriminate violence of the world. The ideal inviolability of art is made apparent not only through efforts to avert sudden physical threats, but also by publicizing conservators' attempts to arrest and conceal more protracted forms of damage and decay.[14] That sense of ideal inviolability transfers easily from art to those who view it. In a very straightforward sense, art museums provide safe havens.

On arrival in a strange city in a foreign land, the visitor can be confident that an art museum will be a pocket of comforting social familiarity. If the museum also happens to have a café, it becomes a self-contained world. The generally contemplative demeanour of visitors and their carefully measured forms of visual and physical interaction (from disavowal of one another's presence to flirtation) promote a sense of control and well-being in socially conforming middle-class people. In this way, art museums might readily be compared with hospitals – though hospitals are sites of far more obvious and prevalent anxiety than are art museums – and religious sites, such as churches, cloisters and classical temples.

The description of art museums as secular cathedrals has become trite. The same is true of the repeated comparisons between museum architecture, classical Greek temples and the evocation of state or other political authority.[15] Museums are not habitually compared architecturally with hospitals, though there are considerable similarities in functional terms (between wards and galleries, operating theatres and conservation laboratories, for example). Yet both are spaces of safety where people and things are set apart for care and close attention. Both share an architectural tradition with ecclesiastical spaces. Many hospitals were originally, and some continue to be, religious foundations.[16] Some art museums are even housed in former ecclesiastical buildings, the Museo di San Marco, Florence being one of the most famous. Some hospitals have been turned into museums, such as the Hôtel Dieu,

Beaune.[17] Much could be made of these parallels and comparisons, but suffice it to note that the social act of discrimination that finds expression in architectural form results in a broadly similar spatial definition, and the provision of buildings in which people find sanctuary.

That sanctuary which is sought and regularly found in art museums is of many kinds. It is available to the office worker who, during a lunch break, does no more than walk through a museum from one entrance to another: from Orange Street to Trafalgar Square in the case of the National Gallery, London. It might be sought by the troubled individual who finds an hour of peace seated in a gallery where his or her presence is unremarkable.[18] Or it is available to a couple – parent and child, woman and man – or a larger group of people. The permutations are innumerable. I shall give but a single example of the testimony of people finding sanctuary in art museums. It can, and must, serve for many:

We haunted museums. They were drowsy and deserted on weekday mornings, and very warm, in contrast to the glacial haze and its red sun that, like a flushed moon, hung in the eastern windows. There we would seek the quiet back rooms, the stopgap mythologies nobody looked at, the etchings, the medals, the paleographic items, the Story of Printing – poor things like that. Our best find, I think, was a small room where brooms and ladders were kept; but a batch of empty frames that suddenly started to slide and topple in the dark attracted an inquisitive art lover, and we fled. The Hermitage, St Petersburg's Louvre, offered nice nooks, especially in a certain hall on the ground floor, among cabinets with scarabs, behind the sarcophagus of Nana, high priest of Ptah. In the Russian Museum of Emperor Alexander III, two halls (Nos 30 and 31, in its northeastern corner), harboring repellently academic paintings by Shishkin ('Clearing in a Pine Forest') and by Harlamov ('Head of a Young Gypsy'), offered a bit of privacy because of some tall stands with drawings – until a foul-mouthed veteran of the Turkish campaign threatened to call the police. So from these great museums we graduated to smaller ones, such as the Suvorov, for instance, where I recall a most silent room full of old armor and tapestries, and torn silk banners, with several bewigged,

heavily booted dummies in green uniforms standing guard over us. But wherever we went, invariably, after a few visits, this or that hoary, blear-eyed, felt-soled attendant would grow suspicious and we would have to transfer our furtive frenzy elsewhere – to the Pedagogical Museum, to the Museum of Court Carriages or to a tiny museum of old maps, which guidebooks do not even list – and then out again into the cold, into some lane of great gates and green lions with rings in their jaws, into the stylized snowscape of the 'Art World', *Mir Iskusstva* – Dobuzhinski, Alexandre Benois – so dear to me in those days.[19]

Thus did the sixteen-year-old Vladimir Nabokov visit museums with his sweetheart, skipping school, in the St Petersburg winter of 1915–16. By this account the art was immaterial: the museums themselves were sanctuaries for the young lovers, offering the temporary enclosure of a substitute domesticity.

Nabokov's account gives a clear sense of varied spaces defined by objects – cabinets, sarcophagi, drawing stands, paintings – and, above all, the walls upon which the latter hung. Most of these spaces were perforce galleries, though the most intimate, containing empty picture frames, was a closet. All were defined by walls.

Walls serve a dual purpose in art museums: to define space, and physically to support the paintings that are hung upon them. When we consider a painting – even as a unique object – we rarely take into account the wall on which it hangs, other than to note the compatibility – or lack thereof – between the colour and pattern of its surface and the painting itself. Yet might we not think of the entire configuration of walls and paintings that make up gallery after gallery in art museums in those terms proposed by the architectural theorist, Robin Evans? In his essay, 'The Rights of Retreat and of Exclusion: Notes Towards the Definition of Wall', he wrote:

[F]or is it not the case that, in shutting out an immanent sector of external reality, one is obliged to substitute for it another that suffers fewer faults? Consider it this way: we used to build walls and then hang pictures on them which obscured the very views that the pictures were supposed to represent, if, as was likely, they conformed to the principles of naturalistic realism.[20]

This much could be claimed for all the paintings in the National Gallery, London, though many of the works displayed depict mythological and sacred realities, rather than the sublunary variety. Evans's claim certainly pertains quite straightforwardly in the case of Vermeer's *Woman Standing at a Virginal*, in which a plausible domestic reality is presented to the viewer. That domestic reality depicted in the painting is itself defined spatially by parts of two walls. This device is a consistent feature of Vermeer's domestic interiors, and I have already discussed (in chapter 3) how white rear walls parallel to the picture plane act as a screen of reference establishing the range of illuminative possibilities within the pictorial world. The walls themselves in the paintings serve to define space, 'shutting out an immanent sector of external reality' within the actual and implied greater pictorial world.

That Vermeer, unlike his contemporaries, never shows the world beyond the window has often been noted. The result in Vermeer's domestic interiors is an effect of the self-containment of the directly represented pictorial world, and its spatially immediate extension as implied adjacent domestic space. This effect of self-containment is enhanced by his representation of the world beyond that depicted domestic space exclusively in the form of further representations – paintings-within-paintings. As we have seen (in chapter 2) these paintings-within-paintings are further pictorial worlds. They therefore function in precisely the manner Robin Evans ascribed to paintings upon walls. The only external space in Vermeer's domestic interiors is a further layer of fiction. The landscapes in the *Woman Standing at a Virginal* (on the wall and on the virginal lid respectively) are ideal spaces: a substitute for the presumably urban surroundings that Vermeer resolutely and consistently excludes. They are oneiric spaces for the virginal player, just as her space is oneiric for the viewer of the *Woman Standing at a Virginal* on the wall in the National Gallery.[21] The viewer therefore sees two layers of recreational fantasy: regenerative landscape as fiction in the paintings-within-the-painting, and regenerative interior domesticity as site of walled seclusion in the virginal player's own pictorial world. And this perception occurs entirely in harmony within the walled seclusion of the viewer's world, that of the gallery itself. There it is one of many fictive worlds that together evoke a plurality of reassurances set against walls that safely

contain paintings and viewers alike. Those walls, to cite Robin Evans again,

> are not simple barriers to energy-transfer, but barricades that prevent entropy of meaning and preserve the holistic and unitary concepts of our dream world, be it a personal or universal dream, by eliminating that part of the other more disparate world which fails to conform to it. Walls are the armoury that preserves our personal integrity against the inroads of the rest of humanity and nature.[22]

It is small wonder, then, that the very experience of voluntary, temporary immurement within an art museum can in itself be therapeutic.[23]

From art museums as sanctuaries in respect of their character as secure, built spaces inherently conducive to therapeutics, I now turn to discuss therapeutic claims made for works of art themselves.

Art has long been held to afford benefits – or dangers – to those who attend to it. Since Plato, these have been expressed in terms ethical, affective or aesthetic, whether simultaneously or by turns. Horace's dictum positing that instruction and delight derive from art has been particularly long-lived.[24] We can best discuss therapeutics, however, in the broad terms of the consolation of art.

In a paper given at the Salzburg Seminar in December 1993, Marilyn Perry, president of the Samuel H. Kress Foundation, a major grant provider to American art museums, described her life in the mid-1960s as a graduate student in London, living in a damp basement apartment:

> I was penniless and as yet without friends. I had left my husband for a course of study for which I was inadequately prepared, and my mother was dying of cancer five thousand miles away. What saved me – it is not too strong a word – was the proximity of the Wallace Collection and, in particular, two paintings that I went to visit almost daily: Velasquez's *Portrait of a Lady with a Fan* and Poussin's *Dance to the Music of Time*. When I think of that period, its terrors and uncertainties are countered by the welcoming warmth of the Wallace Collection and the beauty of the pictures that had become my dearest companions. It was my first intimate experience of the consolation of art.[25]

While not actively denying claims such as those made here by Perry, few art historians have taken them seriously, though, obviously, philosophers have since Plato.[26]

In discussing the consolation afforded by art we must take care to distinguish between consideration of art as causing forgetfulness, or a superficial assuagement on the one hand, and as providing the opportunity for potential confrontation with the entire range of human and divine action, promoting what Aristotle famously defined principally in the *Politics* as catharsis: a wholly therapeutic concept, connected with contemporary medicine, encompassing the purging of pity and fear, thus righting the emotions and the soul.[27] The use of art to provide consolation as simple relief from care may be thought by many to be trivial in comparison with consolation that results from confrontation with representations of aspects of the entire range of human and divine action. While we may admit that the latter is ultimately more enriching than the former – or, if we follow Plato rather than Aristotle, more dangerously effective[28] – individual descriptions of consolatory experiences of art by non-philosophers (such as that given by Marilyn Perry) rarely admit of a distinction between assuagement and catharsis. Neither is this of much concern when we consider the therapeutics of art, for we must accord all such testimonies seriously offered a serious status. If you are troubled, and an encounter with a painting by Velázquez or Poussin eases that trouble, who am I to say that such an assuagement, and the use of art that allows it, are trivial? We might hope that encounters with art will lead to the enrichment of the soul (in Greek terms, including Plato's) irrespective of the observer's mental or physical state. That is to say that, however stable our condition, there is always scope for the therapeutics of art. But we must also take full account of the consolation art can bring to those who are troubled and who know themselves to be troubled. Even if this is purely an assuagement, art is doing useful therapeutic work, and the institutions that make it available – primarily art museums – are fulfilling a useful therapeutic function.

This claim derives in part from group research on chronic suffering conducted at Harvard University between 1994 and 1997 as part of the interfaculty research initiative, *Mind/Brain/Behavior*. The 'Experience of Illness' work group, which was a constituent part of this initiative, was chaired by Arthur

Barsky of the Harvard University Medical School. Its membership was drawn from all parts of the university. Its particular concern was with chronic pain and suffering beyond relief by medical therapeutics. The aim was to expand the terms within which such conditions can profitably be discussed prior to proposing and implementing revised undergraduate and professional medical education. Individual members of the group conducted videotaped interviews with patients in states of chronic suffering. Part of one interview concerned a terminally ill cancer patient's desire to visit art museums. She – Mrs S. – took great pains to see every possible temporary exhibition locally, and travelled from her blue-collar neighbourhood in metropolitan Boston to various cities to see art museums, because what was within them to her constituted among the greatest achievements of humankind. By her own account, a successful art museum visit brought her great relief from suffering. This was a matter of seeing through an entire challenging process of planning and execution, the encounter with the art in the museum being the climax. The whole process, including the encounter, was therapeutic. Mrs S. died before the conclusion of the work group's study, yet art museums remain as places of refuge, as sites of supervised beneficent security, and of therapeutic encounter. In this, they bear comparison with hospitals on an affective level for those who use them.

What can we learn from this research? First, that art museum scholarship should not necessarily be confined to immediate museum matters, but has a collaborative part to play in projects of far wider concern, such as medical education and practice. The interdependence of such socially constitutive institutions as museums, hospitals and universities is a museum scholar's proper concern.[29] Even more important, though, is a respect for the uses of art by visitors to museums. From the perspective afforded by conversation with Mrs S., most art historians seem risibly limited in what they believe we might properly attend to when viewing art, or speak of when discussing how we speak of it. How can we presume to know what use a visitor will make of a painting such as the *Woman Standing at a Virginal*? How can we presume to advocate our art-historical preferences prescriptively?

No one can fully anticipate the circumstances in which the therapeutics afforded by attention to paintings by Vermeer

(and other works of art, of course) will operate. The last of my three examples is the case of the Italian jurist, Antonio Cassese. In 1995 Cassese was the president of the international panel of eleven judges of the War Crimes Tribunal for the Former Yugoslavia in The Hague. In this capacity he had to lead adjudication of the alleged actions of people accused of horrifying atrocities in the course of the civil war in Bosnia-Herzegovina. The journalist, Lawrence Weschler, interviewed Cassese in the midst of a particularly terrible case. He asked the judge:

> How, regularly obliged to gaze into such an appalling abyss, he had kept from going mad himself. His face brightened. 'Ah', he said with a smile. 'You see, as often as possible I make my way over to the Mauritshuis museum, in the center of town, so as to spend a little time with the Vermeers.'[30]

What caused Judge Cassese regularly to look at paintings by Vermeer? This was no casual recreation. Cassese sought the consolation of Vermeer's art as a direct consequence of his confrontation with evil on a daily basis when chairing the war crimes tribunal. The judge himself gave an example of what it was he sought solace from when visiting the Vermeers. He explained some details of the case against an accused war criminal that he was hearing before his tribunal at the time of the interview:

> In addition to the various rapes and murders he's accused of, he is alleged to have supervised the torture and torments of a particular group of Muslim prisoners, at one point forcing one of his charges to emasculate another – *with his teeth*. The one fellow died, and the guy who bit him went mad.[31]

What does this shocking confrontation with only the briefest report of unbearable inhumanity mean for our understanding of art and its uses? At the very least, it means that art museum scholars must take into account the moral observation that the consolation afforded by a Vermeer painting to a person who must deal with depravity is as vital a purpose of its accessibility as is the opportunity for art-historical interpretation. The same is true for the consolation afforded to a terminally ill cancer sufferer, such as Mrs S., or a troubled

graduate student, such as Marilyn Perry once was. The study of therapeutics makes this conclusion inevitable if a variety of legitimate uses of art within art museums is to be respected. Yet there is more. Whatever the legitimate claims of art history, therapeutics – as it pertains both to art museums as buildings, and to the art within them – *demands* that museum scholarship be *action in the world*. In the previous chapter we saw a contrast between the good and poor uses of objects by curators within art museums. The good use by curators of art within art museums allows their good use by viewers, whether art-historical, or therapeutic, or other good uses not touched upon here. Museum scholarship as action must be to promote and permit all those good uses, both identifiable and ineffable. Such conduct by art museum scholars acting in the world is a *practical* gesture against depravity and despair. As an obligation it is absolute.

10 Subjects

In these pages I have made Vermeer's *Woman Standing at a Virginal* 'the deputy of the world', in Ralph Waldo Emerson's phrase, though with a fullness that I hope is not quite all-excluding. In moving towards the conclusion of this enquiry, I now turn to address the topic of subjects: that is, the people who are concerned in the use of the things I have been discussing, principally the Vermeer painting, the museum that houses it and its visible progeny of reproductions. All these subjects are active agents. They share the common concern of being viewers: agents who behold and attend to the *Woman Standing at a Virginal*. I shall distinguish among four types of viewer, each with its own place in history, whether the past or the present, or both.

The first type of viewer is the museum visitor. We can talk of the museum visitor as a representative person. Such a person must be assumed to enjoy a relevant cultural competence that includes familiarity with the notion of painting as an art, but no more.[2] Often, discussions of museum visitors now turn on differentiations among them in accordance with any number of standard sociological categories, such as sex, age, class and ethnicity.[3] Yet we can also talk of individual, real viewers who are, or have been, museum visitors. We have already met four in these pages: Marilyn Perry, the lonely graduate student who became president of the Samuel H. Kress Foundation; the cancer sufferer, Mrs S.; and Antonio Cassese, chair of the War Crimes Tribunal for the Former Yugoslavia in The Hague. I must also count myself, for my own observations as a museum visitor inform much of the discussion.

The second type of viewer is the painter, in this case

210

Johannes Vermeer. The painter views even as he paints, and the painter views what he has painted. Here Michael Fried's permutations of the 'painter-beholder' can be of great assistance.[4] Vermeer, the painter-beholder as the topic of his own art, has been much discussed in the case of *The Art of Painting*, such discussions often incorporating the – at best – questionable assumption that Vermeer in some sense represented himself at work in that painting.[5] This is a canvas to which we shall have reason to return. Even though I am wary of the claim that artists necessarily convey something of themselves by means of their art – whether purposefully or not – that viewers can know, the artist cannot be excluded from the viewership. The artist is in a particular position as a viewer, for the artist experiences like no other the actual process by which the object is constituted. This must have some bearing on any discussion of subjects as agents in relation to works of art. Intentionality is usually the vexed crux of such discussions, and intention has had a hard time surviving the death of the author. Any theory that assumes an artist's intention to be unproblematically accessible is crippled; yet so is any theory that would evade or abolish consideration of intention entirely.[6]

Curators, the museum scholars on whose terms the rest of us view much of the art we see, are themselves viewers. They constitute a third category of viewer. Arranging objects for viewing is at the very heart of their scholarly and public endeavours. As viewers of the works in their charge they have two purposes: first, to present them cogently. In chapter 8, I discussed examples of presentation both justifiable (of the *Woman Standing at a Virginal*) and unjustifiable. But curators would arrange objects to study the relationships both that exist and that can be contrived among them, even in the absence of public access to those arrangements.[7] This occurs in pursuit of their second purpose (without which the first would be impossible): to seek to understand art in as many of its guises as possible, how it is constituted and how it functions. (This can only ever be an art-historical undertaking *in part*.)

The fourth and final category of viewer is in many ways the most fugitive. This viewer is the subject also in another sense, the subject of the painting. This might be most clear if we confine ourselves to our case study. In the *Woman Standing at a Virginal* we can speak of the fourth kind of viewer as she who

considered an object in its own right? In a sculpted human figure, for example, where does the nose begin and end? Why and how is that nose to be distinguished from the rest of the face? How is that face to be distinguished from the rest of the head, and so on?

Seriality presents a parallel problem. Wherein does uniqueness lie? Can we distinguish one teacup from among a set, or one etching from among others in an edition? From a literal point of view, each teacup and photographic print is unique, but does it make any sense to regard it as such if a number of identical cups or prints are in practice indistinguishable from one another? In his essay, 'Art', Emerson addressed the problem of interconnectedness thus: 'Until one thing comes out from the connection of things, there can be enjoyment, contemplation, but no thought.'[10] Thought, of course, specifically about the one thing we call the *Woman Standing at a Virginal*, is what concerns us. Yet a good part of that thought involves perceiving that object in relation to others (other paintings, the wall it hangs upon), for it is only in its relationships that its meanings are released.

We must return briefly to the distinction between mental and phenomenal or material objects. The practice of concep-

79 Adib Fricke (The Word Company), *Words to Watch*, exhibition photograph, 1999, Busch-Reisinger Museum, Cambridge, Mass.

tual art, in particular, has led to claims within the art world, as opposed to the philosophical world, concerning what we might call the hybrid object, that is, the object that has both mental and material constituents.[11] First, the wholly mental object may allow an evasion of commodification, yet any physical trace may be bought or sold, so the hybrid object that presents us with the merest phenomenal materiality is fully commodifiable. Secondly, the wholly mental object is unknowable as such, except to its conceiver (in this case, the artist).[12] In so far as it can be shared at all, it is an object of belief. If language is used to describe such mental objects, as is often the case in conceptual art practice, the object is embedded within another form of material object: a text. It thereby loses its purely mental character to become a different kind of hybrid object. A work by, say, Lawrence Weiner or Adib Fricke, consisting of a text inscribed upon a gallery wall (illus. 79), is therefore no less dependent on a viewing subject's somatic involvement than is a painting such as the *Woman Standing at a Virginal*. Yet, as Susan Hiller has remarked, histories of conceptual art which suggest that it is based totally in language are untrue.[13] Brian O'Doherty has pointed out the importance of Marcel Duchamp's *Mile of String* for later conceptual art practice that works through objects (illus. 80). Duchamp installed supposedly 5,280 feet of string to entangle the inner perimeters of *The First Papers of Surrealism* exhibition at 551

80 Marcel Duchamp, *Mile of String*, installation at *The First Papers of Surrealism* exhibition, New York, 1942.

Madison Avenue, New York in 1942. Even here, though, as is so often the case in contemporary art, language is fully implicated through the vital role played by the title. As O'Doherty remarks, '[T]he unverifiable quantification gives a conceptual neatness to the epigram.'[14]

The manner in which language can negotiate the indistinct boundaries of the mental and material components of the conceptual art object raises the question of the extent to which the art object (conceptual or not) is embedded in the viewer-as-subject's language. The nature of the relationship between the visual (or otherwise sensual) and the linguistic has been much discussed in recent years. That discussion is bedevilled by shallow and inefficacious translations from linguistic theory to the study of visual artefacts. In stating as much I do not claim that semiotics has limited or no applicability to discussions of such objects, but I do claim that the semiotics of uttered language and texts is distinct from the semiotics of objects, however much both may depend on differential deep structures. As in studies within either of these branches of semiotics themselves, differences matter more than coincidences. This matter was discussed in some detail in chapter 1.

It is worth noting that art history is a largely historiographic discipline, while museum scholarship is not, however conscious curators may be of their predecessors' and contemporaries' arrangements of objects. Art historians are often as much concerned with texts produced by their predecessors and contemporaries as with the art objects they are investigating. This unavoidable historiographic component of art history is full of interest. In discussing the *Woman Standing at a Virginal* I have engaged in this aspect of art history, notably in chapter 2. But I have felt compelled to avoid more discussion of the textual articulation of ideas about this painting, and of ideas about textually expressed ideas about this painting (and others) than is necessary, in spite of urging to the contrary.[15] I do this for three reasons. The first is because a history of the reception of Vermeer's art articulated in texts has already been provided by others, notably Christiane Hertel.[16] The second, and more important, reason is that the specifically visual considerations that are the business of the museum scholar must take precedence in this study. This accords with the third reason: a particular concern with visual

thinking, in particular the kind of thinking permitted by painting, for all the subjects under discussion.

Here I ask the question to which Yve-Alain Bois has recently drawn renewed attention: 'What does it mean for a painter *to think*?'[17] However, I would ask this question equally of the other viewing subjects – museum visitors, curators and models – in respect of their viewing. In the case of the painter, William Hazlitt adumbrated the field of response in the passage from his essay, 'On the Pleasure of Painting', quoted as one of the two epigraphs of this book. He compares painting with writing:

> After I have once written on a subject, it goes out of my mind: my feelings about it have been melted down into words, and *them* I forget. I have, as it were, discharged my memory of its old habitual reckoning, and rubbed out the score of real sentiment. For the future, it exists only for the sake of others. – But I cannot say, from my experience, that the same process takes place in transferring our ideas to canvas; they gain more than they lose in the mechanical transformation. One is never tired of painting, because you have to set down not what you knew already, but what you have just discovered. In the former case, you translate feelings into words; in the latter, names into things. There is a continual creation out of nothing going on. With every stroke of the brush, a new field of enquiry is laid open; new difficulties arise, and new triumphs are prepared over them.[18]

Like Hazlitt, and like Bois, I contend that visual thinking – even a particular subset of painterly thinking – occurs independently of language in its uttered or textual forms. Although not wholly independent of semiosis, it is, in effect, a distinct calculus.[19]

We can now turn to consider what the historian Patrick Geary has termed the semipermeability of the boundaries between objects and subjects.[20] Geary draws attention to important ambiguities in the boundaries between objects and subjects. Language is one medium at work in this phenomenon. Objects that are simultaneously subjects, vested, in certain forms of behaviour and discourse, with the capacity for active agency, include, by his reckoning, imperial and royal regalia, entailed estates and sacred images. Subjects that

are also objects (or, at least things-in-the-world) include slaves, and human remains treated as sacred relics. David Freedberg has examined sacred (and other) images as active agents, or subjects;[21] and Elaine Scarry has pertinently noted that 'we think of human artifacts as extensions of sentient human beings and thus themselves protected by the privileges accorded sentience'.[22] Although this attitude can scarcely be thought to be the origin of property rights, its selective application may help to account for the esteem in which certain kinds of artefacts, such as art objects, are generally held, even to the point of arguing for the extension of rights usually associated with human beings to such objects.[23] The ascription of the power of agency to visual artefacts – discussed by David Freedberg as a feature of modern western societies no less than of tribal and hieratic societies – and the self-censorship of the viewer as an involuntarily selective agent, described by James Elkins, remind us that the boundaries between subjects and objects are indeed semipermeable.[24]

Rather than the evasions and suppressions described by Elkins, the 'beholder's share' – as it has come to be termed – is usually discussed in terms of a positive complement brought by the viewer to the object that contributes to what some regard as a determination of how the viewer sees. To consider looking as a constitutive activity is one of the most useful consequences for the study of art of the adaptation of literary theorists' description of reading as a constitutive activity.[25] The transaction between the viewer and the object can be thought of in terms of a negotiation of two forms of work: that performed by the viewer, and that performed by the object. Therefore the viewer is implicated in the work of the object no less than is the object in the work of the viewer. Yet the viewer's observation is not entirely determined by the character of the object observed, just as language does not 'speak us'. We have the ability to break out, to go against the apparent determination: if we did not, even the argument that we cannot do so would be unavailable to us. We can take the object by surprise: go against its grain. Good criticism is just this. It is not the discovery of a quality intrinsic to the object that had not previously been noted, but rather an ascription of a quality to the object that is radically extrinsic to it, but which might plausibly be thought to be intrinsic. Such an observation is seamlessly undetermined.[26]

Although the 'beholder's share' may be more likely to follow one course rather than another in conformity with the culture and ideology within which the viewer operates, there are two factors that allow the viewer unpredictability and variety of response. The first of these is that culture and ideology permit a tolerance, rather than compel a uniformity, of response. Secondly, any viewer can potentially go against the grain of the culture and ideology within which she or he operates, though to do so is not the most likely response. We must recognize the viewer's freedom, even though it exists within a constraining pattern of cultural probability and predisposition. Without such freedom the viewer would scarcely be an active agent, and all responses in any given cultural and ideological circumstances would be entirely predictable. The very existence of art objects that bewilder us means that we know this not to be the case.

We recognize that the viewer-as-subject is compelled to take an active part as an agent in a transaction when confronting an art object. Thus informed, we can return to consider some of the questions that arise concerning the nature of such transactions in the case of all four categories of viewing subjects under discussion: museum visitors, the painter, curators and the model. Yet before doing so, we should be aware of some of the constraints that apply.

I have identified four categories of subject who have used, or might use, the object that principally concerns us, the *Woman Standing at a Virginal*, yet a contingent ideological threat exists to further adequate discussion. That threat is the social atomization of the subject. Identity politics – in certain respects a particular mutation of the fetishization of the individual – now makes it difficult for any one person to act, uninstructed, on behalf of anyone else.[27] There are political limitations to the claims I can effectively make with regard to the social validity of my observations. We are all encouraged to take refuge within the cages of our own prejudices, rather than to imagine how it might be to be different from how and who we are. I would not claim to make universally valid observations, but I would expect to make the effort to imagine what it might have been like for, say, a middle-class Frenchwoman in Second Empire Paris to see the *Woman Standing at a Virginal* in 1866; or what it might have been like for a working-class American woman suffering from metastatic cancer to

have seen the same painting 130 years later. Reserved human sympathy is the historian's ethical imperative, for the historian, like no other, must contend with human actions in their fullest extremes.

Aware of these constraints and obligations, let us review the use of objects by viewers-as-subjects. In particular, let us consider how the *Woman Standing at a Virginal* has been and might be used. In chapter 7, I discussed the variability of use of objects, specifically in the case of the definition of art. Following Goodman and Appadurai, we saw that objects can change from non-art to art and back again; and that art can change from commodity to ex-commodity (or dormant commodity, as I termed it) and back again. It would be hard to imagine the *Woman Standing at a Virginal* being put to use other than as an art object, though it could, potentially, be used as Goodman proposed might be the case for a painting: to replace a broken window, or as a blanket.[28] These uses for the *Woman Standing at a Virginal* are unlikely to have crossed the minds of many among our four categories of subjects as desirable or even real possibilities. However, the example of Susan Hiller in unthreading her own paintings on canvas as itself art (and others might be cited) reminds us that the use of objects not only changes over time, but that objects are unmade even as they are made. This occurs, whether by human intervention or not, and the *Woman Standing at a Virginal* is not only itself constantly undergoing physical and chemical changes, but must one day cease to be. For the time being, though, it remains art in the form that is familiar to us, whether through firsthand examination, or reproduction. Among viewers, we can assume that curators, most museum visitors and the painter at least would have it so.

The use of the painting for the production of further objects is a complex issue. Texts must count as further objects, though in a form that depends on translation. Those texts can be of various kinds, among which we can most conveniently distinguish the scholarly and the fictional. Although our scrutiny of the *Woman Standing at a Virginal* and other paintings by Vermeer may be 'contaminated by language', as W.J.T. Mitchell has put it, to trace the intertextuality of Proustean and many other resonances in the 'Vermeer literature' would be extraneous to this enquiry.[29] I am concerned with the *visual* consequences of this painting and of others by Vermeer.

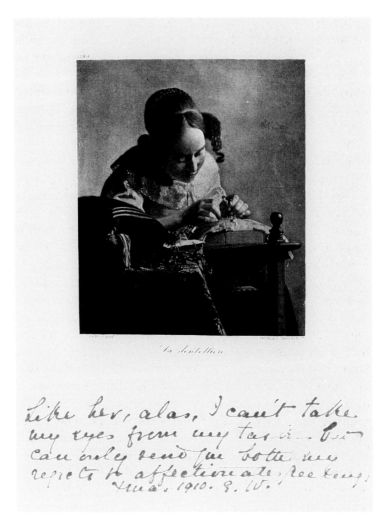

'La dentellière'

*Like her, alas, I can't take my eyes from my task. But can only send you both my regrets & affectionate greetings, Xmas, 1910. E. W.'

81 After Vermeer,
The Lacemaker, 1910,
heliogravure
inscribed by Edith
Wharton. Villa
I Tatti, Florence.

Occasionally, the visual and the textual coincide in a hybrid object, and I give one example: the use made in 1910 by Edith Wharton, then living in Paris, of a heliogravure of Vermeer's *Lacemaker* as a vehicle for Christmas greetings to Bernard and Mary Berenson (illus. 81). She inscribed it, 'Like her, alas, I can't take my eyes from my task – but can only send you both my regrets and affectionate greetings.'[30] Thus she wittily appealed to Vermeer as a way of partially defining herself as shy and industrious to the already renowned art connoisseur and scholar near the beginning of their long friendship.[31]

Artists have responded to Vermeer's paintings by emulation in purely visual terms. Michael Fried argued – not altogether

221

persuasively – that Edouard Manet was principally respond-
ing to the newly revealed art of Vermeer in *Luncheon in the
Studio* (1868) (Neue Pinakothek, Munich).[32] We are on firmer
ground when we look at Edmund Charles Tarbell's *Preparing
for the Matinee* (illus. 82). The Boston painter has adapted
Vermeer's own subject of the single woman in a domestic
interior against a plain wall, engrossed in a characteristic
activity, in this case adjusting her hat before a looking-glass. It
recalls, of course, the Berlin *Woman with a Pearl Necklace*, but
the generic Vermeer allusion is made explicit by Tarbell's
incorporation of a fragment as a painting-within-a-painting in
the upper right corner of the composition. Cut off by that
corner, we see windows and a tiled floor: part of a reproduc-
tion of *The Music Lesson*.

As well as the purely visual uses by artists, there are others
worth mentioning. The extent of John Singer Sargent's admi-
ration of Vermeer's art might not be apparent from his paint-
ings themselves, yet in a letter to Fanny Watts of 1884 he
strongly recommended that she make a point of seeing the
Vermeers in the Van der Hoop Museum and the Six
Collection, should she go to Amsterdam (the *Woman in Blue
Reading a Letter*, the *Little Street* and the *Maid Pouring Milk*).
And in a letter to Vernon Lee, undated but probably from the
same year, Sargent contended that 'some day you may assert
that the only *painters* were Velasquez, Franz Hals, Rembrandt
and Van der Meer of Delft, a tremendous man'.[33]

From use in production, whether visual, textual or hybrid,
I now turn to reproduction. Such use is the most prevalent,
but the least studied. We noted some of the issues concerning
reproduction as far as the *Woman Standing at a Virginal* is con-
cerned, in chapters 4 and 5. As we saw there, its reproduction
was once in the hands of its private owner, Théophile Thoré
(Thoré-Bürger), a very particular kind of user, who made a
very particular use of his opportunity. The right to reproduce
and to control the use of reproductions is now in the hands of
the trustees of the National Gallery, London, delegated to the
museum staff.

Art museums jealously guard the right to reproduce and
publish the works in their collections. This is a vexed and
complex topic that cannot be entered into here, except to note
that museums' retention of control – like artists' – is not
simply a matter of making money, as detractors claim, but

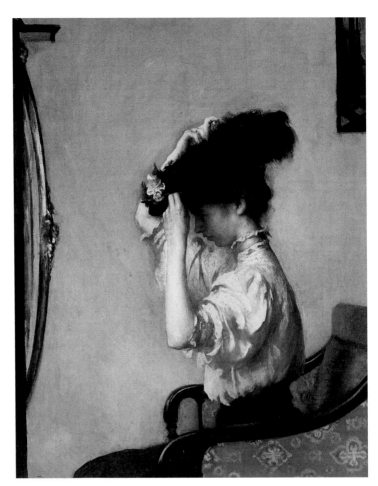

82 Edmund Charles Tarbell, *Preparing for the Matinee*, 1907, oil on canvas, 115.6 × 90.2 cm. Indianapolis Museum of Art (gift of Mrs John G. Rauch, Sr).

concerns anxiety to preserve the reliability of the reproduction, as commonly understood. In so far as a great part of anyone's familiarity with a painting such as the *Woman Standing at a Virginal* is derived from reproductions (photographs, book illustrations, postcards), as I demonstrated in chapter 3, the aim is perfectly worthy. Preservation of reliability is a good use of reproduction and its control. The case of the etched copy that proved purposefully unreliable in the key details of the eyes of the virginal player (as we saw in chapter 5) raises the question as to whether this constitutes a bad use of reproduction, for it resulted in a misrepresentation. Here historical understanding – quick to see, but slow to judge – must prevail.

How do the viewer-subjects use reproductions? Curators use

reproductions in their scholarship, much like art historians, as was discussed in chapter 3. They use them for research, and discursively as starting points and way-markers in narratives, whether in lectures or texts. Some also use reproductions to deceive museum visitors. It is the practice of some museums to show visitors to their print rooms facsimiles of light-sensitive drawings, and only to reveal the prototypes if the deception is noticed. Because of the nature of the medium such measures do not apply to paintings. This is not to say that copies have not played an important part in the life of museums. Collections of casts of classical and later statuary were extremely important to many art museums in the nine-teenth century.[34] Copyists of paintings in museums found a good market for their products. Many a Victorian parlour was graced by such iconic objects as the *Madonna della Sedia* or '*La Belle Jardinière*' in oils, executed before the works themselves in the Pitti Palace or the Louvre (or from firsthand copies of them); and the French government in the early years of the Third Republic experimented with a Musée des Copies in Paris.[35] Scholars themselves had a use for such copies. The common room of the Warburg Institute, University of London is dominated by a full-size, highly competent copy of Rembrandt's *Conspiracy of Julius Civilis: The Oath* (National-museum, Stockholm) commissioned by Aby Warburg. But rather than enter into a discussion of notions of authenticity in so far as they have effected changing curatorial practice with regard to copies, let us look at the domestic sphere that concerns most museum visitors directly.[36]

The place once occupied in the nineteenth century by the copy in oils, or, less expensively, the reproductive steel engraving, has now been taken by the museum colour poster. Museum visitors buy such posters to use predominantly for domestic decoration. High-quality prints are more likely to be framed than are the glossy posters, whether or not they adver-tise an exhibition or the permanent collection. Such posters are popular among the young and relatively impecunious, and in the homes of older affluent people tend to be displayed in the least formal areas: attics, basements, utility rooms, work-shops and subsidiary bathrooms. In this manner innumerable prints of the *Woman Standing at a Virginal* have a domestic presence world-wide. Although they are copies, the place of each one is unique. Each plays a particular role in the

domestic and imaginative lives of those who live with them. That role may diminish with familiarity, once the impulse of regard that prompted the purchase in the first place fades, but a residue remains, even if the poster is successively demoted from primary living space, to attic, to basement.

We can only guess at the appeal of a Vermeer for this purpose, yet the consonance of subject matter and eventual setting – the domestic – prompts the inference that the Vermeer represents a form of ideal for the viewer as purchaser. There is a complementary relationship between paintings by Vermeer and their reproductions as objects in their own right, and the sensitivity to objects depicted within those paintings on the part of those shown in their presence. Equally important is the implied relationship between the artist and his depicted characters, on the one hand, and the objects that contribute to the definition of their worlds, on the other. The poster allows museum visitors literally to domesticate the Vermeer, thus taking this set of relationships to a further stage. The poster can enter their own sphere of seclusion and quotidian somatic engagement with the fundamental things of the world, the tools of the kitchen and reception room, of practical use and intimate social ritual.

A poster of the *Woman Standing at a Virginal* is itself a modest object, but it addresses the life of women in relation to the life of other objects. No commentator has hit upon the significance of these relationships in Vermeer's art more perceptively than Gustave Vanzype. He notes Vermeer's attention to 'inert things':

> He [Vermeer] understood the relationship between these things and man, the solidarity that brings them together in shared lambency in the atmosphere that binds them, the one to the other.[37]

The inert thing to which the woman in our case study painting attends – the virginal – is not, like the maid's milk jug, a modest object, but it is domestic and utilitarian as well as an embodiment of high craft skill that anticipates musical artistry.[38] Indeed, each of the objects in the painting has a domestic use, while itself being the product of a distinct craft skill.

Here is an inventory of the objects represented in the *Woman Standing at a Virginal*: window panes and leads, window frames, plastered walls, glazed and decorated tiles,

two kinds of stone floor tile, upholstered chair, virginal, two paintings and their frames. There is also the dress and jewellery of the virginal player – the pearl necklace and the gold hair ornaments – which exist in a relationship of intimacy to her that is somewhat different from the fabric and furnishings of the room. I make this inventory in the same spirit as the essayist Paul Driver made an 'Inventory of a Shed'.[39] Driver's parents' shed – a lumber room – contains a wealth of shelved domestic things in a place of demotion and seclusion. Just as one might construct a personal world for Driver from the objects he lists, so one might construct a personal world for Vermeer's virginal player from the objects with which she is depicted, even allowing for their real and fictional status respectively.

In the essay that immediately precedes the 'Inventory of a Shed', entitled 'Involutes', Driver discusses Thomas De Quincey's notion of the involute.[40] In De Quincy's words:

> I have often been struck with the important truth – that far more of our deepest thoughts and feelings pass to us through perplexed combinations of *concrete* objects, pass to us as involutes (if I may coin that word) in compound experiences incapable of being disentangled, than ever reach us *directly*, and in their own abstract shapes.[41]

What matters in this consideration of how our thoughts come to us is the fruitfulness for our imaginative lives of our attention to material things. They contribute absolutely to our conditions of existence. This was explicitly understood by Henry David Thoreau who, in *Walden* (1854), gave a detailed inventory (with costs) of the constituents of the cabin he built for himself on Ralph Waldo Emerson's wood lot at Walden Pond in the spring of 1845.[42] That simple list has assumed a tremendous power to evoke Thoreau's philosophical purpose in inhabiting that cabin between 4 July 1845 and 6 September 1847.[43] But a consequent observation he made is of equal moment:

> It would be worth while to build still more deliberately than I did, considering, for instance, what foundation a door, a window, a cellar, a garret, have in the nature of man, and perchance never raising any superstructure until we found a better reason for it than our temporal necessities even.[44]

Thoreau's questioning of the very fabric of domesticity develops an important point made by his mentor, Emerson, when in 'The American Scholar' (1837) he wrote of the significance of 'the meaning of household life':

> What would we really know the meaning of? The meal in the firkin; the milk in the pan; the ballad in the street; the news from the boat; the glance of the eye; the form and the gait of the body; show me the ultimate reason of these matters; show me the sublime presence of the highest spiritual cause lurking, as always it does bristling with the polarity that ranges it instantly on an eternal law; and the shop, the plough, and the ledger referred to the like cause by which light undulates and poets sing; and the world lies no longer a dull miscellany and lumber-room, but has form and order; there is no trifle, there is no puzzle, but one design unites and animates the farthest pinnacle and the lowest trench.[45]

Even if we do not follow Emerson so far as to attribute an all-embracing spiritual order to the modest miscellany of the world, there is a sense in which the physical ordering of things – making, acquiring, housing, arranging – is our resistance to annihilation. This is the case on a humble, daily basis. In extreme circumstances it can be exacerbated from routine to urgency, as in the example of three milk pails, filled with other artefacts and documents, buried by trapped and defeated participants in the 1943 Warsaw ghetto uprising. One of the two that were recovered is displayed in the US Holocaust Memorial Museum, Washington, DC, a fragile, corroded object of ultimate resistance to an annihilation that was to occur imminently and terribly. Even in less immediately ghastly circumstances each of the 'mere things of the world' is an incorrigible point of resistance to glib abstraction.[46] Its making and use results in what Benedict Anderson has described in the case of a modest object – a baby's cap from Laos – as 'a small, mute token of . . . laughter and refusal'.[47] Each thing, even as it carries our thought, evoking a plethora of memories, resists it. Following Vanzype's insight, we might ascribe a similar power to the objects within each of Vermeer's fictional worlds, while viewing the *Woman Standing at a Virginal* itself, and each print of it in domestic use, as similarly resistant objects. The disposition of the painting itself is not at

the discretion of the museum visitor, however – that remains the prerogative of the curator – but a poster reproduction is wholly at the museum visitor's disposal. That poster has its own variable place within the domestic sphere, its use, at the decision of each owner, seamlessly consonant with its subject.

The most modest things, above all, that museum visitors bring away with them are not posters, but postcards. Postcards of works of art serve various purposes, but, above all, they are souvenirs. They allow the storage of a concrete reminder of something seen reduced to a uniform size and format. This in itself signals that each is worth a single, equal segment of memory. In buying each postcard we make an investment for memory, for these objects in their turn 'serve as traces of authentic experience', as Susan Stewart has put it.[48]

As I pause in writing this I glance at two postcards propped near my desk. One is of Winslow Homer's *Playing a Fish* in the Clark Art Institute, Williamstown, Massachusetts. It reminds me of the summer spent at the Clark as a visiting fellow, working on this book, and, at weekends, being out in a canoe, much like Homer depicted. The second is of *Preparing for the Matinee* by Edmund Charles Tarbell, a souvenir of a recent and, to date, only visit to the Indianapolis Museum of Art one damp autumnal Sunday, on my way back to Boston from the annual American Society for Aesthetics conference in nearby Bloomington. These souvenirs are more than functional reminders of paintings seen – though they can be that too, as my earlier discussion of the Tarbell illustrates – they serve as points of origin for a narrative of memory.[49]

An accumulation of postcards (which, for some, may be organized to the extent that it can be called a collection) is the equivalent of Paul Driver's shed ('wooden tennis rackets, . . . A box of clothes-pegs, mostly plastic, . . . My old plankton-net with its small square hard metal frame for shoving into pond-beds with collector's ruthlessness'), for each can evoke a memory. Driver concludes:

> But a thought starts to grow, seeded by some nugatoriness catching my eye: the thought that my life-story could begin from any one of these jumbled but actually all too significant objects – a wooden clothes-peg, if you like – and expand by endless association into volumes, and the telling

would never be done. I'm fascinated yet repelled by the idea. For once embarked on the task, I would be unable to go on properly living, immobilized like Borges's Funes by the world's infinite minutiae, the fatal specifics of memory; living embodiment of the death of invention.[50]

It is just as well, then, that my postcards lose their power of evocation as both they and I age. As I flick through a shoebox-full, many seem blank, but for the images upon them. They cannot threaten the death of invention.

Once again, then, it is utterly fitting that the tablet held by Vermeer's Cupid-Eros in the *Woman Standing at a Virginal* – only a little less than the size of a postcard (to acknowledge an anachronistic thought that seems inevitable) – should be blank. As an object – the ultimate object – it embodies all things in a plenitude of representation that resolves itself as total white saturation (like Hiroshi Sugimoto's cinema screen described in chapter 6).[51] Yet it also represents an infinity of forgetting, of blanking out as memories fade and become irrecoverable, even by means of sudden confrontation with such an infinitely inscribable object.

The varied and complex uses that viewing subjects make of reproductions (and there are, of course, others that I have not touched on) take place in equally varied settings among which we can pick out the institutional and the domestic. These frame the visual experiences to which the subjects attend, and we have seen in chapters 8 and 9 the importance of art museums as such framing institutions. In controlling these institutions – to the extent that anyone is able to – museum scholars make the decisions that more than any others affect possible uses of the objects themselves. I have argued the importance of therapeutic uses, for museum scholars must attend to art objects as matters of present, not exclusively historical, concern. Yet history matters greatly.

The two subjects in the past – the painter and the model – might easily evade our efforts at historical acknowledgement, let alone understanding. Vermeer himself may be unknowable in any simple sense from the traces he has left, but he existed – that much we know from archival documents, and from the complex objects to which we attend carefully and repeatedly. To attend to the objects he made is the best we can do to ensure his recuperation, his escape from annihilation.

We might wish to do more – we might wish to *know* him – but in truth, as I have argued from the outset, we cannot. The very best we can do is accept the wager I ascribed to him by means of robust inference: that it is possible by means of art to embody systematic abstract ideas that constitute methodical thought in purely visual form exclusively by means of the representation of plausible modern domesticity; and secondly, that we apprehend complex pictorial abstraction purely visually by means of the operation on the heart or soul directly through the eyes, evading language, in the manner of love. Thus only through the love proper to art, on the part of artist and viewer, can that art offer its wisdom, solace and reflection. The love proper to art alone allows us to discern these thoughts – these domestic abstractions – in visual terms, but to do so we must take account of the afterlife, including the reproduction and institutionalization, of the object.

What I have defined as Vermeer's wager is, on the face of it, a straightforward art-historical proposition. It might be demonstrated in straightforward art-historical terms within the confines of an unproblematic art history that pays attention to the reproducible and irreproducible characteristics of art objects. Art history does so in an attempt to define what such works meant to those who made them and initially used them. However, our capacity for understanding is largely determined by what has befallen such objects since their making, in short, their afterlife. Part of that afterlife involves the very emergence of the art-historical and museological projects.

One of the conditions of the creation of art objects is that, however they might have been understood and used by their makers and their competent contemporaries, they will inevitably be subject to different uses and understandings thereafter. It is obvious that Vermeer could not possibly have anticipated that the *Woman Standing at a Virginal* would be subject to endless reproduction, first by etching and subsequently by photography, nor be incorporated within the collection of a museum. Yet from our vantage point such knowledge is inescapable, and we must take account of its consequences fully. These are the conditions of our own knowledge in respect of this painting. To assume that these conditions can be ignored in an attempt to retrieve original meaning is mistaken, for original meaning as such must

remain inaccessible. Yet to regard the changes in the world between the original circumstances of the art object and the present time as a screen or obstacle that prevents us from addressing the question of what an original significance might have been is equally mistaken. We might profitably think in terms of historical *understanding* rather than art-historical retrieval. That pursuit of historical understanding must necessarily take account of the conditions that have pro-gressively shaped our own cultural vantage point. Indeed, reproductions and museums, if used correctly, actively help us to achieve historical understanding. Yet they do something else in addition that must be reconciled with the pursuit of historical understanding. The existence and contemporary use of photographic reproductions and the institution of the art museum both contribute to the life of the art object as having an ahistorical presence in the world. This, too, must be taken seriously on its own account, as well as acknowledged in the construction of historical understanding. Indeed, there may even be circumstances, such as the use of art in thera-peutics, in which historical understanding is secondary or not necessarily relevant. Vermeer himself, as subject, is open to our understanding, but only on condition that we take the afterlife of his creations into account, acknowledge the contin-gency of our own historical vantage point and even, paradox-ically, be prepared to set aside historical concerns in favour of allowing art objects and the museums that contain them to work in other ways. Such is the consequence and the dictate of the love proper to art that Vermeer presents in the *Woman Standing at a Virginal*.

As I suggested towards the beginning of this chapter, my fourth subject – the model – is even more fugitive than Johannes Vermeer himself. To think that she existed at all – and was not a figment – is to risk a further wager. Yet not to take that risk, and to assume through lack of evidence that she had no counterpart in actuality, would be to risk acquiescing in the annihilation of a person. In *The Art of Painting* Vermeer presents the discordance between invention and actuality in the person of the model. The person of the model is related to the fiction of the representation. The downcast eyes, evading the painter's gaze (itself inferred) and that of the viewer of the model in *The Art of Painting* contrast markedly with the impassive gaze of the *Woman Standing at a Virginal*. That gaze

itself, as well as the implication of practice examined in the Vienna painting, implies an actuality subtending the painting as an event extending over time. The gaze of that subject is the gaze of the past, not in the indexical manner of the photograph where the actuality of the moment is all too agonizingly apparent,[52] but rather veiled by an impenetrable process of observation and making. Her relationship to reality is impossible to gauge, yet to dismiss her as no more than a figment would be to risk consigning her to the abyss of the past. We must struggle to take that route into the past, for the sake of those who preceded us, and of our own selves for the future. We have to accept that final wager and say, 'However dubious the assumption, however equivocal the admission, she *lived*, and it is my responsibility to know and proclaim it.' For this is the consequence of our attention to art. This is the historical responsibility prompted by the love proper to art. And this is that very love proper to art embodied and declared by Johannes Vermeer in the *Woman Standing at a Virginal*. This is history. This is what we most need to know.

References

INTRODUCTION

1 Wonder is not necessarily in itself indicative of ignorance of causes, as Lorraine Daston and Katharine Park have recently suggested: Lorraine Daston and Katharine Park, *Wonders and the Order of Nature, 1150–1750* (New York, 1998). Wonder can persist in a state of understanding, as Ronald Hepburn has demonstrated in the most important recent discussion of the phenomenon. Hepburn draws attention to Kant's distinction between *Verwunderung* ('which fades as a sense of novelty diminishes') and *Bewunderung* ('which is steady and unthreatened'): R. W. Hepburn, 'Wonder' in *'Wonder' and Other Essays: Eight Studies in Aesthetics and Neighbouring Fields* (Edinburgh, 1984), esp. p. 133.

2 Henry David Thoreau, *Walden and Other Writings*, ed. Brooks Atkinson (New York and Toronto, 1992; 1st edn, 1937), p. 3.

3 This is not a matter concerning subscription to the Cartesian *cogito*, nor yet to Theodor Adorno's witty and pitiless transfixing of professional academics with the ascription to them of the principle *sum ergo cogito*: Theodor Adorno, *Minima Moralia: Reflections from Damaged Life*, trans. E.F.N. Jephcott (London, 1978; 1st German edn, Frankfurt-am-Main, 1951), §41, p. 67. I reserve judgement concerning the dissolution of the singular subject proposed in some contemporary theory.

4 Michael Baxandall, *Patterns of Intention: On the Historical Explanation of Pictures* (New Haven and London, 1985), pp. 105–37.

5 For example, Plato, *Phaedrus*, 250b, c; 255c, d (Plato, *Complete Works*, ed. John M. Cooper [Indianapolis and Cambridge, 1997], pp. 527–8, 532).

6 'Je vous en dis que vous y gagnerez en cette vie; et qu'à chaque pas que vous ferez dans ce chemin, vous verrez tant de certitude du gain, et tant de néant de ce que vous hasardez, que vous connaîtrez à la fin que vous avez parié pour une chose certaine, infinie, pour laquelle vous n'avez rien donné' (Blaise Pascal, *Pensées sur la religion et sur quelques autres sujets*, ed. Louis Lafuma, 3rd edn [Paris, 1960], §343, p. 205). For logical flaws see, for example, Anthony Flew, *An Introduction to Western Philosophy: Ideas and Argument from Plato to Sartre* (London, 1971), pp. 218–21.

7 Jacques Derrida, *Of Grammatology*, trans. Gayatri Chakravorty Spivak (Baltimore and London, 1976), p. 51.

8 M. C. Dillon, *Semiological Reductionism: A Critique of the Deconstructionist Movement in Postmodern Thought* (Albany, NY, 1995), p. 104.

9 Elaine Scarry, *The Body in Pain: The Making and Unmaking of the World* (Oxford and New York, 1985), p. 171 (original emphasis).

10 Saint Augustine, *Confessions*, trans. R. S. Pine-Coffin (Harmondsworth, 1961), pp. 264–6 (§§11, 15).

1 PROBLEMS

1 Arthur K. Wheelock jun., *Vermeer and the Art of Painting* (New Haven and London, 1995), p. 1.

2 See, most recently, Marten Jan Bok, 'Not to be Confused with the Sphinx of Delft: The Utrecht Painter Johannes van der Meer (Schipluiden

1630–1695/1697 Vreeswijk?)' in Ivan Gaskell and Michiel Jonker, eds, *Vermeer Studies* (*Studies in the History of Art*, LV) (Washington, DC, 1998), pp. 67–79.

3 W. Bürger [pseud. Théophile Thoré], 'Van der Meer de Delft', *Gazette des Beaux-Arts*, XXI (1866), pp. 303–4.

4 John Michael Montias, *Vermeer and His Milieu: A Web of Social History* (Princeton, NJ, 1989), pp. 64–5.

5 *Ibid.*, p. 65.

6 *Ibid.*, pp. 219, 338–9.

7 Arthur K. Wheelock jun., ed., *Johannes Vermeer*, exh. cat., National Gallery of Art, Washington, DC and Royal Cabinet of Paintings Mauritshuis, The Hague (Washington, DC, 1995); Gaskell and Jonker, Vermeer Studies.

8 Wheelock, *Johannes Vermeer*, p. 196, no. 21.

9 Neil MacLaren, *National Gallery Catalogues: The Dutch School* (London, 1960), p. 436, no. 1383; Neil MacLaren, *National Gallery Catalogues: The Dutch School 1600–1900*, rev. and expanded by Christopher Brown (London, 1991), vol. 1, p. 466.

10 Richard Wollheim, *Painting as an Art* (*Bollingen Series*, XXXV/33) (Princeton, NJ, 1987).

11 C. S. Peirce, 'Logic as Semiotic: The Theory of Signs', in *The Philosophy of Peirce: Selected Writings*, ed. J. Buckler (London, 1940), pp. 98–119.

12 Umberto Eco, 'Critique of the Image' (with notes by Peter Wollen; first published as Part 1 of 'Articulations of Cinematic Code' in *Cinemantics*, I, 1970) in Victor Burgin, ed., *Thinking Photography* (London, 1982), p. 34.

13 Eco, 'Critique of the Image', p. 34, n. 2.

14 Martin Jay, *Downcast Eyes: The Denigration of Vision in Twentieth-Century French Thought* (Berkeley, 1993).

15 For Derrida's discussion of Saussure, see especially Jacques Derrida, *Of Grammatology*, trans. Gayatri Chakravorty Spivak (Baltimore and London, 1976), pp. 30–57: note, for example, 'Plato, who said basically the same thing about the relationship between writing, speech, and being (idea), had at least a more subtle, critical, and less complacent theory of image, painting, and imitation than the one that presides over the birth of Saussurian linguistics' (p. 33).

16 J. Claude Evans, *Strategies of Deconstruction: Derrida and the Myth of the Voice* (Minneapolis and Oxford, 1991); see also M. C. Dillon, *Semiological Reductionism: A Critique of the Deconstructionist Movement in Postmodern Thought* (Albany, NY, 1995).

17 James Elkins, *On Pictures and the Words that Fail Them* (Cambridge, 1998), p. xiii.

18 Ferdinand de Saussure, *Course in General Linguistics*, ed. Charles Bally and Albert Sechehaye in collaboration with Albert Reidlinger, trans. Wade Baskin, rev. edn (London and Glasgow, 1974; 1st French edn, Geneva, 1915; 1st English edn, New York, 1959), pp. 119–20.

19 See Salim Kemal and Ivan Gaskell, eds, *The Language of Art History* (Cambridge and New York, 1991), especially the chapters by the editors, by David Summers and by Andrew Harrison.

20 Michael Baxandall, *Patterns of Intention: On the Historical Explanation of Pictures* (New Haven and London, 1985), pp. 10–11: 'If we wish to explain pictures, in the sense of expounding them in terms of their historical causes, what we actually explain seems likely to be not the unmediated picture but the picture as considered under a partially interpretative description. This description is an untidy and lively affair.'

21 The most searching exploration of this issue is by David Freedberg, *The Power of Images: History and Theory of Response* (Chicago and London, 1989).

22 Baxandall advocates inferential criticism, though is well aware of its pitfalls: 'Critical inference about intention is conventional in various senses

. . . and also precarious' (Baxandall, *Patterns of Intention*, p. 135.) See also Michael Baxandall, 'The Language of Art Criticism' in Kemal and Gaskell, *The Language of Art History*, esp. pp. 73–4.

23 Expression in visual art is an enormous subject. I would refer the reader in the first instance to Nelson Goodman, *Languages of Art: An Approach to a Theory of Symbols* (Indianapolis, 1976), pp. 85–95, for a discussion of the necessary place of metaphor in expression. I do not take issue here with the notion of pictorial expression as the possession and exemplification of certain qualities generally (as discussed by Goodman), but rather with the amenability to control of those qualities by the artist communicatively. For a quite different approach, which is critical of Goodman's linguistic model, but which should also be considered, see Roger Scruton, *The Aesthetic Understanding: Essays in the Philosophy of Art and Culture* (London and New York, 1983), pp. 49–61. (That he discusses expression in relation to music is no impediment to the application of his arguments to visual material.) Expression is evidently related to intention. This matter is fruitfully addressed by P. D. Juhl, *Interpretation: An Essay in the Philosophy of Literary Criticism* (Princeton, NJ, 1980).

24 Lawrence Gowing, *Vermeer*, 3rd edn (Berkeley, 1997), p. 31.

25 Most importantly, Montias, *Vermeer and His Milieu*.

26 Martin Kemp, *The Science of Art: Optical Themes in Western Art from Brunelleschi to Seurat* (New Haven and London, 1990), p. 193.

27 Albert Blankert, John Michael Montias and Gilles Aillaud, *Vermeer* (New York, 1988), pp. 155–6.

28 Harry Berger jun., 'Conspicuous Exclusion in Vermeer: An Essay in Renaissance Pastoral' and 'Some Vanity of His Art: Conspicuous Exclusion and Pastoral in Vermeer', in *Second World and Green World: Studies in Renaissance Fiction-Making* (Berkeley, 1988), pp. 441–61 and 462–509, respectively.

29 Gift of Mr and Mrs Charles Wrightsman, in memory of Theodore Rousseau jun. (1979.396.1).

30 Except for a period following its theft by the occupying Germans during World War II, the work had been in the hands of successive generations of the French branch of the Rothschild family since at least 1888 (Blankert, Montias and Aillaud, *Vermeer*, p. 188, no. 23). See also Michael Maeck-Gérard, *Johannes Vermeer: der 'Geograph' und der 'Astronom' nach 200 Jahren wieder vereint*, exh. cat., Stadtische Galerie im Städelsches Kunstinstitut, Frankfurt-am-Main (Frankfurt-am-Main, 1997).

31 The collection of Sir Alfred Beit, 2nd Bart., at Russborough House, Blessington, Ireland, which included this work, became a foundation in 1976. The painting was stolen in 1974 and recovered, but stolen once again in 1986. While in the hands of its reputedly politically motivated abductors, it and other works were made over to the National Gallery of Ireland which received it when it was recovered in 1993 (Wheelock, *Johannes Vermeer*, p. 186, no. 19).

32 Properly speaking the *Guitar Player* at Kenwood, London is also not owned by a museum, but is part of the Iveagh Bequest currently administered by English Heritage. Kenwood is open to the public and functions as a house museum.

33 Blankert, Montias and Aillaud, *Vermeer*, pp. 194–5.

34 Suzanna Andrews, 'Bitter Spoils', *Vanity Fair*, no. 451 (March 1998), p. 240.

35 I am grateful to Arthur K. Wheelock jun. for reading an earlier draft of this section, for discussing this case with me, and for disabusing me of misconceptions derived from reading published material. The construction placed upon the events described here remains entirely my own.

36 Joan Nissman (paintings) and Howard Hibbard (introduction and drawings and sculpture), *Florentine Baroque Art from American Collections*, exh.

cat., Metropolitan Museum of Art, New York (New York, 1969), pp. 44–5, no. 39, ill. fig. 22; Wheelock, *Johannes Vermeer*, p. 89, n. 6.

37 Nissman noted the probable existence of more than one version of this subject by Ficherelli and referred to the version published by Mina Gregori with which the painting under discussion has since frequently been compared (Fergnani Collection, Ferrara): Mina Gregori, ed., *70 Pitture e sculture del '600 e '700 fiorentino*, exh. cat., Palazzo Strozzi, Florence (Florence, 1965), p. 49, ill. fig. 18.

38 Wheelock subsequently noted that the examination in 1969 was conducted by Ted Rousseau and members of the conservation department at the Metropolitan Museum of Art (Wheelock, *Johannes Vermeer*, p. 89, n. 3).

39 Michael Kitson, 'Current and Forthcoming Exhibitions: Florentine Baroque Art in New York', *Burlington Magazine*, CXI (1969), pp. 409–10.

40 Kitson: 'If Vermeer could draw on a painting by the Neapolitan, Vaccaro, for the Edinburgh picture, there seems to be no reason why he should not on another occasion have imitated or copied a Ficherelli.' Samuels's advertisement: 'We think that the Edinburgh *Martha and Mary* may be partly based on a Vaccaro. That Vermeer should imitate another Italian painting in the mid-1650s should not therefore surprise us too much.'

41 In 1923 Borenius had proposed that Vermeer derived his figure of Christ in the Edinburgh painting from a similar figure in the *Death of Saint Joseph*, then attributed to Bernardo Cavallino (Museo di Capodimonte, Naples) (Tancred Borenius, 'Vermeer's Master', *Burlington Magazine*, XLII [1923], pp. 37–8). The painting was subsequently reattributed to Andrea Vaccaro (Maria Commodo Izzo, *Andrea Vaccaro Pittore (1604–1670)* [Naples, 1951], p. 137, ill. fig. 12). In 1926 Drost proposed Alessandro Allori's *Christ in the House of Martha and Mary* (Kunsthistorisches Museum, Vienna) as Vermeer's prototype (Wilhelm Drost, *Barockmalerei in den germanischen Ländern* [Potsdam, 1926], p. 209). Gowing identified a *Christ in the House of Martha and Mary* by Erasmus Quellinus the Younger (Musée des Beaux-Arts, Valenciennes) as a far closer likely prototype, but also pointed out that 'the pose and gesture in which the resemblance lies were in fact part of the common rhetorical repertory of the sixteenth and seventeenth centuries' (Lawrence Gowing, *Vermeer* [London, 1952], p. 81). Goldscheider made the same point and cited other Italian examples (Ludwig Goldscheider, *Johannes Vermeer: The Paintings. Complete Edition* [London, 1958], p. 125). Kitson's mention only of a purported relationship to Vaccaro was to cut corners, and Samuels apparently followed suit.

42 See Wheelock, *Johannes Vermeer*, p. 86 and n. 5, for an account of opinions published between 1969 and 1986. See also Wheelock, *Vermeer and the Art of Painting*, p. 190, n. 8.

43 Michael Hunt Stolbach, *Spencer A. Samuels Inaugural Exhibition: Master Paintings, Drawings and Sculpture*, exh. cat., Spencer A. Samuels (New York, 1984), unpaginated, no. 14, col. ill.

44 In 1968, Kühn had published the most detailed technical analysis yet of the material constituents of Vermeer's paintings: Hermann Kühn, 'A Study of the Pigments and the Grounds Used by Jan Vermeer', *National Gallery of Art: Reports and Studies in the History of Art, II* (1968), pp. 154–202.

45 Private communication; see also Paul Richard, 'To Vindicate a Vermeer: The National Gallery's Arthur Wheelock and His Public Belief in "St. Praxedis"', *Washington Post* (20 May 1987), p. D1.

46 Arthur K. Wheelock jun., '*St. Praxedis*: New Light on the Early Career of Vermeer', *Artibus et Historiae*, XIV/7 (1986), pp. 71–89.

47 Wheelock's colleague at the National Gallery of Art, Barbara Miller, conducted her own scientific examination of *Saint Praxedis* (Wheelock, 'St. Praxedis', p. 75, n. 5). Wheelock was faced with the problem of wishing to discuss for good scholarly reasons a painting that was owned by a dealer.

He obtained the sanction of his superior at the National Gallery of Art, and sought to avoid any appearance of 'puffing' the work by stating that it was in a private collection (private communication). Many dealers draw a legitimate distinction between their commercial inventories and their private collections. Although such distinctions can be disingenuous, they need not be.

48 Józef Grabski, ed., *Opus Sacrum: Catalogue of the Exhibition from the Collection of Barbara Piasecka Johnson*, exh. cat., Royal Castle, Warsaw (Vienna, 1990), p. 272; Wheelock, *Johannes Vermeer*, p. 86. The National Gallery of Art had considered acquiring the painting, but had declined to do so, a not uncommon occurrence in art museum procedure which does not in itself detract from the work concerned (see Richard, 'To Vindicate a Vermeer', p. D8).

49 Grabski, *Opus Sacrum*, pp. 272–7, no. 48 (entry by Arthur K. Wheelock jun.).

50 Józef Grabski, ed., *Jan Vermeer van Delft (1632–1675): St. Praxedis. An Exhibition of a Painting from the Collection of Barbara Piasecka Johnson*, exh. cat., International Cultural Centre, The Wawel Royal Castle, Cracow (Cracow and Vienna, 1991). It includes Lionel Koenig, 'Scientific Analysis of the "St. Praxedis" Paintings by Vermeer and Ficherelli' (pp. 22–7).

51 Wheelock, *Johannes Vermeer*, pp. 86–9, no. 1; Wheelock, *Vermeer and the Art of Painting*, pp. 21–7.

52 I discussed this painting while examining it with a number of scholars attending the Vermeer symposium at the National Gallery of Art in December, 1995 and do not recall a single one who was convinced by the attribution.

53 Christopher Brown, 'Exhibition Reviews. Washington and The Hague: Vermeer', *Burlington Magazine*, cxxxviii (1996), p. 281.

54 Ben Broos, 'Vermeer: Malice and Misconception' in Gaskell and Jonker, *Vermeer Studies*, p. 30; Bok, 'Not to be Confused with the Sphinx of Delft', p. 75; Jørgen Wadum, 'Contours of Vermeer' in Gaskell and Jonker, *Vermeer Studies*, pp. 214–19.

55 I hope it is quite clear that I am not reviewing the evidence in favour of or against the attribution here, nor am I suggesting that Wheelock is necessarily mistaken. However, it would be disingenuous of me not to admit that, as a result of, first, examining the painting while exhibited in Washington (scarcely optimum conditions) in conjunction with Vermeer's two early history paintings, secondly, of discussing the work with specialist colleagues and, thirdly, of reviewing the published arguments, I feel unable to accept an unqualified attribution of *Saint Praxedis* to Vermeer.

56 A painting that Gowing ultimately accepted as by Vermeer, though without commentary (*A Lady Seated at the Virginals*, Baron Rolin Collection, Brussels in 1970), is extant (Gowing, *Vermeer*, 3rd edn, p. 157 and pl. 80) and is being discreetly examined by specialists.

57 See Broos, '"Un celebre Peijntre nommé Verme[e]r"' in Wheelock, *Johannes Vermeer*, pp. 47–65; Broos, 'Vermeer: Malice and Misconception', pp. 19–33.

58 A. B. de Vries, *Jan Vermeer van Delft*, rev. edn (London, 1948).

59 There seems to be some equivocation in editions of Gowing's book concerning the *Lady Seated at a Virginal* (Baron Rolin Collection, Brussels in 1970). It is not included in the first American edition of Gowing's book (1953), but reportedly is (as pl. 80) in the English first edition. It appears (as pl. 80 at the very end of the catalogue) in the second and third editions (1970 and 1997) (see also n. 56 above). Goldscheider considered nine 'drawings and paintings attributed by some critics to Vermeer' (Goldscheider, *Johannes Vermeer*, pp. 145–6).

60 Broos, '"Un celebre Peijntre nommé Verme[e]r"', p. 62, referring to Albert Blankert (with contributions by Rob Ruurs and Willem van de Watering),

Johannes Vermeer van Delft 1632–1675 (Utrecht and Antwerp, 1975).

61 A. B. de Vries, *Jan Vermeer van Delft* (Amsterdam, 1939), p. 85, no. 19; pp. 89–90, no. 31.

62 Arthur K. Wheelock jun., 'The Story of Two Vermeer Forgeries' in Cynthia P. Schneider, William W. Robinson and Alice I. Davies, eds, *Shop Talk: Studies in Honor of Seymour Slive* (Cambridge, MA, 1995), pp. 271–5.

63 Scholarly accounts are: Marijke van den Brandhof, *Een vroege Vermeer uit 1937: Achtergrond van leven en werken van de schilder/vervalser Han van Meegeren* (Utrecht and Antwerp, 1979); D. Kraaipoel and H. van Wijnen, *Han van Meegeren, 1889–1947, en zijn meesterwerk van Vermeer*, exh. cat., Kunsthal, Rotterdam and Museum Bredius, The Hague (Zwolle, 1996). See also Hope B. Werness, 'Han van Meegeren *fecit*', in Denis Dutton, ed., *The Forger's Art: Forgery and the Philosophy of Art* (Berkeley, 1983), pp. 1–57.

64 The example is drawn from Montias, *Vermeer and His Milieu*, p. 201.

65 For an illuminating discussion of artist's presence through painterly touch, see Richard Shiff, 'Cézanne's Physicality: The Politics of Touch' in Kemal and Gaskell, *The Language of Art History*, pp. 129–80. The topos goes back at least to early discussions of Titian's art.

66 See, especially, H. Perry Chapman, *Rembrandt's Self-Portraits: A Study in Seventeenth-Century Identity* (Princeton, NJ, 1990), and Ivan Gaskell, 'Rembrandt's Self Portrayed?', *Apollo*, CXXXIII (1991), pp. 362–3.

67 '3. 't Portrait van Vermeer in een Kamer met verscheyde bywerk ongemeen fraai van hem geschildert. 45-0' in the *Catalogus van schilderyen, Verkogt den 16. May 1696. in Amsterdam* in Gerard Hoet and Pieter Terwesten, *Catalogus of naamlyst van schilderyen, met dezelver pryzen*, 3 vols (The Hague, 1752–70), vol. I, pp. 34–40, transcribed in Blankert, Montias and Aillaud, *Vermeer*, p. 212 (see also p. 194). *The Art of Painting* has sometimes been identified with this work, most probably erroneously (Blankert, Montias and Aillaud, *Vermeer*, p. 185, no. 19). Théophile Thoré, in the third of his 1866 articles on Vermeer, identified the lost work with one in his possession now attributed to Cornelis de Man (Bürger [Thoré], 'Van der Meer de Delft', p. 566, no. 42, wood engraving, p. 365).

68 This is not necessarily actually the case, as Nanette Salomon argues: Nanette Salomon, 'From Sexuality to Civility: Vermeer's Women' in Gaskell and Jonker, *Vermeer Studies*, pp. 309–25.

69 Compare Celeste Brusati, *Johannes Vermeer* (New York, 1993), unpaginated.

70 Roland Barthes, 'The Death of the Author' (first published as 'La mort de l'auteur', *Mantéia*, V, 1968) in *Image–Music–Text*, selected by and trans. Stephen Heath (London, 1977), pp. 142–8.

71 Wheelock, *Vermeer and the Art of Painting*, p. 1.

72 I owe the comparison of the two images to Immo Wagner-Douglas and Peter Wippermann, '*The Body is the Message*: das Bild vom Körper in den Medien', *Kunstforum*, CXLI (1998), pp. 192–3, col. ills.

2 IMAGES

1 Albert Blankert, however, reverted to this frame of reference in his discussion of the *Woman Standing at a Virginal* when he wrote: 'He [Vermeer] gives full play to his love of straight edges and right angles: the frame of the landscape on the lid of the virginal, and the sharp strip of light along the right side of the larger painting on the wall even bring to mind the art of Mondrian' (Albert Blankert, John Michael Montias and Gilles Aillaud, *Vermeer* [New York, 1988], p. 134).

2 'Dans ma *Jeune femme au clavecin*, la tête se modèle sur un tableau représentant Cupidon qui accourt avec une lettre à la main. – L'amour lui trotte dans la tête. – Bien sûr, il est en route pour lui apporter quelque billet doux. Naïvement inquiète, elle espère, elle prélude sur son piano, – en attendant

l'amour qui vient' (W. Bürger [pseud. Théophile Thoré], 'Van der Meer de Delft', *Gazette des Beaux-Arts*, XXI [1866], p. 460).

3 Lawrence Gowing, *Vermeer*, 3rd edn (Berkeley, 1997), p. 60.

4 *Ibid.*, p. 61; see also pp. 155–7. He writes similarly of the *Woman Seated at a Virginal* (National Gallery, London).

5 Neil MacLaren, *National Gallery Catalogues: The Dutch School* (London, 1960), p. 437.

6 The most notable example being Svetlana Alpers, *The Art of Describing: Dutch Art in the Seventeenth Century* (Chicago, 1983).

7 E. de Jongh, *Zinne- en minnebeelden in de schilderkunst van de zeventiende eeuw* (n.p., 1967), pp. 49–50.

8 Arthur K. Wheelock jun., ed., *Johannes Vermeer*, exh. cat., National Gallery of Art, Washington, DC and Royal Cabinet of Paintings Mauritshuis, The Hague (Washington, DC, 1995), p. 198.

9 'Ofschoon het kaartje van de geschilderde amor blanco is en het kaartje met de andere cijfers zelfs ontbreekt, lijdt het geen twijfel dat Vermeer van dezelfde gedachte bezield is geweest toen hij de vrouw aan het virginaal schilderde' (de Jongh, *Zinne- en minnebeelden*, p. 50).

10 E. de Jongh, 'Die "Sprachlichkeit" der niederländischen Malerei in 17. Jahrhundert' in Sabine Schulz, ed., *Leselust: niederländische Malerei von Rembrandt bis Vermeer*, exh. cat., Schirn Kunsthalle (Frankfurt-am-Main, 1993).

11 E. de Jongh, 'Vermeers geduldige iconografie: uitlegkunde en inlegkunde', *Theoretische Geschiedenis*, XIII (1996), pp. 316–20.

12 E. de Jongh, 'On Balance' in Ivan Gaskell and Michiel Jonker, eds, *Vermeer Studies* (*Studies in the History of Art*, LV) (Washington, DC, 1998), pp. 353–5: this is virtually a repetition of his argument in de Jongh, 'Vermeers geduldige iconografie'.

13 De Jongh, 'On Balance', p. 354. Compare de Jongh, 'Vermeers geduldige iconografie', p. 319: 'Hoewel de kaart, die door de Cupido van Vermeer wordt getoond, blanco is en het plankje met de andere getallen zelfs ontbreekt, veroorloof ik mij de hypothese, dat de door Vaenius uitgedragen moraal Vermeer voor de geest stond bij het concipieren van zijn schilderij. Dat deze hypothese betrekkelijk weinig zoden aan de dijk zet is mij pas gaandeweg duidelijk geworden. Ook indien zij juist zou zijn, blijven we – zeg ik nu, anders dan vroeger – in onwetendheid verkeren omtrent de precieze intentie van Vermeer. Hoe wenste de schilder – en dit lijkt mij een cruciale vraag – dat de door hem ingebouwde moraal zou funcioneren?'

14 See, for example, Hans Luijten, '"Het dertel wicht" in de Nederlandse emblematiek', *Kunstschrift*, II (1998), pp. 31–5.

15 As the example of contemporaneous photographs of Kasimir Malevitch's architectonic forms demonstrates: see Jean-Hubert Martin and Poul Pedersen, *Malévitch: oeuvres de Casimir Severinovitch Malévitch (1878–1935) (Collections du Musée national d'Art moderne)* (Paris, 1980).

16 It, or another version, has been assumed to be the work listed in a document concerning the division of property between Vermeer's future mother-in-law, Maria Thins (and her siblings), and Reynier Cornelisz. Bolnes on their separation in 1641. It thereby entered the Vermeer household (Blankert, Montias and Aillaud, *Vermeer*, pp. 200–201; John Michael Montias, *Vermeer and His Milieu: A Web of Social History* [Princeton, NJ, 1989], pp. 122, 146).

17 Gregor J. M. Weber, 'Johannes Vermeer, Pieter Jansz. van Asch und das Problem der Abbildungstreue', *Oud Holland*, CVIII (1994), pp. 99–100; the van Asch (oil on canvas, 70 × 80.5 cm) is illustrated, fig. 4.

18 Gregor J. M. Weber, 'Vermeer's Use of the Picture-within-a-Picture: A New Approach' in Gaskell and Jonker, *Vermeer Studies*, p. 297.

19 A.J.J.M. van Peer, 'Drie collecties schilderijen van Jan Vermeer', *Oud Holland*, LXXII (1957), p. 102: 'Boven op de agtercamer . . . een cupido';

Montias, *Vermeer and His Milieu*, p. 341.

20 E.g. Neil MacLaren, *National Gallery Catalogues: The Dutch School 1600–1900*, rev. and expanded by Christopher Brown (London, 1991), vol. 1, p. 466.

21 Gustav Delbanco, *Der Maler Abraham Bloemaert (1564–1651)* (*Studien zur deutschen Kunstgeschichte*, CCLIII) (Strasburg, 1928), p. 64, n. 39: 'Zu diesen Beziehungen kann hinzugetragen werden, dass der Amor auf dem Bilde in der Londoner National-Gallery (früher Samml. Salting [*sic*]) vermutlich ein Gemälde von der Hand des Caesar van Everdingen wiedergibt.'

22 E.g. MacLaren, rev. Brown, *The Dutch School*, vol. 1, p. 466.

23 Anneliese Mayer-Meintschel, 'Die Briefleserin von Jan Vermeer van Delft – zum Inhalt und zur Geschichte des Bildes', *Jahrbuch der Staatlichen Kunstsammlungen Dresden*, XI (1978–9), pp. 91–9. The reconstruction published by Wadum is misleading, for the framed painting of Cupid depicted there is smaller than that in the X-radiograph (Jørgen Wadum, 'Vermeer in Perspective' in Wheelock, *Johannes Vermeer*, p. 73, fig. 10).

24 Neil MacLaren, *National Gallery Catalogues: The Dutch School* (London, 1960), p. 436.

25 See Jean Seznec, *The Survival of the Pagan Gods: The Mythological Tradition and Its Place in Renaissance Humanism and Art*, trans. Barbara F. Sessions (*Bollingen Series*, XXXVIII) (New York, 1953), pp. 102–3; Edgar Wind, *Pagan Mysteries in the Renaissance*, 2nd edn (London, 1967), pp. 141–51 ('Sacred and Profane Love') and pp. 151–70 ('Amor as a God of Death').

26 The painting was among those successfully offered with what was generally known as the Bentinck-Thyssen Collection at Sotheby's, London, 6 December 1995, lot 92 (col. ill.) as 'Follower of Sir Anthony Van Dyck'; Gustave Glück, *Van Dyck: des Meisters Gemälde in 571 Abbildungen*, 2nd edn (Klassiker der Kunst in Gesamtausgeben, XIII) (Stuttgart and Berlin, 1931), p. 266, ill. and p. 548; *Chefs d'Oeuvres de la collection Bentinck-Thyssen*, exh. cat., Nihonbashi Takashimaya Art Galleries, Tokyo, Kumamoto Prefectural Museum of Art, Art Museum 'Toyama Kenminkaikan', Toyama and Miyagi Museum of Art (n.p., 1986), p. 139, no. 21, col. ill. p. 39: canvas, 127 × 92 cm.

27 '1 Cupido van Van Dyck g. 60' (J. Denucé, *Exportation d'oeuvres d'art au 17e siècle à Anvers: La Firme Forchoudt* [*Sources pour l'histoire de l'art flamand*, 1], [Antwerp, 1931], p. 75).

28 'Een Cupidoken van van Dyck' (J. Denucé, *De Antwerpsche 'Konstkamers': Inventarissen van kunstverzamelingen te Antwerpen in de 16e en 17e eeuwen* [*Bronnen voor de geschiedenis van de Vlaamsche kunst*, II], [The Hague, 1932], p. 253).

29 Horst Vey, *Die Zeichnungen Anton van Dycks* (Monographien des 'Nationaal Centrum voor de Plastische Kunsten van de XVIde en XVIIde Eeuw', I) (Brussels, 1962), vol. 1, pp. 209–10, no. 140: 'Amor als Triumphator (Kopie)' (Kupferstichkabinett, Berlin, inv. no. 16718), ill. vol. 2, fig. 181.

30 Pausanias, *Description of Greece*, with an introduction by W.H.J. Jones and H.A. Ormarod (Loeb Classical Library), vol. II (Cambridge, Mass., and London, 1960; 1st edn 1926); p. 443: Bk. 5, 11, 8.

31 Albert Blankert, *et al.*, *Gods, Saints and Heroes: Dutch Painting in the Age of Rembrandt*, exh. cat., National Gallery of Art, Washington, DC, Detroit Institute of Arts and Rijksmuseum, Amsterdam (Washington, DC, 1980), p. 55. See further Eric Jan Sluijter, *De 'Heydensche Fabulen' in de Noordnederlandse schilderkunst, circa 1590–1670* (ac. diss. Rijkuniversiteit te Leiden) (Leiden, 1986).

32 '[E]n daer ten eersten ghewelcomt van Cupido: want soo was sy uytghebeeldt in eenen Tempel in Grieck-landt gelijck Pausanias verhaelt' (Karel van Mander, *Het Schilder-Boeck waer in voor eerst de leerlustighe Iueght den grondt der edel vry schilderkonst in verscheyden deelen wort voorghedraghen . . . Eyntlyck d'wtlegghinghe op den Metamorphosen Pub. Ouidij Nasonis . . .*

[Haarlem, 1604; facsimile edn, Utrecht, 1969], ff. 28v–29r).

33 This painting and its pendant are discussed and illustrated by Peter Hecht in Peter Hecht, *De Hollandse fijnschilders van Gerard Dou tot Adriaen van der Werff*, exh. cat., Rijksmuseum Amsterdam (Maarssen and Amsterdam, 1989), pp. 202–6, nos. 42 and 43.

34 E. de Jongh, *Portretten van echt en trouw: huwelijk en gezin in de Nederlandse kunst van de zeventiende eeuw*, exh. cat., Frans Halsmuseum, Haarlem (Haarlem and Zwolle, 1986), p. 248, ill. fig. 58a.

35 Ivan Gaskell, 'Transformations of Cervantes' "La Gitanilla" in Dutch Art', *Journal of the Warburg and Courtauld Institutes*, XLV (1982), p. 264, ill. pl. 46d. Sturla Gudlaugsson had associated the painting with *La Gitanilla*, but only with the verse version by Jacob Cats (S. J. Gudlaugsson, *De Komedianten bij Jan Steen en zijn tijdgenooten* [The Hague, 1945], p. 33, ill. p. 29, fig. 33; Jacob Cats, *'S Weerelts Begin, Midden, Eynde, Besloten in den Trou-Ringh, Met den Proef-Steen Van den Selven* [Dordrecht, 1637]).

36 Catharina Verwers Dusart, *Spaensche Heydin, Blyspel* (Amsterdam, 1644; 2nd edn, 1657), p. 4.

37 Johan van Beverwyck, *Schat der ongesontheyt, ofte genees-kunde van de sieck-ten* (1st edn Dordrecht, 1642), in *Alle de wercken, soo in de medecyne al chirur-gye* (Amsterdam, 1652), p. 130: he explicitly takes the image of the arrow from Musaeus Grammaticus' early Greek poem (long since translated into Latin and modern European languages) of *Hero and Leander*.

38 '[D]an schildert ock wat ordonnantsij van modarn bij u rommelerij ten eersten op gelick ghij well koent: want dat spoet besst: en blijft ock schoonst en vloeijent int besterven also doende sult ghij well bemint warden met Godt' (Alison McNeil Kettering, *Drawings from the Ter Borch Studio Estate* [*Catalogus van de Nederlandse Tekeningen in het Rijksprentenkabinet, Rijksmuseum, Amsterdam*, v], [The Hague, 1988], vol. 2, p. 864). Kettering discusses the problematic meaning of this passage, mentioning that, while ter Borch most likely had a technical procedure in mind, he also implies the modern subject matter of recent painters in Haarlem and The Hague (n. 5).

39 Montias, *Vermeer and His Milieu*, p. 308, no. 251.

40 Seventeenth- and early eighteenth-century uses of the term and its contemporary synonyms (such as *modesch* and *à la mode*) are noted by Lydia De Pauw-De Veen, *De Begrippen 'schilder', 'schilderij' en 'schilderen' in de zeventiende eeuw* (*Verhandelingen van de Koninklijke Vlaamse Academie voor Wetenschappen, Letteren en Schone Kunsten van België: Klasse der Schone Kunsten*, XXXI, no. 22) (Brussels, 1969), pp. 60, 171, 173–4, 179. Gerrit Dou, Frans van Mieris, Gabriël Metsu and Ludolf de Jongh are among the painters associated with the terms.

41 Gerard de Lairesse, *Groot schilderboek*, 2 vols (Haarlem, 1740), vol. 1, pp. 167–201.

42 *Ibid.*, pp. 175–6.

43 *Ibid.*, p. 176.

44 Lisa Vergara, '*Antiek* and *Modern* in Vermeer's *Lady Writing a Letter with Her Maid*' in Gaskell and Jonker, *Vermeer Studies*, pp. 245–8 with further references.

45 'De nooitvolpreezene *Anthoni van Dyk* was in het Antiek zo wel uitmentende als in 't Modern; hebbende in het laatste zo wel als in het eerste de voorzeide drie bevalligheden gelyk een staale wet gevolgd, en daar door den naam van weergedeloos verdiend' (de Lairesse, *Groot schilderboek*, vol. 1, p. 178).

46 Jacob Cats, 'Selsaem trougeval tusschen een Spaens edelman en een Heydinne; soo als de selve Edelman en al de werelt doen geloofde' in Cats, *'S Weerelts Begin, Midden, Eynde, Besloten in den Trou-Ringh*. No fewer than 23 editions of the *Trouw-Ringh* appeared in the seventeenth century, both alone and as part of the *Complete Works*.

47 On this subject, see in particular Jan Baptist Bedaux, 'Minnekoorts-, zwangerschaps-, en doodsverschijnselen op zeveniende-eeuwse schilderijen', *Antiek*, x (June–July 1975), pp. 17–42, and Einar Petterson, '*Amans amanti medicus*: die Ikonologie des Motivs *Der ärtzliche Besuch*' in Henning Bock and Thomas W. Gaehtgens, eds, *Holländische Genremalerei im 17. Jahrhundert: Symposium Berlin 1984 (Jahrbuch preussischer Kulturbesitz, Sonderband* iv) (Berlin, 1987), pp. 193–224.

48 Discussed by Seymour Slive in Seymour Slive, ed., *Frans Hals*, exh. cat., National Gallery of Art, Washington, DC, Royal Academy of Arts, London and Frans Halsmuseum, Haarlem (London, 1989), pp. 216–19, cat. no. 31. The starting point for such discussions is Enid Welsford, *The Fool: His Social and Literary History* (London, 1968; 1st edn, 1935).

49 *Metamorphoses* 10: 529–59. The pictorial prototype is a print by Antonio Tempesta (Gregor J. M. Weber, '"Om te bevestige[n], aen-te-raden, verbreeden ende vercieren": rhetorische Exempellehre und die Struktur des "bild im bild"', *Wallraf-Richartz-Jahrbuch*, LV [*Studien zur niederländischen Kunst: Festschrift für Prof. Dr Justus Müller Hofstede*] [1994], p. 301, ill. p. 303, fig. 16).

50 Arthur K. Wheelock notes that the arrows may be fire arrows, like those in Schalcken's *Venus Handing Cupid a Fire Arrow* discussed above (H. Perry Chapman, Wouter T. Kloek, Arthur K. Wheelock jun. *et al.*, *Jan Steen, Painter and Storyteller*, exh. cat., National Gallery of Art, Washington, DC and Rijksmuseum, Amsterdam [Washington, DC and Amsterdam, 1996], p. 150, n. 6).

51 Other artists tried yet other methods of incorporating a figure of Cupid; for example, Matthijs Naiveu in *The Lying-In Room*, 1675 (Metropolitan Museum of Art, New York) included a sculpted flying Cupid suspended by a cord near the mother's bed.

52 'Godlijcke cleeren reyn, aen t'lijf haer gaende trecken/En haer schoon blonde hayr met gulden spansels decken' (van Mander, *Het Schilder-Boeck*, f. 29r).

53 P.T.A. Swillens, *Johannes Vermeer: Painter of Delft, 1632–1675* (Utrecht and Brussels, 1950), p. 89.

54 Pliny discusses the association of pearls with Venus (Pliny, *Naturalis Historia*, Bk 9, 54–9), a tradition in western art examined in detail by M. Bratchkova, 'Die Muschel in der antiken Kunst', *Izvestiia na Bulgarskiia arkheologicheski institut (Bulletin de l'Institut Archéologique Bulgare)*, XII (1938), pp. 1–131. See also W. S. Heckscher, 'The *Anadyomene* in the Medieval Tradition (Pelagia–Cleopatra–Aphrodite): A Prelude to Botticelli's *Birth of Venus*', *Nederlands Kunsthistorisch Jaarboek*, VII (1956), pp. 1–38. De Jongh pertinently draws attention to pearls' wide range of associations in seventeenth-century Dutch and Flemish culture (E. de Jongh, 'Pearls of Virtue and Pearls of Vice', *Simiolus*, VIII [1975–6], pp. 69–97).

55 Hans-Joachim Raupp, *Untersuchungen zu Künstlerbildnis und Künstlerdarstellung in den Niederlanden im 17. Jahrhundert (Studien zur Kunstgeschichte*, xxv) (Hildesheim, Zurich and New York, 1984), p. 123, ill. p. 124, fig. 10.

56 *Ibid.*, pp. 220–26. An example is Jan Steen's *Self-Portrait as a Lutenist* (Fundación Colección Thyssen-Bornemisza, Madrid): see Ivan Gaskell, *The Thyssen-Bornemisza Collection: Seventeenth-Century Dutch and Flemish Painting* (London, 1990), pp. 162–7, and Chapman *et al.*, *Jan Steen, Painter and Storyteller*, pp. 180–82, no. 25. Note also the ascription of an untraced painting of a painter in his workshop playing the violin to Vermeer in the catalogue of the L. Schermer sale, Rotterdam, 17 August 1758, no. 67 (Blankert, Montias and Aillaud, *Vermeer*, p. 195, no. 39).

57 Raupp, *Untersuchungen zu Künstlerbildnis und Künstlerdarstellung*, pp. 117–18, ill. p. 118, fig. 7.

58 'Triplex illi fructus est opera sui: unus conscientiae; hunc absoluto opere percipit; alter famae; tertius utilitatis, quem allatura est aut gratia aut venditio aut aliqua commoditas' (Lucius Annaeus Seneca, *De beneficiis* in *Moral Essays* with a translation by John W. Basore, vol. III [*Loeb Classical Library*] [Cambridge, MA and London, 1964], p. 166: *De beneficiis*, Bk. 2, 33: 3). MacLaren cites the 1672 Amsterdam edition of the works of Seneca (MacLaren, *The Dutch School*, p. 193, n. 1).

59 'Hy heeft driederhande vruchten van zijn werk: d'een is't vernoegen van zijn geweeten, 't welk hy door 't volmaken van zijn werk ontfangt; d'ander van't gerucht; en de derde van't voordeel en de nutticheit, die hem, of dor de gift, verkooping, of door eenige andere profijtelijkheyt, aengebracht zal worden' (Samuel van Hoogstraten, *Inleyding tot de hooge school der schilderkonst: Anders de Zichtbaere Werelt* [Rotterdam, 1678], p. 345). Van Hoogstraten's rendering of Seneca's 'conscientia' by 'vernoegen van zijn geweeten' reveals an ambiguity that suggests that the benefit to the artist could be either epistemological or ethical, or both.

60 *Ibid.*, pp. 345–51.

61 Celeste Brusati, *Artifice and Illusion: The Art and Writing of Samuel van Hoogstraten* (Chicago and London, 1995), ill. p. 216, fig. 153, described p. 322, n. 91.

62 On the peepshow (perspective box), see Christopher Brown, David Bomford, Joyce Plesters and John Mills, 'Samuel van Hoogstraten: Perspective and Painting', *National Gallery Technical Bulletin*, XI (1987), pp. 60–85; MacLaren, rev. Brown, *The Dutch School*, vol. I, pp. 204–6; Brusati, *Artifice and Illusion*, pp. 169–217; David Bomford, 'Perspective, Anamorphosis, and Illusion: Seventeenth-Century Dutch Peep Shows' in Gaskell and Jonker, *Vermeer Studies*, pp. 125–35.

63 Van Hoogstraten, *Inleyding tot de hooge school der schilderkonst*, opp. p. 324.

64 Brusati, *Artifice and Illusion*, p. 209. The interpretation of the interior of the peepshow offered here accords with, and is indebted to, Brusati's (pp. 178–82).

65 MacLaren, rev. Brown, *The Dutch School*, vol. I, p. 204.

66 'Vrouw Venus, uit de Zee/En't Godlijk zaet geteelt, zendt daerom, volgenoegen,/Kupyd' om zich altijts by dees Godin te voegen' (van Hoogstraten, *Inleyding tot de hooge school der schilderkonst*, p. 122). The identification was proposed by Brusati, *Artifice and Illusion*, pp. 212–13; see also pp. 240–43.

67 Montias, *Vermeer and His Milieu*, pp. 172, 221, 340.

68 The manuscript album is in the Provinciale Bibliotheek, Leeuwarden. The inscription is dated 15 February 1616: see Cornelis Hofstede de Groot, 'Het vriendenalbum van Wibrand Symonszoon de Geest', *Oud Holland*, VII (1889), pp. 235–40. De Jongh discusses this inscription in the context of the husband-and-wife portraiture of painters (de Jongh, *Portretten van echt en trouw*, pp. 57–9, ill. p. 57, fig. 65).

69 Montias, *Vermeer and His Milieu*, p. 308, no. 249.

70 De Jongh, *Portretten van echt en trouw*, pp. 57–9, 270–78.

71 See Henk T. van Veen, 'Tuscan Visitors for Adriaen van der Werff', *Hoogsteder-Naumann Mercury*, II (1985), pp. 31–2; Barbara Gaehtgens, *Adriaen van der Werff, 1659–1722* (Munich, 1987), pp. 371–2, no. 108.

72 This idea is not in conflict with Barbara Gaehtgens's surmise that Pictura is in the likeness of van der Werff's wife, Margareta Rees, and that the putto facing the viewer is in the likeness of their daughter (Gaehtgens, *Adriaen van der Werff*, p. 372).

73 Van Veen, 'Tuscan Visitors for Adriaen van der Werff', pp. 31–2; Gaehtgens, *Adriaen van der Werff*, pp. 372–4, no. 109.

74 Snoep tentatively identified Margareta Rees as playing the role of Pictura and Maria van der Werff that of an inspiring genius (D. P. Snoep, *Adriaen*

van der Werff, Kralingen 1659–1722 Rotterdam, exh. cat., Historisch Museum Rotterdam [Rotterdam, 1973], p. 24, no. 33), while Raupp saw the mother and daughter as Venus and Cupid, though with no justification (Rüdiger Klessman, ed., *Selbstbildnisse und Künstlerporträts von Lucas van Leyden bis Anton Raphael Mengs*, exh. cat., Herzog Anton Ulrich-Museum, Braunschweig [Brunswick, 1980], p. 22, n. 89).

75 C. H. de Jonge, *Paulus Moreelse, portret- en genreschilder te Utrecht, 1571–1638* (Assen, 1938), p. 98, no. 121, ill. fig. 81.

76 *Ibid.*, p. 99, no. 123, ill. pl. 1.

77 Raupp relates these works to thoughts on the topic by Federico Zuccari on the artist as learned virtuoso (Klessman, *Selbstbildnisse und Künstlerporträts*, pp. 17, 48; Raupp, *Untersuchungen zu Künstlerbildnis und Künstlerdarstellung*, pp. 86, 334–5, with further references).

78 Marsilio Ficino, *Commentaria in Platonem* (Venice, 1496); modern editions with commentaries: Marsilio Ficino, *Commentary on Plato's Symposium on Love*, trans. Sears Jayne (Dallas, 1985), and Michael J. B. Allen, *Marsilio Ficino and the Phaedran Charioteer* (Berkeley, 1981). Festugière demonstrated Ficino's extensive influence on French literature in the sixteenth century (Jean Festugière, *La philosophie de l'amour de Marsile Ficin et son influence sur la littérature française au XVIe siècle* [Coimbra, 1923]) and Kristeller has argued that this influence continued to be felt throughout the seventeenth century through continued reliance on his translations and commentaries (Paul Oskar Kristeller, *The Philosophy of Marsilio Ficino*, trans. Virginia Conant [*Columbia Studies in Philosophy*, VI], [New York, 1943], pp. 19–20).

79 Plato, *Phaedrus*, 255c, d (Plato, *Complete Works*, ed. John M. Cooper [Indianapolis and Cambridge, 1997], p. 532).

80 *Phaedrus*, 250b, c (Plato, *Complete Works*, pp. 527–8). See Michael J. B. Allen, *The Platonism of Marsilio Ficino: A Study of His 'Phaedrus' Commentary, Its Sources and Genesis* (Berkeley, 1984), pp. 185–203.

81 Ficino, *Commentary on Plato's Symposium on Love*, pp. 95–6, 113.

82 André Chastel, *Marsile Ficin et l'art*, 3rd edn (Geneva, 1996), esp. pp. 127–48.

83 Sale, Phillips, London, 15 December 1998, lot 75, as Charles-Alphonse Dufresnoy. The painting is not mentioned by Sylvain Laveissière, 'Les tableaux d'histoires retrouvées de Charles-Alphonse Dufresnoy', *La Revue de l'art*, CXII (1996), pp. 38–58, but the work is accepted by Laveissière, with the necessary reservations proper to his having seen only a photograph (private communication, 8 December 1998).

84 I owe the translation to Colette Czapski Hemingway.

85 See Carlo Pedretti, *The Literary Works of Leonardo da Vinci Compiled and Edited from the Original Manuscripts by Jean Paul Richter: Commentary* (Oxford, 1977), vol. 1, pp. 12–47, esp. p. 34, with further references. The two putti may represent the Senecan benefits of art, as in the cases of works by van Hoogstraten and van der Werff discussed above.

86 Weber, '"Om te bevestige[n], aen-te-raden, verbreeden ende vercieren"', and Weber, 'Vermeer's Use of the Picture-within-a-Picture'.

3 OBJECTS

1 See, in particular, P.T.A. Swillens, *Johannes Vermeer: Painter of Delft, 1632–1675* (Utrecht and Brussels, 1950), pp. 69–90.

2 For Vermeer's perspective constructions, see Jørgen Wadum, *Vermeer Illuminated: Conservation, Restoration and Research* (The Hague, 1994); Jørgen Wadum, 'Vermeer in Perspective' in Arthur K. Wheelock jun., ed., *Johannes Vermeer*, exh. cat., National Gallery of Art, Washington, DC and Royal Cabinet of Paintings Mauritshuis, The Hague (Washington, DC, 1995), pp. 67–79; Jørgen Wadum, 'Johannes Vermeer (1632–1675) and His Use of Perspective' in Arie Wallert, Erma Hermens, and Marja Peek, eds.,

Historic Painting Techniques, Materials, and Studio Practice (Marina Del Rey, 1995), pp. 148–54; and Jørgen Wadum, 'Contours of Vermeer' in Ivan Gaskell and Michiel Jonker, eds, *Vermeer Studies* (Studies in the History of Art, LV) (Washington, DC, 1998), pp. 201–23.

3 I owe this point to John Walsh jun.

4 For example, Edward A. Snow, *A Study of Vermeer* (Berkeley, 1979), p. 46: 'He looks a bit ridiculously cross-eyed . . .' (also Edward A. Snow, *A Study of Vermeer*, rev. and enlarged edn [Berkeley, 1994], p. 48).

5 Plato, discussed in the previous chapter, supposes the ideal discrete entities to be man and boy.

6 See, for example, Mieke Bal, *Double Exposures: The Subject of Cultural Analysis* (London and New York, 1996), pp. 87–134 (the author's patronizing treatment of Gary Tinterow, the curator at the Metropolitan Museum of Art, New York, whose installation of nineteenth-century French paintings she discusses, is breathtaking).

7 In 1998 Christopher Brown left the National Gallery to become director of the Ashmolean Museum, Oxford. The arrangement of Gallery 16 discussed below is essentially Brown's with some adjustments by his successors, David Jaffé and Axel Rüger, in 1999. See above, pp. 48–9, n. 16.

8 Given as 51.7 × 45.2 cm and 51.5 × 45.5 cm respectively in Neil MacLaren, *National Gallery Catalogues: The Dutch School 1600–1900*, rev. and expanded by Christopher Brown (London, 1991), vol. 1, pp. 466, 468.

9 Identified by Marieke de Winkel, 'The Interpretation of Dress in Vermeer's Paintings' in Gaskell and Jonker, *Vermeer Studies*, p. 330.

10 All these points were made by Swillens, *Johannes Vermeer*, p. 109.

11 The prime version is in the Museum of Fine Arts, Boston. The painting also appears in the background of the *Concert* (Isabella Stewart Gardner Museum, Boston; stolen 1990).

12 Brown notes that this interpretation was proposed in a paper given by Carol Armstrong at the Frick Collection, New York in 1976 (MacLaren, rev. Brown, *The Dutch School*, vol. 1, pp. 466–7).

13 For instance, Wheelock, *Johannes Vermeer*, p. 200.

14 Blankert, Montias and Aillaud, *Vermeer*, p. 148.

15 For the provenances, see MacLaren, rev. Brown, *The Dutch School*, vol. 1, pp. 467, 469; and Frances Suzman Jowell, 'Vermeer and Thoré-Bürger: Recoveries of Reputation' in Gaskell and Jonker, *Vermeer Studies*, p. 41, for the additional information that Thoré acquired the *Woman Standing at a Virginal* between 1860 and 1862 from the German dealer Otto Mündler.

16 The attribution of this comparison to Fry was made by David Jaffé, Senior Curator, National Gallery, London (conversation, 19 August 1999). Although highly plausible, neither of us has been able to identify the precise source.

17 John Nash, *Vermeer* (London, 1991), p. 118.

18 See above.

19 Victor I. Stoichita, *The Self-Aware Image: An Insight into Early Modern Meta-Painting*, trans. Anne-Marie Glasheen (Cambridge, 1997), p. 165.

20 Andrew Graham-Dixon touched upon this quality when he wrote: 'Vermeer's illusionistic virtuosity carries with it the knowledge that all illusionism, in painting, is a lie. No other realist has ever presented the real in so many different, competing registers, so variably faithful to fact. To see this even more clearly than in *Street in Delft*, consult the National Gallery's later *Woman Seated at a Virginal*. This is a painting which, in its varyingly achieved treatment of different illusionistic surfaces – the *faux marbre* of the virginal, the painting on the wall behind the young woman, the patterned curtain to one side – seems devoted to a demonstration of the partial correspondence of all painted illusions to the realities they mimic' (Andrew Graham-Dixon, 'Vermeer and de Hooch' [originally published in

Independent, 28 July 1992] in *Paper Museum: Writings about Paintings, Mostly* [New York, 1997], p. 276).

4 COPIES

1 Elizabeth Bakewell, William O. Beeman, Carol McMichael Reese and Marilyn Schmitt, general eds, *Object, Image, Inquiry: The Art Historian at Work* (Santa Monica, 1988); this is an analytical study of working methods derived from interviews with eighteen scholars chosen to represent a broad sampling of art historians active in research in America and Europe from research centres, teaching institutions and museums (p. 3).
2 *Ibid.*, pp. 7, 8, 22.
3 *Ibid.*, p. 22.
4 'Part of what is wrong with traditional art history is that . . . historians work from photographs rather than from actual objects of art . . . [they] lose touch with what's wrong with . . . the slide itself' (*ibid.*, p. 11 [original ellipses and parenthesis]).
5 David Carrier, review of Norman Bryson, *Vision and Painting: The Logic of the Gaze* (1983) in *Art in America*, LXXI/11 (1983), p. 13 (emphasis added).
6 Conversation, 1 October 1998.
7 Nelson Goodman, *Ways of Worldmaking* (Indianapolis, 1978), pp. 67–8, where he proposes five symptoms of the aesthetic, including '(1) syntactic density, where the finest differences in certain respects constitute a difference between symbols – for example, an ungraduated mercury thermometer as contrasted with an electronic digital-read-out instrument'.
8 Bakewell *et al.*, *Object, Image, Inquiry*, p. 12.
9 For an example of the latter, see Donald Preziosi, *Rethinking Art History: Meditations on a Coy Science* (New Haven and London, 1989), p. 72.
10 Bakewell *et al.*, *Object, Image, Inquiry*, p. 19.
11 Anthony Hamber, 'The Use of Photography by Nineteenth-Century Art Historians' in Helene E. Roberts, ed., *Art History Through the Camera's Lens* (*Documenting the Image*, II) (n.p., 1995), p. 103.
12 J. C. Robinson, *A Critical Account of the Drawings by Michel Angelo and Rafaello in the University Galleries, Oxford* (Oxford, 1870), cited by Hamber, 'The Use of Photography by Nineteenth-Century Art Historians', p. 107.
13 Francis Haskell, *Rediscoveries in Art: Some Aspects of Taste, Fashion and Collecting in England and France* (Oxford, 1976), pp. 203–4, n. 75. For Robinson's troubled career, see (in addition to Haskell) Malcolm Baker and Brenda Richardson, eds, *A Grand Design: The Art of the Victoria & Albert Museum*, exh. cat., Baltimore Museum of Art, Museum of Fine Arts, Boston, Royal Ontario Museum, Toronto, Museum of Fine Arts, Houston, Fine Arts Museums of San Francisco and Victoria & Albert Museum, London (New York, 1997), pp. 27–31 and 151–9, with further references.
14 Pierre Rosenberg, 'Federico Zeri, an Independent Mind', *Art Newspaper*, 86 (November 1998), p. 7.
15 Bakewell *et al.*, *Object, Image, Inquiry*, p. 16.
16 Rosenberg, 'Federigo Zeri', p. 7.
17 For one attempt, see Ivan Gaskell, 'History of Images' in Peter Burke, ed., *New Perspectives on Historical Writing* (Cambridge, 1991), pp. 173–8.
18 Rosenberg, 'Federigo Zeri', p. 7.
19 Trevor Fawcett, 'Visual Facts and the Nineteenth-Century Art Lecture', *Art History*, VI (1983), p. 452.
20 The educational potential of lantern slide reproductions of works of art was recognized and discussed at an early date: 'Another advantage of this mode of exhibiting photographs is, that they may be exhibited before large audiences at the same time. What a powerful auxiliary, then, may this not be destined to become in the business of education!' (J. J. Mellor, 'Shadows

in a New Light', *Chambers's Journal*, XII [12 July 1859], p. 29). David Brooke
was kind enough to give me a copy of this article.

21 Fawcett, 'Visual Facts and the Nineteenth-Century Art Lecture', pp. 456–7.

22 Bakewell *et al.*, *Object, Image, Inquiry*, p. 61 (square brackets as in original).

23 *Ibid.*, p. 67.

24 Svetlana Alpers and Michael Baxandall, *Tiepolo and the Pictorial Intelligence*
(New Haven and London, 1994), pp. 107–10.

25 I recall Michael Baxandall telling me over lunch at the Warburg Institute,
c. 1982, that he was about to return to Würzburg specifically to study this
delivery of light.

26 Peter Hecht, *De Hollandse fijnschilders van Gerard Dou tot Adriaen van der
Werff*, exh. cat., Rijksmuseum Amsterdam (Maarssen and Amsterdam,
1989), p. 205.

27 Gustave Glück, *Van Dyck: Des Meisters Gemälde in 571 Abbildungen*, 2nd edn
(*Klassiker der Kunst in Gesamtausgeben*, XIII) (Stuttgart and Berlin, 1931),
p. 266, ill.

28 *Chefs d'Oeuvres de la collection Bentinck-Thyssen*, exh. cat., Nihonbashi
Takashimaya Art Galleries, Tokyo, Kumamoto Prefectural Museum of Art,
Art Museum 'Toyama Kenminkaikan', Toyama and Miyagi Museum of Art
(n.p., 1986), cat. no. 21, col. ill. p. 39; Sotheby's, London, 6 December 1995,
lot 92.

29 Trevor Fawcett, 'Graphic Versus Photographic in the Nineteenth-Century
Reproduction', *Art History*, IX (1986), pp. 188–208. See also Wolfgang M.
Freitag, 'Early Uses of Photography in the History of Art', *Art Journal*,
XXXIX (1979–80), pp. 117–23, who addresses the doubts of several scholars
concerning photographic reproductions, including those of Wölfflin.

30 Fawcett, 'Graphic Versus Photographic in the Nineteenth-Century
Reproduction', pp. 201–2, quoting William Lake Price, *Manual of
Photographic Manipulation*, 1868, pp. 215–16: 'The effects of the colours, as
seen in the picture, may probably be transposed in the photograph, and
thus a light yellow drapery in the high light of the composition, and a
deep blue in the dark portion will, in the photographic copy, produce
startling and precisely opposite effects from those that they did in the
original . . .' See also Philippe Burty, 'Exposition de la Société française
de photographie', *Gazette des Beaux-Arts*, II (1859), p. 211: 'Le jaune vient
au noir, ainsi que le vert; le rouge, au contraire, et le bleu viennent en
blanc.'

31 Bernard Berenson, 'Isochromatic Photography and Venetian Pictures', *The
Nation*, LVII/1480 (November 1893), pp. 346–7, reprinted in Roberts, *Art
History Through the Camera's Lens*, pp. 127–31.

32 Richard Shiff, 'Phototropism (Figuring the Proper)' in *Retaining the
Original: Multiple Originals, Copies, and Reproductions* (*Studies in the History
of Art*, XX) (Washington, DC, 1989), p. 161.

33 Bakewell *et al.*, *Object, Image, Inquiry*, p. 14.

34 Charles Simic and Jennifer R. Gross, intro. Jill S. Medvedow, *Abelardo
Morell. Face to Face: Photographs at the Gardner Museum*, exh. cat., Isabella
Stewart Gardner Museum (Boston, 1998), ill. p. 49.

35 Fawcett, 'Graphic Versus Photographic in the Nineteenth-Century
Reproduction'; see also Roberts, *Art History Through the Camera's Lens*.

36 Fawcett gives the example of Eugène Delacroix in 1853 losing confidence
in Marcantonio Raimondi's engravings after Raphael after having seen
photographic reproductions (Fawcett, 'Graphic Versus Photographic in the
Nineteenth-Century Reproduction', p. 188).

37 The term is the late Jan Białostocki's.

38 Jean Baudrillard, *Simulations*, trans. Paul Fosse, Paul Patton and Philip
Beitchman (New York, 1983), pp. 83–6.

39 Daniel L. Schacter, *Searching for Memory: The Brain, the Mind, and the Past*

(New York, 1996), esp. pp. 39–71, 'Building Memories: Encoding and
Retrieving the Present and the Past'.

40 *Ibid.*, pp. 46–52.

5 ETCHINGS

1 In this discussion I shall use the now customary dual name Thoré-Bürger
which signifies that Thoré's adoption of the pseudonym marked a break
with his earlier predominantly political identity and, rather than being a
mere expedient device, constituted a radical self-fashioning.

2 For an influential account of Vermeer's rediscovery, see Francis Haskell,
*Rediscoveries in Art: Some Aspects of Taste, Fashion and Collecting in England
and France* (Oxford, 1976), pp. 32–8, 146–50. Another account is given by
Jakob Rosenberg, *On Quality in Art: Criteria of Excellence, Past and Present*
(*Bollingen Series*, XXXV/13) (Princeton, NJ, 1967), pp. 67–98. Frances Suzman
Jowell has been Thoré-Bürger's most able apologist: see Frances Suzman
Jowell, 'Thoré-Bürger and Vermeer: Critical and Commercial Fortunes' in
Cynthia P. Schneider, William W. Robinson and Alice I. Davies, eds, *Shop
Talk: Studies in Honor of Seymour Slive* (Cambridge, MA, 1995), pp. 124–7;
Frances Suzman Jowell, 'Thoré-Bürger – A Critical Role in the Art Market'
(*Documents for the History of Collecting*, XXI), *Burlington Magazine*, CXXXVIII
(1996), pp. 115–29; and Frances Suzman Jowell, 'Vermeer and Thoré-
Bürger: Recoveries of Reputation' in Ivan Gaskell and Michiel Jonker, eds,
Vermeer Studies (*Studies in the History of Art*, LV) (Washington, DC, 1998),
pp. 35–57. She disposes of Ben Broos's claim that the need for Vermeer's
rediscovery has been exaggerated (Ben Broos, '"Un celebre Peijntre nommé
Verme[e]r"' in Arthur K. Wheelock jun., ed., *Johannes Vermeer*, exh. cat.,
National Gallery of Art, Washington, DC and Royal Cabinet of Paintings
Mauritshuis, The Hague [Washington, DC, 1995], pp. 47–65; Ben Broos,
'Vermeer: Malice and Misconception' in Gaskell and Jonker, *Vermeer
Studies*, pp. 19–33). She rightly subscribes to Meltzoff's opinion, published
as long ago as 1942, which seems incontestable. He noted that Vermeer was
indeed known in Holland, though adding, 'but none of the Dutch scholars
bothered to reconstruct his work, and the opinion of the Dutch on their
own masters did not affect the centers of taste' (Stanley Meltzoff, 'The
Rediscovery of Vermeer', *Marsyas*, II [1942], p. 160).

3 For the story of the acquisition and new provenance information, see
Wheelock, *Johannes Vermeer*, pp. 124–6.

4 Under 'Pupils and Imitators of Gabriel Metsu' Smith noted: 'Writers
appear to have been entirely ignorant of the works of this excellent artist,
[whose] pictures are treated with much of the elegance of Metsu mingled
with a little of the manner of De Hooge' (John Smith, *A Catalogue of the
Works of the Most Eminent Dutch, Flemish and French Painters* [London,
1829–42], vol. 4, p. 110); and under 'Pupils and Imitators of Peter de
Hooge' he stated: 'This master is so little known, by reason of the scarcity
of his works, that it is quite inexplicable how he attained the excellence
many of them exhibit' (*ibid.*, p. 242). See also the discussion by Albert
Blankert (with contributions by Rob Ruurs and Willem van de Watering),
Vermeer of Delft: Complete Edition of the Paintings, trans. Gary Schwartz *et al.*
(Oxford, 1978), p. 67.

5 For example: Gérard de Nerval, 'Les fêtes de mai en Hollande', *Revue des
deux mondes* (15 June 1853), and Maxime du Camp, *En Hollande: lettres à un
ami, suivies des catalogues des musées de Rotterdam, La Haye et Amsterdam*
(Paris, 1859). On the effect of the opening of rail services between France,
Belgium and the Netherlands, see Meltzoff, 'The Rediscovery of Vermeer',
pp. 147–8, and Christiane Hertel, *Vermeer: Reception and Interpretation*
(Cambridge, 1996), pp. 83–92.

6 'Amsterdam [8 septembre 1861]. Hier, en chemin de fer, je regardais dormir en face de moi, un jeune homme. J'étudiais la valeur d'un coup de soleil sur sa figure, avec la densité de l'ombre portée par la visière de sa casquette. En arrivant devant le Rembrandt qu'on est convenu d'appeler la RONDE DE NUIT, j'ai retrouvé le même effet' (Edmond de Goncourt and Jules de Goncourt, *Journal: mémoires de la vie littéraire*, ed. Robert Ricatte [Monaco, 1956–8], vol. 4, p. 233). This example accords with Georg Simmel's observation, quoted and discussed by Walter Benjamin, that 'Before the development of buses, railroads, and trams in the nineteenth century, people had never been in a position of having to look at one another for long minutes or even hours without speaking to each other' (Walter Benjamin, *Charles Baudelaire: A Lyric Poet in the Era of High Capitalism*, trans. Harry Zohn [from various original texts] [London, 1973], 'The Paris of the Second Empire in Baudelaire', p. 38, quoting Georg Simmel, *Soziologie*, 4th edn [Berlin, 1958], p. 486). Such conditions made possible, *inter alia*, Honoré Daumier's depictions of the interiors of railroad carriages.

7 Albert Blankert (with contributions by Rob Ruurs and Willem van de Watering), *Johannes Vermeer van Delft 1632–1675* (Utrecht and Antwerp, 1975), p. 157, no. 6, citing Smith's copy of the *Catalogue des tableaux de la Galérie Royale de Dresde*, 1826, p. 74, no. 486, in the Rijksbureau voor Kunsthistorische Documentatie, The Hague.

8 Gustav F. Waagen, *Einige Bemerkungen über die Aufstellung, Beleuchtung und Catalogisirung der Königlichen Gemäldegalerie zu Dresden* (Berlin, 1858), pp. 35–6; acknowledged by Thoré-Bürger (W. Burger [pseud. Théophile Thoré], *Musées de la Hollande. II. Musée Van der Hoop, à Amsterdam et Musée de Rotterdam* [Paris, 1860], p. 75).

9 W. Burger [pseud. Théophile Thoré], *Musées de la Hollande: Amsterdam et La Haye. Etudes sur l'école hollandaise* (Paris, 1858), pp. 272–3.

10 W. Burger [pseud. Théophile Thoré], *Etudes sur les peintres hollandais et flamands: Galérie d'Arenberg à Bruxelles, avec le catalogue complet de la collection* (Paris, Brussels and Leipzig, 1859). He reported that the original article was reprinted by the journal *L'Artiste* in Paris and by several German periodicals; also that the catalogue first appeared in the *Revue universelle des Arts* (p. 9).

11 Burger [Thoré], *Galérie d'Arenberg*, p. 27: 'Mais voici un autre grand artiste, un original incomparable, un inconnu de génie, bien plus inconnu que Nicolaas Maes et Philip Koninck, et qui peut-être a plus de génie qu'eux, et qui, comme eux, se rattache aussi, selon moi, à Rembrandt.'

12 *Ibid.*, p. 32: '. . . il faut espérer que *l'Indépendence*, qui va partout, nous en apportera des nouvelles'.

13 Léon Lagrange, 'Mouvement des arts et de la curiosité', *Gazette des Beaux-Arts*, II (1859), p. 60: 'Dans sa revue de la Galérie d'Arenberg, publiée par II *l'Indépendence belge*, M. W. Burger parlait longuement du peintre hollandais Jan Van der Meer (de Delft), un de ces grands talents éclipsés à l'ombre des grands génies. Il cite le peu d'oeuvres connues de lui et fait appel à ceux qui connaîtraient d'autres. M. Dufour possède un tableau de Jan Van de Meer.'

14 Burger [Thoré], *Galérie d'Arenberg*, p. 32n.

15 Burger [Thoré], *Musées de la Hollande. II*, pp. 67–8. For the Museum Van der Hoop and the *Woman in Blue Reading a Letter*, see Wheelock, *Johannes Vermeer*, p. 138.

16 Illustrated by Jowell, 'Vermeer and Thoré-Bürger: Recoveries of Reputation', p. 38 fig. 7.

17 W. Bürger [pseud. Théophile Thoré], *Galérie Suermondt à Aix-la-Chapelle, avec le catalogue de la collection par le Dr Waagen, traduit par W.B.* (Brussels, 1860), pp. 34–41; Waagen's catalogue entry (no. 55) giving the painting to Koninck is at pp. 152–3.

18 Burger [Thoré], *Musées de la Hollande. II*, pp. 81–8, citing Gerard Hoet and Pieter Terwesten, *Catalogus of naamlyst van schilderyen, met dezelver pryzen*, 3 vols (The Hague, 1752–70).

19 Paul Mantz, 'Collections d'amateurs. I. Le Cabinet de M. A. Dumont, à Cambrai', *Gazette des Beaux-Arts*, II (1860), pp. 304–5.

20 Charles Blanc, *Histoire des peintres de toutes les écoles: Ecole Hollandaise* (Paris, 1861), vol. 2, p. 2: 'Malheureusement, Van der Meer de Delft est fort peu connu; ses rares ouvrages n'ont jamais été gravés, et depuis Lebrun, personne en France n'avait prononcé son nom, si ce n'est Gault de Saint-Germain, qui l'a confondu avec l'élève de Berghem, Jean van der Meer, de Jonghe, natif de Harlem (selon van Gool). Mais les erreurs commises par Gault de Saint-Germain ont été fort bien redressées part M. W. Bürger, qui, dans ses *Musées de la Hollande*, a eu l'honneur de réhabiliter, ou pour parler plus juste, de restituer le nom et les oeuvres de Jean Van der Meer, de Delft.'

21 Jean-Baptiste-Pierre Le Brun, *Galérie des peintres flamands, hollandais et allemands* (Paris, 1792–6), vol. 2, p. 49. For Le Brun, see Haskell, *Rediscoveries in Art*, pp. 25–38.

22 Jean-Baptiste-Pierre Le Brun, *Recueil de gravures au trait, à l'eau forte et ombrées d'après un choix de tableaux, de toutes les écoles, recueillies dans un voyage fait en Espagne, au midi de la France et en Italie dans les années 1807 et 1808* (Paris, 1809), vol. 2, no. 166.

23 Its existence was noted by Mantz in a footnote: 'J'ajouterai que ce petit *Géographe* est le pendant d'un certain *Géomètre* [the *Astronomer*], gravé par Garreau, en 1784, dans le galérie Lebrun' (Mantz, 'Collections d'amateurs. I', p. 305, n. 1).

24 Burger [Thoré], *Musées de la Hollande. II*, p. 79.

25 For example, that on the *Portrait of a Young Woman*: Burger [Thoré], *Galérie d'Arenberg*, p. 35.

26 Burger [Thoré], *Musées de la Hollande. II*, p. 68: 'Ce diable d'artiste a eu sans doute des manières diverses.'

27 *Ibid.*, p. 70: 'Nous ne l'avons pas vu non plus; mais, d'après des témoignages très-compétents, c'est un Delftsche incontestable.'

28 W. Bürger [pseud. Théophile Thoré], 'Van der Meer de Delft', *Gazette des Beaux-Arts*, XXI (1866), p. 299: '[P]our obtenir une photographie de tel Vermeer, j'ai fait des folies.'

29 *Ibid.*: he mentions having photographs of paintings catalogued as nos. 2, 3, 5, 6, 7, 8, 13, 28, 32, 34, 35, 49 and 50.

30 Petra ten Doesschate Chu, *French Realism and the Dutch Masters: The Influence of Dutch Seventeenth-Century Painting on the Development of French Painting Between 1830 and 1870* (Utrecht, 1974), p. 7.

31 Mattie Boom, 'Een geschiedenis van het gebruik en verzamelen van foto's in de negentiende eeuw' in *Voor Nederland bewaard: de verzamelingen van het Koninklijk Oudheidkundig Genootschap in het Rijksmuseum* (*Leidse Kunsthistorisch Jaarboek*, X, 1995), p. 282.

32 Philippe Burty, 'Exposition de la Société française de photographie', *Gazette des Beaux-Arts*, II (1859), p. 211: 'La photographie est impersonelle; elle n'interpète pas, elle copie; là est sa faiblesse comme sa force, car elle rend avec la même indifférence le détail oiseu et ce rien à peine visible, à peine sensible, qui donne l'âme et fait la ressemblance . . . mais elle s'arrête à l'idéalisation, et c'est là justement que commence le rôle du graveur et du lithographe de talent.'

33 Philippe Burty, 'La Gravure, la lithographie et la photographie au Salon de 1865', *Gazette des Beaux-Arts*, XIX (1865), p. 93: 'Il est une autre raison pour que nous le suivions avec tant de persistance: c'est l'intérêt immédiat qu'il peut offrir demain à notre public, si les tentatives pour transformer un cliché photographique en cliché d'impression sur métal ou sur pierre, viennent aboutir à des résultats pratiques . . .'

34 Bürger [Thoré], 'Van der Meer de Delft', opp. p. 298. The drawing is in the
Städelsches Kunstinstitut, Frankfurt-am-Main: see Blankert, *Johannes
Vermeer van Delft 1632–1675*, p. 159.

35 Bürger [Thoré], 'Van der Meer de Delft', pp. 325, 561.

36 *Ibid.*, pp. 563, 565.

37 *Ibid.*, opp. p. 569.

38 *Ibid.*, opp. p. 462.

39 *Ibid.*, opp. p. 326.

40 'Nous verrons: si on met des Vermeer, j'en mettrai peut-être alors une ving-
taine, pour décider la réputation' (Jowell, 'Thoré-Bürger – A Critical Role
in the Art Market', p. 126: appen. B, letter 9).

41 On the Exposition rétrospective, see Francis Haskell, 'Old Master
Exhibitions and the Second "Rediscovery of the Primitives"', in *Hommage
à Michel Laclotte: Etudes sur la peinture du Moyen Age et de la Renaissance*
(Milan and Paris, 1994), p. 554; Jowell, 'Thoré-Bürger – A Critical Role in
the Art Market', p. 116; and Jowell, 'Vermeer and Thoré-Bürger: Recoveries
of Reputation', pp. 35–9.

42 The third edition of the catalogue lists 293 paintings: *Exposition rétro-
spective: tableaux anciens empruntés aux galeries particulières*, Palais des
Champs-Elysées, 3ᵉ édition, avec nouveau supplement (Paris, juillet 1866),
in-8° de 86 pages, 293 numéros.

43 The Vrel *Street Scene* is in the J. Paul Getty Museum, Los Angeles (illus-
trated in Jowell, 'Vermeer and Thoré-Bürger: Recoveries of Reputation',
p. 38, fig. 5); the whereabouts of the other three in this category are
unknown (*ibid.*, p. 39, n. 11 with details).

44 *A View of Dunes* (Staatliche Museen zu Berlin, Gemäldegalerie) also
belonged to Barthold Suermondt (it is now recognized as by Dirk Jan van
der Meer; illustrated by Jowell, 'Vermeer and Thoré-Bürger: Recoveries of
Reputation', p. 38, fig. 6), and a *Panoramic Landscape* (whereabouts unknown)
belonged to the Grand Duchess Maria of Russia (*ibid.*, p. 39, n. 12 with
details).

45 See Jowell's discussion of contemporary published critical responses to
Vermeer as seen at the Exposition rétrospective (*ibid.*, pp. 35–9).

46 Quoted *ibid.*, p. 38 (her translation): 'Hier encore, ses mérites si nombreux
n'étaient goûtés que de plus petit nombre – et nous ne croyons point
exagérer en disant que *le Salon rétrospectif* l'a mis en lumière' (n. 8).

47 See Chu, *French Realism and the Dutch Masters*, pp. 9–14; also Haskell,
Rediscoveries in Art, pp. 146–51, and Jowell, 'Thoré-Bürger – A Critical Role
in the Art Market', p. 115, n. 1, both with further references.

48 Champfleury [pseud.], *Les peintres de la réalité sous Louis XIII: les Frères Le
Nain* (Paris, 1862), p. 4: 'Vous êtes revenu, après un long séjour à l'étranger,
apporter votre netteté d'impression dans la discussion du réel; et ainsi que
la nouvelle école de critique qui se base sur le positif, vous avez signalé les
oeuvres curieuses perdues dans les cabinets de l'étranger, leurs charactères
distinctifs en recouvrant ces exactes constatations d'une esthétique hardie
et pleine d'indépendence.'

49 See the editorial, 'In Praise of Positivism', *Burlington Magazine*, CXXXVIII
(1996), p. 299.

50 Jowell, 'Vermeer and Thoré-Bürger: Recoveries of Reputation', p. 41.

51 Neil MacLaren, *National Gallery Catalogues: The Dutch School 1600–1900*, rev.
and expanded by Christopher Brown (London, 1991), vol. 1, p. 467, giving
the provenance as it was established to that date.

52 Henri Béraldi, *Les graveurs du XIXe siècle: guide de l'amateur d'estampes mod-
ernes* (Paris, 1892), vol. 12, p. 169.

53 Wheelock, *Johannes Vermeer*, p. 199, fig. 2.

54 I am obliged to Rick Brettell for immediately confirming that my own eyes
were not playing tricks on me when I first made this observation.

55 In doing so I am not disagreeing by implication with Jonathan Crary's reasonable point that 'paintings were produced and assumed meaning not in some impossible kind of aesthetic isolation, or in a continuous tradition of painterly codes, but as one of many consumable and fleeting elements within an expanding chaos of images, commodities, and stimulation' (Jonathan Crary, *Techniques of the Observer: On Vision and Modernity in the Nineteenth Century* [Cambridge, MA and London, 1990], p. 20). I am simply seeking to demonstrate the detailed functioning of one constituent among many in the circulation of the visual in 1866 and the years immediately following.

56 See, among others, T. J. Clark, *The Painting of Modern Life: Paris in the Art of Manet and His Followers* (New York, 1985), pp. 79–146; Hollis Clayson, *Painted Love: Prostitution in French Art of the Impressionist Era* (New Haven and London, 1991); Griselda Pollock, 'The Gaze and The Look: *Women with Binoculars* – A Question of Difference' in Richard Kendall and Griselda Pollock, eds, *Dealing with Degas: Representations of Women and the Politics of Vision* (New York, 1991), pp. 106–25; Griselda Pollock, 'Beholding Art History: Vision, Place, Power' in Stephen Melville and Bill Readings, eds, *Vision and Textuality* (Durham, NC, 1995), pp. 53–6.

57 Published in *L'Artiste*, 1 June 1868: illustrated by Clark, *The Painting of Modern Life*, p. 114, fig. 37.

58 T. Thoré, *Salons de W. Bürger avec une préface par T. Thoré*, 2 vols (Paris, 1870), vol. 2, 'Exposition universelle de 1867', p. 378.

59 *Ibid.*, p. 380: 'L'insignifiance des sujets dans ces tableaux a donc sa significa-tion, parfaitement expressive des moeurs de la société aristocratique et même bourgeoise.'

60 *Ibid.*, pp. 380–81.

61 William A. Coles, *Alfred Stevens*, exh. cat., University of Michigan Museum of Art, Ann Arbor, Walters Art Gallery, Baltimore and Musée des Beaux-Arts, Montreal (Ann Arbor, 1977), p. 15, no. 7, ill. p. 14.

62 For instance, in the letter to Suermondt cited above, p. 128 and n. 40 (Jowell, 'Thoré-Bürger – A Critical Role in the Art Market', p. 126: appen. B, letter 9).

63 Coles, *Alfred Stevens*, p. 15.

64 For the use of the title in Walloon (and presumably in wider French usage) to connote priggishness, see Charlotte Brontë, *Villette* (1853): '"Voyez-vous!" cried she, "comme elle est propre cette demoiselle Lucie! Vous aimez donc cette allée, Meess?"' (London, 1973), p. 101, and '"C'est cela!" said a voice. "Je la connais; c'est l'Anglaise. Tant pis. Tout Anglaise, et, par conséquent, toute bégeule qu'elle soit – elle fera mon affaire, ou je saurai pourquoi"' (p. 126).

65 Bürger [Thoré], 'Van der Meer de Delft', p. 460.

66 Pollock, 'Beholding Art History', p. 53.

67 'Vous êtes lié, je crois, avec Whistler. Quelle belle peinture, *Au Piano*, no. 1561. Ah, que je voudrais avoir ça pour mettre au milieu de mes vieux maîtres . . . Si le prix n'est pas effrayent, pour un artiste comme moi, je tâcherai [d'acheter?] cette peinture qui s'arrengera très bien avec mes Van der Meers de Delft': Thoré-Bürger to Manet (Glasgow University Library, Birnie Philip Bequest, BP II 452), quoted by Chu, *French Realism and the Dutch Masters*, p. 47. The painting was not available. It had been bought by John Phillip, RA following its successful exhibition at the Royal Academy, London in 1860.

68 Thoré, *Salons de W. Bürger*, vol. 2, p. 206, 'Salon de 1865': 'Qui encourage l'art mythologique et l'art mystique, les Oedipe et les Vénus, ou les madones et les saints en extase? ce qui ont intérêt à ce que l'art ne signifie rien et ne touch pas aux aspirations modernes. Qui encourage les nymphs et les galantes scènes Pompadour? le Jockey-Club et le boulevard Italien. A

qui vend-on ces tableaux? aux courtisans et aux enrichis de la Bourse, aux dissipateurs d'une aristocratie exceptionelle.'

6 PHOTOGRAPHS

1 Petra ten Doesschate Chu, *French Realism and the Dutch Masters: The Influence of Dutch Seventeenth-Century Painting on the Development of French Painting Between 1830 and 1870* (Utrecht, 1974), p. 11.

2 Johann David Passavant, *Rafael von Urbino und sein Vater Giovanni Santi*, 3 vols (Leipzig, 1839–58).

3 J. C. Robinson, *A Critical Account of the Drawings by Michel Angelo and Rafaello in the University Galleries, Oxford* (Oxford, 1870), quoted by Anthony Hamber, 'The Use of Photography by Nineteenth-Century Art Historians' in Helene E. Roberts, ed., *Art History Through the Camera's Lens* (*Documenting the Image*, II) (n.p., 1995), p. 107.

4 W. Burger [pseud. Théophile Thoré], *Musées de la Hollande. II. Musée Van der Hoop, à Amsterdam et Musée de Rotterdam* (Paris, 1860), p. 323.

5 William Henry Fox Talbot, *The Pencil of Nature* (London, 1844–6), opposite pl. VI.

6 Roland Barthes, 'The Photographic Message' (first published as 'Le message photographique', *Communications*, I, 1961) in *Image–Music–Text*, selected by and trans. Stephen Heath (London, 1977), p. 17 (original emphasis).

7 De Saint-Santin, 'De quelques arts qui s'en vont', *Gazette des Beaux-Arts*, XIX (1865), p. 316: '[L]a photographie, toute sotte qu'elle soit, est un miroir, une émanation brute, mais directe, de l'oeuvre créée, et qu'elle ne pourrait nous tromper.'

8 Carl Chiarenza, 'Notes on Aesthetic Relationships Between Seventeenth-Century Dutch Painting and Nineteenth-Century Photography' in Van Deren Coke, ed., *One Hundred Years of Photographic History: Essays in Honor of Beaumont Newhall* (Albuquerque, 1975), pp. 20, 22.

9 Svetlana Alpers, *The Art of Describing: Dutch Art in the Seventeenth Century* (Chicago, 1983), p. 43.

10 Martin Jay, 'Photo-Unrealism: The Contribution of the Camera to the Crisis of Ocularcentrism' in Stephen Melville and Bill Readings, eds, *Vision and Textuality* (Durham, NC, 1995), p. 348. See also Peter Galassi, *Before Photography: Painting and the Invention of Photography*, exh. cat., Museum of Modern Art, New York, Joslyn Art Museum, Omaha, Frederick S. Wight Art Gallery, University of California, Los Angeles and the Art Institute of Chicago (New York, 1981).

11 Jay, 'Photo-Unrealism', p. 348.

12 Lawrence Gowing, *Vermeer*, 3rd edn (Berkeley, 1997), p. 110. In his entry for 11 September 1861, Goncourt wrote: 'LA LAITIERE de Van der Meer. Maître étonnant, plus grand que les Terburg, les Metzus, les meilleurs du petits tableaux. L'idéal de Chardin, un beurre merveilleux, une puissance à laquelle il n'a jamais atteint. Même touche au gros point fondu dans la masse. Empâtement rugneux sur les accessoires. Fond blanchâtre neutre, admirablement dégradé dans la demi-teints. Picotement de touches; presque le même système de petits empâtements juxtaposés, une égrenure beurrée; picotement des bleus dans les chairs, des rouges. – Panier d'osier au fond; table tapis vert; linge bleu; fromage; cruches de grès bleu rocailleux; vase d'où elle verse, rouge; versant dans un autre vase, rouge brun' (Edmond de Goncourt and Jules de Goncourt, *Journal: mémoires de la vie littéraire*, ed. Robert Ricatte [Monaco, 1956–8], vol. 4, p. 236).

13 'Une RUE DE DELFT: le seul maître qui ait fait de la maison briquée du pays un daguerréotype animé par l'esprit' (de Goncourt and de Goncourt, *Journal*, vol. 4, p. 236).

14 A. Hyatt-Mayor, 'The Photographic Eye', *Metropolitan Museum of Art Bulletin*, v (Summer 1946), pp. 15–26. The principal subsequent studies are P.T.A. Swillens, *Johannes Vermeer: Painter of Delft, 1632–1675* (Utrecht and Brussels, 1950); Charles Seymour jun., 'Dark Chamber and Light-Filled Room: Vermeer and the Camera Obscura', *Art Bulletin*, XLVI (1964), pp. 323–31; Heinrich Schwartz, 'Vermeer and the Camera Obscura', *Pantheon*, XXIV (1966), pp. 170–80; Daniel A. Fink, 'Vermeer's Use of the Camera Obscura – A Comparative Study', *Art Bulletin*, LIII (1971), pp. 493–505; Arthur K. Wheelock jun., *Perspective, Optics, and Delft Artists Around 1650* (New York and London, 1977); and Arthur K. Wheelock jun., 'Constantijn Huygens and Early Attitudes Toward the Camera Obscura', *History of Photography*, I (1977), pp. 20–32.

15 'Ever since the Renaissance, artists and craftsmen had used the simple box camera – then called the camera obscura – as an aid to drawing. They traced the image formed by the lens on the ground glass of the camera. In the early years of the nineteenth century this skill of hand was replaced by what was picturesquely called "the pencil of nature": the capturing of the camera's image by photochemical means' (Beaumont Newhall, 'The Pencil of Nature' in Mike Weaver, ed., *The Art of Photography, 1839–1989*, exh. cat., Museum of Fine Arts, Houston, Australian National Gallery, Canberra and Royal Academy of Arts, London [New Haven and London, 1989], p. 12).

16 Gabriel Cromer, 'L'original de la note du peintre Paul Delaroche à Arago au sujet du Daguerréotype', *Bulletin de la société française de photographie et de cinématographie*, 3me sér. 17 (1930).

17 Huygens: 'It is impossible to express its beauty in words. The art of painting is dead, for this is life itself, or something higher, if we could find a word for it.' See Wheelock, *Perspective, Optics, and Delft Artists Around 1650*, p. 156, and Wheelock, 'Constantijn Huygens'.

18 Martin Kemp, *The Science of Art: Optical Themes in Western Art from Brunelleschi to Seurat* (New Haven and London, 1990), p. 192.

19 Swillens, *Johannes Vermeer*, pp. 70–75. For an interesting elaboration of Swillens's project, see Kevin Mount, 'The Love Letter', *Performance Research*, II/1 (1997), pp. 37–44.

20 The remaining five are the *Girl with the Wineglass* (Brunswick), the *Glass of Wine* (Berlin), the *Lady Writing a Letter with Her Maid* (Dublin), *The Music Lesson* (Her Majesty The Queen) and the *Concert* (Boston) (Kemp, *The Science of Art*, p. 194). Steadman published the material himself in Philip Steadman, with photographs by Trevor Yorke and Richard Hearne, 'In the Studio of Vermeer' in Richard Gregory, John Harris, Priscilla Heard and David Rose, eds, *The Artful Eye* (Oxford, 1995), pp. 353–72.

21 Kemp, *The Science of Art*, p. 196; Steadman, 'In the Studio of Vermeer', p. 358.

22 Kemp, *The Science of Art*, fig. 388.

23 *Ibid.*, figs 385–7; Steadman, 'In the Studio of Vermeer', pls 20–25.

24 Fred Dubery and John Willats, *Perspective and Other Drawing Systems*, rev. edn (London, 1983), pp. 74–9.

25 Jørgen Wadum, 'Vermeer in Perspective' in Arthur K. Wheelock jun., ed., *Johannes Vermeer*, exh. cat., National Gallery of Art, Washington, DC and Royal Cabinet of Paintings Mauritshuis, The Hague (Washington, DC, 1995), pp. 67–79; Jørgen Wadum, 'Johannes Vermeer (1632–1675) and His Use of Perspective' in Arie Wallert, Erma Hermens and Marja Peek, eds, *Historic Painting Techniques, Materials, and Studio Practice* (Marina Del Rey, 1995), pp. 148–54; Jørgen Wadum, 'Vermeer and Spatial Illusion' in Ton Brandenbarg and Rudi Ekkart, eds, *The Scholarly World of Vermeer*, exh. cat., Museum van het Boek/Museum Meermanno-Westreenianum, The Hague (Zwolle, 1996), pp. 31–49.

26 Kemp, *The Science of Art*, p. 193. See also Jørgen Wadum, 'Contours of Vermeer' and E. Melanie Gifford, 'Painting Light: Recent Observations on

Vermeer's Technique' both in Ivan Gaskell and Michiel Jonker, eds, *Vermeer Studies* (*Studies in the History of Art*, LV) (Washington, DC, 1998), pp. 201–13 and 185–99.

27 Kemp, *The Science of Art*, p. 193.

28 Other instances might be cited of Foucauldian epistemic ruptures breaking down when thoroughly tested against evidence. Its success in any given instance would appear to depend on the suppression of inconvenient counter-examples. (For an exemplary demonstration of the inadequacy of the Foucauldian model in this respect, see Lorraine Daston and Katharine Park, *Wonders and the Order of Nature, 1150–1750* [New York, 1998].) This is not to contend that ruptures are any less significant in determining the course of human behaviour than is continuity, nor to diminish the usefulness, when approached critically, of Michel Foucault's own work.

29 Walter Benjamin, 'On Some Motifs in Baudelaire' (originally published in *Zeitschrift für Sozialforschung*, VIII/1–2, 1939) in Hannah Arendt, ed., *Illuminations*, trans. Harry Zohn (London, 1973), pp. 176–7. His rhetoric depends, of course, on the technological state of photography in the 1890s, rather than in the 1860s, though that the simplification of the process in relation to manual means of depiction is relative means that the observation is not irrelevant to the early years of the technology.

30 Walter Benjamin, 'The Work of Art in the Age of Mechanical Reproduction' (originally published in *Zeitschrift für Sozialforschung*, V/1, 1936) in Arendt, *Illuminations*, pp. 219–53.

31 Or, as Jonathan Crary put it, 'Historical problems about vision are distinct from a history of representational artifacts' ('Visual Studies Questionnaire', *October*, LXXVII [1996], p. 33). I am grateful to Norman Bryson for referring me to this publication.

32 Pointed out by James Elkins, *The Poetics of Perspective* (Ithaca, NY and London, 1994). For example, many theorists base certain of their notions upon Jacques Lacan's diagrams concerning the constitution of the subject, on which Elkins writes, 'The lack of geometric criticism of Lacan's diagrams may be read in part as a sign that perspective's meanings have nearly evaporated' (p. 254). While notions derived from Lacan's texts can be helpful in more than incidental ways (see, for example, Hubert Damisch, *The Origin of Perspective*, trans. John Goodman [Cambridge, MA and London, 1994; first published as *L'origine de la perspective* (Paris, 1987)]), they are open to criticism on many counts. The most effective implicit critical commentary upon Lacan's key ideas is Groucho, Harpo and Chico Marx's enactment of the mirror scene in *Duck Soup* (1933; directed by Leo McCary, screenplay by Bert Kalmar, Harry Ruby, Arthur Sheekman and Nat Perrin). Of Freudian psychoanalysis in general, we should bear in mind a twentieth-century counter-tradition of scepticism articulated no more brilliantly than by Theodor Adorno, *Minima Moralia: Reflections from Damaged Life*, trans. E.F.N. Jephcott (London, 1978; 1st German edn, Frankfurt-am-Main, 1951), esp. §§37–9, pp. 60–66.

33 Erwin Panofsky, *Perspective as Symbolic Form*, trans. Christopher S. Wood (New York, 1997; first published as 'Die Perspektive als "symbolische Form"', *Vorträge der Bibliothek Warburg 1924–25* [Leipzig and Berlin 1927], pp. 258–330); Damisch, *The Origin of Perspective*; Samuel Y. Edgerton jun., *The Renaissance Discovery of Linear Perspective* (New York, 1975); Martin Heidegger, 'The Age of the World Picture' in *The Question Concerning Technology, and Other Essays*, trans. William Lovitt (New York, 1977); John White, *The Birth and Rebirth of Pictorial Space*, 3rd edn (Cambridge, MA, 1987); Kemp, *The Science of Art*; Elkins, *The Poetics of Perspective*.

34 Wadum, 'Vermeer in Perspective'; Wadum, 'Johannes Vermeer (1632–1675) and His Use of Perspective'; Wadum, 'Vermeer and Spatial Illusion'.

35 Christopher Braider, *Refiguring the Real: Picture and Modernity in Word and*

Image, 1400–1700 (Princeton, NJ, 1993), pp. 174–98, 'The Denuded Muse: The Unmasking of Point of View in the Cartesian Cogito and Vermeer's *The Art of Painting*'. On Cartesianism and perspective, see further Damisch, *The Origin of Perspective*. There is, of course, a vast philosophical literature on René Descartes's production, most of which he published during his long residence in Holland (1628–49).

36 The starting point is Aaron Scharf, *Art and Photography*, rev. edn (Harmondsworth, 1974).

37 On Shahn's use of photography in his painting process, see Kenneth Prescott's discussion in Kenneth W. Prescott, *Ben Shahn: A Retrospective, 1898–1969*, exh. cat., The Jewish Museum, New York, Georgia Museum of Art, University of Georgia, Athens, The Maurice Spertus Museum of Judaica, Chicago, University Art Museum, University of Texas, Austin, Cincinnati Art Museum and the Amon Carter Museum, Fort Worth (New York, 1976), esp. pp. 11–14, with comparative illustrations. Shahn's photography was first given serious attention by Davis Pratt: see Davis Pratt, *Ben Shahn as Photographer*, exh. cat., Fogg Art Museum, Harvard University (Cambridge, MA, 1969). A counter-example, demonstrating the use of photographs as source material for an abstracting precisionism in paint, would be the work of Shahn's contemporary, Charles Sheeler.

38 Charles W. Haxthausen, 'The Work of Art in the Age of its (Al)Chemical Transmutibility: Rethinking Painting and Photography After Polke' in Martin Hentschel and Sigmar Polke, eds., *Sigmar Polke: The Three Lies of Painting*, exh. cat., Kunst- und Ausstellungshalle der Bundesrepublik Deutschland in Bonn and Nationalgalerie im Hamburger Bahnhof, Museum für Gegenwart, Berlin, 1997–8 (as *Sigmar Polke: die drei Lügen der Malerei*) (Osfilden-Ruit, 1997), pp. 185–202 (rev. and expanded from *Photographie in der deutschen Gegenwartskunst* [Stuttgart, 1993]), with bibliographical details of Benjamin, 'The Work of Art in the Age of Mechanical Reproduction'.

39 Benjamin, 'The Work of Art in the Age of Mechanical Reproduction', p. 222.

40 Haxthausen, 'The Work of Art in the Age of its (Al)Chemical Transmutibility', p. 190.

41 Benjamin, 'The Work of Art in the Age of Mechanical Reproduction', p. 223.

42 Benjamin's essay remains hugely useful, but its employment to sanction a host of so-called Postmodern procedures in art practice and theory from the 1970s onwards of 'confiscation, quotation, excerptation, accumulation, and repetition of already existing images' (in Douglas Crimp's formulation: Douglas Crimp, *On the Museum's Ruins* [Cambridge, MA and London, 1993], p. 58) is based on misconception. Rather, Benjamin's essay might more profitably be read as an exercise in contemporary politics, expressing an urgent concern to discredit the appropriation of aesthetic terminology by fascism and Nazism in the production and discussion of film, in contradistinction to correct Soviet socialist procedure in that medium.

43 See Hentschel and Polke, *Sigmar Polke: The Three Lies of Painting*, ills pp. 235, 237, 238, 239, 240.

44 Haxthausen, 'The Work of Art in the Age of its (Al)Chemical Transmutibility', p. 201.

45 In several private conversations, artists who use what were once termed new media held that the reputedly misogynistic renditions of women by Willem de Kooning, in particular, discredited the very medium in which that artist worked.

46 From 1984 onwards in Britain the initiative in terms of exhibition and publishing in promoting and encouraging artists' (as distinct from photographers') use of photographic media was taken by the Cambridge Darkroom Gallery, Cambridge.

47 Having replaced architecture in that regard in the course of the sixteenth century.

48 Susan Hiller, *Thinking About Art: Conversations with Susan Hiller*, ed. Barbara Einzig (Manchester and New York, 1996), 'Beyond Control: A Conversation with Stuart Morgan' (first published in *Frieze*, 23 [1995], pp. 52–8), pp. 242–4, ills pp. 242, 250, 251. Of the importance of the specifically material and visual aspects of art, Hiller noted, 'At present in this country we have an untrue history of conceptualism which suggests it is totally language-based' (p. 244).

49 Ivan Gaskell, 'Photography and Art – What Next?', *Apollo*, cxxx (1989), p. 155.

50 Hiller, *Thinking About Art*, p. 167.

51 Richard Wollheim, *Painting as an Art* (*Bollingen Series*, xxxv / 33) (Princeton, NJ, 1987).

52 Benjamin, 'The Work of Art in the Age of Mechanical Reproduction', p. 238.

53 More properly, cinema is mixed media. Sound has always been essential, even before synchronized sound recording was introduced. One might even consider cinema as no less uniquely material than any other art by taking into account specific conditions of projection and viewing.

54 Nelson Goodman, *Ways of Worldmaking* (Indianapolis, 1978), p. 70.

55 For the term 'scopic regime', see Martin Jay, 'Scopic Regimes of Modernity' in Hal Foster, ed., *Vision and Visuality* (Seattle, 1988), pp. 3–23.

7 COMMODITIES

1 Victor Burgin, *The End of Art Theory: Criticism and Postmodernity* (Basingstoke and London, 1986), p. 171. Burgin's own book was presumably conceived by its commercial publisher, MacMillan, as having exchange value: at least, I paid for my copy.

2 For example, the theoretically inclined art historian Michael Ann Holly expressed the following opinion: '[M]any art historians, like acolytes, still devotionally move about under the conviction that their labors are serving sacred objects, perhaps because the objecthood of such objects is so sacrosanct, often valued as they are in the millions of dollars' (Michael Ann Holly, *Past Looking: Historical Imagination and the Rhetoric of the Image* [Ithaca, NY and London, 1996], p. 80: a metaphorical ascription of an undemonstrated quality followed by a non sequitur).

3 *Ibid.*, p. 75.

4 Jean Baudrillard, *Le système des objets* (Paris, 1968).

5 Martin Heidegger, 'The Thing' (originally published as 'Das Ding', 1951) in *Poetry, Language, Thought*, trans. Albert Hofstadter (New York, 1975), pp. 165–86, the passage quoted being on p. 167.

6 Theodor Adorno, *Minima Moralia: Reflections from Damaged Life*, trans. E.F.N. Jephcott (London, 1978; 1st German edn, Frankfurt-am-Main, 1951), §49, p. 79.

7 Arjun Appadurai, 'Commodities and the Politics of Value' in Arjun Appadurai, ed., *The Social Life of Things: Commodities in Cultural Perspective* (Cambridge, 1986), pp. 9–13, 17: 'The commodity is not one kind of thing rather than another, but one phase in the life of some things.'

8 Igor Kopytoff, 'The Cultural Biography of Things: Commoditization as Process' in Appadurai, *The Social Life of Things*, pp. 64–91.

9 Nelson Goodman, *Ways of Worldmaking* (Indianapolis, 1978), pp. 66–7.

10 Appadurai, 'Commodities and the Politics of Value', p. 16: he appeals to the categorization of commodities proposed by Jacques Maquet.

11 An object can be de-accessioned from a museum's collection, yet retained for such purposes as destructive technical research, or office furnishing or decoration.

12 This is not necessarily the case: destruction of the de-accessioned object is another (rare) possibility, restitution to a claimant yet another.

13 A strong argument can be made that the structural consequences –

specifically leading to censorship – of de-accessioning for financial gain lead to a weakening of the institutions concerned in terms of their perceived scholarly status. In the USA, where university scholars set great store by academic freedom, and seek to protect its – and their – interests by means of tenure, art museums, where academic freedom is demonstrably more equivocal, tend not to flourish as sites of scholarship in terms of academic esteem. In countries such as the United Kingdom and France, where de-accessioning is generally not practised, the scholarly status of at least nationally run art museums is correspondingly higher, and quite on a par with the most distinguished academic institutions.

14 An example is the attribution of works on loan from the Clowes Bequest and works acquired through the Clowes Bequest Fund on loan at the Indianapolis Museum of Art. Numerous attributions that are clearly insupportable from a scholarly point of view have been retained on the object labels.

15 Lawrence Gowing, *Vermeer* (London, 1952; 3rd edn [Berkeley, 1997]); Norman Bryson, *Vision and Painting: The Logic of the Gaze* (New Haven and London, 1983), pp. 111–16; Daniel Arasse, *Vermeer: Faith in Painting*, trans. Terry Grabar (Princeton, 1994; first published as *L'ambition de Vermeer* [Paris, 1993]).

16 As well as paying for my copy of Burgin, *The End of Art Theory*, I also paid for my copy of Holly, *Past Looking*. Furthermore, she, like me, holds a position that affords remuneration derived substantially from income from investments or the sale of services.

17 Frances Suzman Jowell, 'Thoré-Bürger – A Critical Role in the Art Market' (*Documents for the History of Collecting*, XXI), *Burlington Magazine*, CXXXVIII (1996), pp. 116, 118.

18 Goodman, *Ways of Worldmaking*, p. 57.

19 The self-delusion of academics who believe themselves exempt from involvement in the commodification of knowledge was discussed witheringly by Theodor Adorno. He concludes, 'He who offers for sale something unique that no-one wants to buy, represents, even against his will, freedom from exchange' (Adorno, *Minima Moralia*, §41, pp. 66–8).

20 For example, the publications of Gustav Waagen (*Kunstwerke und Künstler in England und Paris* [1837–9]; *Kunstwerke und Künstler in Deutschland* [1843–5]; *Treasures of Art in Great Britain* [1854]; *Galleries and Cabinets of Art in Great Britain* [1857]; *Die Gemäldesammlung in der Eremitage zu St Petersburg und ander dortige Kunstsammlungen* [1864]; *Die vornehmsten Kunstdenkmäler in Wien* [1866–7]). This could be said of Passavant too (for example: *Kunstreise durch England und Belgiën* [1833]; *A Tour of a German Artist in England* [1836]; *Galerie Leuchtenberg: Gemälde-Sammlung Seiner Kaiserlich Hocheit des Herzogs von Leuchtenberg in München* [1851]).

21 Johann David Passavant, *Rafael von Urbino und sein Vater Giovanni Santi*, 3 vols (Leipzig, 1839–58).

22 John Smith, *A Catalogue of the Works of the Most Eminent Dutch, Flemish and French Painters*, 9 vols (London, 1829–42). Smith's achievement remains the basis of most subsequent oeuvre definition in the field of seventeenth-century Dutch art, for Cornelis Hofstede de Groot's own monumental catalogue of the Dutch school was explicitly based upon it (Cornelis Hofstede de Groot, *Beschreibendes und kritisches Verzeichnis der Werke der hervorragendsten holländischen Maler des XVII. Jahrhunderts* [Esslingen and Paris, 1907–28]). That in turn forms the basis of the research apparatus of the Rijksbureau voor Kunsthistorische Documentatie, the great art-historical photographic and document archive in The Hague, which is indispensable to all scholars in the field.

23 See Karl Marx, *Capital: A Critical Analysis of Capitalist Production*, ed. Friedrich Engels, trans. Samuel Moore and Edward Aveling from 3rd

German edn (London, 1889), pp. 41–3, on the object as commodity and its exchange value.

24 One painting by Vermeer – *The Concert* – has been (in Appadurai's terms) recommodified by diversion – that is, theft – though precisely in what manner its disappearance means we are not in a position to understand.

25 Elaine Scarry, *The Body in Pain: The Making and Unmaking of the World* (Oxford and New York, 1985), p. 179. 'That a social relation of production takes the form of an object existing outside of individuals, and that the definite relations into which individuals enter in the process of production carried on in society, assume the form of specific properties of a thing, is a perversion and [a] by no means imaginary, but prosaically real, mystification marking all social forms of labor' which create exchange value' (Karl Marx, *A Contribution to the Critique of Political Economy*, trans. N. I. Stone from 2nd German edn [Chicago, 1904], pp. 30–31, as quoted in Maynard Solomon, ed., *Marxism and Art: Essays Classic and Contemporary* [Brighton, 1979], pp. 38–9).

8 DONORS

1 See, among others, studies exhibiting a wide range of competence, such as Ivan Karp and Steven D. Lavine, eds, *Exhibiting Cultures: The Poetics and Politics of Museum Display* (Washington, DC and London, 1991); Eilean Hooper-Greenhill, *Museums and the Shaping of Knowledge* (London and New York, 1992); Douglas Crimp, *On the Museum's Ruins* (Cambridge, MA and London, 1993); Daniel J. Sherman and Irit Rogoff, eds, *Museum Culture: Histories, Discourses, Spectacles* (Minneapolis, 1994); Tony Bennett, *The Birth of the Museum: History, Theory, Politics* (London and New York, 1995); Carol Duncan, *Civilizing Rituals: Inside Public Art Museums* (London and New York, 1995); Donald Preziosi, 'Brain of the Earth's Body: Museums and the Framing of Modernity' in Paul Duro, ed., *The Rhetoric of the Frame: Essays on the Boundaries of the Artwork* (Cambridge, 1996), pp. 96–110; David Phillips, *Exhibiting Authenticity* (Manchester and New York, 1997).

2 See in particular, Duncan, *Civilizing Rituals*, pp. 72–101, 'Something Eternal: The Donor Memorial'.

3 Even handbooks are generally coy on the issue of finance. See, for example, G. Ellis Burcaw, *Introduction to Museum Work*, 2nd edn (Nashville, TN, 1983), pp. 41–3. Bruno S. Frey and Werner W. Pommerehne, *Muses and Markets: Explorations in the Economics of the Arts* (Oxford and Cambridge, MA, 1989), pp. 61–77, provide a dispassionate introductory analysis. See also Karl E. Meyer, *The Art Museum: Power, Money, Ethics: A Twentieth-Century Fund Report* (New York, 1979); Hans Haacke, 'Caught Between Revolver and Checkbook' in Olin Robison, Robert Freeman and Charles A. Riley, II, eds, *The Arts in the World Economy: Public Policy and Private Philanthropy for a Global Cultural Community* (Hanover, NH and London, 1994), pp. 95–101; and Marilyn Laurie, 'Corporate Funding for the Arts' in Robison, Freeman, and Riley, *The Arts in the World Economy*, pp. 67–76.

4 See the fundamental study by Paul DiMaggio, 'Cultural Entrepreneurship in Nineteenth-Century Boston: The Creation of an Organizational Base for High Culture in America', *Media, Culture and Society*, IV (1982), pp. 33–50, 303–22.

5 See, for example, *Campaign for a New Century: Harvard University Art Museums* (Cambridge, MA, 1995), pp. 15, 19, 23, 'Naming Opportunities'.

6 This is discussed in the case of universities by Igor Kopytoff, 'The Cultural Biography of Things: Commoditization as Process' in Arjun Appadurai, ed., *The Social Life of Things: Commodities in Cultural Perspective* (Cambridge, 1986), p. 77.

7 *Ibid.*

8 The terms of Altman's will of 1909 were extremely strict, enjoining that all Altman's works of art ('paintings, statuary, rock crystals, Limoges enamels') should be in a single gallery, next to another containing his Chinese porcelains. He even stipulated that the paintings should be hung 'in a single line, and not one above the other'. As Calvin Tomkins noted, 'the terms of the bequest have been interpreted rather ingeniously since 1913 (the two adjoining rooms giving way to a somewhat meandering procession of Altman's pieces through several galleries)' (Calvin Tomkins, *Merchants and Masterpieces: The Story of the Metropolitan Museum of Art* [New York, 1970], pp. 169–74).

9 A recent example is the seamless incorporation of the Annenberg Collection within the radically remodelled nineteenth-century European paintings and sculpture galleries that opened in 1993. Mieke Bal's discussion of curator Gary Tinterow's installation is a tour de force of patronizing incomprehension (Mieke Bal, *Double Exposures: The Subject of Cultural Analysis* [London and New York, 1996], pp. 97–112), but at least she recognizes an authorial responsibility, though perhaps only because of the simultaneous publication of an accompanying book (Gary Tinterow, *The New Nineteenth-Century European Paintings and Sculpture Galleries* [New York, 1993]).

10 Felicity Owen and David Blayney Brown, *Collector of Genius: A Life of Sir George Beaumont* (New Haven and London, 1988), pp. 209–17.

11 See Gregory Martin, 'The Founding of the National Gallery in London', *Connoisseur*, CLXXXV (1974), pp. 280–87; CLXXXVI (1974), pp. 24–31, 124–8, 200–207, 272–9; CLXXXVII (1974), pp. 48–53, 108–13, 202–5, 278–83; Duncan, *Civilizing Rituals*, pp. 34–47.

12 The list of members is published in the *National Gallery Report* annually: for example, see *The National Gallery Report, April 1996–March 1997* (London, 1997), p. 10, listing 165 members, one of whom died during the course of the year. Three members were also among the sixteen trustees. The *Report* states the purpose of the group as follows: 'Members of the George Beaumont Group, named after the Gallery's first benefactor, each make a donation to the Gallery which is used for projects that it would not otherwise be able to fund.'

13 'The Corporate Benefactors Scheme was launched to provide the National Gallery with a continuing source of much needed funds. Each member company commits itself to supporting the Gallery at a level of £25,000 per annum for a period of three years. Participating companies are encouraged to become involved in a wide range of Gallery activities and special events. Corporate Benefactors may also host a reception or dinner in the Gallery once a year' (*National Gallery Report 1997*, p. 96). The scheme was launched in June 1991 (*The National Gallery Report, April 1992–March 1993* [London, 1993], p. 54).

14 'The Gallery needs to seek business sponsorship for a wide range of activities from comparatively small amounts for printed material to much larger investment in its exhibitions programme. Corporate assistance is also sought for the purchase of major items of equipment and the funding of new or temporary posts within the Gallery. In return the Gallery is able to offer sponsors valuable benefits, including opportunities for corporate entertaining, privileged access to the Gallery's exhibitions and permanent Collection, and significant publicity' (*National Gallery Report 1997*, p. 96).

15 The National Gallery incorporates into its fund-raising structure the distinction between corporate donation and corporate sponsorship, acknowledging vital business practice. See Laurie, 'Corporate Funding for the Arts', pp. 69–70.

16 *National Gallery Report 1997*, pp. 8, 96.

17 *The National Gallery Report, April 1995–March 1996* (London, 1996), p. 44.

18 *Ibid.*, p. 68.

19 *Ibid.*, p. 78.
20 *National Gallery Report 1997*, pp. 57–8.
21 'The Hanging's Too Good for Them' (editorial), *Burlington Magazine*, CXXXI (1989), pp. 3–4.
22 This case is further discussed, and set in context, in Ivan Gaskell, 'History of Images' in Peter Burke, ed., *New Perspectives on Historical Writing* (Cambridge, 1991), esp. p. 181.
23 *National Gallery Report 1996*, pp. 37–8.
24 See Gaston Bachelard, *The Poetics of Space*, trans. Maria Jolas, rev. edn (Boston, 1994), pp. 17–29. The spatial antithesis of the platforms of Room 28 in the National Gallery was (in Bachelard's terms) the 'cellar', reached until 1993 by descent of a spiral staircase, and devoted to the relative confusion and crowding of the reserve collection. Bachelard identifies the topmost spaces in a building (the attic) with solitary reverie and rationalization, and the cellar with irrationality, fear and oneirism.
25 *National Gallery Report 1996*, p. 37.
26 *Ibid.*, p. 38.
27 Conversation with David Jaffé, senior curator, and Axel Rüger, curator of Dutch paintings, August 1999, who favoured Christopher Brown's Fry-inspired hanging of the Vermeers and Saenredams in Room 16.
28 *National Gallery Report 1996*, p. 44; *National Gallery Report 1997*, p. 68.
29 *National Gallery Report 1996*, p. 44. In the 1997 *Report* the Government of Flanders, the Wolfson Foundation, Mr Robert Noortman and the Richard Green Gallery are acknowledged among the Friends and Benefactors, while Jill Capobianco, Noortman's London associate, appears for the first time as a member of the George Beaumont Group (*National Gallery Report 1997*, pp. 9–10).
30 *National Gallery Report 1997*, p. 54.
31 Such ideas were professed to, and articulated in, the House of Commons *Report from the Select Committee on Arts and Their Connection with Manufactures*, delivered in 1836, discussed by Duncan, *Civilizing Rituals*, pp. 43–7, with further references. I owe my understanding of Neil MacGregor's principles to our several conversations on museum ideals.
32 For an application of this Foucauldian thesis to London in the 1880s and 1890s, see Seth Koven, 'The Whitechapel Picture Exhibitions and the Politics of Seeing' in Sherman and Rogoff, *Museum Culture*, pp. 22–48.
33 See, for example, Colleen Denney in Susan P. Casteras and Colleen Denney, eds, *The Grosvenor Gallery: A Palace of Art in Victorian England*, exh. cat., Yale Center for British Art, New Haven, Denver Museum of Art and Laing Art Gallery, Newcastle upon Tyne (New Haven and London, 1996), pp. 9–36, discussing the Grosvenor Gallery of 1877. A contemporary commercial gallery that retains much of its late nineteenth-century appearance is the first-floor gallery of the premises of Thomas Agnew and Sons Ltd at 43 Old Bond Street.
34 *The National Gallery Report, April 1997–March 1998* (London, 1998), p. 51, caption.
35 For example, I had no idea that Max Factor meant anything more than a range of cosmetics until I had the pleasure of meeting him in Los Angeles.
36 Daniel J. Sherman, 'Quatremère/Benjamin/Marx: Art Museums, Aura, and Commodity Fetishism' in Sherman and Rogoff, *Museum Culture*, p. 123.
37 Ivan Gaskell, review of Douglas Crimp, *On the Museum's Ruins* (1993) (and other books on art museums), *Art Bulletin*, LXXVII (1995), pp. 673–5.
38 For instance, John Walsh, having read this chapter in draft, remarked that Galleries 16 and 17, where until recently the Dutch cabinet pictures were displayed, uniquely in the National Gallery appeared to emulate dealers' showrooms where such paintings are exhibited under powerful spotlights to flattering effect.

39 The extension is known after its designer, Edward Middleton Barry, as the Barry Rooms. The Peel Collection was shown in what was then Room 16, now Room 31. See *Illustrated Catalogue to the National Gallery (Foreign Schools)*, with notes by Henry Blackburn (London, 1878), plan.

40 Duncan, *Civilizing Rituals*, p. 42.

41 MS will of Wynn Ellis, 18 November 1875, fol. 2 (copy in the National Gallery Archive). For Wynn Ellis, see Ivan Gaskell, *National Gallery Master Paintings from the Collection of Wynn Ellis of Whitstable*, exh. cat., Royal Museum, Canterbury (Canterbury, 1990).

42 Then Room 11, now Room 41. See *Illustrated Catalogue to the National Gallery (Foreign Schools)*, plan, and pp. 24–37 for descriptions of the works and a plan of their disposition in the gallery.

43 *The National Gallery Report, April 1991–March 1992* (London, 1992), p. 32; *National Gallery Report 1997*, p. 78. The National Gallery's courtship of Heinz Berggruen appeared to bring to a head the issue of the chronological division of responsibility between itself and the Tate Gallery. 'Under a four-year agreement with the Tate, 1900 is now taken as the dividing line between the two Collections' (*National Gallery Report 1997*, p. 5).

44 Gaskell, review of Crimp, *On the Museum's Ruins*, p. 675.

45 'Rooms 16, 17, 18. These rooms were rebuilt with the generous help of MISS PILAR FLICK, MR DANIEL KATZ AND MR CECIL LEWIS, February 1991'. Daniel Katz is a leading London sculpture dealer.

46 Nelson Goodman, *Ways of Worldmaking* (Indianapolis, 1978), pp. 66–7: 'In crucial cases, the real question is not "What objects are (permanently) works of art?" but "When is an object a work of art?" – or more briefly, as in my title, "When is art?"' His argument is not the same as the institutional theory of art propounded by George Dickie (see, principally, George Dickie, *Art and Aesthetics: An Institutional Analysis* [Ithaca, NY, 1974], and George Dickie, *The Art Circle: A Theory of Art* [New York, 1984]), nor yet that put forward by Arthur C. Danto (see Arthur C. Danto, *The Transfiguration of the Commonplace: A Philosophy of Art* [Cambridge, MA and London, 1981]).

47 For a sophisticated discussion of such strategies, their origins and consequences, see Thierry de Duve, *Kant After Duchamp* (Cambridge, MA and London, 1996).

48 Communication from the curator of European decorative arts and sculpture and ancient art, Ian Wardropper. (A predecessor, Leonid Tarassuk, consulting curator of arms and armour, was responsible for the acquisition.) He points out that the Institute has other twentieth-century arms, though in January 1999 the Wielgus pieces were the only ones on display. They were the subject of an exhibition at the Institute, 'Arms and Art: American and European Firearms Decorated by Raymond J. Wielgus', 16 March–12 June 1988 accompanied by a brochure by Leonid Tarassuk.

49 This is not to deny that some firearms were embellished contemporaneously: the practice has a long tradition.

50 This myth found its most potent expression in the Wild West shows at the turn of the century of William F. Cody ('Buffalo Bill'), Owen Wister's novel, *The Virginian: A Horseman of the Plains* (1902), and its many derivatives, and the Hollywood Western film, which reached its climactic manifestation during the Cold War in the early 1950s. Emblematic of that genre's espousal of the gun are *High Noon* (1952; directed by Fred Zinneman, screenplay by Carl Foreman after *The Tin Star*, by John W. Cunningham), and *Shane* (1953; directed by George Stevens, screenplay by A. B. Guthrie jun. after the novel by Jack Schaefer). Both are all the more persuasive that a violent use of firearms provides a solution owing to their heroes' reluctant – though expert – resort to it.

51 The most penetrating modern discussion of the nature of kitsch is that of

Milan Kundera, *The Unbearable Lightness of Being*, trans. Michael Henry Heim (London, 1985), pp. 243–78, esp. p. 248: "'Kitsch' is a German word born in the middle of the sentimental nineteenth century, and from German it entered all Western languages. Repeated use, however, has obliterated its original metaphysical meaning: kitsch is the absolute denial of shit, in both the literal and figurative senses of the word; kitsch excludes everything from its purview which is essentially unacceptable in human existence.' A more laboured account is given by Tomas Kulka, *Kitsch and Art* (University Park, PA, 1996) with references to the philosophical literature.

52 'In 1975, the museum director Thomas T. Solley contacted the Wielguses about acquiring their Biwat flute stopper figure. The purchase of this object by the museum began a partnership that has resulted in a formal agreement committing the Wielgus Collection to Indiana University.' The work is illustrated in the *Guide to the Collections: Highlights from the Indiana University Art Museum* (Bloomington, 1980), p. 236. For other works from the Wielgus Collection, see pp. 215, 227, 238, 239, 241, 243–7, 251–3, 255.

53 Haacke, 'Caught Between Revolver and Checkbook', p. 95. Haacke uses the quotations from Nazi playwright, Hans Johst ('When I hear the word culture, I reach for my revolver'), and from Jean-Luc Godard's film, *Le Mépris* (1963) ('When I hear the word culture, I reach for my checkbook'), to survey the arts caught between social and economic violence.

54 Haacke, 'Caught Between Revolver and Checkbook', p. 99.

55 Mark Thomson's Esso's *Art in the Making*, 1990, was exhibited in *Post-Morality*, Cambridge Darkroom and Kettle's Yard Open Exhibition, 1990: see Ivan Gaskell, ed., *Post-Morality*, exh. cat., Cambridge Darkroom and Kettle's Yard, Cambridge (Cambridge, 1990), p. 20. For the Rembrandt and its X-radiograph, see David Bomford, Christopher Brown and Ashok Roy, *Art in the Making: Rembrandt*, exh. cat., National Gallery, London (London, 1988), pp. 74–9.

56 I owe the terms to Jonathan Rée, 'Strenuous Unbelief' (review of Richard Rorty, *Achieving Our Country* [1998], and *Truth and Progress*, [1998]), *London Review of Books*, XX/20 (1998), p. 8.

57 Martha C. Nussbaum, *The Therapy of Desire: Theory and Practice in Hellenistic Ethics* (Princeton, NJ, 1994), p. 28.

9 THERAPEUTICS

1 Martha C. Nussbaum, *The Therapy of Desire: Theory and Practice in Hellenistic Ethics* (Princeton, NJ, 1994), esp. pp. 13–47. I follow Nussbaum's use of the term 'soul', which 'simply translates Greek *psuche*, and, like that term, does not imply any particular metaphysical theory of personality. It stands, simply, for all the life-activities of the creature . . . its states of awareness, and so forth' (p. 13, n. 2).

2 For the latter, see, most famously, Michel Foucault, *The Birth of the Clinic: An Archaeology of Medical Perception*, trans. A. M. Sheridan Smith (London, 1973; French edn, *Naissance de la clinique: une archéologie du regard médical* [Paris, 1963]).

3 See Charles E. Rosenberg, *The Care of Strangers: The Rise of America's Hospital System* (Baltimore and London, 1987).

4 Pierre Bourdieu, *Homo Academicus*, trans. Peter Collier (Cambridge and Stanford, 1988), pp. 53–69.

5 *Ibid.*, p. 57.

6 I repeat this argument from Ivan Gaskell, 'Writing (and) Art History: Against Writing', *Art Bulletin*, LXXVIII (1996), p. 406. We might observe that Bourdieu invites a military comparison. Although as a disciplinary institution, the foundation of modern armies predates somewhat that of modern hospitals and art museums, the procedure of professional skill acquisition

is comparable in all three cases (see, in particular, John Keegan, *The Face of Battle* [New York, 1976]). Pertinently, the purpose of the skills acquired by soldiers – the efficient and economical infliction of physical and mental incapacity – is the exact opposite of the therapeutic purpose of the skills acquired by the staffs of hospitals and art museums. See Elaine Scarry, *The Body in Pain: The Making and Unmaking of the World* (Oxford and New York, 1985), for a powerful and persuasive exposition.

7 Harvard University Art Museums Archives: Grenville L. Winthrop file.

8 Douglas Crimp, *On the Museum's Ruins* (Cambridge, MA and London, 1993), p. 287.

9 See further, Ivan Gaskell, review of Douglas Crimp, *On the Museum's Ruins* (1993) (and other books on art museums), *Art Bulletin*, LXXVII (1995), pp. 673–5. The starting point for any detailed discussion of this issue is Pierre Bourdieu and Alain Darbel, with Dominique Schnapper, *The Love of Art: European Art Museums and Their Public*, trans. Caroline Beattie and Nick Merriman (Cambridge and Stanford, 1991; 1st edn, in French, Paris, 1969), and Pierre Bourdieu, *Distinction: A Social Critique of the Judgement of Taste*, trans. Richard Nice (Cambridge and Cambridge, MA, 1984; 1st edn, in French, Paris, 1979). However, conditions have changed greatly since Bourdieu and Darbel first published their research on class responses to museum visits in 1969. Furthermore, conditions differ both among cultures and locally from institution to institution.

10 See Carol Duncan, *Civilizing Rituals: Inside Public Art Museums* (London and New York, 1995), pp. 7–20.

11 The warders form a pseudo-military hierarchy, headed by a chief warder, two deputy chief warders and three warder sergeants. The chief warder reports to the head of security (*The National Gallery Report, April 1996–March 1997* [London, 1997], pp. 93–4). The warders are unionized. They participate fully in the British honours system: a means of according recognition for achievement purely symbolically by a finely graded hierarchy of awards that encourages conformity and effort. For example, on his retirement as a warder supervisor in January 1997, Tom Foley was nominated a Member of the Order of the British Empire (MBE) in the New Year Honours List. He had worked as a room warder and warder supervisor for fourteen years, and had been what the *Report* described as a 'dedicated representative of the Supervisors' Branch of the Public Tax and Commerce Union for much of his time' (*National Gallery Report 1997*, p. 59, with an illustration of Mr Foley holding his insignia). The further training of gallery attendants to impart information on the works displayed is an option being pursued in some museums, those in Glasgow being an example.

12 See David Freedberg, *The Power of Images: History and Theory of Response* (Chicago and London, 1989).

13 Neil MacLaren, *National Gallery Catalogues: The Dutch School 1600–1900*, rev. and expanded by Christopher Brown (London, 1991), vol. 1, p. 468.

14 The National Gallery, London has been in the forefront of presenting exhibitions that make explicit the material nature of paintings, and that publicize their conservation treatment. See, for example, Susan Foister, Ashok Roy and Martin Wyld, *Making and Meaning: Holbein's Ambassadors*, exh. cat., National Gallery, London (London, 1997).

15 For example, for a nuanced interpretation of the architecture of the Berlin museums and nationalism, see Françoise Forster-Hahn, 'Shrine of Art or Signature of a New Nation? The National Gallery(ies) in Berlin, 1848–1968' in Gwendolyn Wright, ed., *The Formation of National Collections of Art and Archaeology* (*Studies in the History of Art*, XLVII) (Washington, DC, 1996), pp. 79–99.

16 I am indebted to John Henderson for discussion of this issue.

17 And to complete the Foucauldian imbrication of these institutions, we might note that to see Claus Sluter's greatest sculptural work, the *puit de Moïse*, in Dijon, we must enter a fully functioning mental hospital.

18 Thus a friend in London has claimed to have slept with the *Rokeby Venus* many times.

19 Vladimir Nabokov, *Speak, Memory: An Autobiography Revisited* (New York, 1989; 1st edn, 1967), pp. 235–6.

20 Robin Evans, *Translations from Drawing to Building and Other Essays* (Cambridge, MA, 1997), p. 45.

21 For detailed discussions of claims made for landscape in both art and nature, see Salim Kemal and Ivan Gaskell, eds, *Landscape, Natural Beauty, and the Arts* (Cambridge and New York, 1993).

22 Evans, *Translations from Drawing to Building*, p. 45.

23 A counter-example might be instructive. I recall being at a very heavily visited art museum where the staff had closed the restrooms. It was admitted to me subsequently that this was done with the express purpose of encouraging the flow of visitors through the museum. By doing so, the staff responsible intentionally turned the museum from a site of comfort to one of discomfort.

24 '[O]mne tulit punctum qui miscuit utile dulci,/lectorem delectando pariterque monendo' (*Ars Poetica*, 343–4: Horace, *Satires, Epistle and Ars Poetica*, with an English translation by H. Rushton Fairclough [Loeb Classical Library], [Cambridge, MA and London, 1978; reprint of the rev. edn, 1929; 1st edn, 1926], p. 478).

25 Marilyn Perry, 'The Art Museum and the Public' in Olin Robison, Robert Freeman and Charles A. Riley, II, eds, *The Arts in the World Economy: Public Policy and Private Philanthropy for a Global Cultural Community* (Hanover, NH and London, 1994), p. 77.

26 Among art historians, a recent exception is David Freedberg, *The Power of Images: History and Theory of Response* (Chicago and London, 1989).

27 A succinct discussion of this much debated topic that stresses the medical analogy is given by G.E.R. Lloyd, *Aristotle: The Growth and Structure of His Thought* (Cambridge, 1968), pp. 280–82.

28 As discussed in the *Republic*. See, recently, M. F. Burnyeat, 'Art and Mimesis in Plato's *Republic*', *London Review of Books*, XX/10 (1998) pp. 3–9 (based on the text of the second of two Tanner Lectures on 'Culture and Society in Plato's *Republic*' delivered at Harvard University, December 1997).

29 My membership of the 'Experience of Illness' work group was, on the face of it, anomalous, yet this was not at all the case because of the great breadth of disciplinary interests and skills its extremely diverse membership represented. Arthur Barsky's unconventional approach was largely responsible.

30 Lawrence Weschler, 'Inventing Peace: What Can Vermeer Teach Us About Bosnia? A Three-Hundred-Year-Old Lesson About Fashioning Order in a World of Chaos', *New Yorker* LXXI/37 (20 November 1995), pp. 56–7.

31 *Ibid*., p. 56.

10 SUBJECTS

1 Ralph Waldo Emerson, 'Art' in *Essays: First Series*, 1841 (Ralph Waldo Emerson, *The Selected Writings of Ralph Waldo Emerson*, ed. Brooks Atkinson [New York, 1992; 1st edn, 1940], p. 276).

2 Ivan Gaskell, 'Vermeer and the Limits of Interpretation' in Ivan Gaskell and Michiel Jonker, eds, *Vermeer Studies* (*Studies in the History of Art*, LV) (Washington, DC, 1998), pp. 232–3, n. 7.

3 See, for example, Ivan Karp, Christine Mullen Kreamer and Steven D.

Lavine, eds, *Museums and Communities: The Politics of Public Culture* (Washington, DC and London, 1992), and Tony Bennett, *The Birth of the Museum: History, Theory, Politics* (London and New York, 1995).

4 Especially as he formulated them in Michael Fried, *Absorption and Theatricality: Painting and Beholder in the Age of Diderot* (Berkeley, 1980). We might concede that James Elkins has a point when, in discussing Fried's later elaborations of the conceit (in Michael Fried, *Courbet's Realism* [Chicago, 1990]), he states: 'Michael Fried's influential concept of the composite "painter-beholder" is elaborated . . . into the outlandish neologism "painter-'in'-the-painter-beholder's gaze into the painting", which I would like to read as a marker of one such limitation of this way of talking about perspective' (James Elkins, *The Poetics of Perspective* [Ithaca, NY and London, 1994], p. 254).

5 For interesting recent discussions of *The Art of Painting*, see Daniel Arasse, *Vermeer: Faith in Painting*, trans. Terry Grabar (Princeton, 1994; first published as *L'ambition de Vermeer* [Paris, 1993]), pp. 40–58; Eric Jan Sluijter, 'Vermeer, Fame, and Female Beauty: The *Art of Painting*' in Gaskell and Jonker, *Vermeer Studies*, pp. 265–83; and Hessel Miedema, 'Johannes Vermeer's *Art of Painting*' in Gaskell and Jonker, *Vermeer Studies*, pp. 285–93.

6 See Michael Baxandall, *Patterns of Intention: On the Historical Explanation of Pictures* (New Haven and London, 1985), for a discussion of various forms of intention. For one conceptual artist's view of the issue, see Joseph Kosuth, 'Intention(s)', *Art Bulletin*, LXXVIII (1996), pp. 407–12.

7 Ivan Gaskell, 'Writing (and) Art History: Against Writing', *Art Bulletin*, LXXVIII (1996), p. 405.

8 Richard E. Spear, *Caravaggio and His Followers*, rev. edn (New York, Evanston, San Francisco and London, 1975; 1st edn, exh. cat., Cleveland Museum of Art, 1971), pp. 9, 17, with further references. Both Vincenzo Giustiniani's and Karel van Mander's discussions, though, may be examples of what Michael Baxandall calls inferential criticism (Baxandall, *Patterns of Intention*, pp. 116–17).

9 Martin Heidegger, 'The Thing' (originally published as 'Das Ding', 1951) in *Poetry, Language, Thought*, trans. Albert Hofstadter (New York, 1975).

10 Emerson, *Selected Writings*, p. 276.

11 See, in the first instance, Lucy Lippard, ed., *Six Years: The Dematerialization of the Art Object from 1966 to 1972: A Cross-Reference Book of Information on Some Esthetic Boundaries: Consisting of a Bibliography into Which Are Inserted a Fragmented Text, Art Works, Documents, Interviews, and Symposia, Arranged Chronologically and Focused on So-Called Conceptual or Information or Idea Art with Mentions of Such Vaguely Designated Areas as Minimal, Antiform, Systems, Earth, or Process Art, Occurring Now in the Americas, Europe, England, Australia, and Asia (with Occasional Political Overtones)* (Berkeley, 1997; 1st edn, New York, 1973).

12 An example is the following by Eduardo Costa: 'A piece that is essentially the same as a piece made by any of the first conceptual artists, dated two years earlier than the original and signed by somebody else. (January, 1970)', from the catalogue to the exhibition *Art in the Mind*, Oberlin College, Oberlin, Ohio, 17 April–12 May 1970, quoted in Lippard, *Six Years*, p. 163.

13 Susan Hiller, *Thinking About Art: Conversations with Susan Hiller*, ed. Barbara Einzig (Manchester and New York, 1996), p. 244.

14 Brian O'Doherty, *Inside the White Cube: The Ideology of the Gallery Space* (Santa Monica and San Francisco, 1986; first published in Artforum, 1976), pp. 71–4, ill. p. 75.

15 Norman Bryson, in conversation, eloquently urged this course. I respect his point of view, but it is not my own.

16 Christiane Hertel, *Vermeer: Reception and Interpretation* (Cambridge, 1996).

17 Yve-Alain Bois, *Painting as Model* (Cambridge, MA and London, 1990),

p. 245: the opening words of his essay, 'Painting as Model'.

18 William Hazlitt, *Table Talk, Or Original Essays*, ed. Ernest Rhys (London and New York, 1908; 1st edn, 1824), p. 7.

19 Bois draws attention to Hubert Damisch's exploration of this question, noting that Damisch 'stresses the extent to which the mode of relation of painting to discourse has become in this century, thanks to abstraction and structural linguistics, a particularly necessary stumbling block in the analysis' (Bois, *Painting as Model*, p. 253).

20 Patrick Geary, 'Sacred Commodities: The Circulation of Medieval Relics' in Arjun Appadurai, ed., *The Social Life of Things: Commodities in Cultural Perspective* (Cambridge, 1986), p. 188.

21 David Freedberg, *The Power of Images: History and Theory of Response* (Chicago and London, 1989).

22 Elaine Scarry, *The Body in Pain: The Making and Unmaking of the World* (Oxford and New York, 1985), p. 174.

23 A proponent of 'objects' rights' relating to works of art is my colleague, Peter Nisbet (in a rhetorical rather than in a philosophical sense).

24 James Elkins, *The Object Stares Back: On the Nature of Seeing* (San Diego, New York, and London, 1996).

25 See, in particular, Roland Barthes, *S/Z*, trans. Richard Miller (New York, 1974; first published in French, Paris, 1970).

26 I leave open whether or not this applies to all objects, or only to art objects as a special case.

27 The ideology of individualism takes an extreme form in the USA. Identity politics depends on a mechanism of individual self-recognition or self-designation, followed by a seeking out of other individuals who recognize or designate themselves similarly. It is a politics of individual choice, entirely consonant with the ideology with which it would seem to be at odds. That ideology strives very successfully to suppress recognition of criteria of differentiation that are not a matter of choice, that is, those that are principally economically determined.

28 Nelson Goodman, *Ways of Worldmaking* (Indianapolis, 1978), p. 67.

29 W.J.T. Mitchell, *Iconology: Image, Text, Ideology* (Chicago and London, 1986), p. 42.

30 Fototeca, Harvard University Center for Italian Renaissance Studies, Villa I Tatti, Florence.

31 Ivan Gaskell, 'Valuing Vermeer' in Gaskell and Jonker, *Vermeer Studies*, p. 9, ill. p. 8.

32 Michael Fried, *Manet's Modernism, or, The Face of Painting in the 1860s* (Chicago, 1996), p. 105 (originally published in Michael Fried, 'Manet's Sources: Aspects of His Art, 1859–1865', *Artforum*, VII [March 1969], pp. 28–82).

33 Richard Ormond and Elaine Kilmurray, *John Singer Sargent: Complete Paintings*, vol. I (New Haven and London, 1997), p. 20, n. 9. I owe this reference to Marc Simpson.

34 The literature on casts is considerable and is growing. See, in the first instance, Francis Haskell and Nicholas Penny, *Taste and the Antique: The Lure of Classical Sculpture 1500–1900* (New Haven and London, 1981), pp. 31–6, 79–91. For a leading example of museum practice in this regard (the Victoria & Albert Museum, London), see Malcolm Baker and Brenda Richardson, eds, *A Grand Design: The Art of the Victoria & Albert Museum*, exh. cat., Baltimore Museum of Art, Museum of Fine Arts, Boston, Royal Ontario Museum, Toronto, Museum of Fine Arts, Houston, Fine Arts Museums of San Francisco and Victoria & Albert Museum, London (New York, 1997), pp. 127–32.

35 Albert Boime, 'Le Musée des Copies', *Gazette des Beaux-Arts*, 6ème per., LXIV (1964), pp. 237–47.

36 The change in attitude that dictates a curatorial preference for the original work, even if of lesser quality, over the accurate copy of great canonical objects has been much discussed. For a case study – that of the Fogg Art Museum – see James Cuno, 'Edward W. Forbes, Paul J. Sachs, and the Origins of the Harvard University Art Museums' in James Cuno *et al.*, *Harvard's Art Museums: 100 Years of Collecting* (Cambridge, MA and New York, 1996), pp. 11–35. For a discussion of authenticity in art museum practice, see David Phillips, *Exhibiting Authenticity* (Manchester and New York, 1997).

37 Gustave Vanzype, *Vermeer de Delft* (Brussels, 1908), p. 61: 'Il a compris les relations entre ces chose et l'homme, la solidarité qui les unit en des frémissements communs dans l'atmosphère qui les relies les uns aux autres.'

38 The virginal in the *Music Lesson* has been compared with examples by Antwerp maker, Andries Rucker the Elder (Christopher White, *The Dutch Pictures in the Collection of Her Majesty the Queen* [Cambridge, 1982], p. 144 with further references; see also Arthur K. Wheelock jun., *Vermeer and the Art of Painting* [New Haven and London, 1995], pp. 85–6), but no specific prototype has been proposed for the virginal in the *Woman Standing at a Virginal*.

39 Paul Driver, *Manchester Pieces* (London, 1996), pp. 266–71.

40 *Ibid.*, pp. 247–65.

41 Thomas De Quincey, 'The Afflictions of Childhood' in Thomas De Quincey, *Autobiographical Sketches* (Boston, 1853), p. 39 (original emphases).

42 Henry David Thoreau, *Walden and Other Writings*, ed. Brooks Atkinson (New York and Toronto, 1992; 1st edn, 1937), p. 46.

43 Thoreau's purpose, as he famously expressed it, is inscribed on the commemorative plaque at the site of his cabin at Walden Pond, Concord, Massachusetts: 'I went to the woods because I wished to live deliberately, to front only the essential facts of life, and see if I could not learn what it had to teach, and not, when I came to die, discover that I had not lived.'

44 Thoreau, *Walden*, p. 43.

45 Emerson, *Selected Writings*, pp. 57–8.

46 The dismissive phrase of the glib abstractionist is Donald Preziosi's (Donald Preziosi, 'Brain of the Earth's Body: Museums and the Framing of Modernity' in Paul Duro, ed., *The Rhetoric of the Frame: Essays on the Boundaries of the Artwork* [Cambridge, 1996], p. 103).

47 Benedict Anderson, 'Soaking in Luang Prabang', *London Review of Books*, xx/12 (18 June 1998), p. 23: 'At the stall of a genial, toothless old Hmong woman, for example, I found an elaborately embroidered baby's cap from which a circle of 12 silver alloy coins dangled, while the scarlet tassled top was held in place by a larger, heavier coin with a hole bored through its middle. The larger coin was inscribed: "1938", "Indochine française" and "5 centimes". The smaller ones, dated 1980, have passed out of circulation because they are still etched with the hammer-and-sickle, and because inflation has anyway made them valueless. High colonialism and high Communism, once mortal enemies, now cheek by jowl on the endless junkheap of progress, can still light up a baby's face. Of all the ethnic groups in Laos, the Hmong suffered most severely, first as cannon fodder, cynically exploited by the CIA during the Vietnam War, and later as the object of the Revolutionary Government's suspicion and vengeance. Tens of thousands fled to Thailand and overseas, and many who stayed behind were forced down from their opium-growing hilltops to more supervisable makeshift lowland settlements. One can't help thinking that the baby's cap is a small, mute token of Hmong laughter and refusal.'

48 Susan Stewart, *On Longing: Narratives of the Miniature, the Gigantic, the Souvenir, the Collection* (Durham, NC and London, 1993), p. 136.

49 *Ibid.*, pp. 136–9.
50 Driver, *Manchester Pieces*, p. 271.
51 Or Wim Wenders's 'Die Weisse Wand', the cinema called 'The White Screen' at the conclusion of *Im Lauf der Zeit* (English title, *Kings of the Road*), written and directed by Wim Wenders, 1975.
52 Although they are the subject of much criticism, I still rely greatly on Roland Barthes's reflections on photography: 'He is dead and he is going to die' (Roland Barthes, *Camera Lucida: Reflections on Photography*, trans. Richard Howard [New York, 1981; first published in French as *La chambre claire*, Paris, 1980], esp. p. 95, caption to Alexander Gardner, *Portrait of Lewis Payne* [Abraham Lincoln's assassin], 1865).

Photographic Acknowledgements

The authors and publishers wish to express their thanks to the following sources of illustrative material and/or permission to reproduce it (excluding sources credited in the captions):

Courtesy of the Busch-Reisinger Museum, Harvard University Art Museums: 66, 79 (Friends of the Busch-Reisinger Museum Fund/Katya Kallsen); Courtesy of the Fogg Art Museum, Harvard University Art Museums: 52 (gift of Bernarda Bryson Shahn), 63–5 (Louis Agassiz Shaw Bequest and the Richard Norton Memorial Fund), 70 (purchased with funds donated by Sylvan Barnet and William Burto in honour of John Rosenfield); © Foundation Johan Maurits van Nassau: 26 (inv. no. 54); © The Frick Collection, New York: 10, 42; Harvard University Fine Arts Library: 46, 48, 49, 52; Courtesy of Susan Hiller: 67; Houghton Library, Harvard University: 47; Steve Hutchinson: 79; Michael Kavanagh/Kevin Montague: 76, 78; Courtesy of Hans P. Kraus, Jr., Inc.: 56; David Mathews: 52, 53; © Mauritshuis: 26 (inv. no. 54), 28 (inv. no. 118); Courtesy of Abelardo Morell and Bonni Benrubi Gallery, New York (© Abelardo Morell): 38; Musée des Arts Décoratifs, Paris (all rights reserved): 19; Courtesy of the Museum of Fine Arts, Boston, reproduced with permission (© 1999 Museum of Fine Arts, Boston, all rights reserved): 16; National Gallery Picture Library: 1, 68; Niedersächsisches Landesmuseum, Hannover: 27; Phillips Auctioneers: 29; Photos © President and Fellows of Harvard College, Harvard University: 52, 63–6, 70, 79; © Rijksmuseum-stichting, Amsterdam: 25, 36, 43, 57; RMN/Gérard Blot: 50; Royal Collection Enterprises (© HM Queen Elizabeth II): 60; John D. Schiff: 80; Soprintendenza per i beni artistici e storici (Gabinetto fotografico), Florence: 24; Courtesy of Sotheby's: 12; Staatliche Kunstsammlungen Kassel: 13, 14; Staatliche Museen Preußischer Kulturbesitz/Jörg P. Anders: 37, 44; © Stichting Vrienden van het Mauritshuis: 7 (inv. no. 670), 40 (inv. no. 92); By Permission of the Trustees of Dulwich Picture Gallery: 18; V&A Picture Library (© the Board of Trustees of the Victoria & Albert Museum): 17; Elke Walford: 53; Trevor Yorke (© Philip Steadman): 58, 59.